Painting in Renaissance Venice

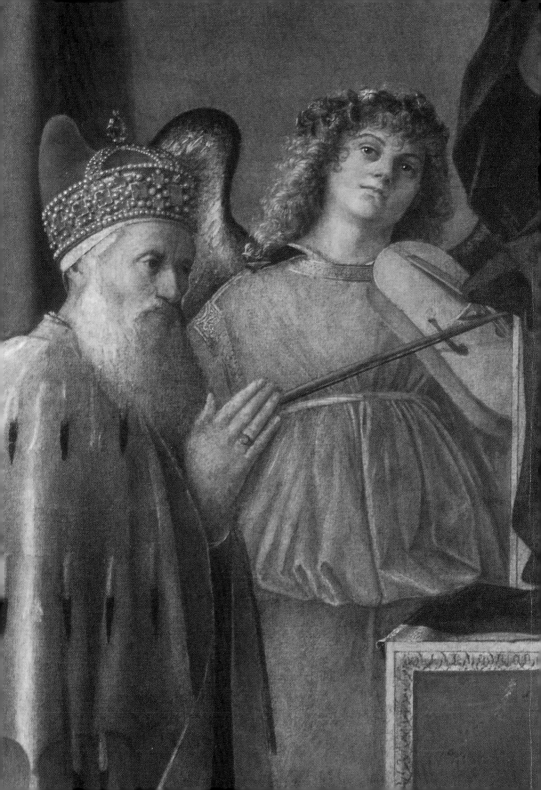

Painting in
Renaissance Venice

PETER HUMFREY

YALE UNIVERSITY PRESS
New Haven and London

For my mother,
Mary Katherine Humfrey

Frontispiece: Giovanni Bellini.
Votive Picture of Doge Agostino Barbarigo.
Detail of Pl. 74.

Endpapers: Titian. *Bacchus and Ariadne.*
Detail of Pl. 110.

Designed by Gillian Malpass
Set in Linotron Sabon by Best-set Typesetter Ltd, Hong Kong
Printed in Hong Kong through World Print Ltd

Library of Congress Cataloging-in-Publication Data
Humfrey. Peter. 1947–
Painting in Renaissance Venice / Peter Humfrey.
Includes bibliographical references and index.
ISBN 0-300-06247-8
1. Painting, Italian – Italy – Venice.
2. Painting, Renaissance – Italy – Venice. I. Title.
ND621.V5H77 1995
759.5′31′09024 – dc20
94-35348
CIP

A catalogue record for this book is available from
The British Library

Contents

Foreword

This book is meant as a brief introduction to painting in Renaissance Venice (1440–1590) and is aimed primarily at the non-specialist. As its title implies, it is not concerned with all the painting of the period that might be described as Venetian, but only with that produced in or for the city of Venice. In other words, the work of painters active mainly on the Venetian mainland such as Pordenone or Jacopo Bassano, or of emigrant Venetian painters such as Lotto, has been relatively neglected. Included, in part compensation, are works by a number of non-Venetian artists, such as Antonello da Messina, Albrecht Dürer and Francesco Salviati, which were painted for Venetian patrons and which may be considered to have made an impact on the local scene. As a way of disencumbering the text of biographical information, short biographies of the main painters are included in an appendix.

During the preparation of the book I have benefited from kind assistance and wise counsel from the following colleagues and friends: Deborah Howard, Paul Joannides, Mauro Lucco and Nicholas Penny. I am grateful also to the British Academy for awarding me travel grants to study Venetian paintings in Paris in 1993 and Madrid in 1994; and to Gillian Malpass of Yale University Press for all her unflagging help and encouragement. Very special thanks, as always, to Margaret, Nicholas and Joseph.

St Andrews, April 1994

Introduction

In the winter of 1545–6 the great Venetian painter Titian paid his first
and only visit to Rome. Part of his reason for making the long journey
from Venice was to deliver his picture of *Danaë* (Pls 1, 4) to his patron
Cardinal Alessandro Farnese, grandson of the reigning pope, Paul III.[1] By
this date Titian was middle-aged and had long been celebrated as the
presiding genius of Venetian painting. As if to justify this reputation to his
Roman public, the artist displayed in his picture many of the charac-
teristics that had already come to be associated – and have been associated
ever since – with Venetian painting in general.[2]

Probably the most immediately striking of these characteristics is the
radiant warmth and intensity of the colour. Although in this particular
work Titian employs a relatively limited range of hues, the overall effect is
still one of great chromatic richness and splendour. Complementing this is
the treatment of light which, by playing over the surfaces of the forms, and
even by seeming to glow from within them, enhances the illusion of
sensuous physical presence; while at the same time, the equally vibrant
areas of shadow evoke a hidden, poetic dimension beyond the world of the
senses. The air is thick, edges are blurred, and forms – like that of the
golden cloud, which spills down coins onto the lap of the reclining girl–
seem constantly on the point of change. All these effects are achieved
thanks to the artist's unprecedented ability to exploit the full range of
resources – expressive and aesthetic, as well as technical – accessible to the
medium of oil painting.

The unmistakably Venetian qualities of the *Danaë* are more, not less,
evident for the fact that Titian has taken account of the Roman destination
of his picture by paying homage to classical antiquity in the figure of
Cupid, and to Michelangelo – the much-venerated leader of the central
Italian artistic tradition – in the figure of Danaë herself. The reclining pose,

1 Titian. Detail of Pl. 4.

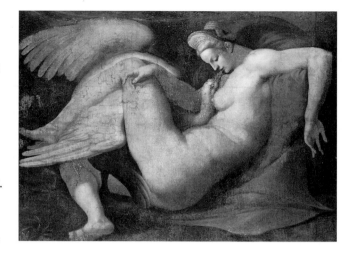

2(right) After
Michelangelo.
Leda. Canvas,
105 × 141 cm.
London, National
Gallery.

3(below) Vasari.
Patience (1542).
Panel, 77 ×
184 cm. Rome,
private collection.

with one knee drawn upwards, is clearly related to that of Michelangelo's now-lost painting of *Leda* (Pl. 2), and more generically, to his *Night* in the Medici chapel in Florence.[3] Michelangelo had been living in Rome since 1534, and Titian must have known that he would meet him there. Indeed, the biographer of both artists, Giorgio Vasari, was later to provide a detailed description of his visit to see the *Danaë* in the company of Michelangelo, and of the great sculptor's reaction to Titian's picture. According to Vasari, Michelangelo had much praise for its colouring (*colorito*), naturalness and power to entrance. But he deplored its defective *disegno* – that is to say, its draughtsmanship, and the quality of its design.[4]

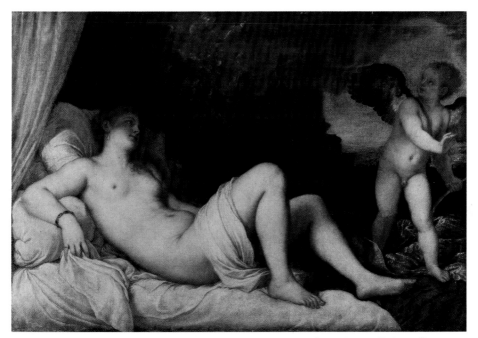

4 Titian. *Danaë* (1545–6). Canvas, 120 × 172 cm. Naples, Museo di Capodimonte.

There is some truth in this criticism, even if one does not share the aesthetic preconception on which it is based. The girl's left leg, for example, is not correctly drawn according to academic standards; and the picture lacks the taut, Michelangelesque design and sculptural surfaces of much of central Italian painting of the period, including that of Vasari himself. In his allegorical representation of *Patience* (Pl. 3), painted four years earlier for the ceiling of a Venetian private palace,[5] Vasari had typically composed his main figure as if it were a piece of relief sculpture; and, as in Michelangelo's *Leda*, the limbs are artificially arranged parallel to the picture plane, and flesh and draperies alike are treated as if carved in marble. Clearly, instead of accommodating himself to local tradition, Vasari sought to provide his Venetian hosts with an almost programmatic demonstration of what he regarded as the superior artistic style of Rome and Florence. Conversely, Titian in the *Danaë* – and also in the triple portrait he painted in Rome of *Pope Paul III and his Grandsons* (Pl. 148) – set out to dazzle his non-Venetian audience with his own, characteristically Venetian, style, based on colour, light and sensuous realism.

Titian was not the first to introduce these qualities into Venetian painting. There obviously exist great differences of style and mood between the *Danaë*, a pagan mythology, and a major religious work such as the S. Giobbe altarpiece (Pl. 5), painted more than sixty years earlier by Giovanni Bellini, Titian's predecessor as leader of the Venetian school. But in contrast to the work of later fifteenth-century Florentine painters such as Botticelli, with their relatively cool colour range and emphasis on sharp, clear outlines, Bellini's picture already shows the warm, atmospheric radiance of Titian's *Danaë*. Similarly, too, while revealing the material substance and surface properties of the forms, the pictorial light also serves to evoke a transcendental world of the spirit. In this case, it is as if the fictive chapel in which the saints stand is filled with the presence of God.

As is suggested by the inclusion in the S. Giobbe altarpiece of the golden semi-dome, with its Byzantine-style mosaics, Bellini was in turn deeply conscious of local artistic tradition, which by the Renaissance period was already several centuries old. It is important to emphasise the longevity and continuity of this tradition at the outset of this book, since the relatively short period covered by it was one of constant artistic innovation and change. In 1440, when Bellini was still a child, the prevailing pictorial style in Venice was still that of the late Gothic; in 1590, sixteen years after Titian's death, European painting stood on the threshhold of the baroque. It will be one of the main tasks of the book to trace how painting in Venice developed during the intervening century and a half, often in response to a wide range of influences from outside. Indeed, part of the greatness of Venetian Renaissance painting lies precisely in its dynamism, in its capacity for constant self-renewal. But another part lies in its inner strength, in its capacity to absorb outside influences and to assimilate them ino its own distinctive tradition; and an underlying theme of the book will accordingly be this continuing awareness among Venetian painters of their own artistic heritage.

When visiting Rome, Titian had more than his own professional reputation at stake. As quasi-official painter to the Venetian government, he was in a sense also acting as an ambassador, charged with the responsibility of upholding the dignity of the Most Serene Republic in a foreign capital. Although Titian's status made him in many ways exceptional among Venetian painters, all of them would have shared a sense of patriotic mission that went beyond purely artistic considerations. Like all Venetians, the painters would have felt a keen pride in the uniqueness of their city, as symbolised visually by its wonderful physical situation in the middle of the sea, and as manifested in its unique and apparently unchanging political,

4

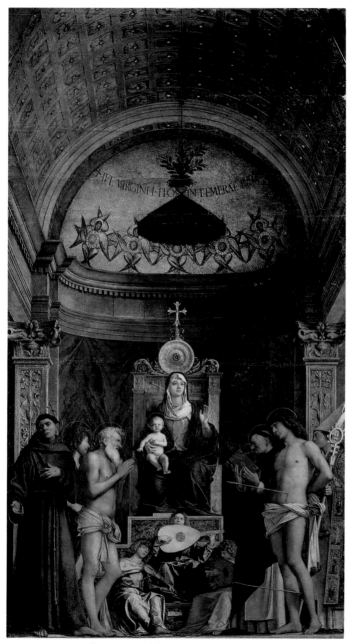

5 Giovanni Bellini. S. Giobbe altarpiece (*c.*1480). Panel, 471 ×
258 cm. Venice, Accademia.

religious and social institutions. To the extent that these physical and cultural conditions provided the background against which Venetian painters lived and worked, it is worth briefly looking at them in more detail here, before we turn in subsequent chapters to look at the way in which painting in Venice developed during the Renaissance.

Geography

Then as now the city of Venice, built in the sea, with canals for streets, was a wonder of the world (Pl. 6). A reaction typical of many foreign visitors is that expressed in 1494 by the French ambassador, Philippe de Commynes:

> I marvelled greatly to see the placement of this city and to see so many church towers and monasteries, and such large buildings, and all in the water; and the people have no other form of locomotion except by these barges, of which I believe thirty thousand might be found.

6 F. Hogenberg. *Perspective View of the City of Venice and its Lagoon* (from G. Braun, *Civitates Orbis Terrarum*, published in Cologne, 1572).

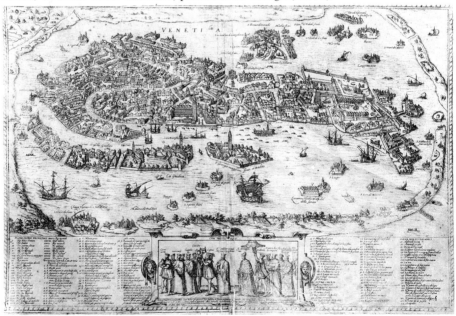

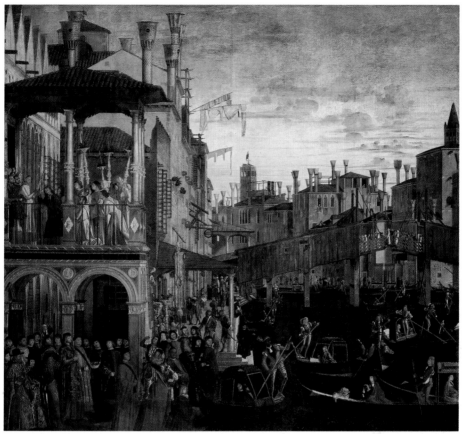

7 Carpaccio. *Miracle at Rialto* (1494). Canvas, 365 × 389 cm. Venice, Accademia.

Commynes goes on to describe the richly painted and marble-clad palaces that lined the Grand Canal, which he calls 'the most beautiful street in the world'; and he ends by declaring Venice to be 'the most sumptuous city which I have ever seen'.[6] A striking visual complement to this verbal evocation of the wealth and bustle of Renaissance Venice, as well as of its extraordinary physical situation, is provided by Carpaccio's *Miracle at Rialto* (Pl. 7), which happens to have been painted in the very year of Commynes's visit.

The unlikely site of Venice, essentially consisting of an archipelago of small islands and mud flats, lying a mile or two off the Italian mainland,

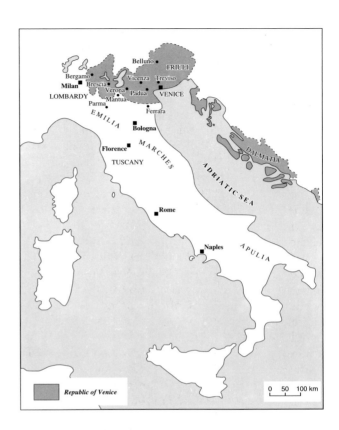

8 Map of Italy, showing the extent of Venetian territorial possessions in the fifteenth and sixteenth centuries.

was originally chosen as a place of refuge by a colony of fishermen during the barbarian invasions that accompanied the collapse of the Roman empire. But during the course of the centuries, Venetian ships travelled increasingly far afield; and in its position in the north-western corner of the Adriatic Sea, Venice was ideally placed to become a centre of trade between east and west, north and south (Pl. 8). The conspicuous wealth admired by Commynes in 1494 was based on almost a millennium of commercial activity, which sent Venetian galleys variously to Alexandria and Beirut in the eastern Mediterranean, to Constantinople and into the Black Sea, round the southern tip of Italy to Sicily and north Africa, and westwards through the straits of Gibraltar to north-western Europe. To protect their commercial interests, the Venetians gradually built up a farflung empire, originally consisting of key ports and islands en route for the Levant, but by the early fifteenth century also covering extensive

8

territories on the Italian mainland, including all of the present-day Veneto, and also the provinces of Brescia and Bergamo in Lombardy. With commercial and territorial expansion went diplomacy, and the Venetians were pioneers in establishing permanent business offices in foreign ports, and later in sending resident ambassadors to the major European courts.

Commynes was much impressed by the large number of foreigners that he saw in Venice; and by comparison with the other great cities of Renaissance Italy – Rome, Florence, Naples, Milan, all situated on the western side of the peninsula – Venice must have appeared not only cosmopolitan, but positively exotic. In particular, centuries of commercial and cultural interchange with the eastern Christian empire had lent earlier medieval art and architecture in Venice a strongly Byzantine character, as is evident above all in the city's most important religious building, the church of San Marco. Built on a Greek-cross plan in imitation of the church of the Apostles in Constantinople, with its five principal cubic spaces all crowned with domes, San Marco was intended from the beginning to be decorated with the utmost material splendour (Pls 9, 10). Thus while the lower parts of the interior walls are sheathed in variegated marbles, the upper parts and vaults are completely covered with mosaics, which glow and shimmer like jewels when caught by the light, before disappearing again into dark, vibrating shadow. The effect of rich luminosity created by the glass tesserae is obviously quite different from that of fresco painting, with its matt surfaces, normal elsewhere in Italy; and as an ensemble, the mosaics of San Marco were clearly intended to convey to the spectator something of the mystery, as well as of the majesty, of heaven.

The continuing importance of San Marco, and of the Byzantine tradition generally, for Venetian painting of the Renaissance period has already been noted in the motif of the golden semi-dome in Bellini's S. Giobbe altarpiece (Pl. 5), where it is combined with a display of sumptuous marble veneer. There are numerous other examples, particularly in this earlier Renaissance phase, of the delight that Venetian painters took in the illusionistic rendition of marbles and mosaics (cf. Pls 15, 63, 65, 72). But on a deeper level, too, the Byzantine background to Venetian painting may be detected in the autonomous expressive power of warm colour and vibrant light already seen both in the S. Giobbe altarpiece and in Titian's *Danaë*.

But Byzantine art was only one ingredient in the melting-pot of Venetian culture. Especially after the conquest of Constantinople by the Turks in 1453, Venetians came into contact with the world of Islam; and the experience is reflected in the frequent subsequent appearance of oriental

9

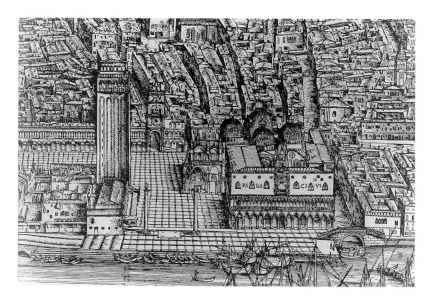

9(above) Jacopo
de' Barbari.
*Perspective View of
Venice* (1500).
Detail showing the
Piazza San Marco.

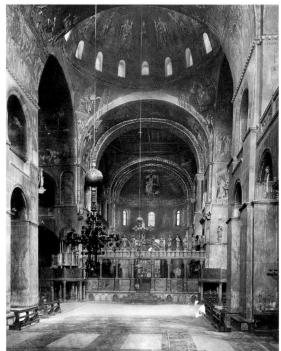

10 Venice, San
Marco. View of
interior.

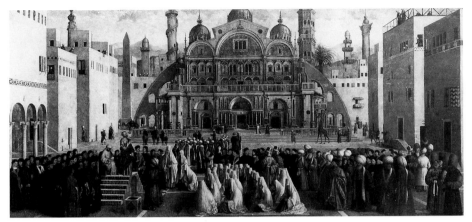

11 Gentile and Giovanni Bellini. *St Mark preaching in Alexandria* (1504–*c*.1510). Canvas, 347 × 770 cm. Milan, Brera.

(or pseudo-oriental) costumes, buildings and other motifs in Venetian painting (cf. Pls 107, 163, 174).[7] A particularly comprehensive example is provided by the huge canvas begun by Gentile Bellini in 1504, and later completed by his brother Giovanni, representing *St Mark preaching in Alexandria* (Pl. 11), in which the large building in the background, while irresistibly recalling the church of San Marco, has assumed an appropriately exotic disguise. Other important non-Italian cultural influences on Venetian Renaissance painting include those from Flanders and from southern Germany. Thanks to the close trading and diplomatic links that existed between Venice and the southern Netherlandish cities of Bruges, Ghent and Brussels, Venice in the second half of the fifteenth century became a major port of entry in Italy for Flemish pictures. In 1451, for example, a panel by the leading Bruges painter Petrus Christus was shipped from Flanders to the Venetian church of S. Maria della Carità; and a few decades later the patrician Bernardo Bembo, on completing his term as ambassador to the court of Burgundy, brought back a devotional diptych by Hans Memling (Pl. 13).[8] Similarly, Venice had closer commercial ties than any other Italian city with Germany; and the large warehouse built by the German merchant community on the Grand Canal at Rialto, known to the Venetians as the Fondaco de' Tedeschi, is visible just beyond the bridge in Carpaccio's painting (Pl. 7). The constant stream of mercantile traffic between Venice and southern Germany made the city the natural first port of call for any traveller from north of the Alps,

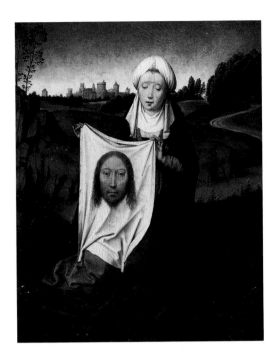

13 Memling. *St Veronica* (?1471). Panel, 32 × 24 cm. Washington, National Gallery of Art, Samuel H. Kress Collection.

including for artists of the importance of Albrecht Dürer, who visited Venice twice in his career, in 1494–5 and in 1505–6 (below pp. 114–15). It was equally natural that German woodcuts and engravings (cf. Pl. 83), for which there existed a lively market in Renaissance Italy, should have arrived first and in greatest numbers in Venice, and should have made a particularly strong impact on local artistic practice.[9]

Conversely, the same well-established network of communications that brought foreign works of art to the city also created a large export market for works of art produced in Venice. By the mid-fifteenth century a leading Venetian workshop such as that of Antonio and Bartolomeo Vivarini was shipping altarpieces, and probably smaller devotional panels as well, to towns and villages situated down both sides of the Adriatic Sea, as far south as Apulia and even Calabria.[10] Antonio's polyptych of 1464, for example (Pl. 44), was painted for the city of Pesaro in the Marches, while Bartolomeo's *Virgin and Child with Saints* of 1465 (Pl. 45) was painted for a church in Bari. Similarly, the westward extension of the Venetian *terraferma* empire meant that customers in the relatively distant provinces of Brescia and Bergamo naturally looked to Venice when commissioning

12 Gentile and Giovanni Bellini. Detail of Pl. 11.

works of art. It is probably true to say, in fact, that Venetian painting was dispersed over a wider geographical area than that of any other Italian centre of the Renaissance period.

Another aspect of Venice's character as a commercial emporium of particular relevance for the history of painting is represented by the trade in artists' materials.[11] Several of the highest-quality minerals used for pigments, most notably lapis lazuli, used to make the rich purply-blue colour called ultramarine, but also orpiment and realgar, used to make yellows and oranges, came to Europe from the Near of Middle East by way of Venice, where they were first processed and made ready for use. Other materials came from less exotic sources: from the eastern Adriatic, from southern Germany, and from the Venetian mainland territories. But whatever the origin, Venetian painters enjoyed privileged access to the whole range of pigments available to artists in the late medieval and Renaissance periods; and, as shown by works such as Bellini's *Feast of the Gods* (Pl. 104), or Titian's *Bacchus and Ariadne* (Pl. 110), or Veronese's *Feast in the House of Levi* (Pl. 180), with their extraordinarily varied and intense colours, the painters exploited their privilege to the full.

On the potentially negative side, the geography of Venice meant that she lacked one of the elements often regarded as a central inspiration behind the civilisation of the Italian Renaissance: the physical remnants of classical antiquity. While all the other major Italian cities could take pride in a history that went back to Roman times, the foundation of Venice was officially placed in the year AD 421. This lack of an antique past did not, as we shall see, preclude an intense antiquarian interest among educated Venetians, which was in turn reflected in paintings such as Titian's *Danaë*, or earlier, in Giorgione's *Sleeping Venus* (Pl. 14). But it is significant that in Venice attitudes towards classical antiquity characteristically assumed a romantic, poetic tinge, as opposed to the more rational and historical approach found elewhere in Italy.

Already by the Renaissance the city of Venice, which comprised one of the largest urban populations in Europe, covered all its available dry land; and although many more areas were given over to gardens and orchards than than now, the character of the city was essentially artificial, with few large, open green spaces. It may seem somewhat paradoxical, therefore, that one of the outstanding contributions of Venice to European art should have been in the area of landscape painting. But, as has often been suggested, it may well have been the very artificiality of the Venetian townscape that instilled in painters and their patrons feelings of nostalgia for the fields, woods and hills of the *terraferma*. Certainly the spirit in

14

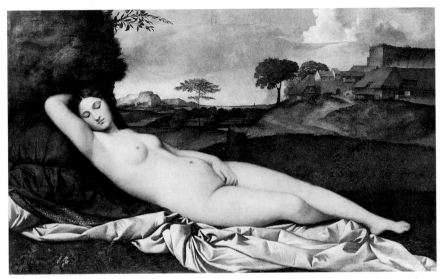

14 Giorgione. *Sleeping Venus* (*c.*1510). Canvas, 109 × 175 cm. Dresden, Gemäldegalerie.

which Venetian painters approached the natural world was characteristically less one of scientific detachment, as it so often was in Florence, than one of emotional engagement, with a highly evocative landscape, as in Giorgione's *Venus*, serving as a lyrical commentary on the human events in the foreground.

Much has also been said in the past about the ways in which the character of Venetian painting might have been affected by the situation of the city in the middle of the water. On a straightforward, practical level, this is evident in the lack of a strong local tradition of fresco painting. This is not to say that frescoes did not exist in Venice: many of the palace façades admired by Philippe de Commynes and represented by Carpaccio, including that of the Fondaco de' Tedeschi, were decorated with frescoes; and since it was certainly not possible to decorate the interior of every Venetian church with mosaics, as in San Marco, fresco was very likely often used as a cheaper substitute. Yet experience had shown that the moist and salty air of the Venetian lagoon condemned frescoes to fade and disappear relatively quickly; and by the end of the fifteenth century the much more durable technique of oil on canvas had come to be preferred for the large-scale decoration of Venetian interiors.

15

The answer to the question of how far, and in what way, the particular quality of light in Venice affected pictorial practice is much more elusive. Contrary to what is sometimes claimed, colours in Venice only rarely match the intensity associated with Venetian painting, and more often the humid, almost palpable atmosphere reduces them almost to monochrome. On the other hand, the same atmosphere tends to soften the edges of forms, obscuring the clarity of their structure, and making them seem to merge with their surroundings in a luminous haze. Furthermore, the shimmering reflections ubiquitously cast by the water onto Venetian buildings may well have stimulated the painters to concern themselves as much with the transient effects of colour, light and air on surfaces as with immutable underlying shapes. To this extent, the characteristically Venetian pictorial qualities of the *Danaë* and the S. Giobbe altarpiece may be related as much to their authors' experience of natural phenomena in the Venetian townscape as to the purely artistic tradition represented by the mosaics of San Marco.

Politics

By the Renaissance it had become commonplace for writers on Venice to see a direct analogy between the unique, seemingly miraculous character of her physical situation and her unique and highly complex political system. Like several of the other Italian city-states that had risen to international prominence during the later Middle Ages, including Florence, Venice was a republic. But unlike Florence and the other cities, Venice did not succumb to autocratic rule during the Renaissance; and, in fact, she was to retain her republican constitution in a remarkably unchanged form right down until the end of the eighteenth century.[12]

The Venetian head of state was the doge. Although this term is literally equivalent to the word 'duke', and by the sixteenth century it had become customary to address the incumbent by the even grander title of 'Most Serene Prince', the doge of Venice was not like dukes and princes elsewhere. His office was elective, not hereditary; and although like that of the pope, he held it for life, his powers of independent action were strictly circumscribed by his electors. Giovanni Bellini's portrait of Doge Leonardo Loredan (Pl. 15), probably painted soon after the sitter's coronation in 1501, is eloquently expressive of his role essentially as a figurehead. Encased within the majestic trappings of his office, and represented with a dignity and authority befitting the head of one of the wealthiest and most

16

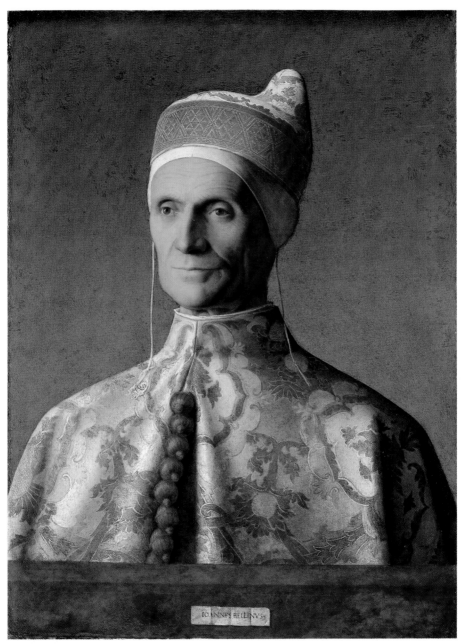

15 Giovanni Bellini. *Doge Leonardo Loredan* (*c*.1501). Panel, 62 × 45 cm. London, National Gallery.

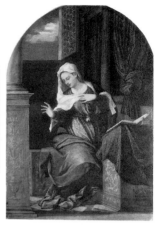

16 Bonifazio de' Pitati. *Annunciation with God the Father* (?1544). Three canvases, cut from a single original: 196 × 135 cm (sides); 166 × 132 cm (centre). Venice, Accademia.

powerful states in the Christian world, Doge Loredan is appropriately reticent in his expression of individual thought and emotion.

The limitation of the doge's personal powers did not mean that the Republic of Venice in any way resembled a democracy. About 95 per cent of the population remained disenfranchised, and the electorate was restricted to the approximately 2,000 male adult members of 150 Venetian families legally defined as patrician, or noble. These 2,000 patricians formed what was called the *Maggior Consiglio*, or Greater Council; and, besides electing the doge, this body elected the members of the various smaller councils, committees and magistracies that conducted the real business of government.

The Venetian constitution had evolved over a period of several centuries, and by the fifteenth century its workings had become highly complicated. But they were largely successful in their prime purpose, which was to prevent the concentration of political power in the hands of a particular individual or family, and thereby also to prevent the factional strife that was so recurrent a feature of politics in the other states of Italy. It was in a spirit of self-congratulation for the harmonious workings of its constitution that Venice styled herself the *Serenissima Repubblica* – the Most Serene Republic.

Already by the middle of the fourteenth century the Venetians' convic-

tion that their own system was superior to that of any other state had been developed by historians and propagandists into a more complex political doctrine, which came to be known as the Myth of Venice.[13] Playing down the evolutionary aspect, the Myth claimed that the Venetian constitution was so just and perfect that it had to be regarded as a gift from God. Furthermore, God had caused Venice to be founded in the year 421 so that a new Christian order would rise out of the ruins of the Roman empire – just as the New Testament had emerged from the Old. It was no accident that the day of the foundation was set at 25 March, the feast of the Annunciation, marking the beginning of the era of Grace. A clear illustration of this nexus of ideas is provided by the tripartite composition by Titian's follower Bonifacio de' Pitati for the offices of a government magistracy (Pl. 16). On the left and right is the Annunciation group, enacting the very moment of the Incarnation of Christ; at the centre is the figure of God the Father hovering over the church of San Marco and the Piazza, and with his arms bringing two miracles into being at once.

Although the Annunciate Virgin makes a frequent appearance in Venetian political iconography, she was not, perhaps, sufficiently distinctive to meet every function demanded of a patron saint. After all, many other Italian cities, most notably Siena, but also Florence, similarly claimed her as their own. Even more ubiquitous in Venice was the image of the evangelist St Mark, whose relics had been physically present in the city since 829.[14] In that year the Venetians, feeling the need to acquire the body of a saint comparable in sanctity and authority to the apostle St Peter, undertook a pious theft, and had the evangelist brought from Muslim Alexandria, where he had been martyred, to Venice, where he was

17 Carpaccio. *Lion of St Mark* (1516). Canvas, 130 × 368 cm. Venice, Doge's Palace.

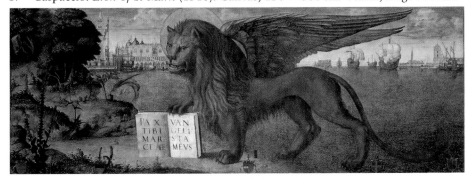

18 Venice, Piazzetta San Marco, with the Doge's Palace and San Marco.

19 Venice, Doge's Palace. View of Sala del Maggior Consiglio, as redecorated after 1577 with Tintoretto's *Paradise* (*c*.1588–92).

20 Anon. View of Sala del Maggior Consiglio before 1577.

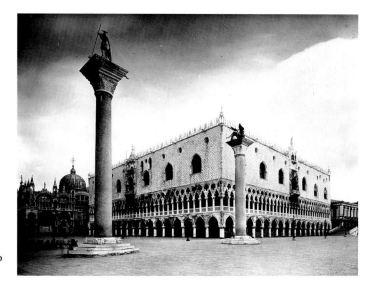

buried under the high altar of the new church dedicated in his honour. As portrayed by Venetian painters, St Mark regularly appears as he does in the scene of his preaching in Alexandria by Gentile and Giovanni Bellini (Pls 11, 12) with a short black beard and a balding head, and dressed in a red robe with a blue cloak (cf. Pls 74, 188). Equally commonly, however, he appears in the guise of his evangelist symbol of the Winged Lion, as in the painting by Carpaccio from another government magistracy (Pl. 17). The inscription on the book PAX MARCE TIBI EVANGELISTA MEUS – 'Peace unto you, Mark my Evangelist' – refers to divine approval of the removal of his body to its final resting-place in Venice. Behind the lion to the right is a view of the Venetian lagoon, and to the left, of the Piazza, with San Marco and the Doge's Palace (cf. Pl. 9).

Carpaccio shows the Doge's Palace as it was rebuilt in the Gothic style of the mid-fourteenth century, and as it survives today (Pl. 18). With its diaper pattern of pink and white marbles in the upper part, and a graceful and open double loggia below, the building is strikingly unlike the heavily fortified communal palaces normal elsewhere in late medieval Italy, and implicitly proclaims the harmonious, peaceful and serene character of the Venetian state. The position of the palace next to San Marco in the city's principal urban space symbolised the indissoluble connection between sacred and secular authority. In other Italian cities, by contrast, a distinc-

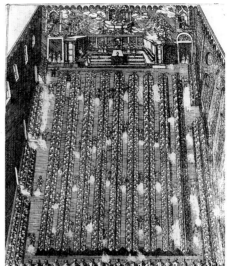

tion was made between the civic centre, with the seat of government, and the religious centre, with the cathedral. San Marco was not, in fact, Venice's cathedral, but simply the ducal chapel; and the chief ecclesiastical authority of the city, the patriarch, had his seat at S. Pietro di Castello, on the eastern fringes of the city. But San Marco represented the spiritual centre of the city and of the Republic, and it was the doge, not the patriarch, who was the chief custodian of the evangelist's relics.

As well as providing a residence for the doge, the Doge's Palace contained all the many council chambers of the Venetian government. The largest of these – and one of the largest rooms in late medieval and Renaissance Europe – was the Sala del Maggior Consiglio, where the Greater Council met to elect the officers of state. The present decoration of the Sala dates from the very end of the Renaissance, and was commissioned to replace a previous decoration destroyed by a disastrous fire that gutted the room in 1577 (Pl. 19).[15] Previously, as shown by an engraving made eleven years earlier (Pl. 20), the end wall was covered in a huge fresco representing the *Coronation of the Virgin* by the later fourteenth-century Paduan painter Guariento. The subject was clearly chosen to do honour to the Virgin as patron saint of Venice; and, as in its post-fire replacement by Tintoretto, the vision of the serried ranks of the court of heaven provides a celestial counterpart to the deliberations of the

21

Greater Council. The Annunciation group over the doors at the sides similarly has a political dimension in its allusion to the foundation of Venice.

The walls of the Sala – unfortunately rendered only schematically in the engraving – were previously decorated with a narrative cycle on canvas, representing the so-called *Story of Alexander III*. This story, which portrays another strand in the complex political propaganda that made up the Myth of Venice, was concerned with events that supposedly took place in the twelfth century, and told of how the reigning doge came to the aid of Pope Alexander III in his conflict with the Holy Roman Emperor, Frederick Barbarossa. As a token of his gratitude, Alexander gave his rescuer a series of gifts symbolising the equality of status between pope, emperor and doge in perpetuity. An original cycle on this subject, painted in fresco, had been begun soon after the completion of Guariento's *Coronation* in the 1360s, and was still in progress in the earlier years of the fifteenth century, when Gentile da Fabriano, Pisanello, and probably also Michelino da Besozzo, another leading representative of the International Gothic style, were called to Venice to contribute one or more scenes. By the mid-century this first cycle was already in a bad state of decay, and in 1474 Gentile Bellini was commissioned to begin the task of gradually replacing the frescoes with canvases. Subsequently, virtually all the great representatives of Venetian Renaissance painting, including Giovanni Bellini, Titian, Tintoretto and Veronese, made contributions to the second cycle, which had only just been completed at the time of the fire of 1577. Despite our very incomplete knowledge of the cycle's appearance, it is clear that it represented by far the most important Venetian decorative ensemble of the entire Renaissance.

Responsibility for overseeing the decoration of the Sala del Maggior Consiglio and of the other main council chambers of the palace lay not with the doge, but with a committee of patricians appointed for the purpose by the government. In keeping with his carefully defined constitutional position, the doge of Venice could only occasionally match the activities of other Italian heads of state in initiating major artistic commissions. As pointed out, however, by Francesco Sansovino in the later sixteenth century:

> It is the custom in this city that the doge during his term of office orders three things. His portrait is taken from life, where it is placed in the Sala del Maggior Consiglio beneath the ceiling in some lunettes; a picture in the Collegio or in the Senate, or whatever other place where it seems

best, in which is represented the Madonna and the Doge kneeling with other figures; lastly, a shield with the Doge's coat-of-arms which in his lifetime is hung on his ceremonial barge and on his death is placed in San Marco to his eternal memory.[16]

The series of ducal portraits, painted first in fresco, and after 1474 replaced with canvases, were, of course, destroyed in 1577, together with the narrative scenes below them. But it is clear from their post-fire replacements (cf. Pl. 75) that they showed each doge in a simple, bust-length format, either in profile or in three-quarter view.[17] The type is probably accurately recorded in a number of surviving late fifteenth-century examples, including Giovanni Bellini's *Doge Leonardo Loredan* (Pl. 15), which were presumably ordered by each sitter, or by a member of his family, as an autonomous, often higher-quality variant.

Fire was also responsible for the wholesale destruction of fifteenth- and sixteenth-century examples of the other major type of ducal commission, that representing the doge kneeling in full length before the Virgin. In 1574, three years before the fire in the Sala del Maggior Consiglio, another disastrous conflagration swept through the most important council chambers at the north end of the east wing, including the Collegio and the Senate, destroying all the existing decorations. By chance, however, at least two examples had already been removed from the building, including a major work by Giovanni Bellini of 1488, known as the *Votive Picture of Doge Agostino Barbarigo* (Pl. 74).[18] This may be taken as illustrating many of the characteristics of the type: as in a church altarpiece such as Bellini's slightly earlier picture for S. Giobbe (Pl. 5), the enthroned Virgin and Child are shown in the company of saints and angels; but in keeping with its destination for the walls of a council chamber, the format is broad rather than high, and the holy figures bestow their attention on the kneeling figure of Doge Barbarigo. Elected in 1486, he is shown dressed in his coronation robes, with his ducal cap studded with jewels, as he is presented to the Virgin and Child by St Mark. While the image may be interpreted in part as an expression of personal devotion by Doge Barbarigo to the Virgin and to his name-saint Augustine on the right, it also serves the more public function of invoking divine protection for the city during his reign, and of expressing the transcendent nature of the political order of the Venetian Republic.

*　　　*　　　*

23

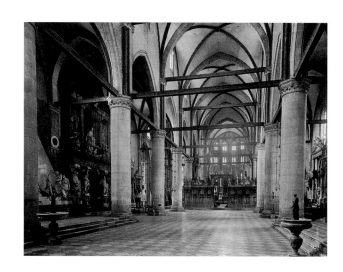

21 Venice, Frari.
View of interior.

Religion

Underlying the grandiose politico-religious claims by the Venetians that
their city was specially favoured by God, and that the doge was invested
with a divine and temporal authority equivalent to that of the pope, were,
of course, much more mundane considerations. The papacy was a major
Italian power, some of whose extensive territories bordered on the Veneto;
and it was natural that the respective political interests of Rome and
Venice should frequently clash. Similarly, while the Venetians did much
to exploit the propaganda value of their ongoing conflict with the Turks
in the eastern Mediterranean, and to present themselves as principal
defenders of the Christian faith against the advance of Islam, their true
interest in the struggle was commercial rather than religious. At the same
time, the claims of official propaganda seemed amply borne out by the
active religious life of ordinary Venetians.[19] In 1493 there existed no fewer
than 137 churches in the city and its surrounding islands, and visitors
were unanimous in reporting that these were attended regularly and
with devotional enthusiasm. Commynes's comment that 'God helps
the Venetians for the reverence which they bring to the service of the
church',[20] while echoing the government line, was clearly also based on his
own direct observation. Furthermore, since many of the churches, and not
just San Marco, held important relics, the round of the saints' shrines of
Venice formed a major initial chapter for the many western European
pilgrims who regularly passed through the city en route for the Holy Land.

Venice truly appeared what she claimed to be: not just a New Rome, but also a New Byzantium, even a New Jerusalem.

After San Marco, the most important churches of Venice tended to be not so much the seventy parish churches, all of which were rather small, as those of the religious orders. As was implied by a previously quoted comment by Commynes (above, p. 6), Venice and her islands were full of monasteries, nunneries and friaries; and the two largest churches in the city belonged to the two leading mendicant orders, the Franciscans and the Dominicans. Respectively entitled S. Maria Gloriosa dei Frari (known as the Frari for short) and SS. Giovanni e Paolo, these two churches, both of which were built in the Gothic style of the fourteenth and earlier fifteenth centuries, remained major foci of pictorial decoration throughout the later fifteenth and sixteenth centuries (Pls 21, 108). In keeping with the Venetian climate, neither of them was ever apparently intended to receive the extensive fresco cycles characteristic of the churches of the mendicant orders elsewhere in Italy; and from the beginning, painting was concentrated on the numerous altars contained in the two churches. Although the huge buildings of the Frari and SS. Giovanni e Paolo were exceptional in being able to accommodate as many as about twenty altars apiece, even the smallest parish church would have contained some three to five, all of which would have required decorating.

The painting of altarpieces represents, in fact, the central type of commission undertaken by Venetian painters throughout the Renaissance, and several of the greatest masterpieces by Bellini, Titian and their colleagues were painted to be displayed above a church altar.[21] It is important to remember, however, that as in the preceding Gothic period, painted altarpieces were more than just pictures, but formed part, together with their frames and sometimes also figurative sculpture, of complex ensembles. Today, the majority of Venetian Renaissance altarpieces have lost their original frames and are housed in museums; but an idea of their originally intended appearance may be gained from a painting by Carpaccio of c.1515 representing the *Vision of Prior Ottobon in S. Antonio di Castello* (Pl. 22). In this presumably topographically accurate view of the interior of the now-demolished Gothic church, two Gothic polyptychs, of a type still current around 1440 (cf. Pl. 35), are to be seen in the first two bays; while the third bay is occupied by an altarpiece of a fully Renaissance type, with a unified picture field, and a frame of a classicising architectonic design (cf. Pls 58, 71). The point that the individual panels of Gothic polyptychs would be fragments without their elaborately carved and gilded wooden frames scarcely needs underlining. But the stone tabernacle that charac-

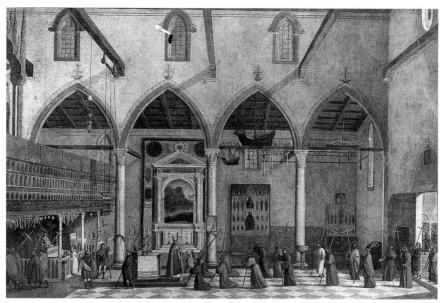

22 Carpaccio. *Vision of Prior Ottobon in S. Antonio di Castello* (*c.*1515). Canvas, 121 × 174 cm. Venice, Accademia.

teristically enclosed every Venetian altarpiece painted after about 1480 played no less important a part in the total aesthetic effect, not only by further articulating and clarifying the painted composition, but now also by creating the illusion of a window, beyond which the painted scene seemed to be taking place.

As elsewhere in late medieval and Renaissance Europe, responsibility for funding the maintenance and decoration of the many altars in Venetian churches tended to lie not so much with the clergy as with the pious laity. Although the local clergy usually retained control of the high altar, as was the case at the Frari, it was customary for patronage rights to the side altars and chapels to be ceded to wealthy families and devotional confraternities, who financed their upkeep in the hope of heavenly reward. The subject-matter of altarpieces, in the period before the Reformation at least, correspondingly tends to express the particular devotional interests of their lay donors rather than the more general teachings of the church on Christian doctrine or ethics. Thus by far the most popular subject of Venetian Renaissance altarpieces, as of Gothic polyptychs before them, was that of a group of saints, usually in the type of arrangement known as

26

a *sacra conversazione* with the Virgin and Child in their midst, as in Bellini's S. Giobbe altarpiece (Pl. 5); or else airborne above them, as in Veronese's high altarpiece of *c*.1565 for S. Sebastiano (Pl. 177). Whatever other meanings such images were intended to convey, the primary purpose of a saintly grouping of this kind was to express the idea of intercession: to express the hope, in other words, that the saints represented would intercede with God on behalf of their devotees in front of the altar, for their material benefit in this life, and for the salvation of their souls after death.

Society

Lay society in Venice was officially divided into three very unequal parts.[22] The top five per cent, as we have seen, consisted of the patriciate, a hereditary élite from whose ranks were drawn not only the doge, but all the members of the various councils and magistracies that constituted the government. Also reserved for patricians were key state appointments such as ambassadors, admirals in the navy, and high-ranking ecclesiastics, including the patriarch. Unlike aristocrats elsewhere, Venetian patricians in the fifteenth century still derived their wealth from maritime trade rather than from landed property; and although this situation was to change somewhat during the course of the sixteenth century, they remained proud of their association with the world of business and practical affairs. Some patrician families naturally became much wealthier than others, and with their greater wealth came a greater influence on the conduct of government. Yet no one family such as the Medici in Florence, or even one group of families, was ever permitted to become dominant.

Between the patriciate and the ninety per cent of the population that comprised the *popolani*, or ordinary people, came an intermediate class of Venetians called the *cittadini*, or citizens. To some extent these may be compared with middle classes elsewhere, since they included professional people such as doctors and lawyers; and socially the citizen class was much more dynamic than the strictly closed ranks of the patriciate, and allowed a considerable amount of upward mobility. But in many other respects, the Venetian *cittadinanza* should be regarded more as a secondary aristocracy than as a bourgeoisie. Like the patricians, the majority of citizens were merchants, while many others held high ranks in the navy and the clergy; and many acquired a wealth at least as great as those of the wealthiest patrician families. A large number of families had also held citizen status for several generations. In any other state, the

continuing disenfranchisement of so important a class might well have posed a serious threat to the social order; but in Venice various means were found for compensating the citizens for their exclusion from the political process, and for assuring their loyalty to the existing constitution. In the first place, several of the highest posts in the civil service, including that of Grand Chancellor of the Republic, were reserved for citizens. Similarly – and more relevantly for the patronage of art – citizens retained an exclusive right to the highest offices of the *Scuole Grandi*.

The word *scuola* in this context signifies not a school, but a devotional confraternity for laypersons, of a kind widespread in late medieval Europe generally.[23] In Venice, these confraternities fell into two main categories: the so-called Scuole Piccole, of which there existed some two hundred; and the Scuole Grandi, which in the Renaissance period numbered only six, each comprising between five and six hundred members. The names of the first four of the Scuole Grandi, founded at the time of the flagellant movement of the thirteenth century, were the Scuola di S. Maria della Carità, the Scuola di S. Giovanni Evangelista, the Scuola di S. Marco, and the Scuola della Misericordia; to these were added a fifth in 1489, the Scuola di S. Rocco, and a sixth in 1552, the Scuola di S. Teodoro.

By the fifteenth century, the Scuole Grandi had lost the penitential zeal associated with their origins, and had become respectable and often wealthy social institutions, active in the administration of charity, and of the many legacies bequeathed by pious testators. Although primarily religious in purpose, with an explicit mission to assist their members in the salvation of their souls, the *scuole* were not subject to the authority of the church, as were confraternities elsewhere, but rather to that of the Venetian state. The internal government of each *scuola* was in turn administered by a small group of annually elected officers, with a *Guardian Grande* at their head; and in this way, as pointed out in 1581 by the Venetian author Francesco Sansovino, the administration of a *scuola* 'to some extent mirrored that of the civic government itself, since the citizens had, as it were, their own republics, in which to gain rank and honour according to their merits'.[24] Certainly the considerable social prestige and economic power available to office-holders seems to have successfully diverted the attention of the citizen class away from political ambitions that might have threatened the position of the patriciate.

The strongly civic and patriotic character of the Scuole Grandi meant that their meeting-houses resembled not so much churches as microcosmic versions of the Doge's Palace. According to a standard pattern that had emerged by the fifteenth century, the meeting houses consisted of three

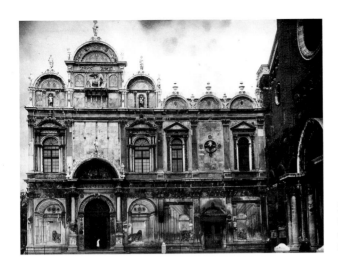

23 Venice, Scuola Grande di S. Marco, with façade of SS. Giovanni e Paolo.

main rooms: a large hall on the ground floor; a chapter hall directly above it on the upper floor; and an adjoining *albergo*, or boardroom, for the use of the officers. The distinction between the three rooms is clearly expressed, for example, by the magnificently ornate façade of the Scuola di S. Marco, as it was rebuilt in the years immediately after 1485 (Pl. 23). Thus the ground-floor hall lies on the longitudinal axis of the main entrance, and the chapter hall, with the two large windows with segmental pediments lies above it on the same axis; while the smaller *albergo*, its windows differentiated by the use of triangular pediments, lies at right angles to the two halls. During the course of the century it also became standard practice for the two rooms on the upper floor to be decorated with painted narrative cycles. In the case of the Scuola di S. Marco these celebrated the life and miracles of its patron St Mark, and included the huge canvas by Gentile and Giovanni Bellini (Pl. 11). As we shall see (pp. 81 ff), the narrative paintings of the *scuole* naturally took as their model the *Story of Alexander III* cycle in the Sala del Maggior Consiglio.

The many Scuole Piccole likewise offered members of the citizen class — and even to some extent the most prosperous of the *popolani* — welcome opportunities for acquiring enhanced social dignity through involvement in the corporate commission of a major work of art. The Scuole Piccole, which were very variable in size and economic means, consisted of three main types: confraternities that were purely devotional in character; confraternities representing the many foreign communities in the city, such as

29

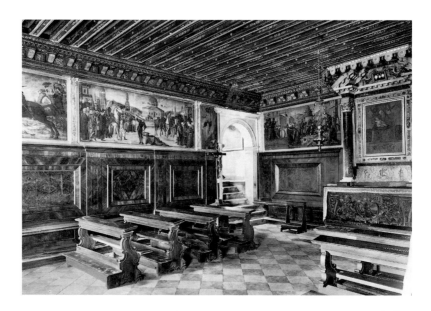

24(above) Venice,
Scuola di S. Giorgio degli
Schiavoni. View of
interior, with canvases by
Carpaccio.

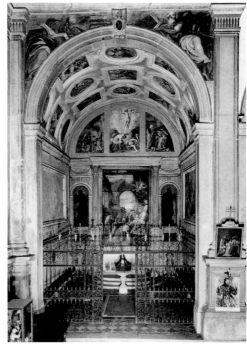

25 Venice, S. Francesco
della Vigna, Grimani
chapel. Frescoes by
Battista Franco (c.1557–
61) and altarpiece by
Federigo Zuccari (1564).

the Germans, the Florentines, or the Dalmatians (*Schiavoni*); and confraternities associated with the guilds, representing trades or crafts. In the sixteenth century a fourth type became increasingly prevalent, the Scuole del Sacramento, dedicated to the proper upkeep of the Holy Sacrament in parish churches (p. 223). A few of the better-off Scuole Piccole possessed their own meeting-houses; and in such cases, they sometimes imitated the Scuole Grandi by commissioning a narrative cycle. A rare example to survive *in situ* is that of the Scuola di S. Giorgio degli Schiavoni, with its sequence of canvases by Carpaccio (Pl. 24). But more often the smaller confraternities met in churches, and concentrated their art patronage on the decoration of their altar. Indeed, some of the finest Venetian altarpieces of the Renaissance, including probably Giovanni Bellini's S. Giobbe altarpiece (Pl. 5), were commissioned by Scuole Piccole.

For a wealthy individual or family, whether of citizen or patrician status, the opportunity to maintain and decorate a church altar with an altarpiece would have been attractive not purely for religious reasons (above, pp. 25–6), but also for reasons of social prestige. This is particularly obvious in a case such as the Grimani chapel in S. Francesco della Vigna (Pl. 25), where Federigo Zuccari's *Adoration of the Magi* of 1564 in its grandiose frame was made the centrepiece of a larger architectural and sculptural programme celebrating the magnificence of one of Venice's most prominent noble families. But even the smallest and most modest altarpieces would, by virtue of their public placing, have constituted statements of pride in the patron's social status, and hence also of solidarity with the social order of the Venetian state.

In the more private context of palace decoration, the generally better–educated patrician class may have been more active than the citizens in commissioning and collecting important works of art. But too little is known of the original owners, for instance, of the many Madonnas and half-length devotional images by Giovanni Bellini, for us to be sure that a high proportion – even a majority – was not commissioned by prosperous and socially ambitious members of the citizen class. Similarly in the next generation, although several of the early owners of pictures by Giorgione, such as Gabriele Vendramin and Girolamo Marcello, were indeed patricians (pp. 117, 127), others, including Giovanni Ram and Andrea Odoni (pp. 168, 178), were citizens. Later in the sixteenth century, major commissions for the interiors of citizen palaces include Titian's *Ecce Homo* of 1543 (Vienna, Kunsthistorisches Museum) for the Flemish merchant Giovanni d'Anna, and Veronese's series of canvases of 1571 (Dresden, Gemäldegalerie) for the Cuccina family.

31

Sources

Unlike in Florence, there existed no strong literary tradition in Venice for writing the lives of famous compatriots. As is illustrated by the office of doge, individual glory was made strictly subordinate to that of the state, and the preferred historiographical genre remained that of the chronicle, with its emphasis on collective history. Somewhat paradoxically, therefore, the earliest biographies of Venetian painters – or at least, the earliest discussions of their work – were provided, as was already mentioned in the case of Titian (pp. 2–3), by the Tuscan Giorgio Vasari.[25] But Vasari naturally knew much less about the painters of Venice than he did about those of Florence and Rome, and was not particularly interested in improving his knowledge. The four Venetian biographies included in the first edition of the *Lives* (1550) – 'Jacopo, Giovanni and Gentile Bellini', 'Vettor Scarpaccia' (i.e. Carpaccio, together with a number of other fifteenth-century painters), 'Giorgione' and 'Palma' – were drawn entirely from Vasari's recollections of his visit to Venice in 1541–2, made before his book was conceived. He returned in 1566 to gather material for the second edition (1568),[26] but this time the visit was undertaken in a great hurry. To the existing lives, all of which were expanded and recast to conform with the new overall design of the book, were now added 'Titian' and 'Battista Franco'. The award of a biography to the latter, a relatively minor painter who had spent some time in Rome in the orbit of Michelangelo, is symptomatic of Vasari's bias in favour of central Italy. Tintoretto and Veronese, by contrast, the two leaders of Venetian painting in the 1560s, are mentioned only in the context of other biographies (of Franco, and of the architect Sanmicheli respectively). The information that Vasari provides on Venetian painters, including Titian, is accordingly sketchy, frequently inaccurate, and subject to distortion by the underlying theme of the *Lives*, which is to promote the universal validity of the central Italian concept of *disegno* (above, p. 2).

In the absence, however, of any Venetian counterpart to the *Lives* before the middle of the seventeenth century, Vasari remains a fundamental source for Venetian Renaissance painting, and only two local sixteenth-century sources match him in usefulness. In the 1520s and 30s the patrician connoisseur and collector Marcantonio Michiel compiled a series of notebooks recording works of art in private collections in Venice and the cities of the Venetian mainland.[27] Besides comprising a major document in the early history of collecting, these *Notizie* are especially valuable for their descriptions of a number of works by Giorgione, not otherwise

recorded in contemporary documents or early sources. Then in 1556 the polygraph Francesco Sansovino, son of the great architect and sculptor Jacopo Sansovino, published a brief dialogue on the art and institutions of Venice, which he followed up in 1581 with the first comprehensive guidebook to the city.[28] The latter, which was republished in revised and expanded editions in 1604 and 1663, provides an extremely useful record of paintings in Venetian churches, palaces and Scuole, the majority of which can be identified with existing works. But although Sansovino often mentions their dates on the basis of inscriptions, the topographical format of his book excluded all but the most perfunctory information about their authors; and he betrays a very defective knowledge of the course of Venetian painting before the early sixteenth century.

The earliest attempt to provide a comprehensive biographical account of the painters of Venice came with Carlo Ridolfi's *Maraviglie dell' Arte* of 1648.[29] This considerably fleshes out the information provided by Vasari, and it is also written more objectively. But Ridolfi also lacked Vasari's critical insight, and living a full century later, he is scarcely more reliable in his attributions. Since he evidently did not know Michiel's *Notizie*, which remained unpublished until the early nineteenth century, Ridolfi's biography of Giorgione is exceptionally unreliable. That of Tintoretto, on the other hand, which provided the starting-point for the book, is based largely on information obtained from the painter's family, and is of major art-historical importance.[30]

Much more critically perceptive, and a much more passionate advocate of the special qualities of Venetian painting, was Ridolfi's contemporary Marco Boschini, whose books *La Carta del Navegar Pittoresco* and *Le Minere della Pittura* were published in 1660 and 1664 respectively.[31] Neither is a history: while the first, a rhapsodical dialogue written in Venetian dialect, is a work rather of connoisseurship and criticism, the second is a topographical guide to the pictures to be seen in Venetian public buildings, updating and enriching the account of Sansovino. In the revised edition of the *Minere* (1674) Boschini added as a preface a brief historical survey of Venetian painting (*Breve Istruzione*); but again, this consists chiefly of a sequence of characterisations of the styles of the principal masters, based on direct observation of a selection of their works, and it provides little reliable new information of a factual kind.

Modern art historiography, beginning in the later nineteenth century, has been able to make good many of the deficiencies of the early sources, both by the rediscovery of original documents relating to works of art, and through a more systematic connoisseurship. Egregious errors that had

33

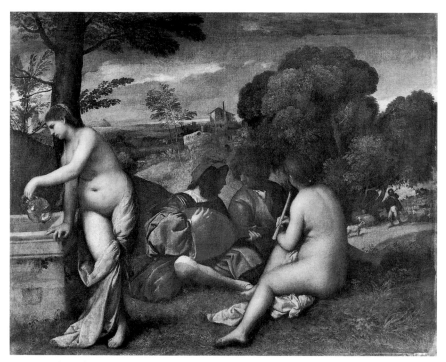

26 Attributed to Giorgione. *Concert Champêtre*. Canvas, 110 × 138 cm. Paris, Louvre.

survived the centuries, such as the assumption that Alvise Vivarini was the eldest of his family of painters instead of the youngest, were finally dispelled. But in other cases, most notably that of Giorgione, disappointingly little new factual information has emerged, and art historians remain dramatically divided about what works he actually painted and when. Emblematic of the uncertainty that still surrounds so much of Venetian Renaissance painting is the *Concert Champêtre* in the Louvre (Pl. 26). While there is general agreement that this picture is one of the great masterpieces of European art, some critics attribute it to the late Giorgione and others to the early Titian, while others again give it to the two painters in successive phases or, on the contrary, to neither of them.

It might be argued that modern research has also failed to dislodge the historiographic model imposed on Venetian painting by the unsympathetic Vasari.[32] The customary subdivision of the Renaissance period into Early,

High and Late (comprising Mannerism), although not exactly correspond-
ing to the way in which Vasari himself subdivided the revival of Italian
art, nevertheless derives from him, and it is valid above all as a way of
charting the various stages of evolution of fifteenth- and sixteenth-century
art in central Italy. When applied to Venetian painting, the tripartite
scheme does not fit so tidily. The boundaries between the early and High
Renaissance are blurred first of all by the fact that the leading Venetian
painter of the fifteenth century, Giovanni Bellini, not only outlived the
notional creator of the local High Renaissance, Giorgione, but also
apparently continued to be regarded as leader until his death in 1516. It is
similarly much more difficult in Venice than in Florence and Rome to say
when the High Renaissance may be deemed to have merged into the late
Renaissance, especially since unlike Raphael, Titian did not die young, and
once more there existed a continuity of leadership in Venice across the
period divide.

Yet history has to be shaped in the writing of it, and the search for
breaks in the evolution of Venetian painting has not revealed any obviously
more meaningful than the conventionally accepted ones. The present book
is accordingly divided into three main chapters, corresponding to the three
standard phases of Italian Renaissance art. The first chapter begins with
the moment of transition from late Gothic to early Renaissance in or
around 1440. The second begins with the artistic revolution created by
Giorgione, conveniently but still accurately datable to the turn of the
sixteenth century. And the third begins in c.1540 with a moment of
particularly strong interest among Venetian painters in the contemporary,
specifically Mannerist, developments in central Italy. This moment did not,
as we shall see in Chapter 3, usher in a period that can unambiguously be
labelled 'Mannerist'; but it does represent a shift of emphasis that may
legitimately be regarded as marking the beginning of a new and distinctive
historical phase. Finally, the deaths of Veronese in 1588 and of Tintoretto
in 1594 clearly mark the end of what has always, and rightly, been
regarded as the golden age of painting in Venice.

1

Early Renaissance (1440–1500)

The Renaissance style was not invented in Venice, and it took several decades to become fully established there. The first glimmerings of a response by the Venetian painters Jacopo Bellini and Antonio Vivarini to the revolutionary artistic events that took place in Florence during the 1420s and 1430s appeared soon after 1440. But it was not until the 1460s, in the early works of Jacopo's son Giovanni, that a pictorial style that may be described as truly Renaissance in character was formulated in Venice. By the 1470s Giovanni Bellini had emerged as the undisputed leader of Venetian painting, a position he was to maintain throughout his long career until his death in 1516. Under his leadership, Venetian painting not only adopted and assimilated the innovations of early Renaissance Florence, but successfully transformed them into a characteristically Venetian idiom. Furthermore, well before the end of the century the Venetian school had developed from one of chiefly local significance, with a markedly conservative character, to one that was as advanced and universally admired as any in Europe.

It is in some ways paradoxical that the period that saw the rise to international eminence of Venetian painting should have coincided with the beginnings of the slow political and economic decline of the Venetian state. In 1440 Venice stood at the height of her power and wealth: following the westward expansion of her *terraferma* possessions in the first decades of the century, she had become the strongest state in Italy; and with her extensive maritime empire in the eastern Mediterranean she was still able to lead the world commercially. But her very success was bound to provoke the hostility of the other Italian states, and for most of the first part of the century, until the Peace of Lodi in 1454, Venice was at war with Milan. Later, in 1483, an anti-Venetian alliance was formed between the papacy, Naples and Milan; and the consequent war of Ferrara was to

27 Cima da Conegliano. Detail of Pl. 68.

be but the prelude to the infinitely more dangerous war of the League of Cambrai, which in 1509 very nearly brought about the destruction of the Venetian state. Meanwhile, the Turks continued their advance in the east. The fall of Constantinople in 1453 was followed by the fall of the Venetian colony of Negroponte in the Aegean in 1470; and in 1479 Venice was forced to surrender more of her colonial possessions to the Turkish sultan, while also agreeing to pay heavy trading levies. At the turn of the century, further disasters occurred to threaten Venice's commercial supremacy, such as the fall of the Garzoni bank in 1499, and the news in 1501 that Portuguese spice-vessels had rounded the Cape of Good Hope.

Yet such reversals of fortune, however disastrous they might have appeared at the time, turned out for the most part to be only temporary setbacks. Bursts of military activity were interspersed with long periods of peace, even with the Turks; and the defeats of 1479 were followed by a successful diplomatic mission to Constantinople, with the painter Gentile Bellini included in the party. The Republic of Venice was, in fact, to survive and prosper for another three centuries. In spite of the clouds on their horizons, many Venetians were able to spend vast sums on the building and decoration of their palaces, churches and *scuole*. Indeed, the very fact that their political posture was now a defensive one may have encouraged them to see lavish expenditure on art as a particularly effective means of visually propagating the Myth of Venice – both in the interests of domestic morale, and for the benefit of important foreign visitors such as Philippe de Commynes. Certainly the most important single pictorial enterprise undertaken in later fifteenth-century Venice – the replacement of the frescoes depicting the *Story of Alexander III* in the Sala del Maggior Consiglio of the Doge's Palace with a resplendent new cycle on canvas— was undertaken in this spirit of defensive propaganda.

In certain instances, the various shifts in Venetian foreign policy may be seen as having a more direct influence on artistic events. This is especially evident in the 1430s and early 1440s, when the enthusiastically pro-Florentine policy of Doge Francesco Foscari created a climate favourable to the reception of Renaissance ideas, and a number of leading Florentine painters and sculptors visited Venice and nearby Padua to execute major commissions. Thus in 1434 Fra Filippo Lippi decorated the chapel of the Palazzo del Podestà in Padua (now lost); in 1442–3 Andrea del Castagno designed a mosaic for a chapel founded by Doge Foscari in San Marco, and painted a series of figures in the vault of the chapel of S. Tarasio at S. Zaccaria, a Benedictine nunnery of which the doge's sister was abbess (Pl. 37);[1] and again in 1443 – with the most momentous art-historical con-

28 Donatello. *St Justina* (1446–8). Padua, Santo.

sequences of all – the great sculptor Donatello arrived in Padua to create his imposing bronze high altarpiece for the church of the Santo (Pl. 28).[2] The subsequent souring of diplomatic relations between Venice and Florence meant that, conversely, there was rather little direct artistic contact between the two cities for several decades; and by the time of Verrocchio's brief visit to Venice in 1469, the Florentine may have been borrowing as much from Venetian artists as he was giving.[3] In the second half of the fifteenth century Venice had, despite periodic disputes, much closer political contacts with the duchy of Milan. Artistically, these benefited not so much painting as architecture and sculpture, and it is significant that the two leading exponents of early Renaissance architecture

in Venice – Pietro Lombardo and Mauro Codussi – both came from Lombardy.

Apparently unconnected with the political events of the moment, and a consequence rather of Venice's longstanding commercial links with the seaports of the Mediterranean, was the visit to Venice in 1475–6 of the Sicilian painter Antonello da Messina. Vasari's conveniently tidy report, according to which Antonello had learnt the 'secret' of oil painting directly from Jan van Eyck in Flanders before then coming to Venice to teach it to the local painters,[4] has long since been discredited; and there is now clear evidence that Bellini was experimenting in oils for at least a year or two before Antonello's arrival (p. 71). Nevertheless, there is no doubt that the presence of the latter acted as a powerful catalyst for local developments, and it was indeed soon after 1475 that under the leadership of Giovanni Bellini, Venetian painters began to abandon traditional tempera in favour of the more flexible medium of oil. This in turn was to form an essential basis for the pictorialism that has always been seen as intrinsic to the character of Venetian painting.

From Gothic to Renaissance

More than thirty years before Antonello's visit, the founders of the two dynasties that were to dominate early Renaissance painting in Venice, Jacopo Bellini and Antonio Vivarini, were also the first to respond to the new artistic currents originating in Florence. Of the two, Antonio was the younger by some fifteen to twenty years, and his earliest works date from about 1440. Jacopo, by contrast, seems to have been born as early as about 1400 (or even earlier), and he was trained by the leading Italian exponent of the International Gothic, Gentile da Fabriano. But Jacopo was a more adaptable and inventive artist than Antonio, and he was to play the more creative role in the long period of transition from Gothic to Renaissance.

The decisive artistic event that continued to determine the character of Venetian painting in the period immediately preceding 1440 was the presence in the city of Gentile da Fabriano for a few years around 1410. As the most celebrated Italian master of his time, Gentile was called to Venice to paint one, and perhaps several, of the frescoes in the original *Story of Alexander III* cycle of the Doge's Palace; and while he was there, he is known to have painted at least one altarpiece for a Venetian church. Nothing of all this now survives, but a slightly later work, a *Coronation of the Virgin* (Pl. 29), probably painted in Florence in 1420, may be chosen

40

29 Gentile da Fabriano. *Coronation of the Virgin* (?1420). Panel, 88 × 64 cm. Malibu, J. Paul Getty Museum.

30 Giambono. *St Michael* (*c*.1440). Panel, 103 × 57 cm. Florence, Berenson Collection. Reproduced by permission of the President and Fellows of Harvard College.

to give a general idea of the highly sophisticated manner he introduced to Venice.[5] Completely characteristic of Gentile as a painter of devotional images is the extraordinary opulence of effect, created above all by the magnificent display of richly patterned brocades. Such richness would have had a strong appeal for the Venetians, whose aesthetic tastes would have been formed by their experience of the gilded splendour of San Marco, and also of travel to the Levant. At the same time, there is nothing Byzantine about the flowing outlines of Gentile's draperies, or the delicate modelling of his forms, or the gentle humanity of his figures; and in relation to fourteenth-century Venetian tradition, his art would have had the simultaneous attraction of appearing both accessible and excitingly modern.

Gentile's continuing impact on the local scene is particularly evident in the work of Michele Giambono, whose *St Michael* of *c*.1440 (Pl. 30) examplifies a style that he practised with little change until his death in 1462.[6] But equally Gentilesque are the earlier works of Jacopo Bellini, a

42

31 Jacopo Bellini. *Virgin and Child with Lionello d'Este* (*c.*1440). Panel, 60 × 40 cm. Paris, Louvre.

close contemporary of Giambono, such as the *Virgin and Child with Lionello d'Este*, also of *c.*1440 (Pl. 31).[7] The meandering golden hem of the Virgin's robe, the elegance of her gesture, and the richness of the fabrics – here achieved largely through the use of stippling with tiny points of gold – all have their counterparts in Gentile's *Coronation*. Also deriving from Gentile's example, in works such as the predella of the Strozzi altarpiece of 1423 (Florence, Uffizi), is the exquisite landscape which, although retaining a certain heraldic stylisation in the foreground, reveals in the background a wonderfully fresh observation of early morning light, as it touches the walls of buildings and peaks of mountains. Jacopo's powers of realism also ensured him a success as a portrait painter, and in 1441 he won a competition against Pisanello, another International Gothic follower of Gentile, to paint the portrait of Lionello d'Este. The competition portrait is sometimes thought to be identical with the *Virgin and Child*, since this includes the diminutive figure of Lionello, the future lord of Ferrara, kneeling as donor. But Pisanello's entry survives (Bergamo, Accademia Carrara), and it is more likely that Jacopo's portrait similarly showed the sitter in an autonomous, bust-length format.

Still obviously indebted to Gentile da Fabriano is Jacopo's altarpiece of the *Annunciation*, delivered to the church of S. Alessandro in Brescia in 1444 (Pl. 32). With its lavish use of gold and dark, rich colours, it retains a strong flavour of the International Gothic; yet compared with those of the *Virgin and Child with Lionello d'Este*, the draperies have acquired a new weight. There is also a new spatial coherence, created for the first time in Venetian painting by the use of the Florentine single-point perspective system. It is not certain that Jacopo ever visited Florence, and he may have owed his knowledge of geometric perspective rather to his contacts with court humanists in Ferrara, where manuscript copies of Alberti's treatise *Della Pittura* were in circulation.[8] It is even possible that Jacopo met Alberti himself, one of the most prominent and lucid exponents of Florentine Renaissance ideas, either in Venice in 1437, or in Ferrara some time in the late 1430s or early 1440s.

Much more than in his paintings, Jacopo's fascination with these new ideas is evident in his two Books of Drawings, one of which is now in the Louvre in Paris, and the other in the British Museum. Very unusually for the period, the drawings seem not to have been made in preparation for paintings, but as self-sufficient works of art, in which the artist explored and recorded ideas with a freedom that would have been inappropriate in a more formal context. Carefully preserved in their bindings, the Books were later inherited by Jacopo's son Gentile, who presented one of them to

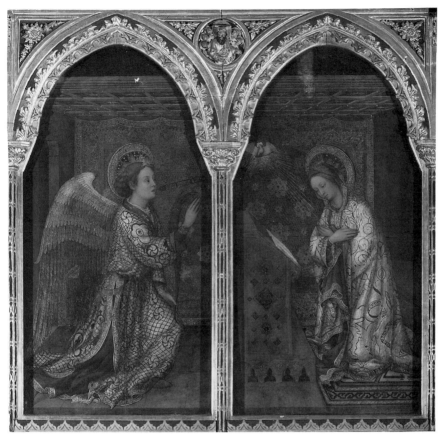

32 Jacopo Bellini. *Annunciation* (1444). Main panels: 219 × 98 cm. Brescia, S. Alessandro.

the Turkish sultan as a suitably luxurious diplomatic gift at the time of his mission to Constantinople in 1479–80. The other was left by Gentile to his brother Giovanni in 1507, and in 1530 it is recorded as one of the treasures in the art collection of the Venetian patrician Gabriele Vendramin.

In the past there has been considerable controversy about the dating, as well as the function, of the Books. Recent research, however, has shown that the Louvre Book is almost certainly the earlier, dating from the mid-1430s to the mid-50s, while the drawings in the British Museum Book

33 Jacopo Bellini. *Feast of Herod* (*c*.1440–5). From the Louvre Book of Drawings, f. 16.

date from the mid-50s to the mid-60s.[9] According to this chronology, a drawing from the Louvre Book such as the *Feast of Herod* (Pl. 33) is datable to *c*.1440–5, close to the *Annunciation* altarpiece; and indeed, it represents a similar moment of stylistic transition. The picturesque episodes and numerous animals that populate the scene are still in the spirit of International Gothic fantasy; and the building in the background, with its spiky crenellations and elaborate balconied window, is strongly reminiscent of the fourteenth-century Doge's Palace (Pl. 18). But more than the altarpiece, the drawing reveals Jacopo's interest in grappling with the problems of perspective, and with creating a coherent space for his figures to inhabit. The various statues that decorate the walls of the courtyard show a comparable interest in problems of anatomy, and in the correct construction of the human figure. Most innovative of all, perhaps, is the freedom with which the painter treats his ostensible subject-matter. Thus the Feast of Herod takes place on the raised terrace in the right middleground, while an only just discernible St John the Baptist is beheaded to the left of the staircase.

Another aspect of Renaissance culture of passionate interest to Jacopo, as documented by both Books of drawings, was the study of classical

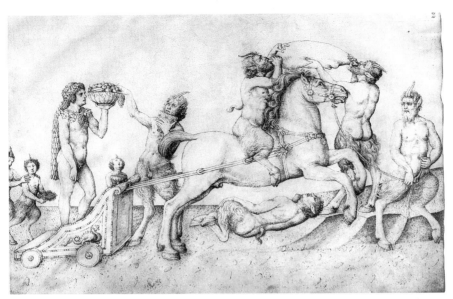

34 Jacopo Bellini. *Triumph of Bacchus* (*c*.1440). From the Louvre Book of Drawings, f. 36.

antiquity.[10] Several of the statues represented in the *Feast of Herod* are likely to have been derived from antique models, although probably in the form of small-scale gems and coins rather than monumental sculpture; and other sheets in the Books incorporate numerous more-or-less free quotations from classical coins, inscriptions and reliefs. All this represents an important precedent for the slightly later, and archaeologically much more correct, reconstruction of an ancient Roman environment by Andrea Mantegna. But of even greater importance for the future of Venetian painting was Jacopo's imaginative recreation of the world of classical mythology. His composition of the *Triumph of Bacchus*, for example (Pl. 34), dating from as early as *c*.1440, is certainly inspired by knowledge of some ancient Bacchus sarcophagus. But equally clearly, it is not a close copy, and the artist has given free rein to his fantasy in inventing new episodes, such as the faun sleeping off his drunkenness, and in investing the scene with a mood that is at once poetic and slightly playful.

Nothing similar is to be found in the art of Antonio Vivarini, whose output consisted almost exclusively of church altarpieces, enclosed in elaborately carved and richly gilded Gothic frames. The design and execution of these ensembles must have involved close collaboration

35 Antonio Vivarini and Giovanni d'Alemagna. *St Sabina* polyptych
(1443). Original frame, 347 × 185 cm. Venice, S. Zaccaria, chapel of S.
Tarasio.

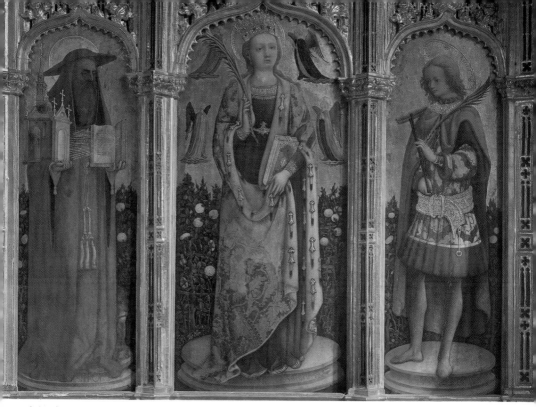

36 Antonio Vivarini and Giovanni d'Alemagna. Detail of Pl. 35.

with the frame-carvers, but Antonio regularly also worked with other painters, first with his brother-in-law Giovanni d'Alemagna, and then after Giovanni's death, with his own younger brother Bartolomeo. It is often difficult or impossible to distinguish the hand of a particular collaborator, especially in the case of Giovanni, by whom only one independent work is known; and a characteristic Vivarinesque production such as the *St Sabina* polyptych (Pls 35, 36), painted in 1443 for the S. Tarasio chapel in S. Zaccaria, is stylistically perfectly homogenous. The aristocratic and expensively dressed saints of the lower tier, together with the decorative, space-denying rose hedge behind them, obviously still belong very much to the world of the International Gothic; and the lavish use of gold in their costumes and in the background fuses them into a natural unity with their frames. These, together with the frame of the larger and more complex polyptych that the painters executed in the same year for the main altar of the chapel, in turn harmonise perfectly with the surrounding Gothic architecture (Pl. 37); and it is the series of uncompromisingly austere and

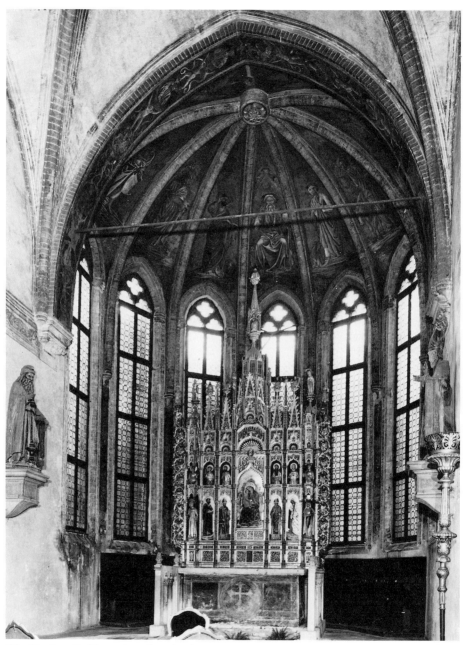

37 Venice, S. Zaccaria, chapel of S. Tarasio. View of interior, with polyptych by
Antonio Vivarini and Giovanni D'Alemagna (1443) and frescoes by Andrea del
Castagno.

38 Antonio
Vivarini.
*Investiture of St
Peter Martyr*
(*c*.1443). Panel,
53 × 35 cm.
Berlin, Staatliche
Museen.

powerfully dynamic figures in the apse vault by Andrea del Castagno that
strikes the stylistically discordant note.

A limited debt to Castagno may possibly be detected in the way in
which the foot of St Achilleus on the right, and the draperies of the central
St Sabina, project illusionistically beyond the confines of their pedestals.
Certainly, compared with the draperies of Giambono's *St Michael* (Pl. 30),
those of the Vivarini saints appear cylindrical, like the pedestals on which
they stand. But Antonio's moderate interest in problems of space and
volume, which he may have owed as much to a knowledge of Fra Filippo
Lippi's works in Padua as to Castagno, is rather more evident in his
smaller narrative works, painted as only subsidiary elements of polyptychs.
In his *Investiture of St Peter Martyr* of about the same date, for example
(Pl. 38), the friars wear simple habits with vertically tubular folds, and the
figures are carefully arranged along orthogonals to create pictorial depth.

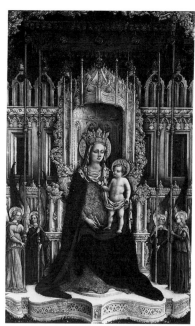

39 Antonio Vivarini and Giovanni d'Alemagna. *Four Fathers of the Church* triptych
(1444). Three canvases: 344 × 203 cm (centre); 344 × 137 cm (sides). Venice,
Accademia.

The linear perspective is not yet constructed as rationally as in Jacopo
Bellini's *Annunciation*, and Antonio's conception of classical architecture
is unquestionably naive. Yet this is a pioneering invention in the context of
Venice of the 1440s, especially at a time when real architecture was still
undilutedly Gothic.

Historically one of the most significant achievements of the collabor-
ation between Antonio Vivarini and Giovanni d'Alemagna is the *Four
Fathers of the Church* triptych, painted for the *albergo* of the Scuola
Grande della Carità in 1446, and celebrating the Virgin as patron saint of
the confraternity (Pl. 39). Beneath the heavy overlay of Gothic ornament
there exists a coherent box-space enclosed by walls on three sides, the
depth of which is again measured by the placing of the saints and angels
along orthogonals. In particular, it may be noted that although the
triptych format is retained, the vertical divisions between the fields barely
interrupt the effect of unified space. In this respect, the work provides an
important precedent for the much more radically innovative tripych that

Andrea Mantegna was to paint more than a decade later for S. Zeno in Verona (Pl. 40), and for the completely unified altarpieces of Giovanni Bellini. Antonio and Giovanni may have been stimulated to develop the spatial composition of the *Four Fathers* by the fact that the work was painted not for a Gothic church, but for the rectangular field between the dado and ceiling of the *albergo* of a *scuola*. The original frame is lost; but it clearly cannot have been of the richly carved, surface-stressing type, with flowing Gothic lines, as in the *St Sabina* polyptych, and it may well have consisted simply of unobtrusive rectilinear mouldings.

But in the *Four Fathers* triptych Antonio Vivarini had reached the limit of his understanding of, or interest in, Renaissance ideas. In 1448 he and Giovanni d'Alemagna were called to Padua to undertake a major commission, that of providing one half of the fresco decoration in the Ovetari chapel in the church of the Eremitani. The other half was to be provided by two much younger local artists, Nicolò Pizzolo and Andrea Mantegna, whose contributions must have seemed bewilderingly avant-garde to the Venetian brothers-in-law. They had completed no more than the vault by 1450, when Giovanni died; whereupon Antonio returned to Venice, leaving the field in Padua to the younger generation.

The Response to Padua

In the two decades around the middle of the fifteenth century the city of Padua, situated inland some twenty miles from Venice, enjoyed a brief spell as the most creative centre of Renaissance art in all of northern Italy.[11] The immediate cause of its sudden transformation from a relative backwater to artistic pre-eminence was the presence in the city, for a decade between 1443 and 1453, of Donatello, and the creation of his equestrian monument to the *condottiere* Gattamelata, and of his high altarpiece for the major pilgrimage church of the Santo (Pl. 28). The series of statues and reliefs for this latter work, with their display of deeply expressive eloquence and their revelation of the new Florentine ideals of anatomy, proportion and perspective, could not have provided a more striking contrast with the current works of leading Venetian painters such as Giambono, Antonio Vivarini, and even Jacopo Bellini. Donatello's example then did much to inspire the revolutionary art of the local painter-sculptor Nicolò Pizzolo, who died tragically young, and that of the painter Mantegna, in his previously mentioned frescoes for the Ovetari chapel, and his S. Zeno triptych of 1456–9 (Pl. 40). To a great extent, these may be regarded as translations of the style of Donatello into paint,

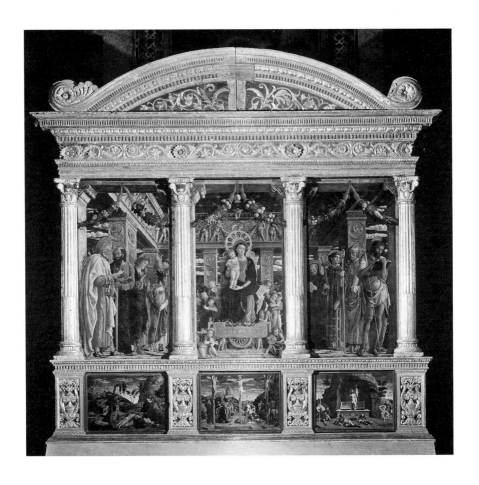

carried through with a highly intelligent comprehension of its underlying principles, and complemented by a personal devotion to the art of classical antiquity.

Arguably the first Venetian painter to respond to these events in Padua was Jacopo Bellini. Although middle-aged by the mid-century, his interest in Renaissance ideas was still much more comprehensive than than that of any of his Venetian colleagues; indeed, there is reason to believe that not only Mantegna, who in 1453 became his son-in-law, but Donatello himself had something to learn from him.[12] Jacopo's adaptability is well illustrated by a comparison between the still Gentilesque *Virgin and Child with Lionello d'Este* of *c*.1440 (Pl. 31) and a *Virgin and Child* of *c*.1455 (Pl.

40(facing page) Mantegna. S. Zeno triptych (1456–9). Main panels: 212 × 125 cm (centre); 213 × 135 cm (sides). Verona, S. Zeno.

41 Jacopo Bellini. *Virgin and Child* (*c*.1455). Panel transferred to canvas, 98 × 58 cm. Lovere, Galleria Tadini.

41). Despite the lingering richness of the haloes and the crown in the later work, and the continuing use of gold stippling, the curvilinear Gothic hems in the earlier picture have been replaced by draperies that fall vertically and naturalistically. Similarly, the figures are conceived as two contrasting cylinders rather than as juxtaposed planes; and the gesture of the Virgin's hand is functional rather than precious. The motifs of the parapet, the *cartellino*, the foreshortened book, and the tangibly hard and solid coral necklace, have obvious analogies in the works of the younger painters active in Padua, and also of Bartolomeo Vivarini (Pl. 45). Yet Jacopo typically employs them with a much greater simplicity and restraint than they, without any of their complications and tensions. The resulting

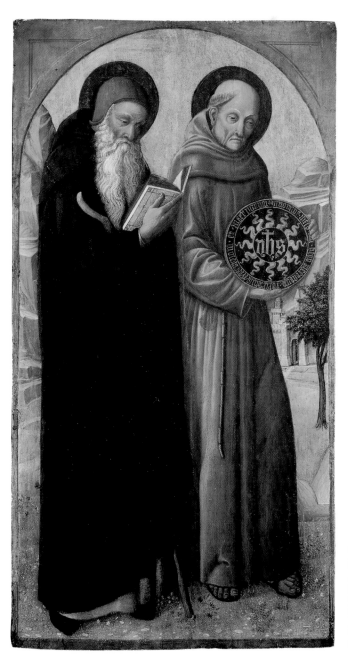

42 Jacopo (and
Gentile?) Bellini. *Sts
Anthony Abbot and
Bernardino* (1459/60).
Panel, 110 × 57 cm.
Washington, National
Gallery of Art, partial
and promised gift.

combination of spiritual gravity and tender humanity was later to typify the half-length Madonnas of his son Giovanni.

In 1460 Jacopo signed, together with his sons, an altarpiece for the funerary chapel of the *condottiere* Gattamelata in the Santo in Padua.[13] It has recently and convincingly been suggested that a panel representing *Sts Anthony Abbot and Bernardino* (Pl. 42), in which there are signs of collaboration by Gentile Bellini, formed the left wing of the altarpiece; and it is also probable that three predella panels, in which Jacopo appears to have been assisted by Giovanni, formed part of the same complex. From the shape of the wing, it may be further deduced that for the first time in large-scale Venetian altar painting, and following the most recent Paduan models such as Mantegna's S. Zeno triptych (Pl. 40), Jacopo's work was set into a Renaissance-style frame. Consistent with the new conception of the picture frame as a window or proscenium beyond which the pictorial space seems to extend, rather than as a richly carved object forming primarily a decorative unity with the painted panels, it is also clear that, although they were still arranged in a triptych format, the three panels were united by a continuous landscape, with a greater effect of spaciousness than in any work by the Vivarini. Jacopo's figures do not, of course, share the heroic grandeur of those of Mantegna, there being no hint, in their simple vertical poses, of classical *contrapposto*. Similarly, the stratified rocks in the background, and the delicate patterned curls of St Anthony's beard, unmistakably reveal Jacopo's Gothic inheritance. Yet as with the recent *Virgin and Child*, the quiet solemnity of the figures, and here also the luminosity of the landscape, were to become essential elements in the art of Giovanni Bellini.

Much of Jacopo's time during the last decade of his life was taken up with the painting of large-scale narrative canvases, first for the Scuola di S. Giovanni Evangelista and then for the Scuola di S. Marco.[14] All this work is lost, but something of the appearance of the lost decorations may perhaps be visualised with the help of the contemporary drawings in the London Book, despite the character of these as autonomous creations. Compared with the earlier *Feast of Herod* in the Paris Book (Pl. 33), the London version (Pl. 43) shows a simpler, grander and more spacious type of architecture, with larger figures, and the fussy, residually Gothic elements removed. But the figures remain small in relation to the space, and the two principal elements of the narrative – the decollation of the Baptist and the feast itself – still appear almost as incidental episodes in a scene from everyday life, set within an architectural environment strongly reminiscent of Venice. All this has close analogies with the narrative scenes

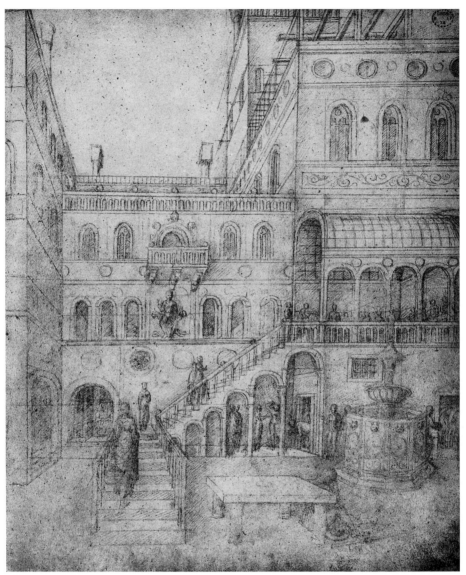

43 Jacopo Bellini. *Feast of Herod* (*c*.1460–5). From the British Museum Book of Drawings, f. 75.

painted for the Scuole Grandi later in the century by Gentile Bellini, Carpaccio and others (Pls 7, 61, 62); and it may well be that these younger painters were following in a tradition of narrative painting largely created by Jacopo.

The later works of Antonio Vivarini, by contrast, have a strongly retrospective character. Depite having worked in the Ovetari chapel at the end of the 1440s, his response to the Paduan Renaissance was minimal; and the succession of polyptychs he painted throughout the 1450s and 60s do not even build on the innovations that he had introduced together with Giovanni d'Alemagna in the works of the 1440s such as the *Four Fathers of the Church* triptych (Pl. 39). In his altarpiece of 1464, for example, painted for the confraternity of St Anthony Abbot in Pesaro (Pl. 44), the Gothic framework, with its tall slender piers, pointed arches, elaborate finials and rich gilding, follows a general arrangement for Venetian altarpieces established a good century earlier. The figures are correspondingly tall and slender, their stances insecure, their legs floppy and boneless, and their faces largely expressionless. Their forms have a certain relief, but the overall effect ramains one of surface decoration, with a stress on soft, flowing outlines and bright, clear colours, repeating one another to make an attractive pattern.

In veiw of the fundamental conservatism of Antonio, it is remarkable that his younger brother and erstwhile collaborator Bartolomeo Vivarini should have emerged as one of the earliest exponents of Mantegnism in Venice. In his *Virgin and Child with Saints* of 1465 (Pl. 45), dating from only one year later than Antonio's Pesaro polyptych, there is a more serious attempt to reveal limbs under draperies and bones under flesh, and Antonio's flowing lines have become taut. An ambition to imitate Paduan antiquarianism is evident in the classical garlands of fruit, the throne and its pilasters, and the angels' robes. Above all, the saints are now shown in a unified space, making the work into perhaps the very earliest Venetian *sacra conversazione*. Yet the limitations of Bartolomeo's comprehension of the Renaissance are also readily apparent. There is consistency neither of viewpoint, nor of scale, nor of space, which is closed off by an International Gothic hedge reminiscent of those painted by Jacopo Bellini and Antonio Vivarini a generation earlier (Pl. 35). The classical garlands do not hang heavily, as in Mantegna's S. Zeno triptych (Pl. 40), but rather create a pattern on the picture surface; and the bright vitreous colours remain close in value and decorative effect to those of Antonio. Ultimately, the traditional Venetian taste for material richness, as is especially apparent in the broad area of the Virgin's brocade mantle, remains much

44 Antonio Vivarini. Pesaro polyptych (1464). Panels: 105 × 30 cm (lower tier); 80 × 50 cm (upper tier, centre). Rome, Vatican Museums.

45 Bartolomeo Vivarini. *Virgin and Child with Saints* (1465). Panel, 121 × 121 cm. Naples, Museo di Capodimonte.

more important to the artist than Mantegnesque logic. Bartolomeo was never, in fact, to resolve the contradiction between these two elements.

The formal principles of the Renaissance style were from the beginning understood much better by the two Bellini brothers, even by Gentile, the elder and less gifted. Like that of his father, Gentile's oeuvre survives in only a very fragmentary form, particularly in his earlier career, when he collaborated with Jacopo on narrative cycles for the Scuole Grandi of S. Giovanni Evangelista and S. Marco. But his stylistic dependence on Padua

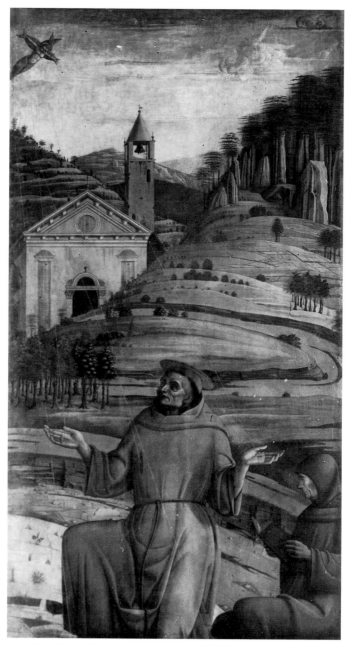

46 Gentile Bellini. *Stigmatisation of St Francis* (*c.*1464–5).
Canvas, 427 × 218 cm. Venice, San Marco.

47 Giovanni Bellini. *Agony in the Garden* (*c*.1464–5). Panel, 81 × 127 cm. London, National Gallery.

during the 1460s is well illustrated by the set of organ shutters he painted for the church of San Marco, one of which represents *The Stigmatisation of St Francis* (Pl. 46). No less than Bartolomeo Vivarini, the painter gives a careful linear description of limbs under draperies and of the bone structure underlying the human skull; but, in addition, there is an ambitious attempt to construct a mountainous landscape extending into the depth of the picture. The attempt, however, is by no means completely successful: there is a dislocation of space between the foreground and the middleground, and the effect of recession is achieved through the rather artificial device of making the ground rise continuously upwards. Furthermore, the linear stratification of the rocks, which in the work of Mantegna has a structural and sculptural quality, appears in Gentile as merely ornamental, with the lines clinging to the picture surface like calligraphy.

If Gentile's talents were to remain better suited to townscape than to landscape, the reverse is true of his brother Giovanni, whose earliest masterpieces in the genre, such as the *Agony in the Garden* of *c*.1464–5 (Pl. 47),[15] date from near the beginning of his independent career. The close compositional relationship between this picture and the slightly

earlier version by Mantegna (also London, National Gallery) has often been pointed out, and Giovanni is clearly also indebted to his brother-in-law for a number of other aspects of his early style, such as the use of sharp, linear creases in the draperies, and of drastic foreshortenings in the figures' poses. But the essentials of the composition are already to be found in Jacopo Bellini's drawing of the same subject of *c*.1455 in the London Book (ff. 43v – 44); and similarly, in its poetically expressive relationship between figures and landscape, Giovanni's picture represents a natural development of earlier paintings in the Venetian tradition such as Jacopo's *Virgin and Child with Lionello d'Este* (Pl. 31). Giovanni would certainly have been further encouraged in this pursuit of a very un-Mantegnesque lyricism by his knowledge of devotional panels imported from the Netherlands. Thus the wonderful effects of dawn light on the hillside, and the play of reflections on the water, making the slightly artificial linear structure of the landscape appear gentler and more natural, clearly represents a sympathetic response to the Flemish tradition of Jan van Eyck, and perhaps in particular to that of Dirk Bouts, an early exponent of sunsets and sunrises.[16] In any case, it is precisely this sensitivity to the external phenomena of nature and to their potential for evoking deeply felt religious emotion, that sets Giovanni apart from the more intellectual and strictly anthropomorphic concerns not just of Mantegna, but of his contemporaries in early Renaissance Florence.

With its small scale and highly refined pictorial handling, the *Agony in the Garden* was presumably painted for the private use of a patron who was both pious and aesthetically sophisticated. The same may be said of another major work of Bellini's early career, the Brera *Pietà* of *c*.1467 (Pl. 48), despite its larger scale and the greater monumentality of the figures. The half-length image of Christ as Man of Sorrows, sometimes accompanied by the figures of the Virgin and St John, had enjoyed a long history at the apex of Venetian polyptychs (cf. Pl. 44). But by adapting it to the needs of private devotion, and by bringing the three figures together into a close physical intimacy, Bellini prompts the spectator to become emotionally involved in their suffering. The expression of grief is all the more powerful for the fact that the linear intricacy of the *Agony* has become simplified, and that the formal composition is locked together by a strong grid of verticals and horizontals. Thus although the contours of the forms remain Paduan in their incisiveness, and the draperies retain a chiselled quality, the lines are longer and more continuous and the planes broader, so that they more readily cohere into a firm tectonic structure. The cool colour scheme and evocation of a chill dawn in the background

48 Giovanni Bellini. *Pietà* (*c*.1467). Panel, 86 × 107 cm. Milan, Brera.

landscape further enhance the mood of bitter sorrow in the foreground. An interesting indication of the painter's growing artistic self-consciousness in these years is provided by the inscription on the foreground *cartellino*, which is an adaptation from the Elegies of the pre-Christian writer Propertius, with the apparent purpose of proclaiming the superior eloquence of modern Renaissance painting over both antique art and poetry in the expression of grief, and in its ability to communicate emotion to the spectator.[17] Such ideas are clearly inspired by humanist thinking, and perhaps by Alberti's *Della Pittura* in particular; but Bellini characteristically puts them at the service of his own deeply Christian artistic purpose.

Another type of devotional image closely associated with the name of Giovanni Bellini is that of the half-length Virgin and Child. A characteristically beautiful and expressive example is the *Madonna Greca* of *c*.1470 (Pl. 49), so-called not only because of the Greek lettering referring

49 Giovanni Bellini. *Madonna Greca* (*c.*1470). Panel, 82 × 62 cm. Milan, Brera.

to Mary as Mother of God, but also because in its composition and mood the picture is strongly evocative of a Byzantine icon.[18] Like that of most of the many Madonnas painted by Giovanni before about 1500, the format of the picture follows that established by Jacopo in the 1450s (Pl. 41), with the Virgin cut off at the waist by a foreground parapet, which also serves as a platform for the Child. But compared with the tender, smiling, still elegantly Gothic Madonna group of Jacopo, Giovanni's is rigid in form, dark in colour, and solemn and remote and remote in mood, in a way that effectively expresses both the special sanctity of the figures, and their melancholy prescience of Christ's eventual Passion and death.

With its long, flowing outlines and deliberately planar composition, the *Madonna Greca* probably provides an accurate general idea of the style of a major altarpiece executed about this time for the altar of St Catherine of Siena in SS. Giovanni e Paolo.[19] This huge panel was destroyed by fire in 1867, leaving only its original, Lombardesque stone frame; but its composition was recorded earlier in the nineteenth century in the form both of an engraving (Pl. 50) and a watercolour. These show that it consisted of a unified *sacra conversazione*, of a type to become canonical in Venetian altar painting during the subsequent half-century, with a picture field consisting of a tall arched rectangle and with the saints grouped symmetrically on either side of the Virgin and Child set on a tall throne. Bartolomeo Vivarini in his *Virgin and Saints* of 1465 (Pl. 45) had already broken down the divisions of the polyptych format; but Bellini has dispelled Bartolomeo's archaisms, and set the sacred figures into a space, which although still relatively shallow and relief-like, nevertheless appears natural and logical. The sense of space is enhanced, moreover, by the unobtrusive use of illusionistic devices that would have made the picture plane appear to dissolve, and the life-size figures appear to exist in a loggia immediately beyond the archway of the frame (Pl. 51). The viewpoint is accordingly low, corresponding to that of an actual spectator before the altar; and the architectural forms of the painted loggia exactly repeat those of the real architectonic frame, so that pictorial fiction and reality are made to fuse. In this way, Bellini has exploited the new classicising style of architecture introduced into Venice by Pietro Lombardo and Mauro Codussi for his own representational interests, and it seems likely that he collaborated closely with the carver on the design of the frame. As a result, just as much as in the Gothic polyptychs of Giambono and Antonio Vivarini, painted and carved elements together form a closely integrated unity, which is now, however, totally Renaissance in character. But as always with Bellini, aesthetic concerns are inseparable from the expression

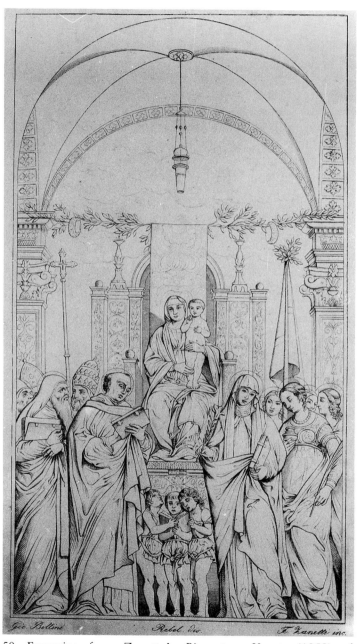

50 Engraving from Zanotto's *Pinacoteca Veneta* (1858) of
Giovanni Bellini's *St Catherine of Siena* altarpiece (destroyed 1867;
formerly Venice, SS. Giovanni e Paolo).

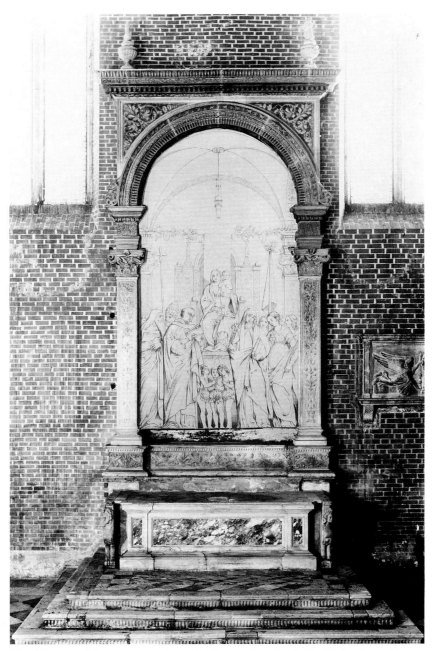

51 Photographic reconstruction of Giovanni Bellini's *St Catherine of Siena* altarpiece in its original frame.

52 Engraving from Zanotto's *Fiore della Scuola Pittorica Veneziana* (1868) of a
detail of Giovanni Bellini's *St Catherine of Siena*.

of spiritual values. In this case, the illusionism would have made the holy figures seem on the one hand physically present and humanly accessible as never before. On the other hand, they were clearly also seen to belong to a separate precinct beyond the altar and church wall, of an infinitely greater sanctity than the world of everyday reality.

Giovanni Bellini and Antonello's Visit of 1475–6

In the first phase of Venetian painting of the early Renaissance, the pictorial technique employed was still the traditional one of egg tempera. Not only Mantegna and other painters in Padua, but also Giovanni Bellini in a masterpiece such as the Brera *Pietà*, deliberately exploited the tendency of the tempera medium to create sharp breaks in the modelling of form, and to endow shapes with a clean, crisp, chiselled quality that would evoke the solidity and permanence of sculpture. But by the early 1470s Bellini was beginning to search instead for a more malleable medium that would lend his surfaces a softer and more natural character. In the case of the *Madonna Greca*, the slight softening of the surfaces had had a flattening effect, since the sharp enclosing contours were retained; and Bellini's chief artistic problem in the early 1470s was to find a way of regaining a sense of plasticity without sacrificing his new-found softness of modelling. The solution to the dilemma lay in the technique of oil painting which, as Bellini would have discovered from his study of panels imported from the Netherlands, permitted an infinitely greater subtlety of tonal transition and depth of colour than did tempera painting, and enabled the evocation of a much wider range of surface textures. Recent technical examination has shown that the artist was already using oils in his *Coronation of the Virgin* (Pesaro, Museo Civico), an important altarpiece datable to *c*.1473–6,[20] and also in his portrait of Jörg Fugger (Pl. 76), which is inscribed 1474 on the back. In other words, his adoption of the technique certainly preceded Antonello da Messina's visit to Venice of 1475–6. At this stage, however, Antonello's mastery of the oil medium was considerably more accomplished; and, as has already been mentioned (p. 40), his timely arrival in person was to have a profound effect on Bellini, and through him on Venetian painting generally.

The principal reason for Antonello's visit seems to have been to undertake a commission by the Venetian patrician Pietro Bon to paint an altarpiece for the parish church of S. Cassiano. But smaller devotional works and portraits by him must already have been imported into the city; and their evident success there may have encouraged him to go in person

and seek out a ready-made Venetian clientele. Certainly the Venetians would have been impressed by the Flemish verisimilitude of his style, with its miniature-like delicacy, marvellous evocation of varied surface textures, and glowing depth of colour, all achieved through a consummate mastery of the Eyckian technique of oil painting.

All this is evident from his tiny *St Jerome in his Study* (Pls 53, 54), with its infinitely subtle rendering of light, gleaming on the foreground bowl, catching the undersides of the background arches, and creating a play of reflections on the tiled floor. The picture is almost certainly identical with one recorded in a Venetian collection in the early sixteenth century by the collector and connoisseur Marcantonio Michiel, who significantly records attributions to Memling and to Jan van Eyck himself, as well as to Antonello.[21] Although some critics have dated the picture to the 1450s, the brilliance of its technique seems to indicate rather that it is a mature work of the 1470s, perhaps brought by the artist personally to Venice as a demonstration of his extraordinary skills, or even painted there during his visit. Further support for this later dating is provided by the close similarity of the luminous landscape glimpsed through the windows to that of an equally Flemish *Crucifixion*, also now in London (Pl. 55), which is inscribed with the date 1475, and must certainly, therefore, have been painted in Venice.

Antonello's Flemish qualities are also apparent in his S. Cassiano altarpiece, where, however, they are complemented by a uniquely Italian feeling for grandeur of form and clarity of structure. The work survives unfortunately only in fragmentary form (Pl. 56); but it is known that the central Virgin was originally flanked by eight standing saints, and that the figures of Sts George and Sebastian were placed at each of the outer edges (Pl. 57).[22] Over and above the purely devotional reasons for choosing these saints, the donor would have known that they provided the painter with an excellent opportunity for a display of his particular skills, with the cold glittering armour of St George sensuously contrasting with the soft, warm nudity of St Sebastian. Within the surviving fragment, the artist's Flemishness is apparent in the similar contrasts between the surfaces of metal, glass and velvet, as well as in the portrait-like realism of the head of St Nicholas. All this is achieved by means of the transparency and luminosity of the oil medium, which at the same time enables the artist to achieve a continuity of modelling, making his forms resemble basic geometric shapes such as spheres, cubes and cylinders. Compared with Bartolomeo Vivarini's restlessly linear, relief-like Child, for example (Pl. 45), that of Antonello consists of a few simple volumes modelled in light

53 Antonello da Messina. *St Jerome in his Study* (*c*.1474). Panel, 46 × 37 cm. London, National Gallery.

54(following page) Antonello da Messina. Detail of Pl. 53.

56 Antonello da Messina. Surviving fragment of S. Cassiano altarpiece (1475–6).
Panel, 115 × 136 cm. Vienna, Kunsthistorisches Museum.

alone, and projected by radical foreshortening into the third dimension. As
Antonello's principal public work in Venice, the S. Cassiano altarpiece
made a deep impression on Venetian painters and their employers; and it
was probably all the more influential because Antonello himself was far
from indifferent to the art he found in Venice, and he clearly made every
effort to accommodate himself to local tradition. Although there is
no record of the appearance of the painted architecture that originally
surrounded his figures, the overall composition clearly closely resembled
that of Giovanni Bellini's recent *St Catherine of Siena* altarpiece (Pl. 50),
while it scarcely resembled that of his own most recent Sicilian altarpiece,
the S. Gregorio polyptych of 1473 (Messina, Museo Nazionale). Several
other pictures painted by Antonello in Venice or soon after his return to

55 (previous page) Antonello da Messina. *Crucifixion* (1475). Panel, 42 × 25 cm.
London, National Gallery.

57 Reconstruction by J. Wilde of Antonello's
S. Cassiano altarpiece.

Sicily – including two representations of the *Pietà* (Venice, Museo Correr, and Madrid, Prado) – show a comparable translation of Bellini's compositional ideas into his own language of three-dimensional geometry.

Bellini in turn had reached a stage in his career when he was ideally equipped to grasp the implications of Antonello's message. His answer to the S. Cassiano altarpiece was a work that can claim to be the central masterpiece of Venetian painting of the later fifteenth century, his very large and imposing *Virgin and Child with Saints* of *c.*1480 for the newly completed Franciscan church of S. Giobbe (Pls 5, 58). The combination of a pyramidal figure group with a tall (originally) arched picture field, largely occupied by a stately architectural setting, follows the same basic scheme as his own earlier *St Catherine of Siena* altarpiece (Pls 50, 51),

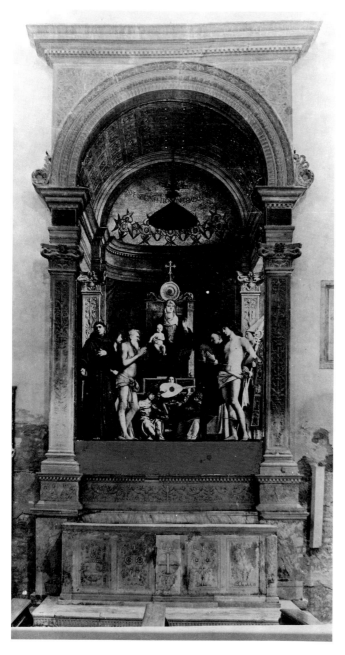

58 Photographic
reconstruction by
S. Sponza of Bellini's
S. Giobbe altarpiece
(Pl. 5) in its original
frame.

thus definitively establishing it as a model for innumerable other Venetian *sacre conversazioni* over the next few decades, and eventually rendering the older polyptych format obsolete. A connection with Mantegna's S. Zeno triptych (Pl. 40) remains in the illusionistic idea of linking the forms of the painted architecture to those of the real frame (still in the church), so that as in the *St Catherine of Siena* altarpiece, the saints appear to be present in an actual chapel leading directly off the nave of the church.[23] But Mantegna's linearism has now largely disappeared, giving way in a figure such as the St Sebastian to a more fluent modelling that makes an earlier nude such as the Christ in the Brera *Pietà* look faceted and wooden. The arrangement of the figures into a semicircle, echoing the concavity of the apse, has a similarly volumetric effect, and again makes that of the *St Catherine of Siena* altarpiece look relief-like by contrast. Echoes of Donatello's statues in the Santo in Padua (Pl. 28) survive in the expressive pathos of the St Francis, and the whole conception would have been unthinkable without a complete assimilation of Florentine perspective and anatomy. Yet the effect is neither sculptural nor intellectual, but rather one of sensuous realism and gentle spirituality that is entirely Venetian. By achieving complete command of a Flemish-Antonellesque evocation of surface texture, through which he is able to imitate the surface properties of marbles, brocades and glass tesserae, Bellini is able to provide an up-to-date and optically sophisticated version of the traditional Venetian taste for material richness, which does not involve – as still in Bartolomeo Vivarini (Pl. 45) – a renunciation of the third dimension. As has already been mentioned, the apsidal semi-dome, revetted in gleaming mosaic and decorated with Byzantine seraphim, would irresistibly have reminded Bellini's contemporaries of the interior of the state church of San Marco, with its combination of opulence and sanctity, majesty and mystery (p. 9). Paradoxically – for Bellini was the most innovative Venetian painter of the fifteenth century – there is an archaic element in his art, perhaps also detectable in the iconic remoteness of the Virgin, which seems to reflect a deep awareness of the Byzantine heritage of Venetian painting and of its appropriateness to the artistic expression of things celestial. As time went on, this awareness was to become even more pronounced, and was to find expression in the broad planes of warm, deeply saturated colour that characterise the artist's late style after 1500 (pp. 143–4). In the S. Giobbe altarpiece, by contrast, the colour is relatively subdued, and remains subordinate to the representation of the softly glowing light. Yet Bellini's sense of the supernatural, lacking in the more purely naturalistic Antonello, was always to be conveyed, as here, by convincingly natural means; and it

is precisely this combination of the real and the other worldly, the sensuous and the spiritual, the human and the divine, that constitutes one of the most moving characteristics of his art.

It was not only on the large scale of altar painting that Antonello's example acted as a stimulus to Bellini. In a work for private devotion such as the *St Francis* in the Frick Collection (Pl. 59), probably roughly contemporary with the S. Giobbe altarpiece, Giovanni seems to be trying to outdo Antonello as a painter of exquisitely detailed and luminous landscapes in the Flemish manner. As in Antonello's *Crucifixion*, or, indeed, in Flemish imports such as Memling's *St Veronica* (Pl. 13), a foreground plateau, filled with minutely described natural objects, dips down to a plain in the middleground, before the land rises up again to

59 Giovanni Bellini. *St Francis* (*c*.1477–9). Panel, 124 × 142 cm. New York, Frick Collection.

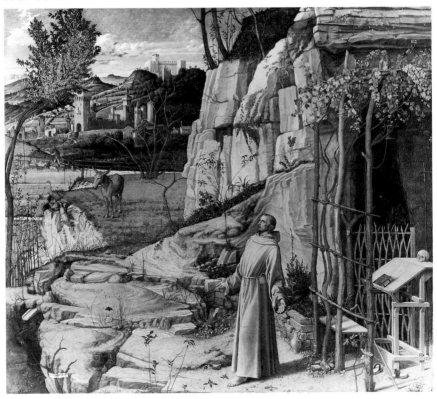

rolling hills in the background. As always in Bellini, the placing of the major forms is determined by a concern for harmonious interval and underlying geometric order. Yet compared to the Mantegnesque artificiality with which the landscape of the early *Agony* (Pl. 47) was constructed, that of the *St Francis* is gentler and more natural-seeming; and this effect is further enhanced by the greater unity of the colour composition, achieved through the use of superimposed layers of transparent oil glazes.[24] As in the S. Giobbe altarpiece, the radiant light that reveals the beauty and plenitude of the natural world, also evokes a sense of the supernatural, and of the immanence of the divine; and this expression of wonder in God's creation is obviously particularly appropriate in the context of a representation of St Francis. Critics have not always agreed about what exactly is supposed to be taking place in the picture; and while some have interpreted it as a representation of the Stigmatisation on Mount Verna (as in Gentile's organ shutter, Pl. 46), others prefer to see it as St Francis singing his Canticle to the Sun.[25] But it is probably more satisfactory to interpret the picture not as the depiction of a particular episode in a particular place, but as a composite image, combining a number of aspects of Francis's life and personality, and expressing the essence of his religious spirit.

Narrative Painting and the Venetian Scuole

One of the most striking developments in Venetian art of the late fifteenth century was the emergence of a distinctive local tradition of large-scale cyclical narrative painting.[26] The two most characteristic surviving examples executed before 1500 are both now in the Gallery of the Accademia: the cycle of the *Miracles of the True Cross*, begun by Gentile Bellini and his assistants in 1493 for the *albergo* of the Scuola di S. Giovanni Evangelista; and the cycle of the *Life of St Ursula*, painted by Carpaccio for the Scuola di S. Orsola between 1490 and c.1498. These were preceded, however, by important but now-lost cycles for the chapter halls of the Scuola di S. Giovanni Evangelista and of the Scuola di S. Marco (pp. 57, 61), as well as by the earliest canvases in the Sala del Maggior Consiglio in the Doge's Palace; and it is likely that these predecessors already displayed many of the most typical features to be found in the surviving examples. Although the type may be seen in some ways as a Venetian counterpart to contemporary fresco cycles by central Italian painters such as Ghirlandaio and Perugino, there remain essential differences. One of the most important is that of context, since unlike central

81

Italian frescoes, which usually decorated churches or chapels, Venetian narrative cycles were painted for the meeting-houses of the *scuole*. They were painted, in other words, for institutions which although devotional in function, were under the jurisdiction of the state, and not of the church (above, p. 28); and although their subject-matter is invariably religious, it carries secular and patriotic overtones almost as pronounced as in the overtly propagandist cycle in the Doge's Palace.

Another major difference between central Italian and Venetian narrative cycles was one of pictorial support. Before the mid-fifteenth century, canvas had been employed by Venetian painters only for comparatively low-cost, unprestigious commissions, or for types of painting that needed to be light in weight and easily transportable, such as organ shutters (cf. Pl. 46) or confraternity standards. In the 1460s, however, canvas had been adopted by Jacopo and Gentile Bellini for the cycle at the Scuola di S. Marco; and then the decision in 1474 to use it for the decoration of the principal council chamber of the Venetian state marked the definitive rejection of fresco painting for large-scale public interiors in Venice. Lacking the practical disadvantages of fresco (p. 15), canvas provided an ideal support for the new medium of oil paint, which as well as allowing unprecedented effects of pictorial realism, enabled painters to recapture much of the glowing richness of Byzantine mosaic. It was only a matter of time, therefore, before canvas was adopted universally as a support for Venetian painting; and although during the fifteenth century it was still used mainly in contexts where fresco would previously have been the norm, by 1500 it had also begun to replace the traditional panel support for altarpieces and small-scale domestic pictures. This change in the type of pictorial support was in turn to stimulate a different approach by Venetian artists to the actual handling of paint.[27] With its comparatively rough, textured surface, even when still covered by the traditional gesso priming, canvas was not conducive to a meticulously smooth type of brushwork, and it tended to encourage a looser, more broken and suggestive handling. Such an approach was to typify Venetian painting in the sixteenth century, above all in the art of Titian; but its beginnings are already to be found in the work of later fifteenth-century painters, such as Carpaccio who habitually used canvas.

Possibly because of his distinguished role as a propagandist for the papacy in the Sistine chapel, in 1494 the Venetian government commissioned the leading Umbrian artist Perugino to paint the ideologically important scene representing the *Battle of Spoleto* in the Sala del Maggior Consiglio. In the event, he did not fulfil the commission; but it is evident

82

from the position of the scene – between the large windows on the south wall (cf. Pls 19, 20) – that by this date all thirteen canvases on the better-lit north wall had either been executed by, or at least commissioned from, the three leading Venetian painters employed on the project up to that date. These included Gentile Bellini, who began there in 1474; Giovanni Bellini, who first became involved in 1479 during his brother's absence on a diplomatic mission to Constantinople, and who worked almost continuously on the cycle in the 1490s; and Alvise Vivarini, who was also employed there from 1488. The surviving information about these lost works is very incomplete, but in general it is clear from the written descriptions of Vasari and Francesco Sansovino that very few of them showed scenes of dramatic action, and that most of them represented scenes of stately ceremonial, involving the presentation of symbolic gifts, and the comings and goings of ambassadors, all set amidst crowds of courtiers and bystanders. In some cases, it is possible to gain a slightly more precise idea of their appearance, especially when such descriptions can be complemented by surviving drawings lby (or after) the painters concerned. One such example (Pl. 60) clearly corresponds to a scene attributed by Vasari to Gentile, and is described by him as follows:

> Then in another part the same Pope is seen standing in his pontifical robes giving his blessing to the Doge who, bearing arms and followed by a crowd of soldiers, is shown setting off on the enterprise. Behind the Doge there are countless gentlemen in a long procession. And in the same part, drawn in perspective, are the palace and St Mark's.[28]

A comparison of Vasari's description with a surviving work of the same type by Gentile such as the *Procession in the Piazza San Marco* (Pl. 61), painted in 1496 for the *Miracles of the True Cross* cycle, suggests that the drawing merely records the principal figures in the foreground, and that these would have been surrounded by numerous accessory figures, many of them perhaps portraits set into the broad stage of the Piazza, with the exterior of San Marco and the Doge's Palace dominating the scene. The close attention to topography is typically Venetian; and it is actually central to the message of the picture, since it appears to confirm the historical veracity of the event depicted, thereby also substantiating the ambitious political claims that followed from it (p. 22). The pictorial cycle of the Doge's Palace may be seen, in fact, as the fullest visual expression of the set of ideas that made up the so-called Myth of Venice; and, as such, it acted as a fundamental inspiration behind all subsequent exercises in visual propaganda by other European states, beginning with the decoration

60 Drawing after Gentile Bellini, *Donation of the Sword*. London, British Museum.

of the Hall of the Great Council in the Palazzo Vecchio in Florence in the early years of the sixteenth century.

As a commission by one of the five original Scuole Grandi – themselves regarded as miniature republics within the Republic (p. 28) – Gentile's *Procession* expresses a closely analogous ideology. In this case, the accuracy of the topography serves to prove the authenticity of a relic of the True Cross owned by the Scuola, since the real subject of the painting is not, in fact, a mere procession, but a miracle performed by the relic in direct response to prayer by a devotee, who is to be seen kneeling inconspicuously to the right of the centre foreground. The calm and orderliness with which patricians, citizens, clergy and populace process is also clearly intended to reflect the civic harmony of the Most Serene Republic; and to this end, Gentile has seen fit to suppress many of the less dignified sights that would normally have been encountered by the late fifteenth-century visitor to the Piazza: the vendors' stalls, for example; or the display of freaks and curiosities, and of criminals in cages; or the latrines. In this way, and in the displacement of the campanile to afford a view of the Doge's Palace, Gentile's view may be seen as a reflection of a project to be

realised only from the 1530s onwards, to restructure the Piazza, in an effort to make it into a more fitting architectural showpiece of the Venetian state (p. 117).

Although Perugino did not fulfil his commission for the Doge's Palace, he did find time during his visit of 1494 to contribute a canvas to the Scuola di S. Giovanni Evangelista cycle. This work is lost, but is known to have represented a seascape; most of the six surviving canvases, however, variously by Gentile's pupils and assistants such as Carpaccio (Pl. 7) and Giovanni Mansueti (Pl. 62), resemble the *Procession* in showing topographically accurate, but appropriately idealised, scenes of fifteenth-century Venice. Although by several different artists, they comprise a remarkably homogenous ensemble: thus most of the scenes are crowded with stiff and stately figures, usually relatively small in scale, yet large enough for numerous portraits of *scuola* officials to be included; the formal compositions tend to lack a clearly defined focal centre, and the eye is encouraged to wander over the surface of the canvas, from one incident to another; the general mood is festive yet dignified; and most of the canvases share the same colour scheme, dominated by reds, golds, blacks and whites. In keeping with the general aim to provide a credible visual chronicle, the canvases present the maximum of information and the minimum of drama and, by Florentine standards, the narrative element is weak and confused. Nor is there much attempt to create the spatial

61 Gentile Bellini. *Procession in the Piazza San Marco* (1496). Canvas, 367 × 745 cm. Venice, Accademia.

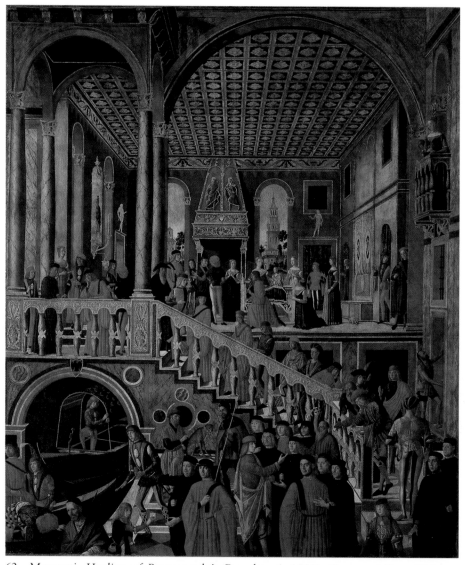

62 Mansueti. *Healing of Benvegnudo's Daughter* (*c*.1500). Canvas, 359 × 296 cm. Venice, Accademia.

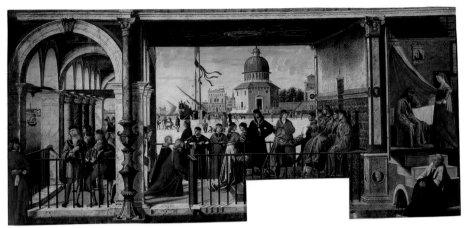

63 Carpaccio. *Arrival of the English Ambassadors* (*c*.1496–8). Canvas 275 × 589 cm. Venice, Accademia.

illusionism characteristic of the Venetian *sacra conversazione* (p. 67). Rather, in conformity with their function as wall decorations and despite the displays of linear perspective, the canvases share the flatness and splendour of tapestries.

Carpaccio's *Life of St Ursula* cycle, as exemplified by the scene that opens the story (Pl. 63), clearly belongs to the same tradition, by now well established. The painter's command of the illusionistic possibilities of Renaissance perspective is everywhere evident – in the extraordinary foreground column, for example, or in the open gate, both of which seem to intrude into the spectator's space – yet the frieze-like arrangement of the figure composition and the use of colour, combine to create an effect that is above all decorative. At the same time, the *St Ursula* cycle differs from that of S. Giovanni Evangelista in the pervasive mood of poetic fantasy. This is partly the result of the different subject-matter: whereas the Miracles of the True Cross had all taken place on home territory in the recent past, the virgin princess Ursula had lived long ago and in far-off places; and thus while the world portrayed in the *Arrival of the English* Ambassadors vividly evokes the city admired by Philippe de Commynes in 1494 (above, pp. 6–7), Carpaccio clearly also sought to make his buildings, landscapes and seascapes even more splendid and fabulous than those of the real Venice. But he was, in any case, endowed with a greater poetic imagination than the more drily factual Gentile Bellini, as is evident

64 Carpaccio. *Dream of St Ursula* (1495). Canvas, 274 × 267 cm. Venice, Accademia.

in his much greater sensitivity to the expressive quality of light. In this sense, the *Dream of St Ursula* (Pl. 64) is much closer to the spirit of Antonello (Pl. 53) and Giovanni Bellini than to Gentile, with the flood of light accompanying the angel's appearance in the open doorway magically transfiguring the saint's bedchamber, with its Flemish still-life details. Carpaccio also surpasses his collaborators on the S. Giovanni Evangelista cycle in the sheer vivacity of his brushwork, which imparts a freshness and

animation to his scenes even when the figures are static. Far more than Gentile or Mansueti, he turned the naturally rough surfaces of his canvases to positive advantage, normally using only a thin priming, and often applying the paint sketchily and suggestively, with bold touches of pure colour, in a way that anticipates Giorgione and Titian.

Devotional Painting after Antonello

Unlike narrative painting, devotional painting in Venice in the last quarter of the fifteenth century was profoundly influenced by Antonello's art, either directly by the works he left behind him, or indirectly by way of Giovanni Bellini. During the course of the 1480s Bellini himself continued to develop and refine upon the response to Antonello already embodied in the S. Giobbe altarpiece (Pl. 5). In the *Madonna of the Pomegranate* of *c*.1485 (Pl. 65), for example, the interest in positioning solid volumes in space has become even more pronounced, with the Child's shoulders and hips now placed obliquely into depth rather than parallel to the plane, and with the use of a wider tonal range to create the transitions from shadows to highlights.

The Vivarini family were slower to respond to the example of Antonello. Bellini's only slightly older contemporary Bartolomeo was unable, in fact, to respond at all; and until his death some time in 1490s he continued to work in an idiom that belonged essentially to the 1460s, and for increasingly provincial markets. His *St James* polyptych, for example (Pl. 66), painted in 1490 for a village church near Bergamo, is decidedly archaic for its date, not only in its retention of the multi-panelled format and gold background (cf. Pl. 44) – features that were probably the choice as much of the patron as of the painter – but also in the metallic linearism of the forms, which is scarely modified from that of the *Sacra Conversazione* of twenty-five years earlier.[29] Bartolomeo's nephew Alvise, on the other hand – Antonio's son – was to become the most consistent and enthusiastic exponent of Antonellism in Venice. Although he participated in the *Story of Alexander III* cycle in the Doge's Palace, his most characteristic works follow the family speciality of altar painting; and his admiration of the S. Cassiano altarpiece (Pl. 56) is overwhelmingly evident in the ambitious altarpiece he painted in *c*.1485 for a devotional confraternity in the *terraferma* town of Belluno (Pl. 67). Apart from near-quotations of Antonello in the figures of Sts George and Sebastian, the painting shows an Antonellesque stress on round volume and lucid space, conveyed with an impressive intellectual rigour. At the same time, Alvise

65 Giovanni Bellini. *Madonna of the Pomegranate* (*c*.1485). Panel, 91 × 65 cm. London, National Gallery.

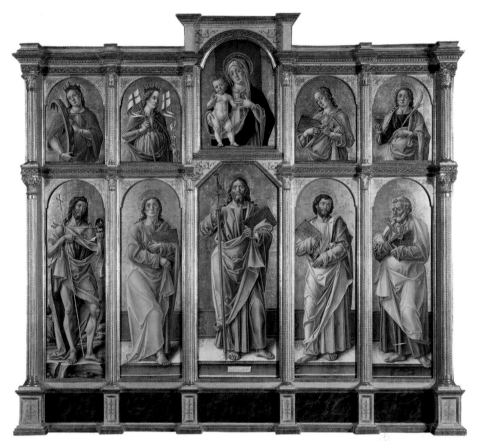

66 Bartolomeo Vivarini. *St James* polyptych (1490) (frame modern). Panels: 144 ×
56 (lower tier, centre); 75 × 52 (upper tier, centre). Malibu, J. Paul Getty Museum.

retains something in common with his uncle in the sharp edges of the folds
and in the hard, steely surfaces; and his figures have an austere, slightly
forbidding quality that again has more in common with Bartolomeo than
Antonello, let alone with the tender humanity of Giovanni Bellini.

Closer to Bellini in both mood and style is Cima da Conegliano, whose
Virgin and Child with a Donor of *c*.1492–4 (Pl. 68) is obviously much
indebted to Bellini's Madonna compositions of the 1480s such as the
Madonna of the Pomegranate (Pl. 65). Cima's Virgin also has a charac-
teristically ingenuous and slightly rustic air compared with the regal

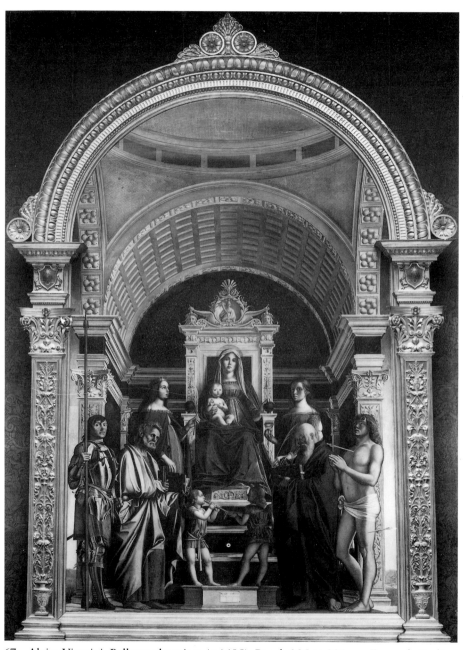

67 Alvise Vivarini. Belluno altarpiece (*c.*1485). Panel, 385 × 231 cm. Formerly Berlin, Kaiser-Friedrich-Museum; destroyed 1945.

68 Cima da Conegliano. *Virgin and Child with a Donor* (*c*.1492–4). Panel, 66 × 90 cm. Berlin, Staatliche Museen.

gravity of the counterpart by Bellini, and she lacks the formal cloth of honour, habitually used by Bellini as a symbol of her divine status. On the other hand, Cima's group retains a certain grandeur and dignity appropriate to its devotional function, which is perhaps lacking in the more anecdotal and humanly appealing treatment of the same theme by his contemporary Carpaccio (Pl. 69). Carpaccio was at his best when telling a story, as in the narrative canvases of the *St Ursula* cycle (Pls 63, 64). When, however, he was required to produce an effect that was timeless and monumental, as in the altarpiece that accompanied the cycle, the result is usually miscalculated and feeble.

As is shown by the beautifully detailed and luminous background of his *Virgin and Child with a Donor*, Cima also owed much to Bellini, as well as to Flemish painting, in the field of landscape. Like Bellini, Cima became something of a specialist in the production of small-scale panels representing saints – usually St Jerome – in an enticingly picturesque

69 Carpaccio. *Virgin and Child with the Child Baptist* (*c*.1493). Panel, 69 × 54 cm. Frankfurt, Städelsches Institut.

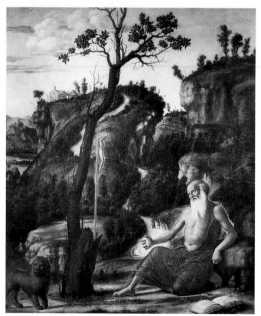

70 Cima da Conegliano. *St Jerome* (*c*.1493–5). Panel, 37 × 30 cm. Milan, Brera.

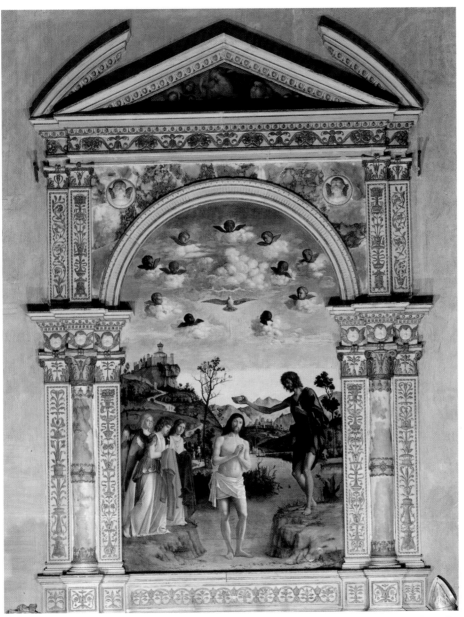

71 Cima da Conegliano. *Baptism* (1492–4). Panel, 350 × 210 cm. Venice, S. Giovanni in Bragora.

wilderness (Pl. 70); and even more consistently than Bellini, Cima introduced landscape backgrounds into his large-scale altarpieces. The early *Baptism* of 1492–4 (Pl. 71) is already a remarkable accomplishment in the genre: even more lucidly than in the Frick *St Francis* (Pl. 59), the eye is led gradually from foreground to distant mountainous background, through a series of bends in the river, mountain paths and wedges of hill; and also more than in the *St Francis*, the character of the landscape is evocative of a particular region, in this case the Dolomite foothills of the painter's homeland. This emphasis on naturalness is again what distinguishes Cima from Bellini, who shows more concern for the inner spiritual significance of the event. Yet Cima clearly understood Bellini's feeling for the poetry of light, and his picture exudes a wonderful sense of dewy freshness and delight in the natural world that must have done much to stimulate the development of landscape painting in Venice.

During the course of the 1490s, when Giovanni Bellini was largely occupied in the Doge's Palace, Cima became the most productive and inventive exponent of altar painting in Venice; and perhaps as a direct result of his interest in landscape painting, he began to relax the strict symmetry of Bellini's *sacra conversazione* compositions. Already in his *St John the Baptist* altarpiece of c.1493–5 (Venice, Madonna dell'Orto), the traditional architectural foreground has become invaded with vegetation, and the three columns on one side of the painting are balanced against a pier and a tree on the other. Then in the Parma altarpiece of c.1496–8 (Pl. 72), an imposing architectural construction to the right is loosely balanced against a view of a distant hill-town on the left. This new and dynamic conception of pictorial balance, the effect of which was not to be lost on Sebastiano del Piombo and Titian, is complemented by the poses of the figures, which are much more mobile than those normal in the work of Bellini, as in the slightly self-conscious *contrapposto* of the St Michael. The sophisticated grace of this figure, which differs both from the grandeur of Giovanni Bellini, and from the rather more rustic appearance of Cima's own earlier saints, may owe something to Perugino, who had painted a canvas for the Scuola di S. Giovanni Evangelista in 1494 (p. 85), and whose *stile dolce* – sweet style – enjoyed a certain vogue in Venice in the last years of the century.[30]

A new interest in twisting movement, also perhaps in part stimulated by Perugino, appears in certain contemporary works by Alvise Vivarini, such as the *Resurrection* of 1497–8 (Pl. 73). The expression of movement is not, perhaps, entirely successful, and the complicated entanglements of the banner and loincloth are suggestive more of restlessness than of true

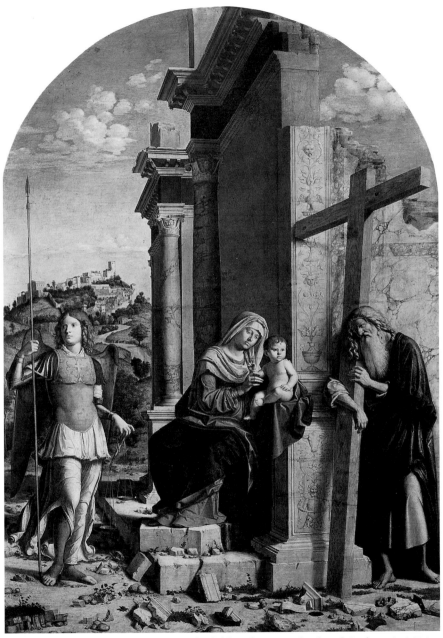

72 Cima da Conegliano. *Virgin and Child with Sts Michael and Andrew* (*c*.1496–8). Panel, 194 × 134 cm. Parma, Galleria Nazionale.

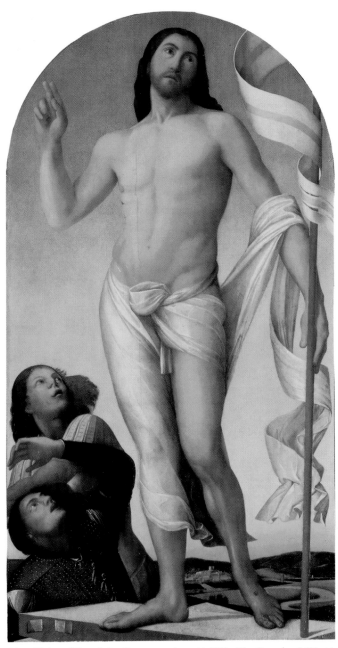

73 Alvise Vivarini. *Resurrection* (1497–8). Panel, 145 ×
76 cm. Venice, S. Giovanni in Bragora.

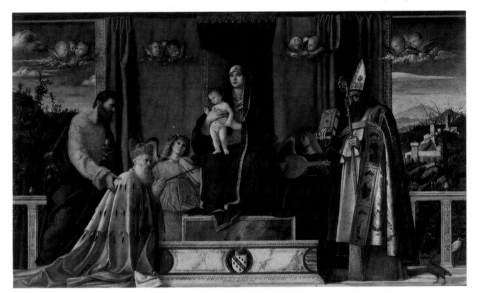

74 Giovanni Bellini. *Votive Picture of Doge Agostino Barbarigo* (1488). Canvas, 200 × 320 cm. Murano, S. Pietro Martire.

drama. Yet the heroic, highly physical treatment of the central figure of Christ does mark a new development in Venetian painting, and it has rightly been seen as anticipating the early work of Titian. Thus, although ultimately Giovanni Bellini was to remain far more important than either Alvise, or Cima, or Carpaccio for the long-term development of Venetian painting, and none was effectively to pursue the implications of their innovations beyond the point he had already reached in 1500, all three deserve credit for having made contributions to future developments quite distinct from those of their great elder rival.

Bellini's own development during the 1490s followed a very different course from those of the three other painters. Although much of his work of this decade is lost, the transition from his Antonellesque phase of the later 1470s and early 1480s to his late style may be traced by way of the *Votive Picture of Doge Agostino Barbarigo* of 1488 (Pl. 74). Originally painted for the Sala dello Scudo in the Doge's Palace,[31] it is in many ways closer in its formal and technical characteristics to the narrative paintings of the *scuole* than to devotional paintings such as the S. Giobbe altarpiece (Pl. 5). As in Carpaccio's work, the canvas support has stimulated the painter to adopt a bolder, more broken application of paint than in the

much more tightly controlled handling in the altarpiece; and the effect of an atmospheric fusion between the forms and their surroundings is correspondingly greater. The spatial composition is also much shallower, with orthogonals into depth masked; and forms and colours are arranged rather to stress the decorative unity of the plane.[32] Although in this case, the character of the work may be interpreted as a response to the particular context for which it was commissioned, the tendencies towards a very un-Antonellesque softness and decorativeness, combined with a mood of stillness and spiritual introspection, were to become characteristic of Bellini's late works in general, and were to be taken even further after 1500 (pp. 143–4).

Fifteenth-Century Portraiture

As has already been mentioned (p. 23), it was the custom in Venice, probably from as early as the 1360s onwards, for portraits of the doges to be placed in chronological order of their reigns in the frieze above the narrative scenes in the Sala del Maggior Consiglio. Then, in the early years of the fifteenth century, Pisanello, and perhaps other painters involved in the original fresco cycle, introduced portraits of contemporary and identifiable persons into his narratives.[33] Pisanello was also celebrated as a painter of autonomous, bust-length portraits; and so, too, must have been Jacopo Bellini, since he defeated Pisanello in this field at Ferrara in 1441 (p. 44).[34] But it is significant that this event took place in the environment of a court, and that the sitter was a member of a ruling dynasty; and in republican, oligarchic Venice individual portraiture did not become properly established as a genre until the 1470s.

According to Vasari, the credit for the dramatic increase in the number of portraits in Venetian painting from this time onwards was due above all to Giovanni Bellini. As Vasari wrote:

> Having devoted himself to doing portraits from life, he started in Venice the custom by which anyone of a certain rank should have a portrait done either by him or by some other painter. So there are many portraits in the houses of Venice, and in many gentlemen's homes one may see their fathers and grandfathers back to the fourth generation, and in some of the more noble houses back further still.[35]

This remark may be somewhat misleading in the image it evokes of the Venetian palace interior as a sort of extended portrait gallery; in fact, many late fifteenth- and early sixteenth-century portraits were intended for

100

contemplation in private, and they were accordingly often equipped with covers of wood or cloth that concealed them from general view.[36] Nevertheless, Vasari may well be correct in his suggestion that in Venice the growing taste for portraiture had less to do with general philosophical notions of individual uniqueness, as it did in Florence, than with family pride, and with a sense of solidarity with the prevailing social and political order. Thus while the period saw a sharp rise in the number of portraits included in large-scale public works, as well as in individual portraits for the home, it is noticeable that in the public domain individuals are almost always portrayed as members of larger groups – such as *scuola* officers, for example, or government magistrates. The votive pictures of the doges represent an exception to this general rule; but it is significant that, unlike in other Italian centres, individual kneeling donors almost never appear in Venetian altarpieces before 1500, and only rarely thereafter.

By contrast, the inclusion of portraits in the narrative cycles of the *scuole* was a well-established tradition by the time that Gentile Bellini (Pl. 61), Mansueti (Pl. 62) and Carpaccio (Pls 7, 63) were painting in the 1490s. The figures that occupy the foreground of Mansueti's picture are certainly identifiable as members of the ruling board of the Scuola di S. Giovanni Evangelista responsible for commissioning this particular canvas. From the care with which the particular features of each head is delineated it is clear that each one would have been instantly recognisable to his contemporaries. On the other hand, there is very little effect of individual personality. Each office-holder takes his place in the solemn bureaucratic order, as the worthy representative of an institution that itself formed part of the larger institution of the Venetian state; and thus although the heads are individually different, the general effect is one of a general sameness. Carpaccio (Pl. 63) was more aware of the dangers of formal monotony, and by making his officers appear to participate more in the narrative action, he was able to introduce a greater variety into the poses and the angling of the heads. But the conflicting needs on the one hand to tell the story, and on the other to maintain the dignity of the officers, meant that he could not afford to carry this process too far.

The fourteenth- and early fifteenth-century series of bust-length images in the frieze of the Sala del Maggior Consiglio had apparently shown the doges in both pure profile and three-quarter profile (above, p. 23). But when called upon to continue the series, Gentile Bellini seems to have opted exclusively for the pure profile, as a more direct echo of ducal coinage, and hence carrying stronger connotations of antique dignity and imperial majesty. Certainly most of the surviving ducal portraits by

75 Gentile Bellini.
Doge Giovanni Mocenigo (c.1478).
Panel, 63 × 46 cm.
Venice, Museo Correr.

76(facing page left) Giovanni Bellini.
Jörg Fugger (1474).
Panel, 26 × 20 cm.
Pasadena, Norton Simon Art Foundation.

77(facing page right) Antonello da Messina. *Portrait of a Man* ('*Condottiere*') (1475). Panel, 35 × 28 cm. Paris, Louvre.

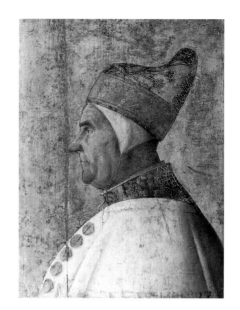

Gentile, such as the portrait of Doge Giovanni Mocenigo of c.1478 (Pl. 75), are of this format. The work typifies his approach to the genre in its combined emphasis on contour, which provides an exact, unidealised account of his physiognomy, differentiating him from any other doge, with an emphasis on rich decoration, which give full due to the dignity and sanctity of the sitter's office, but which effectively denies him any individual personality outside it.

The enormous reputation Gentile enjoyed as a portrait painter – certainly the reason why he was chosen to take part in the diplomatic mission to Constantinople in 1479 – was probably due to this ability to strike just the right balance between accurate descriptiveness and emotional reticence, adding, where appropriate, sumptuous effect. The characteristic Venetian suspicion of strongly individual personalities is also apparent in Giovanni's portraits, even in relatively informal examples such as the *Jörg Fugger* of 1474 (Pl. 76), where the young sitter is not an official of any kind. The three-quarter view here was probably inspired by Flemish prototypes, such as the Eyckian *Marco Barbarigo* now in London (National Gallery).[37] But although the features of Bellini's sitter are clearly accurately recorded, his gaze remains curiously abstracted, and the forms have a decorative and linear quality that counteracts any effect of real physical presence.

The same Venetian admiration for the accurate recording of individual features, already stimulated by the import of portraits from the Netherlands, was bound to guarantee a success in Venice for Antonello's portraits. Two of his portraits are inscribed with the dates 1475 or 1476, and the sources record several more with early Venetian provenances; and Marcantonio Michiel was probably speaking for his compatriots when he wrote approvingly of two that he saw in a Venetian collection in 1532: 'They have great power and vivacity, especially in the eyes.'[38] The so-called *Condottiere* of 1475 (Pl. 77) conveys exactly this illusion of animation; and although there is no historical justification for its traditional nickname, the pugnatious expression and the minute recording of personal details, notably the scarred upper lip, endow the figure with an individuality that strains to the limits the genre of the respectable society portrait. But while Venetian painters were compelled to take note of the astonishing verisimilitude of Antonello's portraits, they also tended to tone down their typically bold assertion of personality. The debt to Antonello of the mysterious painter known as Jacometto, for example (Pl. 78), is obvious in the firm modelling of the forms and the exactitude of the surface description, especially compared with Bellini's *Jörg Fugger*. Yet the expression has reverted to one of dreamy remoteness that was perhaps

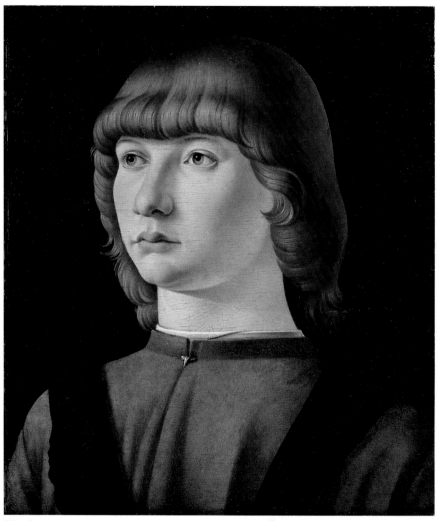

78 Jacometto Veneziano. *Portrait of a Boy* (*c.*1480–90). Panel, 23 × 20 cm. London, National Gallery.

considered more dignified than the aggressive outward stare habitual with Antonello.

In this respect, Alvise Vivarini was Antonello's most faithful follower, both in portraiture and in religious painting. Although his *Portrait of a*

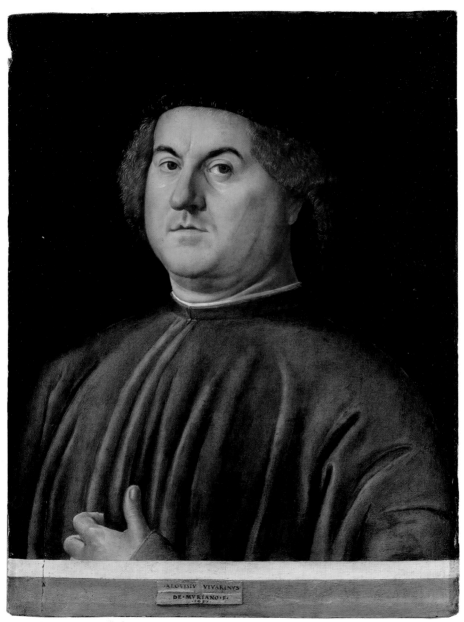

79 Alvise Vivarini. *Portrait of a Man* (1497). Panel, 62 × 47 cm. London, National Gallery.

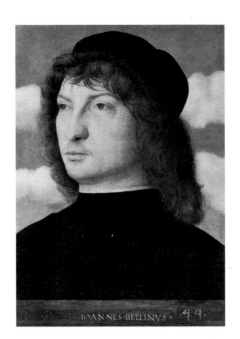

80 Giovanni Bellini. *Portrait of a Man* (*c*.1490). Panel, 30 × 20 cm. Washington, National Gallery of Art, Samuel H. Kress Collection.

Man of 1497 (Pl. 79) lacks Antonello's psychological penetration, the figure shows the uncompromising realism and momentary expression of the *Condottiere*. Indeed, Alvise emphasises further the effect of arrested action by extending the length of the figure to include the hand and much of the arm, thus anticipating early sixteenth-century development (cf. Pl. 95). To judge from the comments of certain humanist writers, Carpaccio, too, may have been innovative in this respect, forming a more important link between Antonello and the early Titian than is now generally realised. The celebrated Tuscan poetess Girolama Corsi Ramos, for example, particularly admired in his portrait of her of *c*.1494−6 his ability not only accurately to record her features, but 'to make me look as if I were about to speak'.[39]

Giovanni Bellini was also profoundly influenced by Antonello, but in a predictably different way. The *Portrait of a Man* now in Washington (Pl. 80) is probably typical of the kind of portrait seen by Vasari in large numbers in Venetian houses. Like Antonello's *Condottiere*, the sitter is seen in three-quarter view and bust-length behind a marble parapet, and the realism is noticeably more emphatic than in the earlier *Jörg Fugger*; yet with his averted glance and dignified bearing, he is presented as a man of

decorum, worthy to be honoured by his family and his society. Since his costume is that worn by members of both the upper layers of the Venetian social order, consisting of a long gown, a black cap and a stole (cf. Pls 7, 11, 61), it is impossible to say in this instance whether the sitter is of the patrician or citizen class. Unlike contemporary Florentine portraits by such artists as Botticelli, he is presented as a man of affairs rather than as a man of thoughts and feelings; nor is there any attempt to endow him with a heroism *all'antica* in the manner of Mantegna or Signorelli.

Also typical of the Venetian portrait of the last quarter of the fifteenth century is the fact that the sitter is a man. Female sitters do occasionally appear in Venetian painting of the period: one example is Gentile Bellini's portrait of Caterina Cornaro, queen of the Venetian colony of Cyprus (Budapest, Szépmüvészeti Múzeum); another is Carpaccio's previously mentioned portrait of Girolama Corsi Ramos. And to judge by a reference in a letter written by Isabella d'Este in 1498 to 'certain beautiful portraits by Giovanni Bellini' in her possession, which she wished to compare with Leonardo's portrait of Cecilia Gallerani (Cracow, Czartoryski Gallery), Bellini himself painted some portraits, now lost, of fashionably elegant young ladies.[40] But these celebrities and courtiers are exceptions that prove the rule; and, in general, the subordinate role played by women in Venetian society, and the traditional Venetian emphasis on male lineage, meant that they were not considered suitable subjects for an art-form that in Venice still fulfilled a mainly social function.

With their deliberately limited expressive range, Giovanni Bellini's portraits are not, on the whole, universal masterpieces on the level of the best of his religious paintings. An exception to this generalisation is his greatest work in the genre, the superb *Doge Leonardo Loredan* (Pl. 15). No less than in the case of Gentile's earlier portrait of Doge Giovanni Mocenigo (Pl. 75), any expression of individual personality would have been out of place; indeed the very impersonality with which the sitter is represented enables him to stand as a symbolic figurehead of the Venetian state, suggesting an ideal combination of wisdom and justice, enlightenment and severity, serenity and vigilance (above, pp. 16–18). Entirely consistent with this duality is the perceptible difference of expression that has been observed between the two sides of the face. Thus on the lit side the mouth is sterner, and the gaze of the eye colder, while on the shadowed side, the mouth begins to smile and the gaze is gentler and more benign.[41] Comparison with Gentile's work provides a measure of Antonello's importance for the development of Venetian portraiture: not only the pose, but the infinitely subtle treatment of the fall of light on the wrinkled

features and on the silky texture of the robe, would have been inconceivable without Antonello's example. Yet it is doubtful whether Antonello would have been capable of conveying the detached solemnity requisite for official portraiture; and, in fact, he is not known to have fulfilled any commissions for official portraiture during his period of residence in Venice. In this sense, Giovanni's portrait has more in common with his brother's, despite its vastly increased optical sophistication. No less than in Gentile's work, the richness of costume and the resonance of colour reaffirm a central Venetian tradition going back to the mosaics of San Marco. Giovanni also shares with Gentile a certain archaic stiffness, compared with which the Antonellesque animation of Alvise's *Portrait of a Man* is in some ways more important for future developments. Yet in their feeling for the essentially pictorial – and essentially Venetian – qualities of light and colour, Giorgione, Titian and the other leaders of the rising generation owed more, and on a deeper level, to the example of Giovanni Bellini.

The Profession of Painter

In his guidebook of 1561 Francesco Sansovino makes his imaginary Venetian host ask of his Tuscan visitor: 'Have you noticed that in Venice there are more paintings than in all the rest of Italy?'[42] Although the question undeniably carries an element of patriotic hyperbole, the growing importance of Venetian painting in the second half of the fifteenth century, in terms of its quality and inventiveness, was indeed matched by a growth in sheer output. In his later years Giovanni Bellini presided over one of the largest painters' workshops anywhere; and in addition to the usual apprentices and studio hands, he employed as assistants at least a dozen lesser masters, generically known as the 'Belliniani'. The prime reason for the dramatic expansion of the size of Bellini's workshop in the 1490s was to enable him to fulfil his extensive commitments in the Sala del Maggior Consiglio and elsewhere in government buildings. But Bellini was also much in demand as a painter of altarpieces and of narrative cycles for the Scuole; and to judge from the very large number of surviving Bellinesque half-length Madonnas, the market for this type of work was virtually insatiable. Thus for every one Madonna picture executed wholly or largely by Bellini himself, there exist several more of varying degrees of quality, from works in which he may have had a hand, to poor replicas or variants after a design by him.[43]

But Bellini's workshop was exceptional only in its size; and in its

organisation it still conformed to the rules governing the exercise of trades and crafts laid down by the late medieval guilds. Thus, as in any other trade, a boy intending to become a painter was apprenticed to a master to learn his skills for a carefully regulated number of years, before he himself graduated to the status of master painter; whereupon the might set up an independent shop, or else offer his services as an assistant, or journeyman, to another master. As a youth Bellini would have passed through the same system, in his case in the workshop of his father Jacopo; and it was probably as a recently graduated master, but while still working as an assistant in the family shop, that he co-signed the Gattamelata triptych in 1460 with his father and brother (p. 57). The tradition of the family workshop was strong in Venice, and many other leading painters of the Renaissance period, including the Vivarini, Carpaccio, Titian, Tintoretto and Veronese, similarly had fathers, sons or brothers who were also painters. This tradition, which implies a conception of the art of painting as a craft to be learnt, and on which two or more family members might collaborate, is clearly completely consistent with the mentality of the medieval guild.[44]

Unlike in Florence, where the painters belonged to a large conglomerate guild, the Arte dei Medici e Speziali, Venetian painters had a guild of their own, the Arte dei Pittori. This autonomy would have encouraged them to think of their own profession as distinct from that of other crafts; and partly perhaps as a consequence, few or no Venetian painters also practised, as did so many of their central Italian counterparts, the sister arts of architecture and sculpture. On the other hand, the Arte dei Pittori comprised every kind of painter, from gilders to textile designers and decorators of saddles; and officially the figure painters (*depentori de figure*) enjoyed no special status or privileges over their colleagues. Indeed, when at a guild meeting in 1511 Cima proposed that two *depentori de figure*, instead of just one, be included on the governing committee, he received a severe reprimand from the officers, and his proposal was decisively rejected.[45] It was not, in fact, until the mid-eighteenth century that an academy along the lines of that founded by Vasari in Florence in 1563 was established in Venice, and an official distinction was finally made between the art of figure or history painting, and the craft practised by other types of painter.

Yet Cima's proposal would not even have occurred to anyone a century earlier, and it reflects a shift of perception among Venetian painters of their own status. In the first place, there is evidence of a gradual improvement in the social position of at least the leaders during the course of the

109

fifteenth century. Probably no local painter active around 1400 could have aspired to the social recognition given by the Venetian government to the foreigner Gentile da Fabriano who, according to Francesco Sansovino, was granted a salary of a ducat a day, and the extraordinary privilege of wearing open, 'ducal' sleeves.[46] But in 1441, the victory over Pisanello by Gentile's pupil, Jacopo Bellini, at the court of Ferrara, gave him an international prestige greater than that enjoyed by any previous Venetian painter; and it is surely no accident that it was in the same year that Jacopo, himself the son of a tinsmith (*stagnero*), made a significant advance up the domestic social ladder by being elected to office in the Scuola di S. Giovanni Evangelista.[47] As hereditary citizens, his own sons Gentile and Giovanni were then similarly eligible to hold office in the Scuole Grandi, as indeed both did at the Scuola di S. Marco on several occasions from the mid-1480s. From the later 1470s onwards both brothers were awarded a lucrative annual salary by the Venetian government in recognition of their work in the Doge's Palace, and were given special dispensation from their obligations to the guild.[48] In other words, as with court appointments in other states, they were given the financial security of a regular income, instead of being paid exclusively by piece-work. As quasi-official painters to the Republic, neither painter worked extensively for non-Venetian patrons, but both attracted at least as much admiration from foreign princes as their father. In 1469 Gentile anticipated Titian in receiving a knighthood from the Holy Roman Emperor (p. 164), and a decade later he was again knighted by the Sultan of Turkey, who bestowed on him a golden chain as insignia. From the late 1490s Giovanni was persistently courted by the Marchesa Isabella d'Este of Mantua, who as well as acquiring 'beautiful portraits' by him (p. 107), wanted him to paint a secular allegory for her humanist *studiolo*; and around 1512 her brother Alfonso, duke of Ferrara, commissioned the *Feast of the Gods* (Pl. 104) for his own private apartments (p. 144). Of course, only a few Venetian masters enjoyed this kind of international success in the mercantile environment of Venice, and the great majority remained the artisans that their guild told them they were. Yet the Bellini were not alone in their achievement, and in the 1490s Cima, for example, worked for the lord of the Emilian principality of Carpi, while in 1511 Carpaccio was in contact with the Marchese of Mantua concerning the purchase of a large painting on canvas.[49] And to judge from Dürer's often-quoted comparison in 1506 between the status of painters in Venice and in his own city of Nuremberg – 'Here I am a gentleman, at home a parasite'[50] – social respectability was not restricted to just a happy few.

But in saying this, Dürer would have had in mind another, more intellectual aspect of the Renaissance redefinition of the profession of painter. As early as 1448 Jacopo Bellini inscribed a now much-damaged *Virgin and Child* (Milan, Brera) with the words HAS DEDIT INGENUA BELINUS MENTE FIGURAS ('Bellini produced these forms with his genius');[51] in other words, as in Giovanni's later Brera *Pietà* (Pl. 48), the spectator is being asked no longer simply to pray to and adore the holy figures by way of their images, but also to admire the power of the artist to evoke their living presence (p. 65). The notion of the painter as creator on a par with the poet was one propagated by Alberti, and would have been current in humanist circles at Ferrara when Jacopo was there in 1441. Significantly, Jacopo's victory over Pisanello was celebrated in verse by the Venetian humanist Ulisse degli Aleotti; and, later, similar literary praise was bestowed on Gentile and Giovanni. Unusually among Venetian painters of the fifteenth century, but like their brother-in-law Mantegna, Gentile and Giovanni are also known to have included intellectuals and humanists among their close acquaintances and friends.[52]

At the same time, therefore, that Giovanni Bellini and his shop were turning out innumerable Madonna compositions to meet the strictly devotional needs of a mass market, he was also painting refined and highly finished panels with religious subjects for persons capable of appreciating their originality of conception and quality of execution. The original owner of the Brera *Pietà* is unknown, but that of the Frick *St Francis* (Pl. 59) has been identified as Zuan Michiel, a government official and later secretary to the Council of Ten, who is also known to have owned a manuscript illuminated by Jacometto, and so who may be presumed to have taken a particular delight in the precise rendering of natural detail.[53] Zuan Michiel was one of a number of wealthy and educated Venetians who pioneered the habit in the last decades of the fifteenth century of collecting works of art, as much for aesthetic as traditional devotional reasons.[54] Another such was Michele Vianello, whose collection, part of which was later acquired by Isabella d'Este, is known to have included a representation of the *Supper at Emmaus* by Bellini, a portrait of the owner by Antonello, and two panels by (or attributed to) Jan van Eyck: one a self-portrait, and the other representing the *Crossing of the Red Sea*. During the course of the sixteenth century, Venice was to become celebrated for the number and quality of its art collections; but already in the first decade, the emergence of a younger generation of aesthetically self-conscious connoisseurs provided an essential background for the revolutionary art of Giorgione.

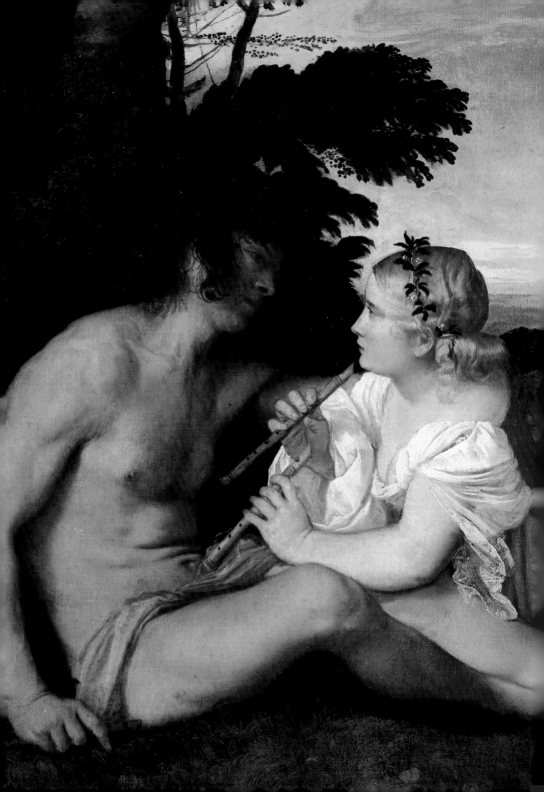

2

High Renaissance (1500–1540)

The opening two decades of the sixteenth century were a period of extra-ordinary ferment in Venetian painting. An older generation of artists led by Giovanni Bellini, and including Cima and Carpaccio, was still active, still much in demand, and not unresponsive to the dramatic pace of change. The younger generation, led by Giorgione, and including Sebastiano del Piombo and Titian, owed much to the characteristically Venetian version of the early Renaissance style evolved by their elders. But together they entirely transformed it, and thereby created a local equivalent to what Vasari called the 'maniera moderna' of Leonardo, Michelangelo and Raphael in Florence and Rome. Already by 1510, however, Giorgione was dead, and in the following years Sebastiano left Venice to join the central Italian camp in Rome; and it was left to Titian to inherit the mantle of leadership from Bellini when he died in 1516. In the following year and decades Titian decisively consolidated his position, first asserting his primacy over a successive, and again highly gifted generation of Venetian painters, and then extending his circle of admiring patrons beyond Venice to the courts of northern Italy, and beyond them to the Holy Roman Emperor, Charles V.

In the revised version of his Life of Giorgione, Vasari was careful to portray the Venetian High Renaissance not as an autonomous phenom-enon, but as directly inspired by the founding father of the Florentine High Renaissance, Leonardo da Vinci.[1] Vasari did not explain how Giorgione and his companions were supposed to have known the works of Leonardo, and later Venetian critics such as Boschini hotly contested his version of events as biased in favour of Florentine artists. But archival research in the nineteenth century discovered that Leonardo did indeed pay a brief visit to Venice in the early months of 1500 – at the very moment, in other words, when Giorgione was reaching artistic maturity. It is true that Leonardo's

82 Leonardo da
Vinci. *Head of a
Woman* (c.1485).
Turin, Galleria
Sabauda.

main business in Venice was as a consultant to the government on military engineering, and he did not apparently execute any artistic commissions during his stay. But the visual evidence suggests that he brought with him and made public a corpus of drawings (cf. Pl. 82); further, his visit evidently stimulated a wider interest among Venetian artists and patrons in pictures by Leonardo and his close followers.[2]

Another foreign visitor to make a major contribution to the stylistic revolution of the first decade was Albrecht Dürer from Nuremberg. Dürer had been in Venice as a young artist in 1494–5, and was profoundly affected by the experience; and an early engraving such as the *St Jerome* (Pl. 83) shows him exploring a traditional Venetian theme (cf. Pl. 70). But his prints in turn found a highly receptive audience in Venice, and his fame there led in 1505 to an invitation by the local confraternity representing expatriate Germans – the Scuola dei Tedeschi – to return to paint an altarpiece for its chapel in the church of S. Bartolomeo di Rialto.[3] In the

114

83 Dürer. *St Jerome*
(engraving) (*c*.1496).

resulting work, the so-called *Feast of the Rosegarlands* (Pl. 84), with its pyramidal Virgin and Child group and its musician angel, Dürer pays gracious homage to the *sacre conversazioni* of Giovanni Bellini (cf. Pls 5, 50), as well as to the tradition represented by the *Votive Picture of Doge Agostino Barbarigo* (Pl. 74). But he makes no attempt to imitate Bellini's tranquil, contemplative mood and easy spaciousness, and instead presents a throng of moving, talking, vividly characterised figures in a natural setting that is equally teeming with life and incident. Dürer himself records the success scored by the picture with the Venetian public, from the doge and the patriarch downwards. But the new dynamism that began to infuse Venetian painting from about this time bears witness to the electrifying effect it made on local painters as well. [4]

It is not always evident from the works themselves, and especially not from pastoral idylls such as the *Concert Champêtre* (Pl. 26), that the Giorgionesque revolution took place against the background of one of the

84 Dürer. *Feast of the Rosegarlands* (1506). Panel, 162 × 195 cm. Prague,
National Gallery.

most severe crises in Venetian history. In 1508 Pope Julius II and the
Emperor Maximilian I – the very potentates whom Dürer had represented
two years earlier kneeling in the foreground of his *Rosegarlands* – formed
an alliance, together with France, known as the League of Cambrai, with
the purpose of breaking Venetian power in Italy for once and for all. In
1509 the League inflicted a terrible military defeat on the Venetians at
Agnadello, depriving them of virtually all their mainland territories, and
bringing the Republic to the very point of extinction. By the end of a
protracted war, lasting until 1516, Venice had managed not only to
survive, but to regain all her lost possessions. Eloquently expressive of
official satisfaction with the return to the *status quo* is Carpaccio's *Lion of
St Mark* of the same year (Pl. 17), with its prominently inscribed PAX,
and its representation of the winged lion stepping back onto land from the
sea. As events turned out, however, Venice was never again to be the

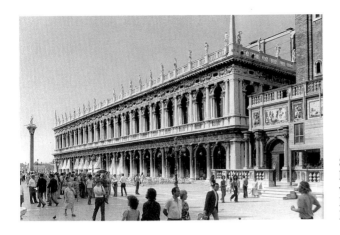

85 Venice, Piazzetta San Marco, with the Marciana Library and Loggetta.

major world power she had been in the earlier fifteenth century; and, from now on, Venetian foreign policy, both in Italy and in the face of the Turkish advance in the east, was essentially one of damage limitation, and of seeking peace with her neighbours through diplomacy. The peace, indeed, was to last, with minor interruptions, for the rest of the century and beyond; and more than ever, Venetian art fulfilled a propagandistic role, constantly and with renewed vigour proclaiming Venice's character as the most prosperous and most opulent, as well as the Most Serene Republic. This is quite explicit in the case of the ambitious architectural renewal of the ecclesio-political heart of the city, the Piazza San Marco (Pl. 85), promoted by Doge Andrea Gritti (1523–38) and executed by the Florentine architect-sculptor Jacopo Sansovino, who settled in Venice in 1527 after fleeing from the Sack of Rome.[5] But the self-image of Venice as a place of luxury and security, far from the turbulence and conflict elsewhere in Italy, may also be regarded as implicit in the pictorial magnificence of the mature art of Sansovino's colleague and friend, Titian.

Giorgione

Many characteristics of the artistic revolution created by Giorgione in the years around 1500 are to be found in a single famous work: the so-called *Tempest* (Pl. 86), first recorded by Marcantonio Michiel in 1530 in the house of the Venetian patrician Gabriele Vendramin.[6] Perhaps the most immediately striking departure from fifteenth-century tradition is the subject, which clearly does not belong to the comparatively narrow range

117

of religious themes painted by Giovanni Bellini and his contemporaries, and which is almost certainly secular. Michiel described the picture as 'the little landscape on canvas with the tempest, with the gypsy and soldier'. Although he was certainly right to stress the compositional subordination of the figures to the sultry summer landscape with its oncoming storm, his description remains tantalisingly vague. It is not clear, for instance, whether he considered that the figures were characters in a story that he chose not to identify, or whether he regarded them simply as the typical, anonymous inhabitants of a landscape picture. During the course of the past century innumerable art-historical attempts have been made to penetrate the meaning of Giorgione's picture, usually on the basis of Michiel's brief description; but so far no interpretation has won the agreement of more than a handful of scholars. A step forward may have been taken, however, by the recent observation that Michiel may have been mistaken in believing the female figure to be a gypsy and, more importantly, that he was certainly wrong to identify the male, who carries neither armour nor a weapon, as a soldier.[7] In 1569 a Vendramin family inventory described the latter rather as a shepherd;[8] and although this description may not be quite accurate either, it does tend to support a substantial body of opinion in Giorgione studies which points to a relationship between his various landscape pictures, and the pastoral movement in contemporary Italian poetry, as represented by such works as Jacopo Sannazaro's *Arcadia* and Pietro Bembo's *Gli Asolani*.[9] Basing themselves on classical models by Theocritus and Virgil, these poets set out to evoke a long-lost golden age, in which shepherds and shepherdesses, nymphs and satyrs, made love and music in idyllic landscapes full of shady groves and rippling brooks. Not all of these typical elements are present in the *Tempest*, but the Arcadian revival does provide a conceptual framework for the dominance of the landscape, the picturesque figures and the pervasive mood of poetic enchantment; and the picture may be regarded as a conscious attempt by Giorgione to create a painted equivalent of a pastoral poem, a *poesia*. Within this general context, it is further possible that the figures were intended to represent particular characters from classical mythology. Thus, according to a recent suggestion along these lines, the youth is the beautiful huntsman Iasion, who gazes towards his lover, the goddess Ceres, who suckles their child Plutus, while the angry Jupiter appears in the form of a thunderbolt in the background.[10] The problem with any interpretation of this specific kind is that Giorgione does not provide the information that would confirm it beyond a doubt. The nude is not, for example, accompanied by the ears of corn that would

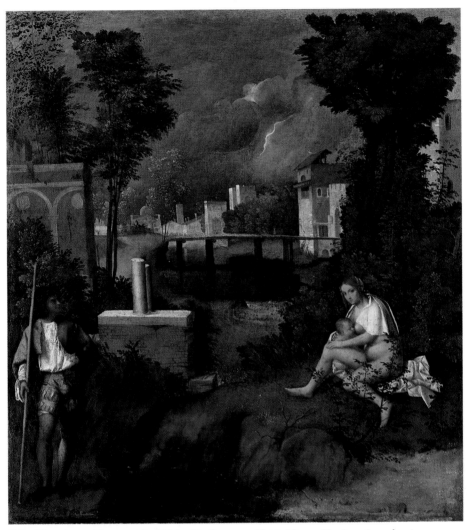

86 Giorgione. *Tempest* (*c*.1505–6). Canvas, 68 × 59 cm. Venice, Accademia.

unambiguously identify her as Ceres. Yet this is not necessarily to dismiss the interpretation, since lyric poetry was similarly allusive, evoking characters and situations known from classical literature without attempting to represent them with textual accuracy. On the contrary, the challenge to the poet – and now also to the painter of *poesie* – was to use one or more

119

literary sources as the basis for a new and autonomous invention, which surpassed its prototypes in the range of poetic effects it introduced.[11]

To some extent a precedent for the small scale of Giorgione's figures in relation to the landscape had already been set by later fifteenth-century devotional panels such as Bellini's Frick *St Francis* (Pl. 59), or Cima's *St Jerome* (Pl. 70). But as well as secularising the human content of such works, Giorgione introduced a completely new approach to the landscape itself. Whereas the landscapes of Bellini and Cima had been neatly packed with botanical and zoological detail, and controlled by a static compositional structure, the *Tempest* shows nature in a state of flux and meteorololgical drama. As in Dürer's prints and *Feast of the Rosegarlands* (Pls 83, 84), the composition is shaped by a series of dynamic curves, and the vegetation seems to quiver with vitality. At the same time, Giorgione's forms are not as incisively linear as Dürer's; and, as in Leonardo, edges are melted by the humid enveloping atmosphere, and the contrasting pools of bright illumination and deep shadow.

All these compositional departures from Bellinesque tradition are matched by a correspondingly innovative pictorial technique. Even after adopting the oil medium, Bellini had retained many of the habits of a tempera painter, carefully planning every aspect of his composition on paper in advance, and then systematically following through his plan, introducing only minor adjustments during the execution process. As already pointed out by Vasari, Giorgione dispensed with detailed preparatory drawings, and sketched his composition with the brush directly onto the canvas;[12] and the accuracy of this information has been borne out by modern investigative techniques such as x-rays, which have revealed, for instance, that the building on the left was an afterthought, and that the left background originally consisted of a view of distant mountains. An even more radical change of plan took place in the left foreground where, at one stage, Giorgione represented a female nude sitting on the riverbank, but then replaced her with the standing youth.[13] This procedure by trial and error – one that has made the problem of identifying the subject even more difficult – was made possible by the malleability of the oil medium; and it is evident even to the naked eye in the character of Giorgione's brushwork which, instead of being uniformly smooth, like that of Bellini, is highly variable in its application, with smooth areas expressively enlivened with bold touches of broken, impasted colour. In this respect, Giorgione's handling also differs from Leonardo's, with its infinitely subtle blending, and represents a pioneering stage in what was to become a characteristically Venetian tradition of the sixteenth century.

120

87 Giorgione. Castelfranco altarpiece (*c.*1498–1500). Panel, 200 × 152 cm. Castelfranco, Duomo.

88 Giorgione.
*Portrait of a Young
Man* (*c*.1498–1500).
Canvas, 58 × 46 cm.
Berlin, Staatliche
Museen.

89(below)
Giorgione. *Three Ages
of Man* (*c*.1500–5).
Panel, 62 × 77 cm.
Florence, Pitti.

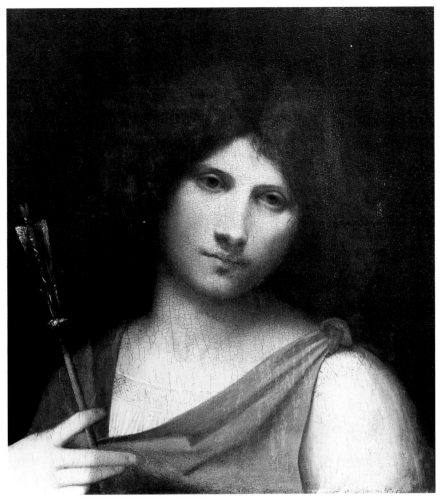

90 Giorgione. *Boy with an Arrow* (*c*.1506). Panel, 48 × 42 cm. Vienna, Kunsthistorisches Museum.

Only one surviving painting by Giorgione – the *Laura* of 1506 (Pl. 91) – is reliably dated, while in the past the *Tempest* has been dated to virtually every stage in the painter's short career. Perhaps a date of *c*.1505–6, coinciding with Dürer's visit and close to the *Laura*, is the most plausible; in any case, the picture is difficult to reconcile with a small group of religious panels which critics generally agree in seeing as the painter's

earliest works. The principal of these, an altarpiece painted for his home town of Castelfranco (Pl. 87), perhaps around the turn of the century, is still comparatively conventional in style, technique and content, and clearly belongs in the tradition of the Bellinesque *sacra conversazione*. The slim, slightly sentimental figures and the gently rolling landscape may also owe something to Perugino; already characteristic of Giorgione, by contrast, is the element of poetic strangeness and dreamy introspection. Probably from about the same date is the *Portrait of a Young Man* in Berlin (Pl. 88), with its similarly fine-boned figure and use of timid gesture. The compositional formula, with the foreground parapet and neutral background, is again derived essentially from Bellini (Pls 15, 80); but significantly, the anonymous sitter is not a middle-aged official gazing aloofly into the distance, but a richly dressed young man who looks directly outwards, as if inviting the spectator to share his most intimate thoughts and feelings.

Of the rather small number of generally accepted works by Giorgione, a relatively large proportion consists of bust- or waist-length figures, placed against a background of enveloping darkness.[14] Some of these, as in the Berlin *Young Man*, are clearly portraits of particular individuals; others, however, occupy a more ambiguous status, and are more idealised or generic in character. In the *Boy with an Arrow* if *c.*1506, for example (Pl. 82), recorded by Michiel in the house of the Catalan merchant Giovanni Ram, the figure responds to the spectator's presence with an incipient smile, and hints with his arrow at amorous emotions in his breast, in a way that resumes the theme of the *Young Man*. Yet the boy is not sufficiently particularised to constitute a real portrait; and with his androgynous beauty, clearly inspired by an ideal Leonardesque type, he is probably intended to represent a character from classical mythology such as the young Apollo. Rather harder to interpret is the so-called *Three Ages of Man* (Pl. 89) which, probably earlier than the *Boy*, marks a response to Leonardo's visit to Venice in 1500. The picture actually represents a music lesson, and given the secular dress of the figures, it may be assumed that the boy at the centre is learning to sing a madrigal. The themes of secular music and erotic love, previously virtually unknown in Venetian painting, probably reflect Giorgione's acquaintance with the courtly cultures of Ferrara, Mantua or Milan, and under his influence they were to become extremely very popular in Venetian painting in the following two decades. As in the *Boy with an Arrow*, Leonardo's influence is unmistakable in the way in which the softly lit forms emerge from the surrounding darkness; and here it is further evident in the turning pose of the elderly man (cf. Pl.

124

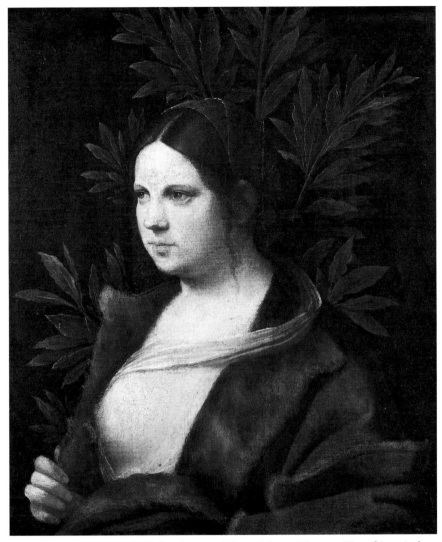

91 Giorgione. *Laura* (1506). Canvas, 41 × 34 cm. Vienna, Kunsthistorisches Museum.

82), and in the choice of sharply contrasting physiognomical types. But are the participants intended to be anonymous, and is this a genre picture into which some of the formal devices of portraiture have been incorporated?

Or rather is it a triple portrait, in which the format traditional for portraiture has become expanded and enriched through the introduction of a shared action?

Similarly complicated in its relation to straightforward portraiture is the *Laura* of 1506 (Pl. 91). The canvas has been cut at the bottom, and originally the figure's arm in its sumptuous, fur-lined red sleeve formed a horizontal base for the composition, reminiscent of the traditional Bellinesque parapet. The expansion of the Bellinesque format to include both hands, in a way that implies gesture and movement, again reflects knowledge of Leonardo's portraits, including, perhaps, the *Ginevra de' Benci* (Washington, National Gallery of Art), commissioned by the Venetian patrician Bernardo Bembo,[16] and/or the *Cecilia Gallerani*, which was briefly in Mantua in 1498 (p. 107). But does Giorgione's *Laura* represent a real person? And what is the significance of the stiffly emblematic spray of laurel from which she derives her name? In favour of her reality is the fact that her somewhat plump features lack the ideal regularity of the Castelfranco *Madonna* (Pl. 87) and the *Sleeping Venus* (Pl. 14), and her velvet-and-fur robe lacks the pseudo-classical character of the costume worn by the *Boy with an Arrow*. Yet in her state of undress, with one breast exposed, she is hardly likely to represent a member of respectable Venetian society; and the laurel motif unavoidably associates her with an ideal figure of the past, the mistress of the poet Petrarch, who wrote a pair of sonnets on her portrait by Simone Martini. According to Petrarch, perfect feminine beauty, such as that of his beloved Laura, could not be adequately portrayed by the painter, since he is limited by visible reality, and cannot penetrate to the sitter's soul. But as if to challenge the poet and to demonstrate the superior power of his own art over the abstract language of poetry, Giorgione's own *Laura* provides an image of the beloved that at once transcends the limiting particularity of real portraiture, while at the same time evoking her living presence with an unprecedentedly sensuous immediacy.[17]

Certainly the *paragone* – or debate on the relative merits of the different arts – was a favourite topic of discussion among the intelligentsia of the north Italian courts, and Leonardo in particular was a tireless proponent of the superiority of painting over the sister arts of poetry and sculpture. A standard argument in defence of the art of sculpture was that a statue in the round could be viewed from all sides, whereas the painted figure was limited to a single view. According to Vasari, Giorgione ingeniously countered this argument by painting a picture in which a man was to be seen in back view, standing in front of a stream, with a discarded cuirass

on one side and a mirror on the other; by means of his reflection in the shining surfaces surrounding him, the man was thus made visible to the spectator from four different viewpoints.[18] Although this account may be apocryphal, and such a picture may never have existed, there is ample evidence in a number of Giorgione's surviving works, and especially in those of his followers in the next decade (cf. Pls 97, 126) of his fascination with mirrors, shining armour and other reflective surfaces.

One of the most remarkable aspects of Giorgione's mature work is that it fell outside the context of traditional pictorial genres such as altarpieces, narrative cycles and devotional half-lengths, all of which existed to serve a range of well-defined religious, social and political needs. For the most part secular and literary in content, Giorgione's pictures were typically painted rather for the private enjoyment of the members of a culturally sophisticated élite, many of whose collections were described by Marcantonio Michiel, and who would have been intrigued by the very ambiguities of Giorgione's art and admiring of its inventiveness and novelty. By contrast, until the very end of his career, Giorgione seems to have undertaken very few large-scale public commissions of the traditional type. In 1508, however, he was commissioned to undertake the fresco decoration of the exterior of the Fondaco de' Tedeschi, the warehouse of the German merchant community on the Grand Canal at Rialto. By the eighteenth century Giorgione's frescoes were in ruins, but several of the most important figures, including a standing female nude (Pl. 92), were engraved before they finally became illegible.[19] In its monumental scale and ideal, classical proportions the *Nude* is unlike anything previously seen in Giorgione's oeuvre, and it apparently reflects a new interest on the part of the painter in antique sculpture. A similar female nude, but in a slightly more complex, twisting pose, then appears in the *Sleeping Venus* (Pl. 14). First recorded by Michiel in the house of the patrician Girolamo Marcello in 1525, this conceptually highly original picture became the prototype of innumerable sleeping or reclining nudes painted in Venice in the first half of the sixteenth century (cf. Pls 120, 123).[19] Comparison with the small-scale and anatomically much more awkward nude in the *Tempest* reveals the rapidity of Giorgione's development within a matter of no more than four to five years; and Michiel's information that the landscape of the *Venus* and the figure of Cupid (now overpainted) were executed by Titian, seems to confirm that the work was begun, but not completed, by Giorgione in the last year or two of his life. The brilliantly painted, but rather over-assertive foreground drapery may also have been an addition by Titian. On the other hand, the serenely languorous and

92 Engraving by
A. M. Zanetti
after Giorgione's
Standing Nude on
the façade of the
Fondaco de'
Tedeschi (1508).

gently undulating landscape is in perfect harmony with the reclining figure, and in the main part of the picture Titian clearly remained faithful to . Giorgione's intentions.

Vasari was later to comment on Titian's works of this period that they resembled Giorgione's so closely that many people mistakenly thought that they were by the elder master. Titian's ability not only to imitate the externals of Giorgione's style but to capture its inner spirit as well, has naturally caused almost impossibly difficult problems for connoisseurs, not just in Vasari's day, but ever since. Within a group of some five to ten

pictures with attributions that oscillate between the late Giorgione and the early Titian, the *Concert Champêtre* (Pl. 26) is probably the work that still finds critics most evenly divided. Beyond doubt is the fact that it is a typically Giorgionesque *poesia*, the precise subject of which is difficult to penetrate, but which clearly includes many of the themes introduced by Giorgione into Venetian painting: music, love, pastoral dalliance. According to an attractive recent interpretaion, the lutenist in the luxurious red doublet is Apollo, instructing the shepherd Paris in the art of music in the company of two Muses,[21] but there exists a host of alternative readings, most of which are purely allegorical. Probably a majority of contemporary experts considers the picture to be by Titian,[22] and, indeed, there are numerous parallels of style and motif with Titian's works in the phase just before and just after Giorgione's death in 1510. But Titian's earliest experiments with multi-figured compositions, while highly ambitious, lack the mature harmony of ends and means evident in the *Concert Champêtre*; and comparison with an only slightly later work by Titian representing a similarly Giorgionesque theme, the *Three Ages of Man* of *c.*1513–15 (Pls 81, 98), reveals a number of fundamental differences of approach.[23] Characteristic of Titian is the emphasis on expressive silhouette in the *Three Ages*, as in the relief-like arrangement of the two main figures and in the dark foliage behind them. The colour planes, as in the girl's red dress and white blouse, are broad and decorative. The energetic brushwork, as in the swirls of opaque white pigment in the her left sleeve, is even less smoothly blended with neighbouring areas than in the *Tempest*. The girl is a creature of flesh and blood, and her physical and psychological contact with her lover is frank and direct. In the *Concert Champêtre*, despite the greater scale of the figures compared with those of the *Tempest*, they are similarly integrated with their spatial surroundings, both through their poses, more complex than those of the *Three Ages*, and through the more gradual transitions from light to shade. As in the *Tempest*, the range of colours is limited to reds and green, and colour planes, while retaining their characteristically Venetian warmth and intensity, are broken up by the deep Leonardesque shadows, and merge into one another. The standing female nude resembles that of the Fondaco and the *Venus* in her somewhat abstract beauty, and the emotional relationship between the figures, again as in the *Tempest*, would remain enigmatic, even if the subject were satisfactorily explained. Together these features combine to evoke a mood of mystery and poetic suggestiveness altogether lacking in Titian's *Three Ages*, and one that may be seen rather as intrinsic to the genius of Giorgione.

The Younger Generation

Probably slightly older than Titian was Sebastiano del Piombo, some of whose earliest works have similarly been confused with those of Giorgione, but who even before Titian made an important and quite distinctive contribution towards the creation of the High Renaissance style in Venetian painting. In the *St Louis of Toulouse*, for example (Pl. 93), the inside face of one of a pair of organ shutters executed for S. Bartolomeo di Rialto in about 1509–10, the young painter succeeded in applying a fully up-to-date, Giorgionesque idiom to a traditional type of large-scale religious commission. The motif of the golden half-dome, combined with the fictive marble in the outer spandrels, unmistakably refers back to Bellini's altar-pieces and beyond them, to the mosaics of San Marco. But the head of the youthful saint, half in deep shadow and wearing an expression of romantic yearning, resembles rather the heads in the Castelfranco altarpiece (Pl. 87) and the *Boy with an Arrow* (Pl. 90). The magnificent red and gold cope is similarly indebted to Giorgione in its broad handling and impasted high-lights; indeed, it goes further than anything by Giorgione himself in the direction of a characteristically Venetian pictorial virtuosity.

In 1511 Sebastiano left Venice for Rome, where he was to become one of the closest associates of Michelangelo. But even before the move, his style had begun to assume a more self-consciously sculptural character. The *Judith* of 1510 (Pl. 94) – traditionally called *Salome*, but recently and more convincingly shown to portray the Old Testament heroine[24] – constitutes a variation of the Giorgionesque theme of the ideally beautiful half-length woman, exemplified by the *Laura* (Pl. 91); and Sebastiano's picture also adopts the Giorgionesque (and ultimately Leonardesque) motif of the look over the shoulder (cf. Pl. 82). Equally rooted in Venetian tradition are the glamorous sheen on Judith's ultramarine robe, and the rosy glow of the dawn landscape. Yet compared with the *Laura*, and also with Sebastiano's own comparatively slender and elongated figure of *St Louis*, the *Judith* represents a much fuller, more mature physical type; and despite the softening effects of the *chiaroscuro*, her features and limbs are now modelled with much greater sculptural clarity. Consistent with this is the tightly structured design, and the treatment of the figure in terms of classical high relief, with the forms swelling outwards at the centre of the composition.[25] Painted during the worst phase of the war of Cambrai, when the Republic was threatened with extinction by enemies from all sides, Sebastiano's voluptuous yet stern figure provides a highly compelling image of heroic feminine patriotism. There is a certain irony, therefore, in

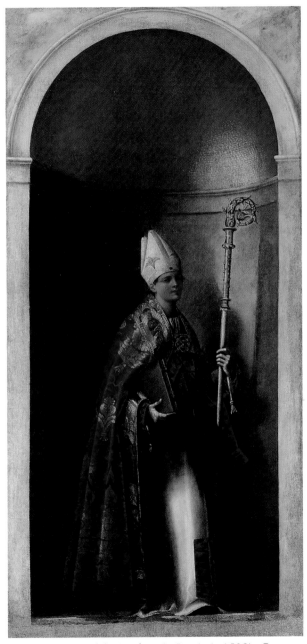

93 Sebastiano del Piombo. *St Louis* (*c*.1509). Canvas,
293 × 137 cm. Venice, S. Bartolomeo di Rialto.

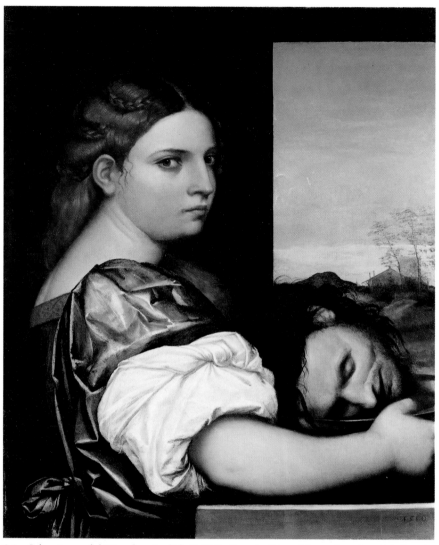

94 Sebastiano del Piombo. *Judith* (1510). Panel, 55 × 45 cm. London, National Gallery.

95 Titian. *Man with a Blue Sleeve* (*c.*1510–12). Canvas, 81 × 66 cm. London, National Gallery.

96 Titian. *Gypsy Madonna* (*c*.1510). Panel, 66 × 84 cm. Vienna, Kunsthistorisches Museum.

the fact that within months of completing it, the painter himself should have abandoned his native city to spend the rest of his days at the court of the leader of those enemies.

Similar to the *Judith* in composition and in the ample proportions of the figures, are works by the young Titian of about the same date, such as the so-called *Gypsy Madonna* (Pl. 96), and the *Man with the Blue Sleeve* (Pl. 95). Although the *Man* retains the uninterrupted foreground parapet of Bellinesque portraiture (cf. Pls 14, 80), the anonymous sitter shares with the *Judith* and with Giorgione's *Three Ages of Man* the waist-length format, the turning pose and the sharp glance outwards, all of which contribute to the greatly enhanced effect of physical presence and the force of individual character. Despite his luxurious costume of quilted blue silk, not unlike the fancy dress worn by Giorgione's *Young Man* (Pl. 88), Titian's sitter has every appearance of a man of action, and has nothing of the dreamy introspection made fashionable by Giorgione. As in Sebastiano's *Judith*, the bulky sleeve creates an effect of convexity at the centre of the composition. But Titian's handling of form is characteristically pictorial rather than sculptural, and the outer edges of the forms (including the right hand) become blurred, merging with the surrounding atmosphere. In the *Gypsy Madonna*, too, Titian introduces into a genre intimately associated with the art of Giovanni Bellini (cf. Pl. 49) a number of features of design and motif derived from Giorgione (the asymmetrical design; the sunset landscape, with its mountain repeating that of the *Sleeping Venus*;

134

the romantic motif of the resting soldier in his shining cuirass). But again, the painter energises the work as a whole with the vitality of his own artistic personality. Completely characteristic of Titian in this initial phase of his career are the boldly simplified and contrasting planes of intense colour, and of light and shade.

As well as revolutionising the traditional genres of portraiture and half-length Madonnas, the young Titian created a number of important variations on the Giorgionesque themes of the pastoral and ideally beautiful women. A splendid example of the latter category, perhaps dating from c.1514–15, is the *Woman with a Mirror* (Pl. 97). Like the *Laura* (Pl. 91), the figure is probably not meant to be recognised as a particular woman, but represents rather a visual counterpart of the feminine ideal celebrated in Petrarchan love poetry.[26] Personal to Titian, however, is the more frankly erotic presentation of the figure, with her fashionable green dress and white chemise not securely fastened, and her luxuriant blond hair falling caressingly over her bare shoulder. Furthermore, in this state of intimate undress she is asscompanied by her ardently solicitous lover, a half-seen figure with which the male spectator naturally identifies himself. In each hand the lover holds up a mirror, so that she, as well as the spectator, can admire her beauty from the back as well as from the front. While the motif of the mirror, like the jar of perfume on the foreground parapet, is naturalistically plausible in a scene of feminine toilette, it may well also have been intended, as in the art of Giorgione, as an implicit challenge to the art of sculpture. As in sculpture, the figure is visible from more than one view; but the sensuous vividness with which the painter makes her seem to live and breathe is beyond the reach of cold, inert marble.

Probably contemporary with the *Woman with a Mirror* is another early masterpiece by Titian, which again takes up the theme of love and beauty, and perhaps also of their inevitable transience, this time in a pastoral setting: the *Three Ages of Man* of c.1513–15 (Pl. 98). Until recently the traditional allegorical title has remained unchallenged; but as in the *Tempest* and the *Concert Champêtre*, it may be that the figures were also meant to represent characters from classical mythology, in this case the lovers Daphnis and Chloë, whose abandonment as infants by their parents is alluded to in the group on the right.[27] On the left the pair, who have grown up separately in the woods and fields, are brought together by the enchantment of music; while in the background, Daphnis's aged father laments the death of his two elder children. Whether or not this particular interpretation is accepted, the general theme of the picture is manifestly

97 Titian. *Woman with a Mirror* (*c.*1514–15). Canvas, 96 × 76 cm. Paris, Louvre.

Giorgionesque; but Titian approaches it in a typically robust manner, with none of Giorgione's languour and elusiveness (above, p. 129). In the enlarged scale of the figures in relation to landscape, the painter also reveals a growing interest in contemporary developments in central Italian

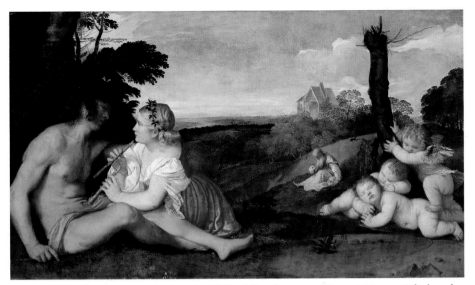

98 Titian. *Three Ages of Man* (*c*.1513–15). Canvas, 90 × 151 cm. Edinburgh, National Gallery of Scotland; on loan from the Duke of Sutherland.

99 X-ray mosaic of the *Three Ages of Man*.

art. It has often been pointed out that the pose of the boy is close to one in Michelangelo's already celebrated cartoon for the *Battle of Cascina*. Yet it is also true that Titian's figure has nothing of Michelangelo's tension, and that the fluently composed figure groups are reminiscent rather of the art of the mature Raphael.[28]

As in Giorgione's *Tempest*, x-rays of the picture (Pl. 99) are very revealing about the painter's technical procedures, while at the same time creating new problems for the iconographer.[29] Clearly visible in the x-ray photograph are, for example, several more skulls scattered round the old man in the background, and an object perhaps identifiable as a quiver on the foreground tree; but it remains to be explained why Titian then decided to eliminate these motifs. More generally, the x-ray reveals an approach to pictorial composition as one of constant experiment and adjustment, as is especially evident in the figure of the girl, whose head was originally turned more outwards, whose left hand has been placed in several positions, and whose dress is painted over the background landscape. All this is very different from the approach of Bellini, who even in his late, most pictorially liberated style, typically made his final decisions regarding the poses and relative positions of his figures before beginning to paint. Similarly, his backgrounds were painted up to the edges of the foreground figures, not underneath them.

Remaining closer to fifteenth-century tradition in terms of technique was another highly talented and original member of the younger generation of Venetian painters, Lorenzo Lotto. Compared with an early portrait by Titian such as the *Man with a Blue Sleeve* (Pl. 95), Lotto's portrait of Bishop Bernardo de' Rossi of 1505 (Pl. 100) shows a much tighter pictorial handling, with more precisely delineated contours; and although not very Bellinesque in character, the portrait may be seen as a natural successor of the 'speaking' portraits of Antonello (Pl. 77) and Alvise Vivarini (Pl. 79). At the same time, the picture reveals a new quality of interior life, of thoughtfulness, even of melancholy, which reflects the painter's interest in Dürer's portraiture (cf. Pl. 84), and beside which the portraits of Lotto's fifteenth-century predecessors appear psychologically superficial. Indeed, it was his power to combine sharply drawn individual features with expressive intensity that was to make Lotto, together with Titian, one of the greatest portrait painters of the sixteenth century.

Unusually among portraits of the period, the panel originally painted by Lotto as a protective cover (see p. 101) for the *Rossi* portrait happens to survive (Pl. 101).[30] The complex iconography of the cover, combining heraldry with allegory, may have been typical of a category of image

100 Lotto. *Bishop Bernardo de' Rossi* (1505). Panel, 54 × 41 cm. Naples, Museo di Capodimonte.

now very rare. On either side of the bishop's escutcheon are represented *paysages moralisés* of deliberately contrasting characters: to the left, the path of virtue is symbolised by the industrious child, set in a foreground of rocks and thorns, but against a background of sunny pastures; while the path of vice on the right is symbolised by the drunken satyr, lounging in a pleasant grove, but with a storm and shipwreck represented beyond him. As in the portrait, the meticulous realism with which the foreground details are represented may to some extent be seen as an aspect of Lotto's Bellinesque heritage. But of even greater inspiration for the young painter, as revealed by the nervous, bristling vitality of the vegetation, was again the art of Dürer (Pls 83, 84).

By contrast, and despite its character as a secular allegory, the cover shows relatively little impact of Giorgione: and in general, Lotto remained remarkably untouched by the prevailing Giorgionism of the first decade of the sixteenth century, both in his style and in his preferred subject-matter.

101 Lotto. *Allegory of Virtue and Vice* (1505). Panel, 57 × 43 cm. Washington, National Gallery of Art Samuel H. Kress Collection.

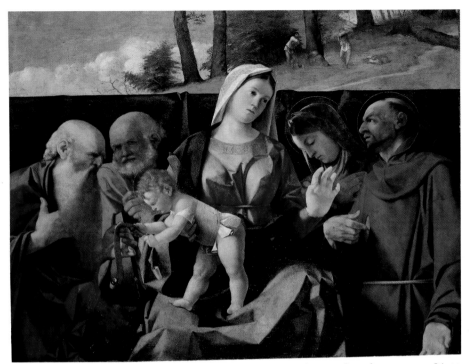

102 Lotto. *Virgin and Child with Saints* (*c*.1505). Panel, transferred to canvas, 81 × 103 cm. Edinburgh, National Gallery of Scotland.

Apart from portraits, the great majority of commissions he undertook throughout his career were of a traditional religious type, comprising either church altarpieces or smaller-scale devotional images. A fine early example of the latter is the *Virgin and Child with Saints* of *c*.1505 in Edinburgh (Pl. 102), in which a basically Bellinesque (and Cimesque) compositional type is reanimated by a new restlessness of drapery patterns, by a group of saints whose awkward expressiveness verges on the eccentric, and by the mysteriously autonomous slice of Düreresque landscape, with its glimpse of woodcutters in a forest.

In the earlier phase of his activity, Lotto worked extensively in the area of Treviso, in the diocese of his patron Bernardo de' Rossi, and apparently not at all in his native Venice. Then in 1506, at a time when the careers of Sebastiano and Titian had still scarcely begun, Lotto moved to the town of Recanati in the Marches, in connection with an important commission to

paint an altarpiece. He was to remain absent from Venice, residing first in the Marches and then in Bergamo, for a period of sixteen years; and by the time he returned in 1525, the artistic situation in Venice had become dramatically transformed.

The Older Generation

Giorgione's meteoric career and the initial diffusion of Giorgionism among the members of the younger generation took place while the commanding position in Venetian painting was still occupied by Giovanni Bellini. Already in his mid-sixties at the turn of the new century, Bellini continued to enjoy a virtual monopoly of the most important public commissions, including large-scale altarpieces and history paintings, up to the time of his death in 1516. In 1507, for example, in the midst of his ongoing commitments in the Doge's Palace, he undertook to complete the vast *Preaching of St Mark in Alexandria* (Pl. 11), commissioned by the Scuola di S. Marco from his scarcely less long-lived elder brother Gentile in 1504; and as late as 1515 Giovanni went on to sign the contract to paint an equally vast canvas representing the *Martyrdom of St Mark* for the opposite wall in the Scuola's *albergo*.

The execution of the *Preaching* seems to have been well advanced by the time of Gentile's death in 1507, and the elder painter was certainly responsible for its overall composition, so strongly reminiscent of that of his own earlier *Procession in the Piazza San Marco* for the rival Scuola di S. Giovanni Evangelista (Pl. 61).[31] In keeping with the documentary spirit of Venetian history painting, Gentile has transformed the Piazza into a square in first-century Alexandria, with the church replaced by the Temple of Serapis; and the painter has accordingly filled the picture with a wealth of circumstantial detail: the Islamic costumes; the recognisable Alexandrian landmarks, including an obelisk inscribed with hieroglyphs and the so-called Pompey's Pillar; the exotic animals, including camels, and even a giraffe. All this was designed to lend credibility to the pictorial reconstruction of a real historical event – the establishment of the church in Alexandria by St Mark – and to express the pious hope that one day the Islamic Near East would be converted back to the true religion of Christianity. Representing the followers of St Mark is the group of Venetians in their official togas in the left foreground, including at the very front the painter himself, in his capacity as office-holder of the Scuola, and wearing the golden chain bestowed on him by the Turkish sultan.

Recent technical investigation suggests that Giovanni's contribution to

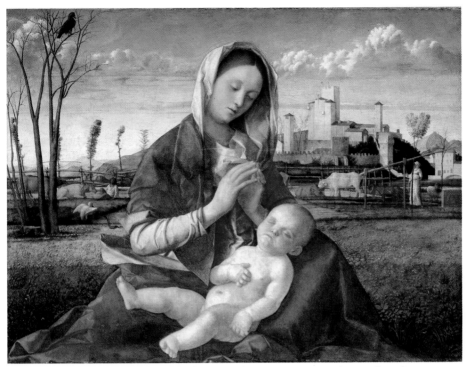

103 Giovanni Bellini. *Madonna of the Meadow* (*c*.1505). Panel, transferred to canvas, 67 × 86 cm. London, National Gallery.

the *Preaching* was relatively limited, and consisted chiefly of clarifying the figure composition in the foreground and of simplifying the buildings at the sides, replacing some of Gentile's busy detail with broader planes of luminous colour. These tendencies in Giovanni's own later work are well illustrated by a Madonna picture of the same decade, the *Madonna of the Meadow* of *c*.1505 (Pl. 103). As in his earlier Madonnas (Pls 49, 65), the picture is endowed with a deep religious seriousness, with the sleep of the naked Child here serving as an expressive metaphor for his future self-sacrifice; and, as in the early Passion scenes (Pls 47, 48), the elegiac mood of the foreground is complemented by the background landscape, with its evocation of the chill of early spring. Now, however, foreground and background are interlocked more tightly than ever before by the geometric clarity of the formal design, in which the firmly based triangle of the Virgin is echoed in the fortified hill and the distant mountains, and by the

143

decorative repetition of a limited range of colours in broad planes across the picture surface. Accompanying this shift from an Antonellesque clarity and separateness of form and space to a more unified pictorial texture is a much greater softness of modelling, so that the clouds appear unprecedentedly fluffy, and the draperies seem almost to billow.

Although there are certain parallels between Bellini's late style, with its softness of handling and chromatic intensity, and that of Giorgione and his followers, it may be seen as a natural evolution from Bellini's own earlier work, and not in the first place as a reaction to the innovations of the younger generation. But with his extraordinary and never-failing capacity for responding to and absorbing a wide range of outside influences, Bellini could not remain indifferent to Giorgionism; and towards the end of his life he painted for the first time a number of pictures with secular-allegorical and mythological subjects. The finest and most ambitious of these is the *Feast of the Gods* (Pl. 104), commissioned by Alfonso d'Este for his *camerino*, or private apartment, in the castle at Ferrara, and completed in 1514.[32] Alfonso's original plan, formulated around 1511, was to invite leading painters from all over Italy, including Fra Bartolomeo in Florence and Raphael and Michelangelo in Rome, as well as Bellini in Venice, to contribute to a cycle of canvases depicting themes associated with the pagan god of wine, Bacchus, and goddess of love, Venus. In the event, two of the central Italians died before executing their commissions, and the lion's share of the project was taken over by Titian (pp. 152–4), who subsequently also repainted the landscape background to the left of Bellini's *Feast*, to make it harmonise better with his own three contributions. As confirmed by x-rays, the wooded crag on the left, with its dramatic contrasts of light and shade, is entirely the work of Titian, and originally the screen of trees represented in the right middleground extended across the entire picture.

It is now generally accepted that the subject of Bellini's canvas is based on an episode recounted in Ovid's *Fasti*: while the Olympian gods were drowsy with wine, the libidinous Priapus attempted to rape the sleeping Lotis (on the extreme right); but before he could succeed, the braying of Silenus's ass (near the left) aroused the gods, who chased away the transgressor with their laughter.[33] Most of the gods are clearly identifiable by their attributes; Bacchus himself is shown in the unusual form of a child, with vine-leaves in his hair, filling a jug from the wine-barrel. Compared with *poesie* already painted by Giorgione and Titian such as the *Concert Champêtre* or the *Three Ages of Man*, with their sensuous, maturely classical figures, the *Feast of the Gods* appears somewhat quaint in its

144

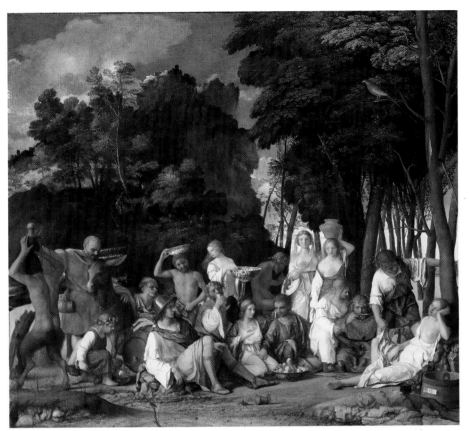

104 Giovanni Bellini. *Feast of the Gods* (1514). Canvas, 170 × 188 cm. Washington, National Gallery of Art, Widener Collection.

treatment of the erotic and bacchanalian subject-matter. The frieze-like arrangement of the figures (and originally of the screen of trees) resembles that of fifteenth-century narrative cycles in its lack of central focus, and contributes to a similar effect of staid calm and dignity. It has sometimes been supposed that Bellini felt ill at ease with secular, poetic subjects; and some documentary evidence for this may be found in the persistent excuses made in the years 1496–1505 to Alfonso's sister Isabella, when she attempted to commission an allegory for her own private apartment in the ducal palace in Mantua. But Bellini may simply have found Isabella's elaborately detailed instructions oppressive, and there is no reason to think

145

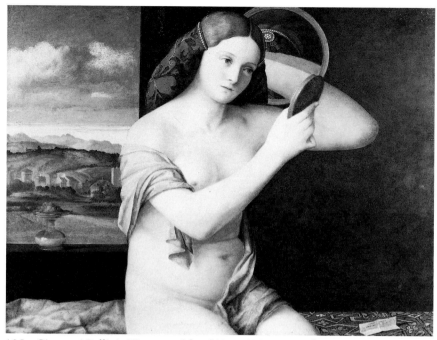

105 Giovanni Bellini. *Woman with a Mirror* (1515). Panel, 62 × 79 cm. Vienna, Kunsthistorisches Museum.

that he was reluctant to undertake this more straightforward commission from Alfonso. Many years earlier, his father Jacopo had taken evident delight in devising a similarly bacchic theme (Pl. 34), albeit in the more intimate context of an album of drawings; and the exceptional refinement of Giovanni's execution, as in the meticulous rendering of all the tiny details in the foreground (the plants and pebbles, the kingfisher, the still-life of the bowl of fruit, the gods' attributes), or in the unusually wide range and exquisite choice of colours in the draperies, suggests an equally whole-hearted commitment on the part of the aged painter to Alfonso's project.

A year later, Bellini signed and dated the *Woman with a Mirror* (Pl. 105). Although sometimes called a *Venus*, and perhaps based on an antique statue of Venus known to have been owned by his brother Gentile, the picture is more likely to constitute a variation on the theme of the ideally beautiful woman, of the type represented by Giorgione's *Laura* (Pl. 91),

and more recently by Titian's own *Woman with a Mirror* (Pl. 97). In keeping with this poetic theme, the signed *cartellino* takes the form of a love-letter written by the painter himself;[34] and it is as if the aged master, while paying tribute to his youthful model, is emphasising that it is through the power of his art that her beauty will be made immortal. In this sense, the mirror may be interpreted as an unassertive *vanitas* motif, referring to the transience of youth and beauty. As in Titian's version, the mirror may also refer to the Leonardesque idea of the *paragone* with sculpture. Certainly the picture is painted, like the *Feast of the Gods*, with particular aesthetic self-consciousness, evident here in the way in which the main colours of the foreground – pink, white, green and blue – are exactly repeated in the background landscape. At the same time, the pensive expression of the figure, which may be compared with that of Bellini's characteristic image of the Virgin (cf. Pl. 103), lends her a humanity and inner life found all too rarely in representations of the female nude in western art.

Bellini's younger contemporaries Cima and Carpaccio, while looking increasingly old-fashioned with the advance of Giorgionism, similarly maintained their place in public esteem well into the second decade of the century. Cima continued to be a successful painter above all of altarpieces and Madonnas; but he, too, made a distinctive, if modest contribution to the novel genre of mythological painting. A particularly attractive example is represented by a pair of little *tondi*, representing *Endymion Asleep* and the *Judgement of Midas* (Pl. 106), and probably intended to decorate the lid of a keyboard instrument such as a spinet.[35] Highly appropriate to such a function would have been the complementary subjects, alluding respectively to Poetry and Music, while also conforming to the currently fashionable taste in literature and painting for pastoral themes. As with the *Feast of the Gods*, certain liberties are taken with the classical texts on which the subjects are based; but the figures and episodes are at least clearly identifiable, and have nothing of the wilful elusiveness of Giorgione's *poesie*. Similarly, while the crispness that characterised Cima's style of the 1490s has become perceptibly softer, and the landscape backgrounds are executed more broadly and suggestively, the slender proportions of the figures and the accumulated details of plants and animals in the fore-ground remain deeply rooted in fifteenth-century tradition.

Even less responsive to the innovations of the younger generation was Carpaccio, whose principal work of the first decade of the new century, a series of narrative canvases for the confraternity of the Dalmatian community in Venice, the Scuola degli Schiavoni, continues to adhere to the

106 Cima da Conegliano. *Endymion Asleep* and *Judgement of Midas* (*c*.1505–10). Panels, 24 cm diameter. Parma, Galleria Nazionale.

principles of style and composition already evident in his earlier *Life of St Ursula* cycle. The scene representing *St George baptising the King and Princess*, for example (Pl. 107), one of a sequence of three showing scenes from the life of the confraternity's patron saint, is composed in a manner very similar to that of the *Arrival of the English Ambassadors* (Pl. 63) of a decade earlier, with its frieze-like procession from left to right, stage-set

107 Carpaccio. *St George baptising the King and Princess* (1507/8). Canvas, 141 × 285m. Venice, Scuola di S. Giorgio degli Schiavoni.

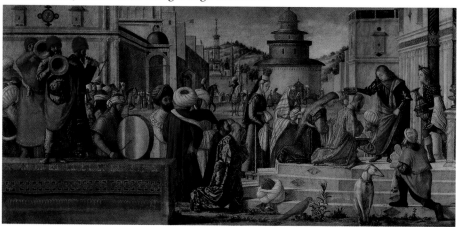

wings and backdrop, and density of picturesque accessories. The principal difference between the two works is one of local flavour: since, according to legend, St George slew the dragon in Libya in north Africa, Carpaccio followed Gentile Bellini's *Preaching of St Mark* in filling his canvas with Islamic costumes and appropriately exotic-looking architecture. The Scuola degli Schiavoni canvases possess a particular charm, thank partly to their intimate scale, and partly to the fortunate chance that they remain in their original building (Pl. 24). For the most part, too, they retain a high level of quality of execution and originality of invention; but Carpaccio's final, decidedly weak contribution to the cycle – the *St Tryphonius exorcising a Demon* of *c.*1508 – already heralds his more general decline in inspiration and importance after about 1514.

Titian: The Years of Maturity

It was probably in the last year of Bellini's life that Titian received the commission to paint a huge panel representing the *Assumption of the Virgin* for the high altar of the church of the Frari (Pls 108, 109).[36] Up to this time he had been active principally as a painter of portraits, half-lengths and other Giorgionesque subjects such as the *Three Ages of Man*; and his principal large-scale public works had comprised the comparatively unprestigious fresco decorations at the Fondaco de' Tedeschi (on a different, less visible façade from those of Giorgione), and in the Scuola del Santo in Padua (1510–11). In 1513 Titian ambitiously staked his claim to succeed Bellini as leader of the Venetian school by offering to paint the important scene in the Sala del Maggior Consiglio representing the *Battle of Spoleto*, commissioned from, but left unexecuted by, Perugino in 1494 (p. 82). But although the government accepted the offer, Titian was to make little progress on this project until the mid-1530s, perhaps because he felt that the lighting conditions in the Sala would not show off his work to best advantage. The site at the Frari, by contrast, was both highly prestigious and highly conspicuous; and Titian made the most of his opportunity, creating a work of extraordinary dramatic power and visual impact, and one that immediately established his reputation not only as the leading painter in Venice, but as a worthy rival of Raphael and Michelangelo in Rome.

Although the subject of the Assumption is obviously perfectly appropriate for the high altar of church dedicated to the Glorious Virgin, other Marian themes such as the Coronation, or the *sacra conversazione* with a central Virgin, had previously been much more common in Venetian

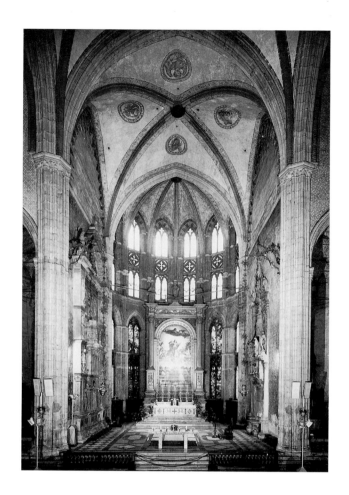

108 Venice, Frari.
View of chancel,
with Titian's
Assunta.

altarpieces. In this case it is possible that the painter himself, with a keen sense of the dramatic possibilities inherent in the Assumption story, may well have played a key role in recommending it to the local Franciscan clergy. An effect of potential movement, of physical and mental alertness, had already distinguished his earliest works from the languorous intro-spection of Giorgione. But now in the *Assunta* – as the picture is always known – the figures move into vigorous action, with the disciples below straining their faces and limbs upwards in wonder and astonishment, while the Virgin herself raises her arms in ecstasy as she rises to be embraced by God the Father in the apex. Encircling her like a garland is the equally

109 Titian. *Assumption of the Virgin* (*'L'Assunta'*) (*c*.1515–18). Panel, 690 × 360 cm. Venice, Frari.

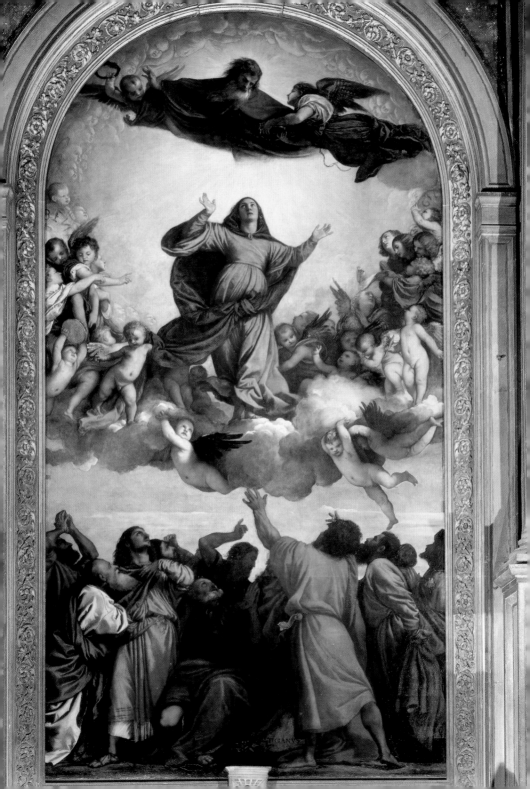

excited throng of jubilant child-angels. Hair and draperies seem to flutter, as if caught by a sea-breeze; and the sensation of physical movement is further emphasised by the insistent diagonals, which zigzag continuously upwards from earth to heaven. At the same time, all these energies are held in check by the firmly tectonic underlying composition, which consists essentially of a rectangle below and a circle above, united by an over-lapping triangle. This formal composition is then complemented and clarified by the distribution of the contrasting areas of light and shade, and of the broad planes of intense colour. Thus the three strong accents of red in the two disciples below and the Virgin above, correspond to the three corners of the central triangle. Titian's new-found ability to orchestrate complex groups of highly active and heroically proportioned figures within an overall design of harmony and legibility certainly owes much to a knowledge of the work of the mature Raphael. The *Assunta* has often and relevantly been compared with the latter's *Transfiguration* (Rome, Vatican Museum);[37] and although in fact this work slightly postdates the *Assunta*, Titian may well have known prints and drawings after, or based on, other works by Raphael, including an unrealised project for an Assumption.[38]

As in *sacre conversazioni* by Bellini such as the *St Catherine of Siena* and S. Giobbe altarpieces (Pls 51, 58; pp. 67, 79), the grandiose classicising frame of the *Assunta* plays a major role in mediating between the painting and its architectural surroundings.[39] Placed against the Gothic windows of the apse (Pl. 108), it similarly creates an effect of a gigantic opening through the back wall of the church. But the illusion is no longer of a chapel, in which solemn saints and musician angels provide an ideal counterpart to the liturgical celebrations taking place at the real altar just in front and below. Rather, the archway opens onto a vision, in which the miraculous event of the Virgin's bodily assumption into heaven is vividly re-enacted before the worshipper's very eyes. Again, there is a reference back to Bellini and to Byzantine tradition in the golden dome that sur-rounds the Virgin, and in the gesture of her hands, which recalls the *orant* pose of her Byzantine predecessors. But instead of imitating the material properties of glittering mosaic, Titian evokes the infinity of his celestial setting by means of softly painted cherub-heads, which merge imper-ceptibly with the clouds of glory that surround God the Father, in a way that was to provide a lasting inspiration for Rubens and other painters of the age of the baroque.

The joyful exuberance with which Titian endows the religious theme of the Assumption was also to find expression in the three mythological pictures be painted for Alfonso d'Este's *camerino* in the castle at Ferrara

110 Titian. *Bacchus and Ariadne* (1520–3). Canvas, 175 × 191 cm. London, National Gallery.

between 1518 and 1525 (above, p. 144). The subject of the second of the three, the *Bacchus and Ariadne* of 1520–3 (Pl. 110), is drawn mainly from the *Carmina* of Catullus; and Titian depicts the moment in which the god of wine, at the head of his noisy and drunken retinue, suddenly notices the beautiful mortal Ariadne walking alone by the seashore, and leaps out of his chariot to embrace her. Celebrating the twin joys of wine and love, the subject was obviously highly appropriate to the programme of the *camerino* as a whole; but it is equally significant that Catullus's text consists of an *ekphrasis*.[40] In other words, it is not a simple account of a mythological story, but rather a description of that story as it was portrayed in an

embroidery on the wedding-bed of two other mythological characters, Peleus and Thetis, the parents of the hero Achilles. Like his two other contributions to the *camerino*, therefore (both now Madrid, Prado), Titian's canvas was conceived as an imaginative recreation of a work of art that is supposed to have belonged to a king and a goddess in classical antiquity, in a way that was boviously highly flattering to the proprietorial pride and dynastic pretensions of the Duke of Ferrara.

Entirely in keeping with this conception are the clear references to classical sculpture, as in the densely packed, sarcophagus-like arrangement of the bacchic train, or in the close quotation from the recently excavated *Laocoon* group in the figure of the foreground satyr, wrestling with snakes.[41] More generally, and as already in the *Assunta*, Titian's figures and poses resemble those of Raphael, the modern painter generally regarded as the most faithful recreator of the art of classical antiquity. In this case, the resemblance was particularly appropriate since the *Bacchus and Ariadne* was planned as a thematic and compositional pendant to Raphael's own projected contribution to the *camerino*, representing the *Indian Triumph of Bacchus*;[42] and although Raphael had provided no more than a compositional drawing for this work, in 1517 Alfonso commissioned the minor Friulian painter Pellegrino da San Daniele to execute a full-sized canvas on the basis of the drawing. It is clear, in fact, that several on Titian's figures and motifs, including the exotic cheetahs that draw Bacchus's chariot, were consciously introduced to balance or to contrast with their counterparts in Raphael's design.

At the same time, Titian's painting consists of far more than a mere compendium of appropriate sources and quotations; and again as in the *Assunta*, he brings his story vividly to life through the boisterous energy of his figures, and through the splendour of his pictorial effects. Like Bellini's *Feast of the Gods*, the *Bacchus and Ariadne* shows an exceptionally wide colour range, achieved through the use of all the most powerful pigments available at the time.[43] These include in the draperies of the central nymph with the cymbals, glowing mixtures of the precious yellow-orange minerals orpiment and realgar, which are sensuously contrasted with the same purply-blue ultramarine that recurs in the robe of Ariadne, and with an undiminished intensity in the background mountains and sky.

At this date there did not yet exist a market for large-scale mythological canvases of this type in Venice itself, and the most challenging types of commission that Titian could expect from his compatriots were the traditional ones of the church altarpiece and the history painting. During the 1520s he executed a series of compositionally highly innovative altar-

pieces, two of the most important of which were painted respectively for the Frari – following up the success of the *Assunta* in the same church – and for the other principal mendicant church in the city, SS. Giovanni e Paolo. The first (Pl. 112), painted for the noble Pesaro family between 1519 and 1526, and including a group portrait of its male members, is relatively traditional in subject.[44] As in the *sacre conversazioni* of Giovanni Bellini and Alvise Vivarini (Pls 5, 67), it shows the Virgin and Child on a tall throne, surrounded by saints and set within and architectural space. Compositionally, however, the Ca' Pesaro altarpiece marks a radical break with the strict symmetry of the fifteenth century, and the shift of the Madonna group well to the right of the central axis creates a much more dynamic balance of forces. Similarly, Titian develops further the process already begun by Dürer in his *Feast of the Rosegarlands* (Pl. 84) of making the figures seem to move, talk and interact with one another, thereby investing the essentially static and timeless theme of the *sacra conversazione* with something of the drama of the exactly contemporary *Bacchus and Ariadne*.

The narrative and tragic theme of Titian's other major Venetian altar-piece of the decade, the *Death of St Peter Martyr* of 1526–9 (Pl. 113), surpasses even the *Assunta* and the *Bacchus and Ariadne* in the explosive-ness of its drama, and in the energetic muscularity of its figures.[45] This great work, which until its destruction by fire in 1867, together with Bellini's *St Catherine of Siena* altarpiece (p. 67), was probably the most universally admired of all Titian's paintings. Commissioned by a local Scuola Piccola dedicated to the Dominican preacher Peter Martyr, it represented a real, and comparatively recent event, the assassination of the Scuola's patron saint by a heretic as he was travelling with a fellow friar through a forest north of Milan. Titian shows the moment in which the dying victim looks up to see a vision of angels bearing the palm of martyrdom. In keeping with his role as a champion of militant Christianity, the saint's recumbent figure is based closely on his counterpart in Raphael's now-lost cartoon for the *Conversion of Saul* (cf. Pl. 114), a work that was actually present in Venice from 1521 in the collection of the Grimani family. Elsewhere Titian quotes from other major monuments of the Roman High Renaissance, including Michelangelo's Sistine ceiling, from which the pendentive figure of Haman provided a model for the panic-stricken friar on the left. But again, Titian's painting was completely Venetian in the emphasis it also laid on effects of nature. Painted copies and written descriptions record that its colour composition consisted of bold and simple contrasts of deep reds and blues, complemented by

112 Titian. Ca' Pesaro altarpiece (1519–26). Canvas, 478 × 268 cm. Venice, Frari.

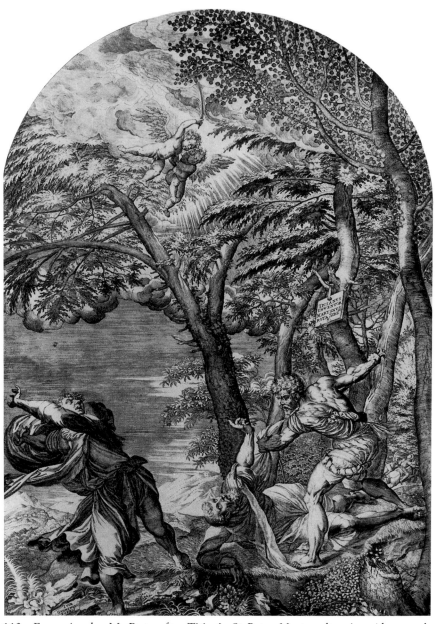

113 Engraving by M. Rota after Titian's *St Peter Martyr* altarpiece (destroyed 1867; formerly Venice, SS. Giovanni e Paolo).

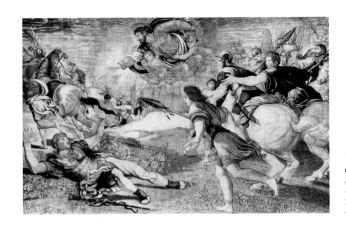

114 Tapestry. after design by Raphael, *Conversion of Saul*. Rome, Vatican Museums.

equally bold and sudden contrasts of light and shade. Even from an engraving of the work, it is clear that, like Bellini before him, Titian was one of the great landscape painters of his century. But whereas Bellini's landscapes were characteristically serene and idyllic, Titian's huge, storm-tossed trees – monumental variants of those of Giorgione's *Tempest* (Pl. 86) – echo the human tragedy with unprecedented turbulence and violence.

Titian's most important public works in Venice in the following decade were not altarpieces, but history pictures. In 1534 the Scuola Grande di S. Maria della Carità – prompted perhaps by the recent completion by Paris Bordone of the decoration of the *albergo* of the Scuola di S. Marco (pp. 142, 173) – commissioned Titian to paint a large canvas depicting the *Presentation of the Virgin* on the main wall of its own *albergo* (Pls 115, 116).[46] As in Paris's *Fisherman delivering the Ring* (Pl. 129), elements from Titian's unusually elaborate architectural background are derived from designs by the Roman-trained architect Sebastiano Serlio who, like Jacopo Sansovino, had sought refuge in Venice after the Sack.[47] But much more than the self-consciously modern composition of Paris, with its deep perspective space, that of Titian represents a deliberate alignment with the Venetian tradition of narrative painting, as represented by Gentile Bellini (Pls 11, 61) and Carpaccio (Pls 63, 107). As in the work of these prede-cessors, the figures in the *Presentation* are arranged in a processional frieze parallel to the plane, and portraits of confraternity officers mingle with the historical cast. Similarly, the dynamic compositional diagonals of the *Bacchus and Ariadne*, the Ca' Pesaro altarpiece and the *Death of St Peter Martyr* have reverted to a calm grid of verticals and horizontals.

But the critical assumption sometimes made that this calm is charac-

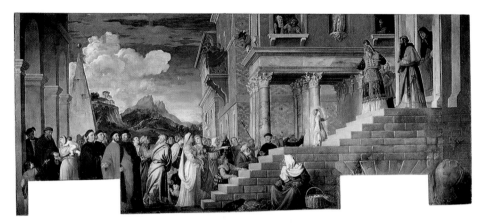

115 (above) Titian. *Presentation of the Virgin* (1534–8). Canvas, 345 × 775 cm. Venice, Accademia.

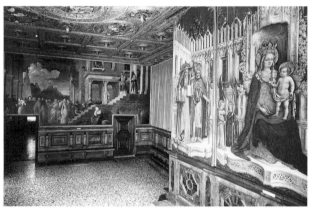

116 View of former *albergo* of Scuola Grande della Carità with Titian's *Presentation* and the Vivarini *Four Fathers of the Church* triptych (Pl. 39).

teristic of Titian's art in general during the 1530s – in contrast to the drama of the 1520s – is belied by the history painting completed simultaneously with the *Presentation*. This was the *Battle of Spoleto* for the Sala del Maggior Consiglio, commissioned more than two decades previously in 1513 (p. 149), but which Titian had neglected for more attractive engagements. In 1537, however, the Friulian painter Pordenone, who was probably already engaged on another canvas for the Sala, offered to take on the *Battle* as well; and pressure was brought to bear on Titian to fulful his longstanding commitment. The picture was destroyed in the fire of 1577 (above, p. 21), but its composition is recorded in Titian's preparatory sketch (Paris, Louvre) as well as in copies (Pl. 117). These

160

117 Engraving by G. Fontana after Titian's *Battle of Spoleto* (destroyed 1577; formerly Venice, Doge's Palace).

show a vortex-like design, quite different from that of the *Presentation*, but obviously highly appropriate to express the violence and confusion of the subject. Perhaps in a deliberate effort to counter the challenge from Pordenone, but again in perfect accord with the theme, Titian adopted a number of stylistic features characteristic of his rival, including inflatedly muscular figures and drastic foreshortenings (cf. Pl. 135).

But similar characteristics were also to be found in the work of the erstwhile pupil of Raphael, Giulio Romano, who since 1524 had held the post of court painter of Federigo Gonzaga, duke of Mantua. The duke – son of Isabella d'Este and nephew of Alfonso – shared his uncle's admiration for the art of Titian; and while the *Battle* was progress, the painter is known to have visited Mantua in connection with a commission to paint a series of portraits of the Roman emperors for the ducal palace (now lost). Several years earlier, in 1529, Titian had painted a magnificent portrait of the duke (Pl. 118), in which the Bellinesque parapet still present in the early *Man with a Blue Sleeve* (Pl. 95) has become reduced to a low table on the left, and the sitter is now portrayed in the more imposing format of the three-quarter length. Dressed in a sumptuous blue doublet embroidered with gold and fondling a white lapdog, the duke presents a slightly foppish figure, and the picture lacks the deep psychological penetration of Titian's greatest portraits (cf. Pls 148, 151). But the dignified simplicity of the pose, combined with the virtuoso brilliance of the pictorial handling, must have delighted the duke, and have done much to confirm Titian's growing reputation as the finest portrait painter in Italy.

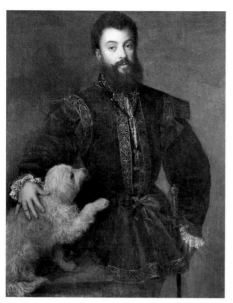

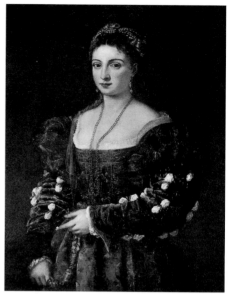

118 Titian. *Federigo Gonzaga, Duke of Mantua* (1529). Canvas, 125 × 99 cm. Madrid, Prado.

119 Titian. *La Bella* (1536). Canvas, 100 × 75 cm. Florence, Pitti.

It was through the Mantuan connection that Titian became acquainted during the course of the 1530s with a series of other princely patrons, a development that was gradually to lead to his withdrawal from public commissions in Venice, and eventually to an almost exclusive concentration on private commissions for foreign royalty. In 1532, for example, he met the Duke of Mantua's brother-in-law, Francesco Maria della Rovere, duke of Urbino; and two of his most celebrated and refined works of the later 1530s were painted for Francesco Maria and his son Guidobaldo. At first sight the so-called *Bella* (Pl. 119), dispatched to Francesco Maria in 1536, resembles a female counterpart to the *Duke of Mantua* portrait; and with her magnificent and fashionable costume, the sitter looks as if she might be some important lady at court. But in a letter to his agent Francesco Maria calls the sitter 'the woman in a blue dress', implying that as far as he was concerned she was anonymous; and the picture therefore belongs rather to the category of ideal female beauties initiated by Giorgione's *Laura* (Pl. 91), and subsequently developed in such works as Sebastiano's *Judith* (Pl. 94), Titian's *Woman with a Mirror* (Pl. 97) and Palma Vecchio's *Flora* (Pl. 124). Fully in keeping with this tradition is

the fact that the picture was originally equipped with a painted cover, indicating that it was intended for male delectation in private, rather than for public display.[48]

In this sense, the thematic pendant of the *Bella* is not so much the portrait of some male courtier as the so-called *Venus of Urbino* (Pl. 120), which apparently shows the same model, but this time in the nude.[49] Painted for Guidobaldo a year or two after the *Bella*, the *Venus* obviously represents a variation on another by-now traditional Venetian theme, again initiated by Giorgione in his *Sleeping Venus* (Pl. 14), and developed by Palma in such works as the Fitzwilliam *Venus and Cupid* of *c*.1520–5 (Pl. 123). Although Titian's reclining nude inevitably continues to evoke the goddess of love, she lacks the figure of Cupid that would serve to identify her unequivocally as Venus herself; and the fact that she is shown in a domestic interior rather than in a landscape, with maidservants in the background busying themselves with her clothes, suggests the temporary nakedness of a beautiful mortal as much as the permanent, ideal nudity of a goddess. The erotic implications of this situation are emphasised by the

120 Titian. *Venus of Urbino* (*c*.1537–8). Canvas, 119 × 165 cm. Florence, Uffizi.

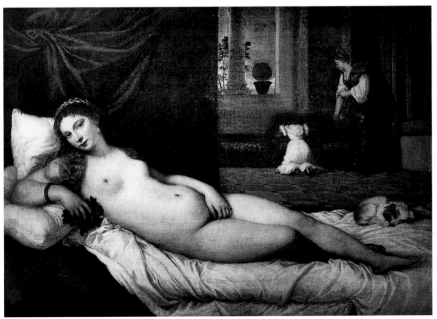

figure's consciousness of being watched, and by the position of her left hand, which coinciding with the central vertical axis of the composition, does more to draw attention to her crotch than to hide it. Highly sensuous, too, is the contrast between the background, which resembles that of the contemporary *Presentation of the Virgin* in its stable, architectonic order, and the voluptuously flowing rhythms of the woman's body. Yet there is nothing vulgar or pornographic in this frank celebration of the female nude; and, as with the *Bella*, Titian's image would certainly have retained links with Petrarchan love poetry, and with contemporary discussions on the nature of ideal love and beauty, and perhaps also of marriage and licit procreation. In keeping with its courtly destination, its pictorial handling is of the utmost refinement, with crisp details offset by broader, more neutral areas, and with a colour scheme based on decoratively repeated planes of red and green.

An even more important patron to emerge for Titian during the 1530s was the Emperor Charles V. On the recommendation of the Duke of Mantua, Charles summoned Titian to attend him on his visit to northern Italy in 1532–3, and the result was two portraits. In the first, now lost, Titian represented the emperor in armour in the three-quarter format of the *Duke of Mantua*; while the second, in which Titian was required to copy an existing portrait by the German court portraitist Jakob Seisenegger, the emperor appeared in full-length (Madrid, Prado). Up to this time, the full-length format had been extremely rare in Italian portraiture, but its adoption now by Titian created a new demand for it among high-ranking sitters, and the painter was greatly develop its expressive potential during the course of the 1540s (pp. 200, 203). As a reward for painting his portrait, the emperor created Titian Count Palatine and Knight of the Golden Spur, titles of nobility that surpassed even those bestowed on Gentile Bellini (p. 110), and raised Titian to the highest social rank ever attained by a painter.

Titian's Contemporaries

Despite the disappearance from the scene by 1511 of Giorgione, Sebastiano and Lotto, Titian was by no means the only outstandingly gifted painter of his generation to remain active in Venice in the earlier decades of the sixteenth century. Palma Vecchio, for example, although tending to shadow the movements of Titian during a rather short career cut off in 1528, nevertheless possessed a quite distinctive artistic personality, and was capable of producing paintings of great beauty. Characteristic of one

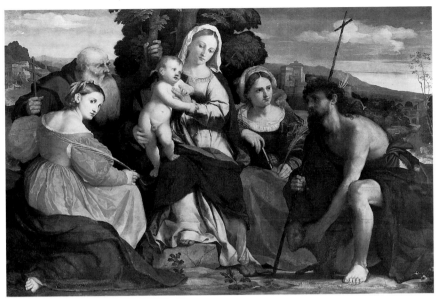

121 Palma Vecchio. *Virgin and Child with Saints in a Landscape* (*c*.1518). Panel, 133 × 198 cm. Vienna, Kunsthistorishches Museum.

of the types for which he is best known, as well as of his pictorial style in general, is the *Virgin and Child with Saints* of *c*.1518 in Vienna (Pl. 121). The type, showing an informal gathering of holy figures sitting, squatting or kneeling in a serene landscape, constitutes a religious variant of pastorals such as the *Three Ages of Man* (Pl. 98), and it seems to have been invented *c*.1511 by Titian himself in such works as the *Virgin and Child with Saints in a Landscape* (Edinburgh, National Gallery of Scotland, Duke of Sutherland loan). Palma's figures are typically placid, and lack the clarity of articulation and latent energy of those of Titian; but the rich, warm colours of the draperies, and the sensuous pictorial handling are magnificently successful. A thematic variant of the type, in which the Old Testament subject seems to have been chosen primarily for its picturesquely bucolic associations rather than for any deeper religious meaning, is the *Jacob and Rachel* (Pl. 122), datable to *c*.1525. Palma's works are frequently difficult to date; but in this case, the sequence of natural coulisses, which lend the landscape a more carefully structured character than that of the Vienna picture, and the relatively active figures, suggest that the painter had seen the *Bacchus and Ariadne* (Pl. 110) and Titian's

165

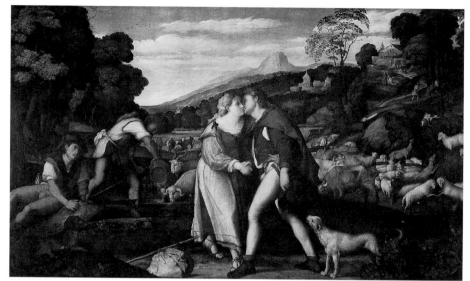

122 Palma Vecchio. *Jacob and Rachel* (*c*.1525). Canvas, 147 × 251 cm. Dresden, Gemäldegalerie.

123 Palma Vecchio. *Venus and Cupid* (*c*.1520–5). Canvas, 118 × 209 cm. Cambridge, Fitzwilliam Museum.

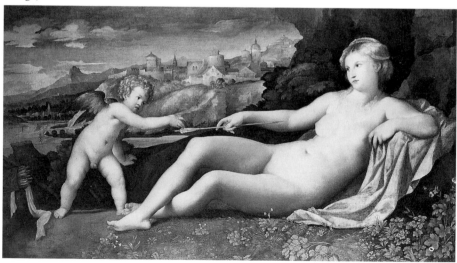

124 Palma Vecchio. *Flora* (*c.*1520–5). Panel, 78 × 64 cm. London, National Gallery.

other mythologies for the Duke of Ferrara. Palma's picture has nothing of the high drama of these predecessors, but in compensation the two main figures provide a moving expression of ordinary human affection.

Palma's two other main specialities – the half-length anonymous beauty

and the nude in a landscape – both similarly develop themes first formulated by Giorgione, within a colourfully decorative style based on that of the early Titian. Often represented in the guise of a historical or mythological figure such as Judith, or Flora, or a Sibyl, Palma's comfortably plump beauties tend to be more blatantly provocative than their more subtly alluring counterparts by Titian. In the *Flora* of *c.*1520–5, for example (Pl. 124), the figure's chemise has slipped further than in Titian's *Woman with a Mirror* (Pl. 97) to reveal her breast; and her inviting glance and gesture of offering a posy of flowers together carry a broad hint that she is also offering herself. Similarly, the dreamy remoteness of Giorgione's *Sleeping Venus* (Pl. 14) has given way in the Fitzwilliam *Venus and Cupid* (Pl. 123) to a mood of selfconscious eroticism. Marcantonio Michiel lists several of Palma's half-lengths in the houses of Venetian collectors, who evidently prized them for their aesthetic refinement as well as for their erotic suggestiveness; and although he does not mention any reclining nudes by Palma, his record of a now-lost nude by Savoldo in the possession of Andrea Odoni suggests that like Titian's *Bella*, such works were meant to be enjoyed in the privacy of the bedchamber.[50]

Savoldo, like Palma, while also undertaking a number of commissions for altarpieces, painted his finest and most characteristic works for private collectors. Despite the lost *Nude*, however, the serious thoughtfulness of his temperament and the solid realism of his style inclined him less towards erotic and mythological than towards religious and genre subjects, with figure types rooted in ordinary, everyday experience. These tendencies are well illustrated by a monumental variation on the traditional Venetian theme of St Jerome in the Desert (Pl. 125; cf. Pl. 70), in which the ponderous, unidealised, almost peasant-like figure of the penitent saint is lent an impressive, looming grandeur by his placing close to the picture plane, and by being seen slightly from below. Any effect of mere ordinariness is further dispelled by the spiritual intensity with which he gazes at the image of the crucified Saviour, and by the poetically transfiguring twilight landscape, with its view on the left of the church of SS. Giovanni e Paolo across the Venetian lagoon. The contrasts between the planes of light and deep shadow, and between the glowing crimson of the saint's tunic and the deep blue of the mountains and sky, are all the more effective for their boldness and simplicity.

One of the now-lost pictures by Giorgione recorded by Michiel, in the same collection as Savoldo's *Nude*, was a *St Jerome in a Moonlit Landscape*;[51] and although his own *St Jerome* is not a night scene, Savoldo's work in general shows a deep interest in the special lighting

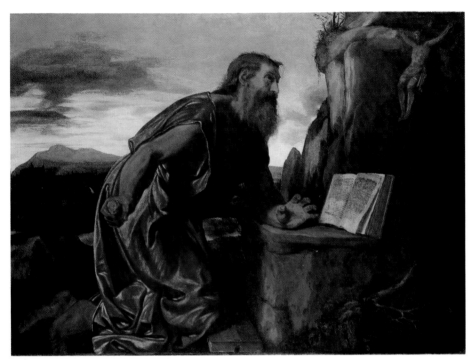

125 Savoldo. *St Jerome* (*c*.1527–30). Canvas, 120 × 159 cm. London, National Gallery.

effects previously explored by Giorgione. Another aspect of this interest is evident in the so-called portrait of the French general *Gaston de Foix* (Pl. 126) – actually an unknown sitter – with its virtuoso display of a complicated system of reflections. The idea of surrounding a figure with mirrors and pieces of shining armour clearly follows that of a similar virtuoso piece by Giorgione, recorded by Vasari and by Savoldo's pupil Paolo Pino (pp. 126–7, 216); and, like its prototype, the picture represents a carefully meditated contribution to the ongoing debate on the relative merits of painting and sculpture. The expansive pose (although actually deriving from one of Titian's Ferrara mythologies),[52] the psychologically immediate relationship with the spectator, and the circumstantially described surroundings, all make Savoldo's portrait very different from the type of fashionable portraiture practised by Titian in the 1520s and 30s (cf. Pl. 118); and in these respects it resembles rather several of the portraits painted by Lotto during this period (cf. Pl. 132).

169

126 Savoldo. *Portrait of a Man* ('*Gaston de Foix*') (*c*.1527–30). Canvas, 91 × 123 cm. Paris, Louvre.

Many of Savoldo's pictures show a single figure and, unlike Titian, the painter was not a master of dramatic narrative. But it is not always clear whether the figure is meant to portray a real person, as is presumably the case with the *Gaston de Foix*, or whether, in characteristically Giorgionesque fashion, it represents some literary, historical or allegorical figure. These two possibilities are not, however, mutually exclusive, and the physiognomically highly individualised *Shepherd with a Flute* (Pl. 127), may well portray a gentleman affecting a rustic guise, perhaps in illustration of Baldassare Castiglione's comment that even when a gentleman is dressed as a shepherd, his true rank should still be evident.[53] Whatever the specific meaning of the picture, the theme of the music-playing shepherd clearly goes back to Giorgione; as in Palma's *Jacob and Rachel*, however, and later in the work of Jacopo Bassano (cf. Pls 158, 161), the dreamy arcadian world of the *Concert Champêtre* has given way to one that is characterised rather by busy agricultural activity.

The continuing attraction of ambivalent Giorgionesque themes for Venetian patrons and painters two or three decades after Giorgione's

127 Savoldo. *Shepherd with a Flute* (*c*.1535?). Canvas, 97 × 78 cm. Malibu, J. Paul Getty Museum.

128 Paris Bordone. *'Two Lovers'* (*c*.1525). Canvas, 204 × 436 cm. Milan, Brera.

death may also be illustrated by an early work by Paris Bordone, such as the so-called *Two Lovers* (Pl. 128). As in Giorgione's *Three Ages of Man* (Pl. 89; above, pp. 124–6), the image combines elements of portraiture, genre and allegory; and critics remain uncertain about how the interaction among the three figures is to be interpreted. Thus, according to one recent reading,[54] the picture is a straightforward triple portrait, painted to commemorate a marriage contract, with the couple accompanied by a witness; and, indeed, this would seem to be supported by the fashionable

and respectable costumes, and by the realism of the faces. Yet this reading does not take account of the mysterious character of the third man, or of the relation of such images – including Titian's compositionally similar *Woman with a Mirror* (Pl. 97) – to literary musings on the joys and sorrows of love; and according to another, more convincing interpretation,[55] the picture is meant rather to evoke the bitter-sweet emotions caused by a love triangle – in which case, the figures would probably not portray real people at all. In terms of its pictorial style, the *Two Lovers* owes much less to Giorgione than to Paris's master, Titian; personal to the painter himself, however, is the rigidity of the forms under the silky softness of their surfaces, and the restless linear highlights that zigzag across the woman's green dress.

Paris's most important public commission, and the central masterpiece of his career, is the *Fisherman delivering the Ring* (Pl. 129), painted for the *albergo* of the Scuola di S. Marco, probably in the mid-1530s.[56] The final scene in the cycle, begun by Gentile Bellini in 1504 (Pl. 11; cf. p. 142), Paris's canvas represents a posthumous episode in the Life of St Mark, in which a poor Venetian fisherman presented the doge with a ring that had been miraculously given to him by the saint himself. Like Titian in his slightly later *Presentation* for the rival Scuola della Carità (Pl. 115), Paris takes full account of the narrative tradition represented by the canvases by Gentile and his follower Mansueti already hanging in the *albergo*. His story is similarly also set in a stage-like space created by elaborate architectural scenery, and is acted out by crowds of figures in ceremonial costume. In the same spirit, the vaults of the foreground loggia are decorated with golden mosaic, and the official togas set up a warm pattern of scarlets and crimsons. But the artist has modernised fifteenth-century tradition with his amply proportioned figures, and especially with the plunging perspective, which situates the main episode well into the picture space, and then leads the eye beyond it to the architectural vista in the background. This vista, with its un-Venetian emphasis on deep spatial recession and its use of grandiose, Romanising architectural forms, was clearly inspired, like the more restrained background of Titian's *Presentation*, by the designs of Serlio;[57] and the reference certainly reflects Paris's ambition to be fully up-to-date with the latest central Italian fashions. The utopian vision of the Venetian cityscape – no longer the topographically exact view recorded by Gentile Bellini's *Procession* (Pl. 61) – also reflects the ideologically motivated campaign of urban renewal, involving the architectural restructuring of the Piazza, promoted by Doge Andrea Gritti in the early 1530s (above, p. 117; cf. Pl. 85). It is hardly an accident,

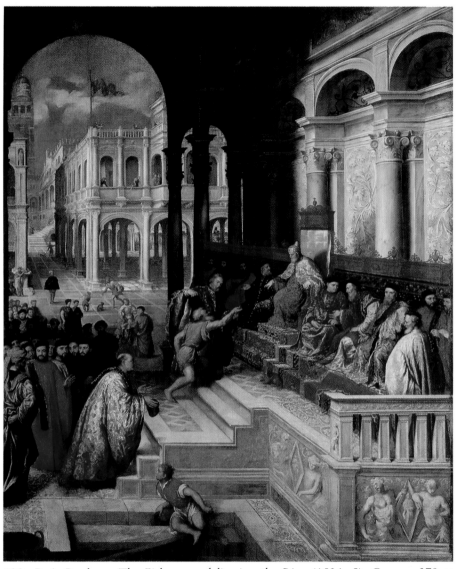

129 Paris Bordone. *The Fisherman delivering the Ring* (1534–5). Canvas, 370 × 300 cm. Venice, Accademia.

130 Bonifacio de' Pitati. *Dives and Lazarus* (*c.*1535–40). Canvas, 204 × 436 cm. Venice, Accademia.

therefore, that the doge portrayed in the canvas bears a close physiognomical resemblance to Gritti.

A similarly glamorous vision of Venetian life in the mid-sixteenth century – only this time in the relaxed surroundings of the garden of a country villa – is provided by Bonifacio de' Pitati's probably closely contemporary *Dives and Lazarus* (Pl. 130). The undramatic, tapestry-like style of the picture echoes that of works by Titian of the mid-1530s such as the *Presentation* and the *Venus of Urbino*, as well as of fifteenth-century narratives such as Carpaccio's *Arrival of the English Ambassadors* (Pl. 63); and it is easy to forget that underlying this apparent celebration of a life of luxurious ease, filled with the pleasures of music and country sports, is the awful warning embodied in Christ's parable (Luke 16: 19–31). Beyond the confines of the foreground loggia to the right is the beggar Lazarus, pleading in vain to Dives for charity, while the view of hell-fire in the background refers to the rich man's ultimate fate. The theme of Bonifacio's picture, like that of Lotto's *St Antoninus* altarpiece (Pl. 131), closely reflects the preoccupation of the Venetian government in the 1530s and 40s with the practical and urgent problems of poor relief; and for this reason, it is probably reasonable to assume that it was painted for a public setting, perhaps for the office of some magistracy, rather than to adorn a private palace.[58]

* * *

175

Lotto and Pordenone in Venice

During the third and fourth decades of the sixteenth century, painting in Venice was greatly enriched by the intermittent presence of two other close contemporaries of Titian, but whose largely peripatetic careers had been spent in a variety of provincial centres on the Italian mainland. In 1525 Lotto returned to his native city from Bergamo, where he had resided for the previous decade, and continued to live mainly in Venice until 1549; and in 1527 Pordenone, from the Friulian region of the Veneto, settled in the capital for the first time, and remained there until shortly before his death in 1539. Of the two, Lotto was the more refined and sensitive artist, but Pordenone secured a greater public success, and was arguably more influential on the course of Venetian painting.

Lotto may have been attracted back to Venice by the commission to paint the *St Antoninus* altarpiece for the transept of SS. Giovanni e Paolo, even though it was not completed until 1542 (Pl. 131).[59] As in his earliest works (cf. Pl. 102), a somewhat old-fashioned tightness of handling, attention to detail and symmetry of design, co-exist with an extraordinarily original interpretation of the subject-matter, and a deeply expressive portrayal of human action and feeling. In keeping with the government's concern with poor relief in the city, and also with the new stress laid by leading representatives of the Catholic Reform movement with the pastoral responsibilities of bishops, the saintly fifteenth-century Archbishop of Florence is no longer shown in passive meditation, as in a fifteenth-century *sacra conversazione*, but actively engaged in the caring for the spiritual and material welfare of his flock.[60] But although Lotto was to paint numerous altarpieces during his stay in Venice, the great majority were destined for export to the Bergamask or the Marches; and as a religious artist he was more in demand among local Venetian patrons as a painter of smaller-scale, domestic works such as the *Virgin and Child with Saints in a Landscape* of c.1528–30 (Pl. 132). This dazzlingly beautiful picture clearly conforms to a type made popular by Palma (Pl. 121); indeed, when undertaking the commission, Lotto may have been consciously moving to fill a gap in the market created by the premature death of his colleague in 1528. But in place of Palma's stable pyramidal composition, that of Lotto is based on unstable diagonals, and in place of Palma's broad, warm and harmonious colour planes, those of Lotto are cool and dissonant, and broken by the restless meanderings of the draperies.

As in his previous period in Bergamo, Lotto also painted a large number

131 Lotto. *St Antoninus giving Alms* (completed 1542). Canvas, 332 × 235. Venice, SS. Giovanni e Paolo.

132 Lotto. *Virgin and Child in a Landscape with Saints* (*c*.1527–30). Canvas, 113 × 152 cm. Vienna, Kunsthistorisches Museum.

of portraits in Venice. On the whole his sitters belonged to a lower social status than those of Titian, and rather than of princes and patricians they tended to consist of merchants, shopkeepers and professionals of the citizen class. At the same time, it is clear that many of them were highly sophisticated in their intellectual and aesthetic tastes; and to cater for these, Lotto developed a portrait formula very different from that customarily employed by Titian. Thus Lotto's formats are characteristically horizontal rather than vertical, and the sitter is placed in a circumstantially described environment, often laden with emblematic significance. In his portrait of Andrea Odoni of 1527, for example (Pl. 133), the wealthy merchant of Milanese origin, whose very distinguished art collection is described in detail by Michiel (cf. pp. 168, 187), the display of six fragments of marble sculpture seems to be more symbolic than documentary in character, and it provides a reminder of the transience of earthly possessions.[61] In keeping with this moralising message is the melancholy expression on Odoni's face and the insistence of his gestures, with one hand holding out an emblematic

object and the other placed over his heart. Similarly, in the portrait of Lucrezia Valier (Pl. 134), the slightly awkward pose is devised not to be elegantly natural in the manner of Titian, but to draw emphatic attention to the drawing and the inscribed paper,[62] both of which make an explicit parallel between the sitter and her classical namesake Lucretia, who preferred death to a loss of virtue. Exceptionally in this case, Lotto's sitter was a member of the ruling patrician class; and any want of elegance in the pose is more than compensated for by the brilliant execution of her luxurious green and orange dress, of the transparent veil that plays around her shoulders, and of the jewellery suspended from her bodice.

At several points in his career on the Italian mainland, Lotto had won commissions to paint large-scale decorations, including fresco cycles; and

133 Lotto. *Andrea Odoni* (1527). Canvas, 95 × 112 cm. The Royal Collection, Hampton Court.

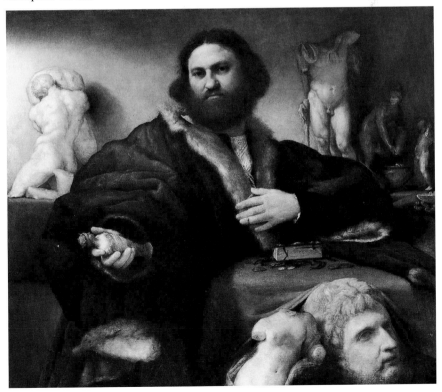

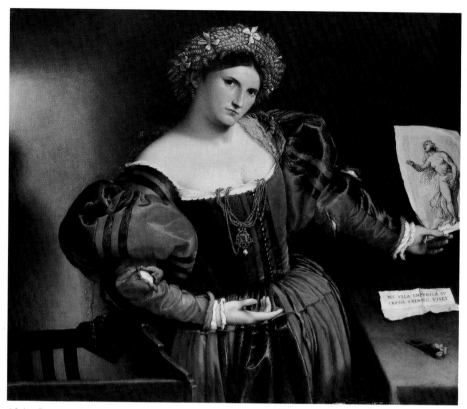

134 Lotto. *Lucrezia Valier as Lucretia* (*c*.1533). Panel, 95 × 110 cm. London, National Gallery.

the fact that no such commissions were forthcoming in Venice provides an indication of his failure to achieve a more than marginal status in the Venetian artistic establishment. Pordenone, by contrast, made his Venetian début as a painter of frescoes in the exceptionally well-frequented church of S. Rocco; and he went on to paint and Old Testament cycle in the cloister of S. Stefano (surviving fragments in Venice, Ca' d'Oro) and a pioneering ceiling decoration for the Scuola Piccola di S. Francesco (now dismembered).[63] Although his bid to win the commission for the *Fisherman delivering the Ring* at the Scuola di S. Marco was rejected in favour of Paris Bordone (p. 173), Pordenone succeeded in getting canvases allocated to himself in the Sala del Maggior Consiglio and in the *albergo* of the

Scuola della Carità. In both of these last contexts, his ambitions represented a direct challenge to the commanding position held by Titian (pp. 159–60); and the aggressively competitive personality suggested by Pordenone's manoeuvres seems confirmed by the character of his art. His frescoes for S. Rocco have survived in an only fragmentary form, but a panel of *Sts Martin and Christopher* (Pl. 135), originally painted as the outside doors of a cupboard in the same church, typically shows powerfully plastic figures, seen from a dramatically low viewpoint, as if about to burst through the picture plane into the real space of the spectator. Unlike in Titian, and in followers of Titian such as Palma, Paris Bordone and Bonifacio, colour is not rich and decorative, but is made subordinate to the strongly emphasised light and shade. Equally in contrast to that of the Venetians, including Savoldo and Lotto, is the bold simplicity, even coarseness, of the pictorial execution.

Pordenone made greater concessions to Venetian tradition in the work

135 Pordenone. *Sts Roch and Christopher* (1528–9). Panels, dimensions unrecorded. Venice, S. Rocco.

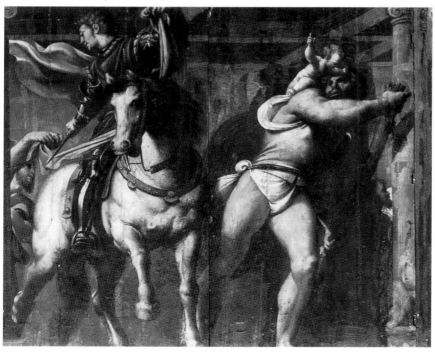

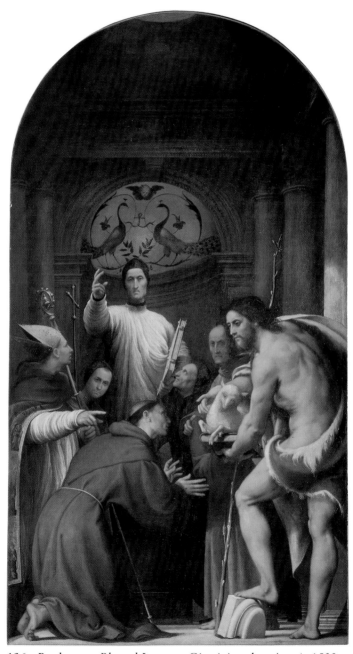

136 Pordenone. *Blessed Lorenzo Giustinian* altarpiece (*c.*1532–
5). Canvas, 420 × 220 cm. Venice, Accademia.

that is probably the finest of his metropolitan career, the altarpiece he painted in the early 1530s for the altar of the patrician Renier family in the church of the Madonna dell'Orto (Pl. 136).[64] These concessions are evident in the suppression of the tempestuous action of the *Sts Martin and Christopher*, in the greater warmth of the colour, and in the Bellinesque motif of the apse mosaic; but they remain combined with a bulgingly muscular, Michelangelesque Baptist in the immediate foreground, and a tunnel-like perspective that sucks the eye deep into the picture. Pordenone's tendencies towards sculptural weight, violent foreshortenings and expressive exaggeration have sometimes led critics to label him a Mannerist.[65] Although it is probably advisable to reserve this term for the much more elegant style that became fashionable in Venice during the 1540s, following the visit of Francesco Salviati of 1539–41 (pp. 188ff), Pordenone's art undeniably made a strong impact on certain developments during this most Mannerist decade of Venetian painting, as is particularly evident in the work of the young Tintoretto (pp. 219–20, 229), but also in that of Titian himself (pp. 161, 200).

3

Late Renaissance (1540–1590)

Since 1981, when an important exhibition dedicated to the theme of Venetian Mannerism was held in the Doge's Palace,[1] it has been generally recognised that the year 1540 marked a turning-point in the history of Venetian Cinquecento paining. Present in Venice in that year were Francesco Salviati, one of the leading exponents of central Italian Mannerism; and his visit was immediately followed by one by his friend and fellow arch-Mannerist, Giorgio Vasari. According to the exhibition organisers, the visits by the two Florentines created a revolution in Venetian painting, prompting a 'Mannerist crisis' even in the work of Titian, and establishing Mannerism as the dominant style in Venice for the next half-century. It is difficult to accept unreservedly this view of events, and 'crisis' is certainly too strong a term to describe the local reaction to the Venetian works of the two visitors. Nevertheless, there can be no doubt that they stimulated a new interest in the most recent stylistic fashions in Florence and Rome, and gave the Venetians a new awareness of the differences between their own artistic tradition and that of central Italy. Nor was it an accident that the two most Mannerist decades of Venetian painting, the 1540s and the 1550s, also saw the rise in Venice of a body of art theory and criticism, much of which dwelt on the relative characteristics and merits of the two schools (pp. 212ff). To some extent, too, the broad stylistic changes that took place after 1540 were complemented by the introduction of a new range of subjects. Thus the Giorgionesque-Titianesque themes of the half-length beauty, for example, or of the Holy Family in a Landscape, so typical of the first four decades, now gave way to an increasing number of mythological narratives and secular allegories.

Although the creative dialogue with central Italian art was to become more intense than ever after 1540, the specifically Mannerist phase in

137 Veronese. Detail of Pl. 174.

Venetian painting was all but over by 1560; and for this reason, the more neutral historiographic term 'late Renaissance' has been used to describe the period as a whole up to 1590. Until his death at an advanced old age in 1576, Titian continued to be a venerable presence; but he had long since withdrawn from major public commissions in the city, and from the 1550s onwards, the decoration of the city's churches, palaces and confraternities was dominated by the two leading members of a younger generation, Tintoretto and Veronese. It is their leadership over a period of four decades that not only lends the period a continuity and coherence, but has permanently endowed the interior spaces of Venetian public buildings with a prevalently late Renaissance character.

Despite the occasional military victory, such as the much-celebrated defeat of the Turks at Lepanto in the gulf of Patras in 1571, Venetian sea-power in the Mediterranean continued its inexorable decline throughout the later sixteenth century. A more accurate reflection of the real situation was the loss of Cyprus earlier in the same year. But the policy of neutrality versus the many conflicts in the rest of Italy and Europe ensured that the Venetian Republic retained its peace, integrity and prosperity; and, more than ever, Venice presented herself to the outside world as the 'most sumptuous city', as she had been called by Philippe de Commynes in 1494.[2] In 1574, for example, the government celebrated a visit by Henry III, king of France, with a never-ending succession of regattas, parades and banquets, all set against a backdrop of buildings, furnishings and costumes of the utmost luxury and magnificence; and a similar spirit informed the redecoration of the Doge's Palace after the fires of 1574 and 1577 (pp. 255ff). The architectural renewal of the Piazza San Marco begun by Sansovino under Doge Gritti in the 1530s (p. 117), continued throughout the second half of the century; and part of the same campaign of civic beautification was the building of the two monumental churches designed by Palladio, S. Giorgio Maggiore (begun 1565) and the Redentore (begun 1577), both of which make important contributions to the Venetian cityscape by being situated on islands prominently visible from the Piazza.

Apart from these two, rather few new churches were built in the city in the later sixteenth century. But the wealth of Venice made it possible for the climate of religious renewal of the period to be accompanied by a vast programme of ecclesiastical refurbishment and pictorial redecoration. In the 1520s and 30s, the attitude of the government towards the religious crisis unleashed by the Reformation had been equivocal; and the traditional Venetian rivalry with the papacy (p. 24) and the high importance placed on trade with Germany (p. 11), had resulted in an initial tolerance

of Lutheran ideas. By the mid-century, however, the official need to control dissent had combined with traditional Venetian piety to create a mood largely sympathetic to the aims of the Counter-Reformation; and after the publication of the decrees of the Council of Trent in 1564, the doctrinal and disciplinary teachings they embodied were systematically promoted in Venice. In keeping with the positive advocacy of sacred images by the Tridentine fathers,[3] paintings in pre-Palladian Venetian churches now spread from altars to cover large areas of walls and ceiling (cf. Pl. 175); and instead of merely reflecting the particular devotional interests of their lay donors (pp. 26–7), the new pictorial decorations assumed a more insistently didactic role. Entirely consistent with this spirit are the Last Suppers of Tintoretto and Veronese (Pls 170, 185), with their explication of the central Christian mystery of the Eucharist, and the various representations by the same painters of scenes of martyrdom (Pl. 178; cf. Pl. 193), with their implicit exhortation to the Catholic faithful to consecrate their lives to Christ.

In the secular sphere, a growing taste for domestic comfort as well as for material luxury, led to a parallel increase in the quantity of pictorial decoration in private palaces.[4] Already in the years around 1500 Venice was remarkable for the number and quality of its art collections, many, but by no means all, of which were described in detail by Marcantonio Michiel. But in this earlier period, privately owned pictures, typified by the works of Giorgione, tended to be rather small in scale, and were usually kept in rooms such as studies and bedchambers, for their owners' private enjoyment. This was still partly true in 1532, when Michiel recorded Savoldo's *Nude* in Andrea Odoni's bedroom (p. 168); but Michiel also recorded that a number of other pictures, including a *St Jerome* by Giorgione, a *Conversion of Saul* by Bonifacio and a *Continence of Scipio* by Savoldo, were displayed in the *portego*, or large reception room on the main floor.[5] As the century progressed, this tendency to display pictures in public rooms became more widespread, and commissions for such works multiplied. With the change to a more public setting naturally also came an increase of scale; and works such as Veronese's *Rape of Europa* (Venice, Doge's Palace) and Jacopo Bassano's *Departure for Canaan* (Pl. 161), commissioned in the 1570s and 1580s by the cultivated patrician Jacopo Contarini, are truly princely in their dimensions.[6]

<p style="text-align:center">* * *</p>

The Mannerist Experiment

No Venetian family commissioned paintings for its palace on a more lavish scale than the Grimani of S. Maria Formosa, and it was to work for this family that Francesco Salviati came to Venice in 1539. The Grimani maintained close ties with the papal court over successive generations, and its members regularly held several of the most important Venetian bishoprics; and, as is also evident in the decoration of the Grimani chapel in S. Francesco della Vigna (Pl. 25), the family cultivated a self-consciously Romanophile taste in its patronage of art.[7] Salviati's principal works during his two-year visit consisted of the decoration of two ceilings in the latest antiquarian manner in the Grimani palace at S. Maria Formosa, one of which he executed in collaboration with Raphael's former assistant Giovanni da Udine; and, before he departed in 1541, he also painted a *Lamentation* altarpiece for another Venetian patrician, Bernardo Moro (Pl. 138).[8] Entirely characteristic of Salviati's High Mannerism, which makes no concession to local Venetian tradition, are the chiselled contours, the polished uniformity of the surfaces, and the relief-like packing of the forms. Despite the deep religious significance and sorrowful character of the subject, poses and gestures seem devised more for the sake of elegance than for emotional expression. A closely similar style was then exhibited by Vasari a year of two later in his ceiling panels for the Palazzo Corner-Spinelli (Pl. 3; cf. p. 3); and it is significant that, like the Grimani, the Corner family also had strong ecclesio-political links with Rome.[9] While in Venice Vasari was also commissioned to paint another ceiling, that of the church of S. Spirito in Isola. But he did not pursue the commission, and it was later transferred to Titian (p. 200).

The works executed in Venice by Salviati and Vasari would probably not by themselves have changed the course of Venetian painting. The Grimani family had already owned a much more distinguished example of central Italian art, Raphael's cartoon for the *Conversion of Saul* (cf. Pl. 114), since 1521; and further examples of the style of the mature Raphael would long have been available through the prints of Marcantonio Raimondi. Mannerism of a particularly graceful variety would similarly have been available through prints by or after Parmigianino (Pl. 139). But the presence in person of two representatives of the Tusco-Roman avant-garde clearly had the effect of focusing new attention on developments in central Italy, all the more since Vasari brought with him copies of two major proto-Mannerist paintings by Michelangelo, the *Leda* (cf. Pl. 2) and the *Venus and Cupid*.[10] The momentum was then maintained by the

138 Francesco Salviati. *Lamentation over the Dead Christ* (1540). Canvas, 322 × 193 cm. Viggiù, church of the Beata Vergine del Rosario (on deposit from Milan, Brera).

139 Parmigianino.
*Lamentation over the
Dead Christ* (*c*.1535)
(etching).

decision of Salviati's pupil Giuseppe, who also adopted his master's name, to stay on in Venice after 1541. As a result, a version of Mannerism – duly adapted to local tastes and traditions – became the prevailing mode in Venice during the 1540s, and for much of the 1550s.

Salviati and Vasari (born in 1510 and 1511 respectively) were still relatively young at the time of their Venetian visits, and it is natural that they should have made a greater impact on their younger Venetian contemporaries than on members of the generation of Titian. Lotto, for example, who was sixty in 1540, remained entirely unresponsive; and although much has been written about a supposed 'Mannerist crisis' in the art of Titian himself, there is actually rather little of his work of the 1540s to suggest that he was much impressed by the Florentine visitors. On the other hand, the styles of both Bonifacio and Paris Bordone did undergo a significant shift in a Mannerist direction in these years. Already in the 1530s, Bonifacio had introduced a number of borrowings from

140 Paris Bordone. *Jupiter and Io* (*c*.1560). Canvas, 136 × 118 cm. Göteborg, Konstmuseum.

Marcantonio into his cycle of canvases for government offices in the Palazzo dei Camerlenghi. But now in the *Annunciation* group of *c*.1544 for the same cycle (Pl. 16), the spatial, circumstantial and richly textured world of the *Dives and Lazarus* (Pl. 130) has given way to one that incorporates something of the planar, abstract and elegant calligraphic manner of Salviati's *Lamentation*. Similarly Paris Bordone, whose figures had always possessed a greater sculptural rigidity and artificiality of pose than those of his master Titian, moved further in this direction during the 1540s; and even more than before, Paris delighted in exploiting the piquant contrasts between frozen forms and soft surfaces, between cold and warm colours, and between planar poses and deep, unoccupied space. In a late work such as the *Jupiter and Io* of *c*.1559–61 (Pl. 140) – painted, significantly enough, on a visit to the French court[11] – the mythological lovers are composed as if in high relief, with their elongated limbs complicatedly interlaced.

191

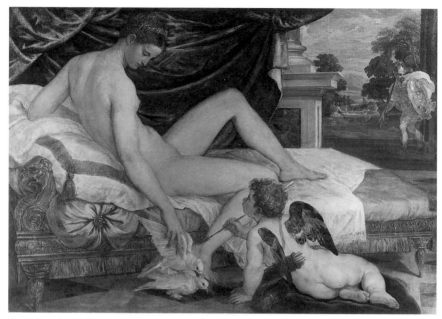

141 Lambert Sustris. *Venus, Cupid and Mars* (*c*.1548–52). Canvas, 134 × 183 cm. Paris, Louvre.

More closely aligned with the mainstream of Italian Mannerism – although as much with its Emilian, Parmigianinesque version as with the Tusco-Roman – is the art of the younger painters Lambert Sustris and Andrea Schiavone. Sustris, originally from Amsterdam, had entered Titian's studio in the mid-1530s as a specialist in landscape painting, and may have been responsible for much of the landscape background of the *Presentation* (Pl. 115). He remained personally close to his master, and apparently accompanied him to Augsburg in 1548 and/or 1550–1; and his *Venus, Cupid and Mars* (Pl. 141) was probably painted on one of these occasions for the local plutocratic Fugger family. But while representing a compositional variant of Titian's *Venus of Urbino* (Pl. 120), Sustris's picture clearly reflects his interest in the gracefully elongated and somewhat languid figures of Parmigianino (cf. Pl. 139); and while the freedom of handling and the softness of surfaces remain characteristically Venetian, the painter tends to draw with his brush, and to model with rhythmical lines as much as with light and shade. This fusion between the formal vocabulary of Mannerism and a Venetian expressiveness of brushwork is

192

142 Andrea Schiavone. *Diana and Callisto* (*c*.1548–50). Canvas, 19 × 49 cm. Amiens, Musée de Picardie.

even more complete in the work of Schiavone. In the *Diana and Callisto* of *c*.1550, for example (Pl. 142), the figures' anatomies are drastically reshaped to conform with an abstract ideal of human beauty and with the cursive rhythms of the frieze-like composition; at the same time, colour is applied with a breadth and energy, leaving thick blobs and ridges of impasted paint, in a way that was unprecedented, even in the work of Titian. Similarly in the *Annunciation* of *c*.1555 (Pl. 143), painted as a pair of organ shutters for the church of S. Pietro in Belluno, the Mannerist grace of the flying angel is evoked with curvilinear swirls of the brush, while the sunset landscape – and even the Virgin's bedchamber – begin to dissolve in a shimmering haze of broken colour and light.

Stylistically close to Sustris and Schiavone in his earliest works was their slightly younger contemporary, Tintoretto. Although few art historians now accept the earlier twentieth-century view of Tintoretto as one of the most typical representatives of Italian Mannerism in general, a work of the mid-1540s such as the *Apollo and Marsyas* (Pl. 144) is closely comparable to Schiavone's *Diana and Callisto* in its combination of a Mannerist approach to composition and figure types with a Venetian freedom of pictorial handling. Like Schiavone's panel, Tintoretto's *Apollo and Marsyas* was originally incorporated into the panelling of a domestic interior, in this case as part of a ceiling decoration in the house of the critic Peitro Aretino;[12] and it was probably not by chance that the subject is a repeat of a scene painted by Francesco Salviati on a ceiling in the Palazzo Grimani. But already within two or three years Tintoretto was to abandon this kind of planar and elegantly decorative composition for the dramatic

143 Andrea Schiavone. *Angel Gabriel* and *Virgin Annunciate* (*c*.1555). Two canvases,
272 × 183 cm each. Belluno, Duomo.

foreshortenings and plunging perspectives of the *Washing of the Disciples'
Feet* of 1547 (Pl. 162; p. 224).

Partly, perhaps, because of this change of direction, as well as because of
the personal hostility of Titian, Tintoretto was excluded from partici-
pation in one of the most comprehensive monuments of Venetian
Mannerism, the ceiling decoration of the Reading Room of the recently
completed Marciana Library in the Piazza San Marco (Pl. 85). The
architect Sansovino's original plan to build it with a stone vault in the
Roman fashion was abandoned when the vault collapsed in 1545; and a
wooden ceiling, designed to accommodate twenty-one painted roundels,
was constructed instead (Pl. 145).[13] In 1556 seven painters were each
allotted three roundels, on which they were to depict allegorical themes

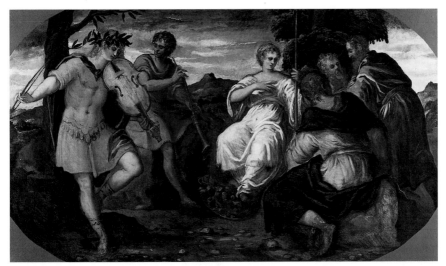

144 Tintoretto. *Apollo and Marsyas* (1544–5). Canvas, 137 × 236 cm. Hartford, Wadsworth Atheneum. The Ella Gallup Sumner and Mary Catlin Sumner Collection Fund.

appropriate both to the particular function as a place of learning, and to the wider concern of the government to portray Venice as a haven of wealth, peace and civilisation (above, pp. 117, 186). Each roundel was to focus on a limited number of mythological figures and personifications

145 Venice, Marciana Library. Interior of Reading Room.

195

146 Giuseppe Salviati. *Wisdom between Fortune and Virtue* (1556–7). Canvas,
130(?) cm diameter. Venice, Libreria Marciana.

147 Veronese. *Music* (1556–7). Canvas, 130(?) cm diameter. Venice, Libreria Marciana.

which, according to a convention for ceiling painting recently established by Titian's Old Testament cycle at S. Spirito in Isola (p. 203), were seen from a low, semi-illusionistic viewpoint. Characteristic both of the learned and propagandistic programme of the ceiling, and also its prevalently Mannerist style, is one of the contributions by Giuseppe Salviati, Francesco's former pupil and namesake (Pl. 146). At the centre of the composition is Minerva (or Pallas), goddess of wisdom, and hence a tutelary deity of the Library. Behind her is the figure of Fortune, who tempts her with a crown. But the latter is blindfolded, and in her other hand she holds a noose, alluding to the equal possibility of a less attractive fate. The path of wisdom, therefore, is to reject blind chance and to turn instead to the virtues on the right, which include Prudence and Fortitude. By 1556 Giuseppe had resided in Venice for nearly two decades, and he

had inevitably come to make concessions to local pictorial tradition. But his handling of form remains hard and sculptural; and the way in which the outside arms of Fortune and Fortitude follow the curving contours of the picture field is fully consistent with the relief-like effect created by the tight, airless patterning of the limbs across the surface.

The other contributors to the Reading Room cycle included Schiavone and the Rome-trained, Michelangelesque painter Battista Franco, as well as a pair of lesser exponents of Venetian Mannerism. When, however, Titian and Sansovino were asked to award a golden chain to the most distinguished contribution, they chose one of the least Mannerist of the roundels, Veronese's *Music* (Pl. 147). The young Veronese had shown a certain interest in Parmigianino when still working in his native Verona before 1553, and was clearly sensitive to the ornamental beauty his style. But although the lightness of the colours in the *Music* are not traditionally Venetian, and reflect rather his *terraferma* origins, Veronese's roundel is much more pictorial in its handling than those of Giuseppe Salviati and Battista Franco, while remaining much more normative and natural than that of Schiavone. The edge of the picture field resembles an opening into a world of air and sunlight; and although the colours are highly decorative in effect, there is ample space in which the figures may move and breathe. It is as if Veronese, like Tintoretto a few years earlier, was deliberately turning his back on the stylistic experiment initiated around 1540. With this gesture, which won the public approval of Titian, he showed that the heyday of Venetian Mannerism was over.

Titian: The Later Career

In the earlier 1540s the contacts that Titian had already made with the Emperor Charles V (p. 164) were extended to include Pope Paul III and the various members of his family. In 1542 the painter executed the portrait of the pope's grandson, Ranuccio Farnese (Washington, National Gallery of Art) during a visit to Venice; in the following year the pope himself sat to Titian in Bologna (Naples, Capodimonte); and in 1543/4 Ranuccio's elder brother, Cardinal Alessandro Farnese, saw the *Venus of Urbino* (Pl. 120) in the ducal palace in Pesaro, and wrote to commission a similar nude for himself. The result was the *Danaë* (Pl. 4), which Titian delivered in person to the cardinal in Rome in 1545 (pp. 1–3).[14]

X-ray photographs have revealed that the original background of the *Danaë* resembled that of the *Venus of Urbino*, and it may be that Titian

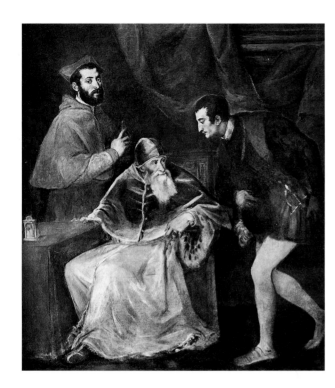

148 Titian. *Pope Paul III and his Grandsons* (1545– 6). Canvas, 210 × 174 cm. Naples, Museo di Capodimonte.

initially conceived his recumbent nude for the cardinal in similarly ambivalent terms. Some indication of the patron's priorities is provided by a letter from the papal nuncio in Venice to the cardinal, assuring him that when completed the *Danaë* would be more beautiful than the *Venus of Urbino*, and would make the earlier figure look like a nun by comparison. The change to a scene taken from classical mythology, in which the girl Danaë is embraced by Jupiter in the form of a shower of gold coins, was perhaps then made to lend the erotic theme, and Titian's highly sensuous treatment of it, a greater intellectual respectability. But the choice was also singularly appropriate, since there is reason to suppose that the figure was represented with the features of the cardinal's mistress, a courtesan named Angela; and by extension, therefore, the cardinal is flatteringly compared with Jupiter.

While Titian was in Rome he was also commissioned to paint the large triple portrait *Paul III and his Grandsons* (Pl. 148), in which Cardinal Alessandro is represented with another younger brother, Ottavio Farnese,

in a scene of courtly ceremony in attendance on the pope.[15] The ambitious scale may be regarded in part as a natural extension of the full-length format already adopted for the emperor and other grandees; but in part, too, it belongs to a tradition of official papal portraiture, in which the seated pontiff is represented with members of his family and court. Titian would certainly have seen, for example, Melozzo da Forlì's fresco of *Sixtus IV and his Court* in the Vatican Library, and he would have known at least a version of Raphael's *Leo X with Two Cardinals* (Florence, Uffizi). Both these predecessors were conceived in part as statements of dynastic ambition; and similarly, Titian's portrait reflects the aged Paul III's hopes of investing the members of his neither very ancient nor noble family as princes both of the church and of secular states in Italy. So far he had succeeded in marrying Ottavio to an illegitimate daughter of the emperor, and in creating him duke of the papal state of Camerino; but the pope held still higher ambitions for his grandsons. It is clear from the acute characterisation of the figures and from the psychological interaction between the pope and Ottavio that Titian was keenly attuned to the atmosphere of Machiavellian intrigue and fratricidal jealousy that pervaded the papal court; and because the canvas remains not quite finished (as is most obvious in the absence of the pope's right hand), it has sometimes been supposed that the sitters were displeased by what it revealed of their personalities. But there is no real evidence to support this and, according to a recent suggestion, Titian intended to return to Rome to complete the picture, but never did so because soon afterwards the pope shifted his favour to yet another grandson, Orazio, and the political message of the portrait became outdated.

Eighteen months after returning to Venice from Rome, Titian set out on another long journey, this time to the court of Charles V at Augsburg. Perhaps datable to the intervening period are three Old Testament scenes painted for the ceiling of the church of S. Spirito in Isola (Pls 149, 150).[16] Originally given to Vasari in 1542, the commission, as we have seen, was then abandoned by him; and it had traditionally been supposed that Titian took it over and completed it before the Rome visit. Certainly, while there is nothing in the canvases of the ornamental elegance of Vasari, or of Salviati, there do seem to be reminiscences, as in the *Battle of Spoleto* of the later 1530s (cf. Pl. 117) of Pordenone and Giulio Romano, in the violence, even the brutality, with which the events are portrayed. But Titian's main inspiration here seems to be Michelangelo, and in particular the very recently completed *Conversion of Saul*, which Titian would have seen in the chapel founded by Paul III in the Vatican. As in Michelangelo's

149 Titian. *David and Goliath* (*c*.1542–4). Canvas, 280 × 280 cm. Venice, S. Maria della Salute.

fresco, Titian's figures are thickset and unbeautiful, the landscape is rocky and barren, and the mood sombre and tragic. Also, as in the *Conversion*, the compositions of all three canvases disconcertingly combine powerful diagonals across the surface with sudden lunges into depth.

Partly, perhaps, because they were painted in a hurry, and because in any case they were meant to be seen only from a distance, the Old Testament paintings show a comparatively crude quality of execution. They are of considerable historical importance, however, since they established

201

150 Reconstruction by J. Schulz (1968) of Titian's ceiling for S. Spirito in Isola.

the conventions for Venetian ceiling painting that were then adopted in all the subsequent major examples of this increasingly practised genre, including Veronese's ceiling for S. Sebastiano in the 1550s (Pls 175, 176), Tintoretto's ceilings for the Scuola di S. Rocco in the 1560s and 70s (Pl. 169) as well as in the Library and in the Doge's Palace (Pls 146, 147, 189, 190). Titian's canvases were removed from their original site in S. Spirito as early as the middle of the seventeenth century, but it is known that as in these later examples, they were mounted in an elaborately carved and gilded wooden framework designed by the architect of the church, Jacopo Sansovino. The viewpoint chosen by Titian for his narratives, and followed by his Venetian successors, was the result of a compromise between the two principal systems existing elsewhere in Italy.[17] In the interests of drama and illusionism, he rejected the central Italian convention (recently adopted by Tintoretto in his *Apollo and Marsyas*) of the *quadro riportato*, whereby ceiling paintings were conceived no differently from wall paintings, and the figures were seen from a normal viewpoint. But he also rejected as unpractical the radical solution of *quadratura*, as exemplified by the ceilings of Mantegna and Giulio Romano in Mantua, and of Correggio in Parma, in which the figures are seen in worm's eye view, as if directly from below. In Titian's ceiling, the figures are instead seen obliquely from below, as if from the bottom of a steep slope; and although this compromise lacks the strict logic of *quadratura*, it succeeds in lending the narrative greater legibility, while also conveying an appropriate and dramatic sense that it is actually taking place above the spectator's head.

The most important work that Titian painted during his visit to Augsburg in 1548 was the largest and perhaps the greatest of all his portraits, the *Charles V on Horseback* (Pl. 151). As in the *Paul III with his Grandsons*, the format of the portrait has been expanded to show the sitter not merely in full-length but engaged in action; and the novel idea here of portraying the emperor in armour on horseback was inspired by the latter's victory in the previous year over a league of Protestant princes at the battle of Mühlberg. But there is no sign of battle in the landscape background, and the emphasis is laid rather on Charles's conception of his role as Holy Roman Emperor, and the symbolic significance of his victory. Riding forward on his charger, spear in hand, he is presented at once as a new Constantine, championing the Christian faith against false religion, and as a new Charlemagne, defending the political integrity of his world empire.[18] Such allusions would obviously have greatly heightened the propagandistic power of the image; yet it is significant that Titian chose to

151 Titian. *Charles V on Horseback* (1548). Canvas, 332 × 279 cm. Madrid, Prado.

ignore the advice of Aretino to make it even more flattering by including allegorical figures, in a manner that was subsequently to become common in the baroque age. Charles's facial expression is, in fact, by no means one of careless or frivolous heroism; rather, his features are grimly set, almost

as if he were aware that in reality it was already too late to turn back the tide of Protestantism and to maintain the unity of his vast and unwieldy empire. According to more than one contemporary witness, Titian came to enjoy considerale intimacy with the emperor during his stay in Augsburg, and to be trusted by him as a confidant;[19] and it is clear that during their conversations, the painter developed a keen sympathy with Charles as a man, and an understanding of the complexities and paradoxes of his historical predicament. In this grandest of state portraits – as also in the later *Charles V Seated* (Munich, Alte Pinakothek) – Titian succeeds in conveying a deep sense of the lonely, melancholy, introspective character of the emperor, as well as of the personal dignity with which he conducted himself in his high office.

Charles continued to be a loyal patron even after his abdication in 1556, but it was his son Philip, who succeeded him as king of Spain, who was to become the most important of all Titian's patrons. Titian first met Philip in Milan in 1549, and apparently soon afterwards sent him a variant (Madrid, Prado) of the *Danaë* that he had painted for Cardinal Farnese. He then met Philip again – for the second and last time – at Augsburg in the winter of 1550–1, when plans were laid for the painter to start sending regular consignments of religious and mythological pictures, in return for a generous annual salary. In this way, Titian could enjoy all the social and financial advantages of a court appointment, without having to submit to the servitude of actual attendance at court;[20] and the arrangement turned out to suit both parties so well that it continued for the next quarter of a century, until it was ended by the painter's death in 1576.

The most important result of Titian's association with Philip was the addition to the initial *Danaë* of a series of seven large and magnificent mythologies, executed between 1554 and 1562. It has sometimes been supposed, by analogy with the earlier series for the Duke of Ferrara (p. 144) that the mythologies, or *poesie*, for Philip were devised according to a coherent iconographic programme, perhaps with an underlying allegorical-moralising message; and further, that they were intended for a particular room in one of the Spanish royal palaces. Although neither supposition is borne out by the historical and visual evidence, and Titian seems to have devised the subjects himself on an *ad hoc* basis, he did apparently conceive the pictures in terms of thematically and compositionally matching pairs. This is particularly obvious in the case of the *Diana and Actaeon* and the *Diana and Callisto* of 1556–9 (Pls 152, 153). Both subjects are drawn loosely from Ovid's *Metamorphoses*, and both refer to punishments inflicted by the chaste and cruel moon-goddess on her innocent victims. In

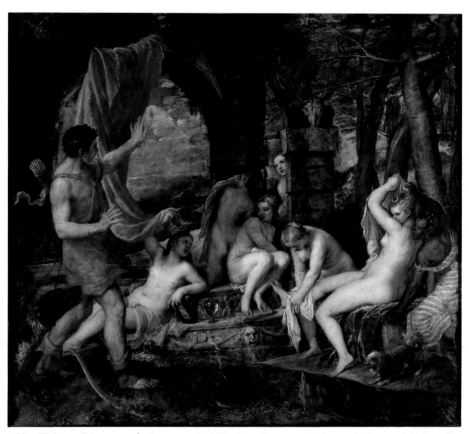

152 Titian. *Diana and Actaeon* (1556–9). Canvas, 185 × 202 cm. Edinburgh, National Gallery of Scotland; on loan from the Duke of Sutherland.

the first canvas, the handsome young huntsman Actaeon is seen stumbling upon Diana and her nymphs as they bathe by a pool; and, as is hinted by the skull on the rusticated pillar, she will take her revenge by transforming him into a stag, which will then be torn apart by his own hounds. In the second, Diana orders her nymphs to expose the shameful pregnancy of Callisto, who has been seduced by Jupiter in the guise of the goddess herself, and who is then metamorphosed by Juno into a bear. The latter subject had recently been treated on a much smaller scale by Schiavone (Pl. 142), and the fact that Titian portrays Diana with markedly Mannerist proportions – in a way that somehow enhances the cruel imperiousness

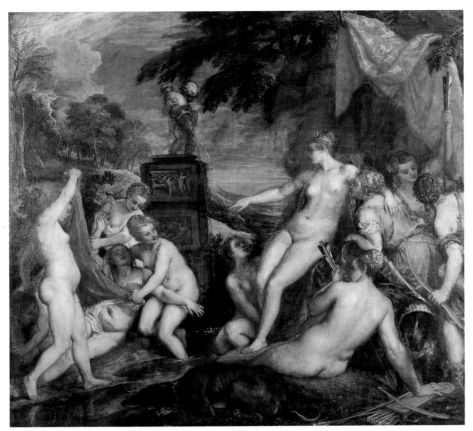

153 Titian. *Diana and Callisto* (1556–9). Canvas, 187 × 205 cm. Edinburgh, National Gallery of Scotland; on loan from the Duke of Sutherland.

of her gesture – suggests that he was well aware of this precedent. The thematic parallels between the two *Diana* pictures for King Philip are further underscored by their matching size, by the similar cast of figures, and by the balancing motifs in the two compositions.

 In choosing these subjects Titian would have been guided by a number of considerations. As in his earlier works for princely patrons such as the dukes of Ferrara and Urbino and Cardinal Farnese (pp. 153, 162, 199), the erotic aspect was clearly of major importance. Both *Diana* pictures had the advantage of requiring a cast of bathing nymphs, who could be admired in a variety of different poses and from a variety of different

views. In a letter to Philip of 1554 regarding the recently completed *Venus and Adonis* (Madrid, Prado), Titian specifically refers to his concern to include in his paintings a varied repertory of female nudes:

> Because in the *Danaë* which I have already sent Your Majesty one sees everything from the front, I wanted this other *poesia* to vary it and to show you the opposite side, so that the chamber where they have to hang will be more attractive. I shall be sending you immediately the *poesia* of *Perseus and Andromeda*, which will have a different viewpoint, and likewise *Medea and Jason*.[21]

But his passage also suggests that the erotic interest of his subjects was combined with the more disinterestedly aesthetic one of the *paragone*; and by showing his figures from a variety of viewpoints Titian was implicitly renewing the old challenge to the rival art of sculpture (p. 126).[22] As was suggested in the Introduction (pp. 1–2), Titian probably deliberately adapted a figure from Michelangelo in his *Danaë* for Cardinal Farnese as a way of demonstrating the superiority of Venetian *colorito* over central Italian *disegno*. But the borrowing would equally well have served to demonstrate the superiority of the art of painting, with its ability to evoke soft, warm flesh, over Michelangelo's own art of carving in cold marble. Similarly in the more complex *Diana* pictures, several of the poses are appropriately derived from well-known examples of antique statuary,[23] but they are then brought to life by the softening effects of light, colour and enveloping atmosphere.

Furthermore, Titian transcends both mere eroticism and aestheticism by investing his retelling of the mythological stories with a deep sense of poetry and humanity. As well as introducing a number of divergences of detail, he provides a highly personal gloss on his literary text by evoking a mood of foreboding and tragedy foreign both to Ovid and to his own earlier *Bacchus and Ariadne* (Pl. 110). The effect of psychological tension between Diana and her antagonists Actaeon and Callisto, created by means of furious glance and imperious gesture, is expressively complemented by the violently tilting compositional axes and turbulent landscapes, and especially also by means of Titian's most powerful artistic resource of all, his unparalleled mastery of the medium of oil paint. The colours are as intense and varied as in the *Bacchus and Ariadne* (p. 154), but the planes are constantly broken by brushstrokes of different colour, breadth and thickness, so that the overall chromatic effect is not so much of bold, decorative contrasts as of a vibrating, textured irridescence. The

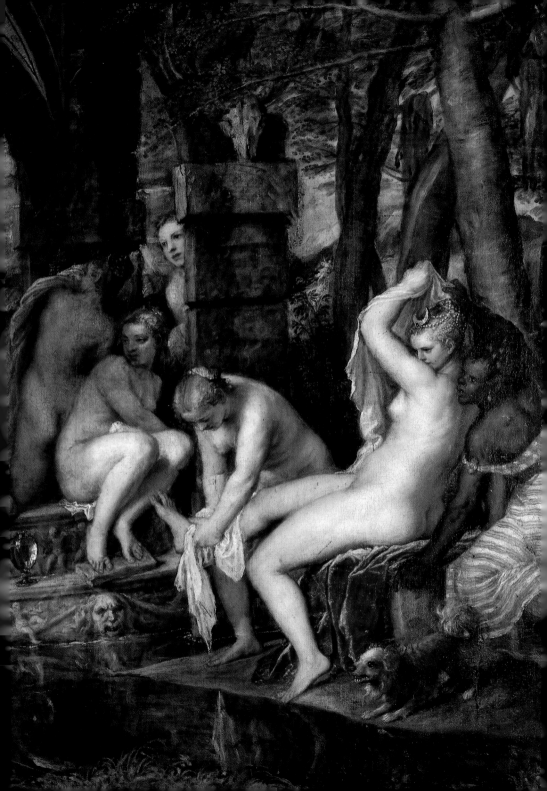

155 Titian. *St Jerome* (1571–5). Canvas, 184 × 170 cm. El Escorial, Nuevos Museos.

way in which forms and colours in the *Diana* pictures seem to be in a constant state of flux is characteristic of Titian's late style in general, but in their case it also provides an eloquent visual analogue to the underlying theme of metamorphosis.

In one of the last works that Titian painted for King Philip, the *St Jerome* (Pl. 155) sent to Spain in 1575, the figure and objects in the foreground are painted in a style similar to that of the *Diana* pictures, while the landscape is treated even more freely. The foliage at the top, for example, is evoked with squiggles of pure unblended whites, reds and yellows, which when superimposed on broader, more neutral areas nevertheless cohere to create form. Colour is also the vehicle for strong emotional expression, as in the sonorous contrast between the pinks and wine-reds in the saint's drapery, and the deep ultramarine of the mountains and sky. The picture shows the painter in the final years of his life taking up a theme, which while obviously appropriate to the royal palace-cum-Hieronymite monastery of El Escorial, had been traditional in Venetian painting since the days of Giovanni Bellini (cf. Pls 59, 70). But instead of representing the saint against a background of smiling fields and meadows, Titian places him in a wild, inhospitable mountainous landscape reminiscent of his own native Cadore, in a way that makes the saint appear tragically isolated in his penitential grief.[24]

That the penitent Jerome may have had a particular personal significance for the aged painter is suggested by the reappearance of the saint with his own features in the *Pietà* (Pl. 156), a work that Titian left unfinished at the time of his death in 1576.[25] The picture has a complicated history, which has not yet been completely unravelled; but according to a credible tradition, the painter originally intended it to accompany a tomb for himself and his family at the altar of the Crucifix in the Frari. Certainly it may be regarded from many points of view as his artistic and spiritual testament. The motif of the apse with its half-dome gilded in shimmering mosaic, obviously looks back both to Giovanni Bellini and Byzantine tradition; while scarcely less obviously, the two statues at the sides and the central Pietà group renew the *paragone* with Michelangelo. It is as if Titian wished the image above his tomb to constitute a worthy celebration of his life's work in particular, and of the art of Venice in general. At the same time, by representing himself in the guise of semi-naked St Jerome, who gazes intensely not at a crucifix, as in King Philip's picture, but at the actual body of the crucified Saviour, the painter is also expressing his hope for salvation in a spirit of humility and sorrowful penitence. This message is reinforced by the presence of another celebrated penitent, the wildly

grieving St Mary Magdalen, and by the votive tablet in the lower right-hand corner, upon which are represented Titian and his son Orazio, kneeling in prayer before a vision of the dead Christ, again in the lap of his Mother.

In the event, although Titian was indeed buried in front of the altar of the Crucifix, a dispute with the friars about the endowment of the altar prevented the *Pietà* from ever accompanying his body there. The picture was subsequently acquired by Palma Giovane, who was responsible for painting in the figure of the flying angel but who, perhaps out of sense of piety towards the great master, seems to have made no attempt to bring the other figures to the same state of definition as that, for instance, of the Escorial *St Jerome*.[26] Yet there remains something particularly poignant about the work in its unfinished state, in which the figures of the once most robust and sensuous of painters have only half-materialised from the flickering, chromatic haze that envelops them, to express a religious emotion that is all the more profound for having become internalised and mysterious.

Theory and Criticism

Unlike in Florence, where there had existed a lively tradition for writing about art and artists since the earlier fifteenth century, there was little or no written discussion about painting in Venice until the middle years of the sixteenth. In 1548, however, Savoldo's former pupil Paolo Pino published his treatise *Dialogo di Pittura* (*Dialogue on Painting*), and nine years later the polygraph Lodovico Dolce published his own *Dialogo della Pittura*, also known as *L'Aretino*.[27] Both writers were inevitably deeply influenced by their Florentine predecessors, and adopted many of their critical categories and assumptions. But Dolce's treatise in particular was conceived to express a specifically Venetian viewpoint, and to counter what he saw as an excessive emphasis given to Florentine art by Vasari, the first edition of whose *Lives* had appeared in 1550. The debate was then carried forward by the second edition of the *Lives* (1568), in which Vasari's account of the reception of Titian's *Danaë* in Rome (p. 2) neatly crystallises two or three decades of written and verbal discussion of the relative merits of the two schools. Implicit in the account – which twenty years after the event may well have been elaborated for ideological purposes – is the aesthetic opposition of Florence and Venice, Michelangelo and Titian, *disegno* and *colorito*.[28]

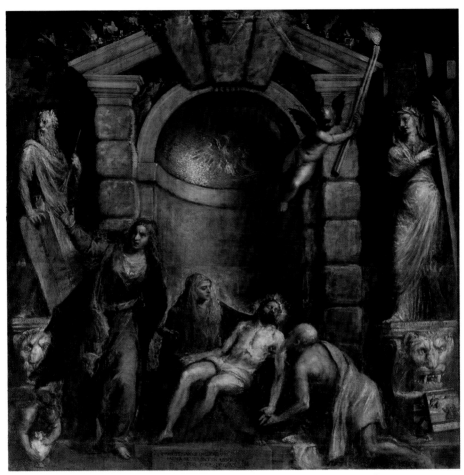

156 Titian. *Pietà*. (*c*.1575–6). Canvas, 351 × 389 cm. Venice, Accademia.

It is characteristic of the Venetian approach to discussions on art that the treatises of Pino and Dolce are cast not in theoretical or biographical form but as dialogues, in which a pair of gentlemen pursue an informal conversation. The principal speaker in Dolce's *Dialogo* is named as Pietro Aretino, who had died in 1556, the year before its publication; and indeed, many of the attitudes expressed reflect and develop those of Aretino's own, equally informal and conversational *Letters*.[29] Aretino had come to Venice in 1527, in the same year as his fellow Tuscan and friend Jacopo

157 Titian. *Pietro Aretino* (1545). Canvas, 98 × 78 cm. Florence, Pitti.

Sansovino; and during his career in the city he made full use of the Venetian printing-press and liberal censorship laws for his prolific, and often scurrilous journalism. Although the *Letters* cover a wide range of subjects, they reflect a profound interest in art, as well as in manipulating artists and patrons. His taste in painting was eclectic, and was broad enough to accomodate both the Venetian and the central Italian traditions. He was responsible for bringing Vasari to Venice in 1541, and perhaps for helping to stimulate there a more general appreciation for Mannerism; and during the 1520s and 30s he was a great admirer of Michelangelo. Following a snub by the latter, however, Aretino's admiration turned to hostility, and a blistering attack on the *Last Judgement* was timed to coincide with the arrival of his friend Titian in Rome in 1545.[30] Earlier in the same year Titian had painted a splendid portrait of Aretino (Pl. 157), in which the writer's notorious corpulence is not played down, but is

214

exploited to lend him an air of grandeur; also captured is a sense of his intellectual energy, and even of his ruthlessness. Almost from the beginning of his career in Venice, Aretino had acted as a highly effective publicity agent for Titian, and had done much to further his career at various Italian courts. Although his change of attitude towards Michelangelo was caused more by personal pique than by any aesthetic reassessment, Aretino clearly did have an instinctive sympathy for the quintessentially painterly qualities of Titian's art. This sympathy found its fullest literary expression in a letter of May 1544 addressed to the temporarily absent painter, in which Aretino describes the view seen one evening from his balcony overlooking the Grand Canal:

> I fell to gazing at the marvellous spectacle presented by the countless number of barges, crammed by no fewer strangers than townspeople, which were delighting not only the onlookers but the Grand Canal itself, the delight of all who navigate her . . . And after all these various streams of humanity applauded happily and went their way, you would have seen me, like a man sick of himself and not knowing what to do with his thoughts and fancies, turn my eyes up to the sky; and ever since God created it, never had it been so embellished by such a lovely picture of lights and shades. Thus the air was such that those who envy you because they cannot be like you would have longed to show it. As I am describing it, see first the buildings which appeared to be artificial though made of real stone. And then look at the air itself, which I perceived to be pure and lively in some places, and in others turbid and dull. Also consider my wonder at the clouds made up of condensed moisture; in the principal vista they were partly near the roofs of the buildings, and partly on the horizon, while to the right all was in a fused shading of greyish black. I was awestruck by the variety of colours they displayed: the nearest glowed with the flames of the sun's fire; the furthest were blushing with the brightness of partially burnt vermilion. Oh, how beautiful were the strokes with which Nature's brushes pushed the air back at this point, separating it from the palaces in the way that Titian does when painting his landscapes![31]

What is remarkable about this passage is that the particular scene it describes is not one that Titian would ever have painted, and the factually topographical opening recalls rather the work of Carpaccio (cf. Pl. 7). But the highly poetic evocation of the evening sky that follows, and of the changing effects of air, light and colour is deeply Titianesque in spirit; and although Aretino did not make his appreciation into the cornerstone of

any coherent aesthetic doctrine, his eloquence must have done much to open the eyes of others, and to inspire Dolce in his more comprehensive defence of Venetian *colorito*.

But before Dolce, the contrast between Venice and central Italy is made more explicit by Pino's *Dialogo*, written in the immediate aftermath of Titian's visit to Rome. The dialogue is between a Florentine and a Venetian, and Michelangelo and Titian are regularly invoked as the champions of the two schools. The range of topics discussed by the speakers is somewhat conventional and derviative, and the tone of the debate is not particularly polemical; indeed, in one passage the Venetian speaker declares that the perfect painter would be the one who combined Michelangelo's *disegno* with Titian's *colore*.[32] Nevertheless, the treastise advances the Venetian cause by paying particular attention to questions of colour and light, and especially also by according praise to the medium of oil painting – implicitly contradicting central Italian claims for the superiority of fresco painting.[33] Similarly, in Pino's rehearsal of the *paragone* debate, in which he provides a detailed account of a picture by Giorgione showing an armoured St George by a pool of water,[34] the author make it clear that his sympathies lie with painting rather than with sculpture.

The more sharply polemical stance of Dolce's *Aretino* of 1557 was prompted by the publication in 1550 of the first edition of Vasari's *Lives*. Although this did not yet have the fully developed critical framework of the second edition, and Vasari was not particularly concerned to draw attention to the characteristics and faults of Venetian painting, the painters of Venice were implicitly slighted by being neglected. Since the only living artist to be accorded a biography was Michelangelo, even Titian received only passing mention. In retaliation, Dolce through his mouthpiece Aretino consistently denigrates Michelangelo at the expense of Raphael, and then proclaims the superiority of Titian to both central Italians.

Dolce's dialogue begins by discussing the advances made by Titian on the work of his local predecessors. The scene is set in the church of SS. Giovanni e Paolo, and a comparison is made between Giovanni Bellini's *St Catherine of Siena* altarpiece (Pl. 45) and Titian's *Death of St Peter Martyr* (Pl. 103). Bellini is praised in somewhat condescending terms as a 'good and careful master' for his time; but both he and Giorgione are deemed to have been 'a thousand leagues outdistanced by Titian'.[35] In this view of the history of post-medieval painting as one of continuous progress, rising to a climax in the art of his own day, Dolce was at one with Vasari. The great masters of the High Renaissance – Michelangelo and Raphael as well

as Titian – were possessed with divine powers that transcended the highest talents of the fifteenth century. But for Dolce, the source of Titian's greatness was not just his 'heroic majesty', but his 'system of colouring (*colorito*) so very soft, and so close to reality in its tones, that one can well say that it goes in step with nature'. Later the author expands on his praise of Titian's *colorito* as more truthful to nature than the hard-edged, sculptural style of Michelangelo; and he also makes it clear that by *colorito*, he is not simply referring to the painter's choice of pigments, but to his mastery of the full range of chromatic effects available to his medium:

> Certainly colouring is so important and compelling that, when the painter produces a good imitation of the tones and softness of flesh and the rightful characteristics of any object there may be, he makes his paintings seem alive, to the point where breath is the only thing missing in them ... The main problem in colouring resides in the imitation of flesh, and involves diversifying the tones and achieving softness ... Let no-one think that what gives colouring its effectiveness is a beautiful palette, such as fine lakes, fine azures, fine greens and so on; for these are just as beautiful without being put to work.[36]

Finally, Dolce explains that this is not verisimilitude for its own sake, but for the more effective communication of emotion:

> The figures should stir the spectators' souls – disturbing them in some cases, cheering them in others, in others again inciting them to either compassion or disdain, depending on the character of the subject-matter. Failing this, the painter should not claim to have accomplished anything.[37]

In other words, by means of his *colorito* Titian succeeds in evoking appropriately contrasting moods of joy in the *Assunta* (Pl. 109) and tragedy in the *Death of St Peter Martyr* (cf. Pl. 117), in a way that moves the spectator more deeply than the artificial and contrived works of Michelangelo and his central Italian followers.

Vasari could not be expected to agree with all this, and in his second edition he made *disegno* into a central pillar of the entire historiographic scheme. In the passage describing the reception of Titian's *Danaë* in Rome, Vasari does not deny the naturalness of the picture, and he has particular praise for Titian's portraits. But, putting words into the mouth of Michelangelo, Vasari stresses that the mere imitation of nature – 'some of whose aspects tend to be less than beautiful' – is not enough, and that true

beauty results from a careful distillation of nature through the filter of the mind, and through the discipline of drawing.[38] In another passage, at the beginning of the Life of Titian, Vasari made the provocative claim that Venetian painters, including Giorgione, Palma and Pordenone, habitually concealed 'under the charm of their colouring their lack of knowledge of how to draw'.[39] But he reserved his most scathing remarks for Tintoretto, who according to Vasari 'worked at random and without design, as if to show that this art is a trifle'.[40] One might have expected a less harsh judgement, considering that Tintoretto fully shared Vasari's adulation of Michelangelo, was more prolific as a draughtsman than his Venetian colleagues, and cultivated the kinds of difficult foreshortening usually admired by Vasari. But the Florentine was genuinely shocked by what he saw as the carelessness and crudeness of Tintoretto's execution, which for him summed up all that was worst in Venetian painting.

A full-scale rebuttal of Vasari's views did not come until the middle of the next century, with Marco Boschini's *Carta del Navegar Pittoresco* of 1660 (p. 33).[41] A eulogy of the expressive brushstroke, Boschini's poem boldly identified the pictorialism of the great masters of the Venetian Cinquecento – Tintoretto, Veronese and Bassano, as well as Titian – with the art of painting itself. As a major contribution to seventeenth-century aesthetics, the *Carta* helped shape critical attitudes towards the great age of Venetian painting that have survived to this day.

Jacopo Bassano and Venice

Jacopo Bassano occupies a somewhat anomalous position in the history of painting in Renaissance Venice. As recognised by Boschini, he was one of the four great exponents of the Venetian pictorial tradition of the later sixteenth century. Yet except for a brief period in the capital in the mid-1530s, when he was a member of the workshop of Bonifacio, he spent his entire long life in his small native town of Bassano del Grappa, some forty miles north-west of Venice at the edge of the mountains. There he worked chiefly for employers from Bassano and the surrounding region, and occasionally, too, from the relatively distant cities of Belluno, Treviso and Vicenza. But it is clear that from an early date he established a foothold in the Venetian market for pictures for the home; and by the end of his career, his bucolic paintings in particular enjoyed a huge popularity among Venetian collectors. Thanks to these contacts, Bassano was able to keep in constant touch with artistic developments in the capital; and, conversely, his work remained a force that the metropolitan painters had to reckon with.

158 Jacopo Bassano. *Adoration of the Magi* (1542). Canvas, 183 × 235 cm.
Edinburgh, National Gallery of Scotland.

A work of Bassano's early maturity that illustrates all the qualities that
Venetian patrons would have admired is the large and splendid *Adoration
of the Magi* of 1542 (Pl. 158). Commissioned by one Jacopo Ghisi,
probably identifiable with a member of the Venetian patrician family of
that name,[42] the picture would originally have graced a reception room in
a Venetian palace. Apart from its devotional aspect, the subject was ideally
suited to cater for a characteristically urban taste both for magnificent
costume and pageantry, and for the kind of picturesquely rustic setting,
involving animals and landscape, previously represented by such works as
Palma Vecchio's *Jacob and Rachel* (Pl. 122). Stylistically, the *Adoration*
still shows some relationship with the richly decorative art of Bonifacio (cf.
Pl. 130), and inevitably also with that of Titian of the 1530s. But the
bulgingly muscular figure of the kneeling servant at the lower right, and
the animated group of men and horses beyond, also reveal an interest in

219

159 Jacopo Bassano. *Way to Calvary* (*c.*1550–1). Canvas, 94 × 114 cm. Budapest, Szépmüvészeti Múzeum.

Pordenone, while the group of ruined buildings on the left derives from a woodcut by Dürer.[43] Throughout his career, in fact, Bassano was to continue to draw on a wide range of pictorial and graphic sources; but it was his genius to transform them into a style that was entirely his own, in which a vivid realism based on direct observation also played a major role.

This naturalistic ingredient, evident here above all in the treatment of the animals, became less important during a phase from the mid-1540s to the later 1550s, when Bassano developed his own version of the Mannerism currently fashionable in the metropolis.[44] In the *Way to Calvary* of *c.*1550–1, for example (Pl. 159), the spatial setting has become drastically compressed, and the forms of the elongated figures have become simplified to conform with the swaying rhythms of the composition. Thus while the kneeling figure at the lower right is recognisably the counterpart of the one in the *Adoration*, the Pordenonesque plasticity and the naturalistic detail

220

160 Jacopo
Bassano. *Sts Peter
and Paul*
(*c*.1560). Canvas,
288 × 123.
Modena,
Galleria Estense.

of the earlier version have become generalised almost to the point of abstraction. As is evident for the group of gracefully long-necked female figures at the left, Bassano's Mannerism, like Schiavone's (cf. Pl. 142), owed a large debt to Parmigianino's prints (cf. Pl. 139). But like Schiavone's, Bassano's pictorial handling is not at all similar to Parmigianino's, and remains characteristically Venetian in its breadth and in its attention to transient effects of light and colour.

Although a high proportion of Bassano's oeuvre consists of altarpieces, these were typically commissioned by patrons in or close to the town of Bassano, and he only ever painted three for churches in Venice. One of these, the *Sts Peter and Paul* (Pl. 160), painted around 1560 for the original church of the Jesuits in the city, S. Maria dell'Umiltà, is relatively simple in composition and restrained in detail, but is highly impressive in the way that it invests rather ordinary human types with a dignity and

221

161 Jacopo Bassano. *Departure for Canaan* (*c*.1575–80). Canvas, 150 ×
205 cm. Venice, Doge's Palace.

grandeur appropriate to their status as apostles. Contemporaneously,
Veronese was painting three canvases for the ceiling of the same church
(now SS. Giovanni e Paolo, Cappella del Rosario), and this circumstance
may well have prompted Bassano to introduce a new lightness of colour
and airiness of effect into his altarpiece, and to substitute the Mannerist
abstraction represented by the *Way to Calvary* with a return to naturalism.

A closeness to nature was to characterise the type of production for
which Bassano was most highly prized by collectors in the later part of his
career, that of the pastoral genre, in which large numbers of figures
and animals were shown in an extensive landscape, usually in conditions
of twilight, involving a pronounced chiaroscuro.[45] The type is well
exemplified by the *Departure for Canaan* of *c*.1575–80 (Pl. 161), painted
for the important Venetian patron and collector Jacopo Contarini, who
had also commissioned Veronese's *Rape of Europa* (Venice, Doge's
Palace). The biblical theme, like that of other popular favourites by Bassano
such as the *Entry of the Animals into the Ark*, or the *Return of the
Prodigal Son*, was little more than a pretext for representing scenes from

bucolic life, with peasants shown busy at their tasks, in a way that evidently inspired feelings of nostalgia among the wealthy inhabitants of the lagoon-city for the countryside of the *terraferma*. To meet the apparently insatiable demand for this type of picture, Bassano made extensive use of his three painter sons, the most talented of whom, Francesco, took up residence in Venice in 1578. Rather unusually for its type, however, the *Departure* seems to have been painted mainly by Jacopo himself;[46] and although many of the figures are based on a stock of drawings kept in the workshop for future re-use, the brushwork has much of the vivacity and poetic suggestiveness of the painter's late work at its best.

Tintoretto

Unlike Bassano, Tintoretto was a native of Venice, and his most characteristic works consist of large-scale religious canvases for the walls and ceilings of Venetian public buildings. His greatest achievement consists of the decoration of the three principal rooms of the Scuola di S. Rocco, and cumulatively his work there, executed over a period of more than twenty years from 1564, still has the power to astonish and overwhelm. But Tintoretto was slow to gain the confidence of patrons, and was not allowed to find his true metier until he was nearly thirty, in the later 1540s. Then, in 1547–8, he painted two large and dramatic pictures that broke definitively with the ornamental Mannerism of the *Apollo and Marsyas* of 1544–5 (Pl. 144): the *Washing of the Disciples' Feet* for the Scuola del Sacramento at the parish church of S. Marcuola (Pl. 162); and the *Miracle of the Slave* for the chapter hall of the Scuola di S. Marco (Pl. 163).

The Scuola del Sacramento at S. Marcuola was the first of several such confraternities for which Tintoretto worked during the course of his career.[47] Inspired by a special devotion to the Holy Sacrament, the Scuola had custody of a chapel to the left of the chancel; and Tintoretto did much to establish the convention, to become increasingly common with the advance of the Counter-Reformation, for such chapels to have a painting with an appropriately eucharistic theme on each of the side walls. The pendant of the *Washing of the Feet* was a *Last Supper*, still in the church; and the choice of the former subject as a pendant was doubly appropriate: because the gospel episode took place directly after the Last Supper, and was ideologically closely linked with it; and because the confraternity

162 Tintoretto. *Washing of the Disciples' Feet* (1547). Canvas, 210 × 533 cm. Madrid, Prado.

members were required to demonstrate their humility and brotherly love by imitating Christ's example, and washing the feet of the poor in an annual ritual on Maunday Thursday. Tintoretto's concern to relate his painting to the personal experience of the rank and file of confraternity members, many of whom would have been tradesmen and artisans, while yet doing justice to the spiritual significance of the event, results in a paradoxical combination of elements. On the one hand, the figure poses are highly rhetorical, and the nobly classicising setting is derived, like the backgrounds of Titian's *Presentation* (Pl. 115) and Paris Bordone's *Fisherman delivering the Ring* (Pl. 129), from the architectural treatise of Serlio.[48] But on the other hand, the physiognomies are ordinary and unidealised, and the picture is full of details from humble everyday life such as the wooden trestle-table, the tub, and the Bassano-inspired dog.[49] Already characteristic of the mature artist is the unashamedly theatrical lighting, which is devised not to imitate natural appearances, but to animate the composition by creating bold contrasts, and to enhance the tense energy of the poses, as in the flame of light that silhouettes the back of the disciple at the extreme left. Equally characteristic of Tintoretto is the choice of multiple viewpoints and unusual compositional relationships, as in the removal of the most important figure group, with Christ, Peter and John, from the centre to the right edge. This particular novelty may have been inspired by the fact that the canvas was originally placed on the left wall of the chapel, so that the scene would have been first viewed by the advancing spectator obliquely from the left.[50] But even so, Tintoretto's aim was not to create an illusion of reality, but to engage the emotions of his audience with the sacred events.

163 Tintoretto. *Miracle of the Slave* (1548). Canvas, 415 × 541 cm. Venice, Accademia.

The Miracle of the Slave was painted for the physically very different surroundings of the chapter hall of the Scuola di S. Marco; and in keeping with its original placing on the short wall between the two large windows facing out on the Campo SS. Giovanni e Paolo (cf. Pl. 23), its composition is much more centralised than that of the *Washing of the Feet*. It is also more compact, and the tightly knit figure group is restricted to a foreground stage unconnected with the screen-like architecture beyond. The placing of the figures along converging diagonals serves to focus attention on the vertical axis, and on the powerful magnetic force that links the naked figure of the Christian slave with the outstretched right arm of the airborne St Mark. The saint's miraculous intervention to protect his devotee from torture and death is visible only to the slave; yet every movement and gesture of the frustrated torturers and the bystanders is calculated to register their profound amazement. Helping to clarify the composition, and to counteract the spatial thrust created by the sharply

foreshortened poses of the two main figures, are the bold repetitions of a limited range of colours, consisting chiefly of crimsons, oranges, olive-greens and slate-blues. But the planes are constantly broken by linear slashes of contrasting white highlight and black shadow and, unlike in the fifteenth-century narrative tradition or in Titian's *Presentation*, the effect of the colour composition is not restful and decorative but agitated and dissonant.

The decoration of the neighbouring *albergo* had been completed in 1534 with Paris Bordone's *Fisherman delivering the Ring* (above, p. 173), and the *Miracle of the Slave* was commissioned as the first in a new cycle in honour of St Mark, with further posthumous scenes from his legend. The highly dramatic and explicitly miraculous subject was ideally suited to Tintoretto's temperament; and according to his biographer Ridolfi, the completed work caused a sensation, and left the members of the Scuola's governing board divided among themselves about whether or not to accept it.[51] Similar controversies were to surround the painter throughout his career, and his subsequent trio of contributions to the *St Mark* cycle, executed more than a decade later in 1562–6, also caused the Scuola unease. This time the cause of complaint was that the *Guardian Grande*, a wealthy and self-promoting physician named Tommaso Rangone, was portrayed too prominently in all three,[52] and indeed, in the *Removal of St Mark's Body from the Funeral Pyre* (Pl. 164), Rangone in his official robes appears not, like his fifteenth-century predecessors, passively and at the margin of the composition (cf. Pls 11, 63), but at the very centre, where he lends active assistance to the saint's disciples. But Rangone's placing is by no means the only unconventional element in this extraordinary composition. As in Gentile Bellini's *Preaching of St Mark* for the *albergo* (Pl. 11), the architectural background is probably deliberately meant to resemble the Piazza San Marco (cf. Pls 9, 85), and to allude to the fact that the saint's final resting-place was to be not Alexandria but Venice. But the rapidly receding vista, the inexplicable disjunctions of scale, the oppressively dark sky, and the strange, wraith-like figures of the Muslims fleeing from the storm into the arcade on the left, all contribute to a mood of eeriness and disquiet that is certainly appropriate to the miraculous nature of the event, but which is likely to have left many of Tintoretto's contemporaries uncomfortably disconcerted.

Among those who, on the contrary, were clearly deeply impressed by the *Removal of St Mark's Body* and by other works of Tintoretto's earlier maturity, was a transient visitor from Crete, El Greco, who was present in Venice for a brief period in the late 1560s. One of the few pictures that can

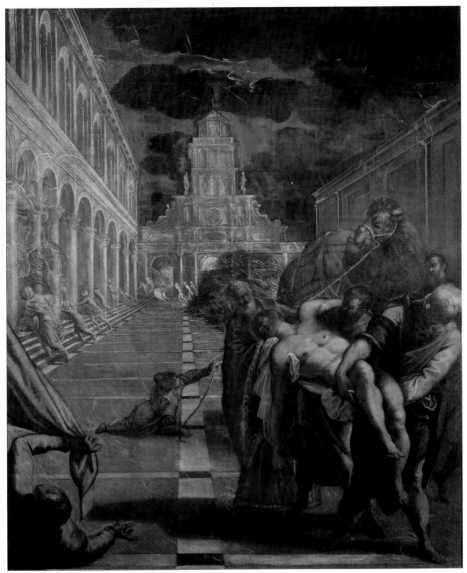

164 Tintoretto. *Removal of St Mark's Body from the Funeral Pyre* (1562–6).
Canvas, 415 × 541 cm. Venice, Accademia.

165 El Greco.
*Christ healing the
Blind* (c.1567–70).
Panel, 66 × 48 cm.
Dresden,
Gemäldegalerie.

be convincingly allocated to this period is his rendering of the Counter-Reformation theme of *Christ healing the Blind* (Pl. 165), in which the deep perspective vista, agitated figures, asymmetrical composition and turbulent sky are all reminiscent of the *Removal*; while the incongruously central placing of the dog also recalls the *Washing of the Feet*. In his attempt to westernise his style, El Greco may well have found Tintoretto's visionary and often anti-naturalistic painting, in which the linear white highlights are reminiscent of the striations of Byzantine art, a more sympathetic model than that of any other Venetian painter; it should be said, however, that he was clearly also attracted to works of the Mannerist phase of Jacopo Bassano (cf. Pl. 159), which he could have seen in Venetian private collections. El Greco's rather small-scaled Venetian pictures were all presumably similarly painted for private settings; certainly, he did not receive any public commissions during his visit. Although in his subsequent career in Rome and in Spain, his style was to move a long way from that of the *Christ healing the Blind*, a Venetian ingredient was never wholly to disappear from the art of his maturity.

Probably just completed at the time of El Greco's arrival in Venice was Tintoretto's single-handed decoration of the *albergo* of the Scuola Grande di S. Rocco (1564–7; Pl. 166). The Scuola was much younger than the other four Scuole Grandi, and was founded as a Scuola Piccola as late as 1478; but it grew rapidly in size and wealth, thanks to the huge popularity of the cult of its patron saint. As a seaport with close commercial links

228

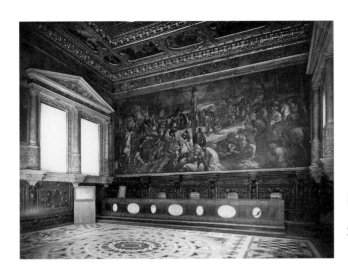

166 Venice, Scuola di S. Rocco: view of *albergo* with Tintoretto's *Crucifixion*.

with the Near East, Venice was particularly vulnerable to successive epidemics of bubonic plague; and in the absence of effective medicine, supernatural protection was avidly sought from the saints, and in particular from saints with a special interest in the plague, such as St Sebastian, and now also St Roch. The body of Roch was brought from France to be reburied in Venice in 1485, and the church newly founded for the purpose was given into the custody of the Scuola, which also proceeded to build for itself a magnificent new meeting-house alongside the church. Tintoretto's first contacts with the Scuola had taken place in the late 1540s, when he painted a canvas for the church; indeed, the direct experience of the works already there by Pordenone (pp. 180–1) may have acted as a further encouragement to develop the highly dramatic style of the *Miracle of the Slave*. Then, in 1564, the Scuola announced a competition for the commission to paint the ceiling of the *albergo* of its newly completed meeting-house. According to Vasari,[53] Tintoretto outmanoeuvred his rivals by painting the central oval 'with his usual speed', and installing it on the ceiling, before the other painters, including Veronese, Giuseppe Salviati and the Roman painter Federigo Zuccari, had even submitted their designs. When the confraternity officers complained at this behaviour, Tintoretto replied that they could have his painting free of charge. Naturally they could not refuse the offer, and as a result he succeeded in gaining the commission not only for the ceiling, but for the walls as well. Vasari, and no doubt Tintoretto's rivals, were offended by these aggressive and un-

167 Tintoretto. *Crucifixion* (1565). Canvas, 538 × 487 cm. Venice, Scuola di S. Rocco.

scrupulous tactics; but for the officers, the evidence that Tintoretto could deliver promptly and cheaply must have acted as a strong inducement to take him on. For his part, Tintoretto never enjoyed the consistent support of culturally influential patricians such as the Barbaro brothers, who were so important in promoting the career of Veronese (p. 244); and to realise his ambitions he was forced into active self-promotion.[54]

The principal painting in the *albergo* of the Scuola di S. Rocco is the huge *Crucifixion* (Pl. 167), which Tintoretto painted in the year after the competition for the ceiling for the wall opposite the entrance. In an analogous position to Gentile Bellini's *Preaching of St Mark* (Pl. 11) and Titian's *Presentation of the Virgin* (Pls 115, 116) in their respective *alberghi*, Tintoretto's canvas shares with them the crowds of figures (including portraits), the wealth of subsidiary episodes, and the creation of pictorial unity by means of decoratively repeating patches of colour. But in the measureless fluidity of its pictorial space, the *Crucifixion* departs not just from these predecessors but also from Tintoretto's own earlier works, up to and including the *Removal of the Body*, which for all its strangeness, retains the armature of a geometric perspective; and encircled by surging groups of humanity, busily attentive to the digging, the rope-pulling and all the rest of the physical labour involved in the triple crucifixion, the lonely figure of Christ on the Cross appears as the still centre of a whirlpool of activity. The lighting, which has become even more arbitrarily theatrical than in the *Washing of the Feet*, further adds to the drama and to the sense of the terrible and sublime nature of the unfolding event.

It was usual in Venice for several painters to contribute to large-scale

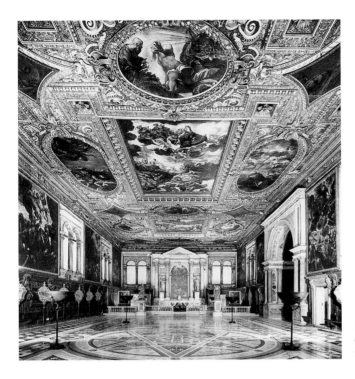

168 Venice, Scuola
di S. Rocco. View of
Chapter Hall.

pictorial cycles, but in the following decade Tintoretto persuaded the
Scuola officers, partly again by means of a tactical gift, to give him
exclusive control of the decoration of the much large chapter hall (Pl.
168). The ambition of the scale is matched by the coherence and com-
plexity of the iconological programme, in which the sequence of gospel
scenes round the walls finds typological parallels in the Old Testament
scenes on the ceiling, and all are intended to reflect the avowed mission of
the Scuola to bring comfort to the sick and suffering, and to help its
members attain the salvation of their souls.[55] It is not by chance, therefore,
that one of the three huge rectangular canvases on the ceiling, the
Gathering of Manna (Pl. 169), is aligned with the wall painting of the *Last
Supper* (Pl. 170); and significantly, the manna that drops from heaven
onto the naked and straving children of Israel takes the form of a shower
of eucharistic wafers. The viewpoint adopted for the *Gathering* is the by-
now conventional one, as if from the bottom of a steep flight of stairs. But
characteristic of the mature Tintoretto is the sense of the infinity of space,
and also the illogicality with which it is constructed, so that the eye is

231

169 Tintoretto. *The Gathering of Manna* (*c*.1577). Canvas, 550 × 520 cm. Venice, Scuola di S. Rocco.

constantly led into spatially unrelated pockets. Equally original is the composition of the *Last Supper* – or more precisely, the *Institution of the Eucharist* – with the immediate foreground occupied by representatives of the poor and needy, and Christ himself placed deep into space, on about half their scale, at the other end of the obliquely disposed table. Yet Christ is made unambiguously the focus of attention by the converging lines of the perspective, and by the nimbus of light that separates his head from the dark, enveloping shadows.

170 Tintoretto. *Last Supper* (1579–81). Canvas, 538 × 487 cm. Venice, Scuola di S. Rocco.

It was Tintoretto's practice to prime his coarsely woven canvases with a dark ground, and to build up his compositions by making the forms seeming to emerge from the darkness.[56] Many of them remain only broadly suggested, while others receive their final definition by means of a network of quickly sketched black-and-white lines. In the boldness and

freedom of his brushwork, so much criticised by Vasari (p. 218), Tintoretto may be regarded as a leading exponent of Venetian *colorito*; on the other hand, the range of colours used at the Scuola di S. Rocco is relatively limited, and their intensity is relatively subdued. Rather, it is made subordinate to the powerful chiaroscuro, which serves both to give clear articulation to the often very crowded compositions, and to enhance the effect of drama and religious mystery. By setting his biblical stories in humble, mundane and shadowy surroundings, and then illuminating them with sudden pools and shafts of light, Tintoretto triumphantly succeeds in conveying a sense that the world of ordinary sinful humanity is subject to the workings of divine providence.

Although Tintoretto's relations with the governing committees of the various *scuole* he worked for were often difficult, he clearly approached the type of commission they offered with a deep sense of personal commitment. By contrast, he does not appear to have had any particular interest in the secular genres of portraiture and mythology, even though throughout his career he practised both. A fine and typical late example of his portraits is that of *Marco Grimani* (Pl. 171), an illustrious Venetian patrician, second cousin to the branch of the family that had brought Francesco Salviati to Venice in 1539, and contender for the office of doge in 1577, and again in 1578.[57] With the elderly sitter represented in little more than half-length against a neutral background, the format is simple compared with those of earlier portraits by Titian and Lotto; and while he is lent an approriate aura of sagacious, even slightly melancholy dignity, he is not endowed with any strong individual personality. Paradoxically, it may have been Tintoretto's very reticence as a portrait painter that recommended him to the notoriously conservative tastes of the patriciate, a social group that otherwise showed a marked preference for the art of Veronese. In this sense, Tintoretto's series of images of elderly, unostentatious and psychologically remote Venetian senators in their official scarlet or crimson, may be seen as a late sixteenth-century counterpart to the portraits painted a century earlier by Giovanni Bellini (pp. 106–7).

Tintoretto's qualities and limitations as a painter of mythologies are well illustrated by the *Origin of the Milky Way* of *c*.1580 (Pl. 172), commissioned by the Emperor Rudolf II as one of a set of four scenes from the life of Hercules. In the lifetime of Titian, not just Tintoretto but even Veronese were largely disregarded by Italian dukes and foreign royalty; but after 1576 Tintoretto received for the first time a number of commissions both from Guglielmo Gonzaga, duke of Mantua, and from the newly elected Holy Roman Emperor. Rudolf II was passionately interested

171 Tinoretto. *Marco Grimani* (*c*.1575–80). Canvas, 77 × 63 cm. Madrid, Prado.

not just in the arts, but also in astronomy;[58] and the choice of subject here – the origin of the Milky Way in a spray of milk from Juno's breast as the infant Hercules is put to it – may have been made with both interests in mind. Although the work on the picture coincided with that on the *Last Supper* for the Scuola di S. Rocco, Tintoretto adopts a very different style for the mythology, presumably to correspond with its very different destination. Thus the colour-range in the *Milky Way* is much wider, the chiaroscuro is less pronounced, and some of the draperies have an uncharacteristic richness of substance and texture, in a way that suggests that Tintoretto was deliberately setting out to approximate to the styles of Titian and Veronese. But refined as it is, the *Milky Way* lacks the human and tragic dimension of Titian's mythologies for Philip II; and equally, it lacks the expressive urgency of Tintoretto's own canvases for the Scuola di S. Rocco, as if the painter could not take the delightful mythological fable seriously.

235

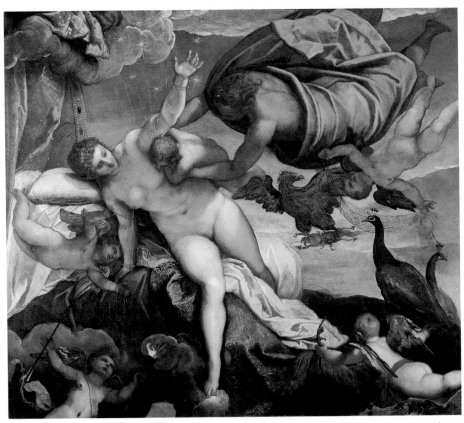

172 Tintoretto. *Origin of the Milky Way* (*c.*1580). Canvas, 148 × 165 cm. London, National Gallery.

In the last decade of his life, contemporaneously with his work on a third great project at the Scuola di S. Rocco, the lower hall, Tintoretto became involved in the extensive campaign of redecoration in the Doge's Palace (pp. 257, 262–3). In keeping with normal workshop practice, he would have long since made use of assistants; but now, more than ever, his son Domenico, daughter Marietta and son-in-law Sebastiano Casser, were involved in much of the execution. The inevitable result was a certain decline in quality in most of Tintoretto's late works; but there remains a number of pictures, including the *Entombment* of 1592–4 for Palladio's church of S. Giorgio Maggiore (Pl. 173), in which the painter's own voice

173 Tintoretto. *Entombment* (1592–4). Canvas, 288 × 166 cm. Venice, S. Giorgio Maggiore.

still speaks clearly. Although painted for the mortuary chapel of the Benedictine monks and not for his own tomb, the work may be compared to Titian's *Pietà* (Pl. 156) as a final meditation on the image of the dead Christ by the painter as he approached death. As in Titian's picture, it may well be that the bearded old man – in this case presumably Joseph of Arimathea – whose intense gaze is fixed on the Saviour's face, constitutes a self-portrait of the painter.[59] The mood of bitter sorrow is intensified, not relieved, by the fact that the faces of the mourners are deep in black shadow and their facial expressions are difficult to read; and Christ's wounds are emphasised by the repeating planes of blood-red drapery. At the same time, the placing of Christ's blood-stained body across the central axis, aligning it with the place of the Sacrament below, and the close resemblance of the stone slab in the foreground to an altar table, serve as potent reminders of the theological significance of Christ's self-sacrifice, and give hope to his followers for eventual resurrection.

Veronese

Tintoretto's younger contemporary Paolo Veronese had reached artistic maturity before he settled in Venice in the early 1550s, and during the subsequent two and a half decades he practised the style that he had already formulated with little essential modification. Most of the painter's extraordinary qualities are illustrated by the magnificent *Family of Darius before Alexander* (Pl. 174), probably painted for the noble Pisani family in the mid- or late 1560s. The episode is taken from ancient history, and tells of how the family of the defeated Persian king made the potentially disastrous mistake of pleading for mercy from one of Alexander's generals, and of ignoring the conqueror himself. But the chivalrous Alexander – identifiable as the figure in scarlet armour – chose to interpret the mistake as a deserved compliment to his general, and was indeed merciful to the supplicants. The theme, then, is of dignity in defeat and magnanimity in victory; and Veronese's figures – with whom the members of the Pisani family presumably identified themselves – are appropriately presented as noble in bearing and handsome of aspect. They are also dressed in extremely sumptuous costumes, and these give the painter an opportunity to demonstrate his consummate mastery both of orchestrating a wide range of colours, and of evoking a wide range of surface textures, from glinting armour to fur, and to shimmering silks and brocades. Characteristic of Veronese is the fact that the figures are neither static nor dramatic, but move in a stately rhythm in a plane parallel to the shining

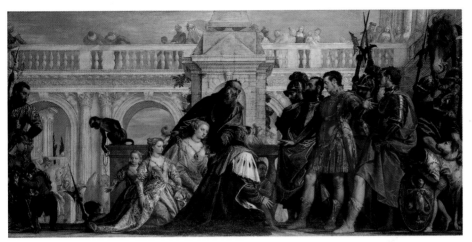

174 Veronese. *Family of Darius before Alexander* (*c.*1565). Canvas, 236 × 475 cm. London, National Gallery.

white architectural backdrop, which is in turn parallel to the surface. In the absence of a legible middleground, the figure composition resembles a frieze; but the resemblance is not with the self-consciously artificial, relief-like arrangement of central Italian Mannerism (cf. Pl. 138), but with the festive and decorative tradition of Venetian narrative painting, as represented by Titian's *Presentation* (Pl. 115), and earlier by the Scuola paintings of Gentile Bellini and Carpaccio. Consistent with this tradition are the picturesque accessories, such as the exotic headgear worn by some of the bystanders, and the various animals, including the lapdogs on the extreme left, the monkey, the hound on the extreme right, and the horse at the top right, the quizzical expression of which adds a touch of gentle wit to the dignified proceedings. Conversely, while the figures are all of splendid physique, they have nothing of the exaggerated muscularity of the Michelangelesque tradition, nor of the artificially attenuated beauty of Parmigianino.

Veronese's effortless ability both to align his art with a local tradition going back to the fifteenth century, and at the same time to update it in line with the more advanced classical tastes of the later sixteenth century, made him a superb painter of large-scale wall and ceiling decorations in the public buildings of Venice. Even before he was awarded the prize of a golden chain for his contribution to the ceiling of the Reading Room in 1557 (Pl. 147), he had participated in important ceiling projects in the

175 Venice, S. Sebastiano. View of interior.

Doge's Palace (1553–4) and in the sacristy of the Hieronymite church of S. Sebastiano (1555). Then, between 1556 and 1565, he went on to cover the inside of the main body of S. Sebastiano with an extensive pictorial cycle, comprising three large ceiling paintings, frescoes on the upper parts of the wall, organ shutters, narrative canvases for the side walls of the chancel, and the high altarpiece (Pl. 177). The church of S. Sebastiano represents, in fact, almost as comprehensive a monument to Veronese's art as the Scuola di S. Rocco does to that of Tintoretto; indeed, it may even be that the sight of the near-complete S. Sebastiano in 1565 inspired the tirelessly competitive Tintoretto to undertake a rival project on an even larger scale. Like Titian's earlier ceiling for S. Spirito in Isola and Tintoretto's later one for the chapter hall of the Scuola di S. Rocco, the three ceiling canvases at S. Sebastiano show Old Testament scenes, in this case from the story of Esther, chosen as a prefiguration of the life of the Virgin.[60] Veronese also adopts Tintoretto's oblique low viewpoint, to particularly dramatic effect in the *Triumph of Mordecai* (Pl. 176), with its pair of prancing horses and white architecture seen in steep foreshortening against the serene sky.

176 Veronese. *Triumph of Mordecai* (1555–6). Canvas, 500 × 370 cm. Venice, S. Sebastiano.

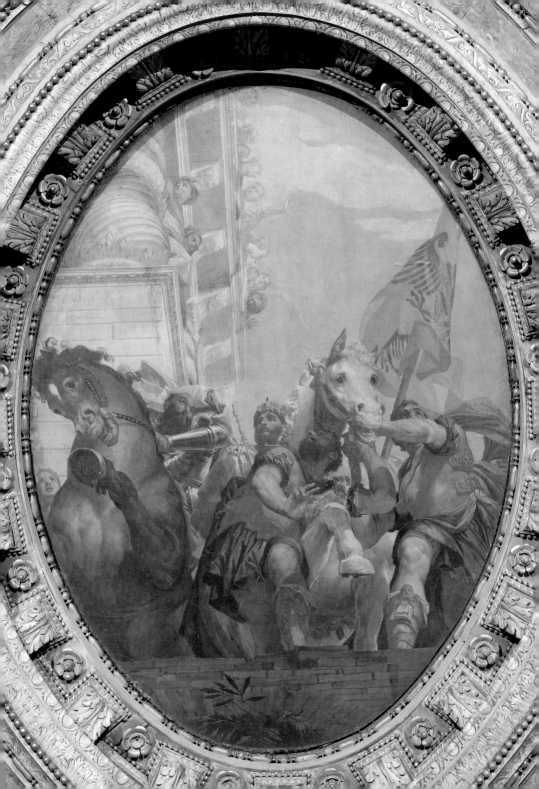

Veronese's high altarpiece for S. Sebastiano, the architectural frame of which he designed himself, represents a revision of the traditional theme of the *sacra conversazione* in keeping with the mood of the Counter-Reformation. Developing a compositional idea introduced into Venetian painting by Titian as early as 1520, Veronese removed the central Virgin and Child and musician angels from the earthbound throne employed by Giovanni Bellini (cf. Pl. 5) to clouds of glory in the apex. Meanwhile the accompanying saints – with Sebastian as the patron of the church at the centre – no longer stand passively by, but gaze upwards in fervent adoration. No particular event is portrayed, and the movements and gestures are restrained compared with those of Tintoretto. Yet, as in another key-work by Titian, the Ca' Pesaro altarpiece of 1519–26 (Pl. 112), the asymmetry of the composition, the fluency of the poses and the vibrant effects of light and colour all lend the work an animation calculated to play on the emotions of the pious spectator. Veronese's talents as a painter of sensuously beautiful yet spiritually inspiring altarpieces are equally well illustrated by the closely contemporary high altarpiece he painted for Verona (Pl. 178). Again, the crucial Venetian prototype for altarpieces representing a scene of martyrdom was provided by Titian in the 1520s, in his *Death of St Peter Martyr* (cf. Pl. 113). But since then, the idea had been followed up only sporadically, and Veronese's *Martyrdom of St George* now also became an important model for the huge crop of martyrdom pictures to be produced in Venice and the Veneto from the mid-1560s onwards (cf. Pl. 193). A powerful impetus for this development was created by the publication at the beginning of 1564 of the decrees of the Council of Trent, including that of December 1563 recommending the use of sacred images 'because through the saints the miracles of God and salutory examples are set before the eyes of the faithful, so that they may . . . fashion their own life and conduct in imitation of the saints and be moved . . . to cultivate piety'.[61] In other words, with this greater stress now placed by the church on the didactic value of images (cf. p. 187), scenes from the lives, and especially from the deaths of saints, providing examples of truly Christian conduct, became much more common as subjects for altarpieces and wall paintings. Thus Veronese shows the naked St George in the centre foreground preparing to sacrifice his own life for refusing to worship the pagen idol of the left of the picture – signifying for the Catholic faithful the false religion of Luther.

There is evidence that the choice of subject for Veronese's altarpiece was influenced by the advice of the patrician prelate Daniele Barbaro who,

177 Veronese. *Virgin and Child in Glory with Saints* (*c.*1565). Canvas, 420 ×
230 cm. Venice, S. Sebastiano.

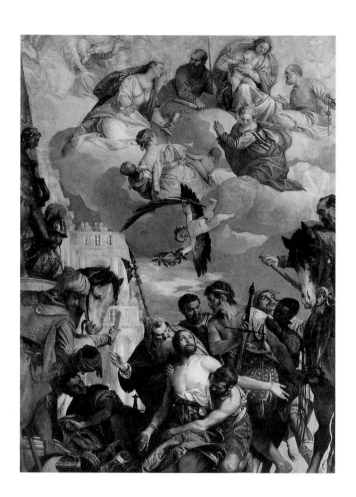

178 Veronese.
*Martyrdom of St
George* (*c*.1564).
Canvas, 426 ×
305 cm. Verona,
S. Giorgio in
Braida.

according to Vasari, visited S. Giorgio in Braida on his way back from the
Council of Trent at the end of 1563.[62] Barbaro was also a learned
humanist, with an especially strong interest in architecture; and together
with his brother Marcantonio, he had commissioned Palladio to build a
country villa at Maser, near Castelfranco, and Veronese to decorate it with
fresco.[63] From the middle years of the century it was becoming increasingly
fashionable for wealthy Venetians to build villas on the *terraferma*, partly
for economic reasons in response to general shift in investment in trade to
landed property, but partly also for reasons of literary and intellectual
taste. Thus the same urban nostalgia for the pleasures of the country

179 Maser (near Castelfranco), Villa Barbaro. View of crossing with frescoes by Veronese (*c*.1560–1).

reflected in the taste for Giorgionesque pastorals and the bucolic subjects of Jacopo Bassano prompted Venetians to build themselves rustic retreats where they could relax from the cares of government and business. Veronese's light-toned, festive and wittily conceived frescoes at Maser conform perfectly to this spirit, and they represent the supreme example of Venetian villa decoration of the sixteenth century. In the principal public area, for example (Pl. 179), he has incorporated the real cornice and door frames into an illusionistic system of fluted columns, reliefs, niches, balustrades and openings, blurring the borderline between reality and fiction. An apparently real little girl steps through the half-open door on the right; but are the allegorical female figures in niches to the sides similarly real, or are they statues? On either side of the door on the left are views onto pure landscape, counterparts of the views through real windows onto the real landscape of Maser, and similarly prompting musings on the beauty and tranquillity of nature.

Although Veronese's altarpieces for S. Sebastiano and S. Giorgio in Braida may be regarded as fully consistent with the letter and spirit of the Tridentine decree on images, the painter was summoned in 1573 by the Inquisition to answer charges that his picture now known as the *Feast in the House of Levi* (Pl. 180) was in breach of the rules of religious decorum. During the 1560s Veronese had built up a considerable repu-tation as a painter of biblical feasts and suppers for monastic refectories, most notably with the vast *Wedding Feast at Cana* (Paris, Louvre) painted in 1562–3 for the newly built Palladian refectory at S. Giorgio Maggiore.

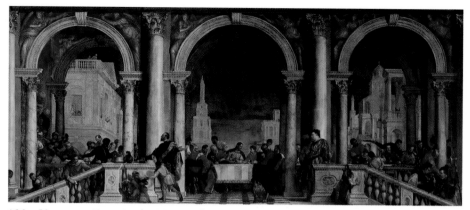

180 Veronese. *Feast in the House of Levi* (1572–3). Canvas, 555 × 1310 cm. Venice, Accademia.

When the refectory at SS. Giovanni e Paolo with its *Last Supper* by Titian was burnt down in 1571, Veronese was the obvious candidate to provide a replacement; and the resulting work was originally similarly intended as a Last Supper. Destined to cover the entire end wall of the refectory above a dado, the picture was conceived, like the frescoes at Maser, in semi-illusionistic terms, with the giant order of half-columns apparently supporting the cornice of the room, and the arches of the smaller order apparently set in the same plane as the wall. In a more complex version of Maser, the wall is then dissolved by the views through the arches, while the balustraded steps on either side, together with the platform in the immediate foreground, are understood to project forwards into the real space of the refectory. Besides creating an arresting illusion and lending the scene an aura of classical nobility, the arcaded architecture – closely reminiscent of that of Sansovino's Library in the Piazza San Marco (Pl. 85) – performs the essential service of structuring and organising the multifigured composition. The figure of Christ is placed on the central axis of a strongly centralised design, and the main actors are similarly all seated under the central arch. The moment chosen is not so much the Institution of the Eucharist as the announcement of the betrayal; and Judas may be identified as the figure behind the foreground dog, sharply and guiltily turning his face away from Christ. Other disciples are attempting to comprehend the meaning of his words, while those still further along the table have still not properly heard him.[64] The expressive contrast between the quiet drama taking place at the centre of the composition, and the

246

busy feasting at the sides, is somewhat compromised, however, by the prominent inclusion in the central section of the figure in scarlet and ermine, who has no connection with the Last Supper story. Technical examination has shown that this figure was in fact added to the original design, cancelling a much less obtrusive serving-boy; and it has been suggested that Veronese got wind in advance of the Inquisitors' objections, and hastily tried to transform his picture into a Feast in the House of Simon, with the figure in scarlet and ermine introduced to play the part of Simon.[65] But at the tribunal, the Inquisitors still objected to the inclusion in the picture of 'buffoons, drunkards, Germans, dwarfs and similar vulgarities', which they considered were not appropriate either to a Last Supper or to a Feast in the House of Simon; furthermore, they were not deceived by the painter's hasty alterations, since the figure of Mary Magdalen, indispensable to a Feast in the House of Simon, was still not present. Veronese was accordingly ordered to 'improve and change' his painting;[66] but instead of making any further alterations, he simply added an inscription identifying the subject neither as the central Christian mystery of the Last Supper, nor as the Feast in the House of Simon, but as the theologically less sensitive and virtually unknown episode of the Feast in the House of Levi. Although in this way he ingeniously avoided doing damage to his picture, Veronese's experience with the Inquisition evidently made an impression on him, since he painted no more suppers in this festive vein. When he returned to the subject of the Last Supper more than a decade later, his approach was much more austere and spiritually committed (cf. Pl. 185).

Some of the figures in narrative compositions such as the *Feast in the House of Levi* and the *Family of Darius before Alexander* have the appearance of portraits, and indeed, although Veronese was not a prolific painter of autonomous portraits, he made a distinguished contribution to the genre. While still in Verona he adapted the full-length format reserved by Titian for his princely patrons for the provincial nobility; and he used it again in the elegantly casual *Portrait of a Man* of c.1560 (Pl. 182). Unfortunately, the sitter's identity is unknown: although the inclusion of the church of San Marco in the left background might seem to suggest that he was a Venetian, the costume is not that of a Venetian patrician, and he may well have been a foreign visitor to the city. In this connection it is worth recalling that when the Elizabethan courtier-poet Sir Philip Sidney visited Venice in 1574, he chose to sit to Veronese;[67] and although Tintoretto was the more highly favoured as a portrait painter by Venetian senators and officials (p. 234), it is easy to imagine that Veronese would

181(following pages) Veronese. Detail of Pl. 180.

182 Veronese. *Portrait of a Man* (*c*.1560). Canvas, 193 × 135 cm. Malibu, J. Paul Getty Museum.

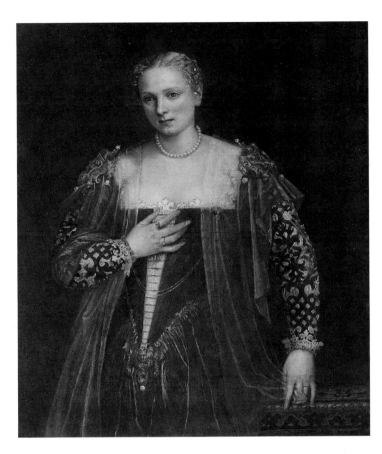

183 Veronese. *'La Bella Nani'* (*c*.1560). Canvas, 119 × 103 cm. Paris, Louvre.

have been more successful in conveying an air of aristocratic distinction and cultivated intelligence appropriate to Sidney. Also unlike Tintoretto, Veronese's range extended to women, as is superbly illustrated by the so-called *Bella Nani* (Pl. 183) – the beautiful woman of the Nani family. The painter here shows his customary technical brilliance in the evocation of a range of luxurious textiles, and in the sensuous contrast between these and the flesh tones; but more than this, he accords to his female sitters the same dignity that he gives to the *Portrait of a Man*. Although neither portrait can be described as psychologically profound, the thoughtful, even slightly sad expression on the face of the woman lends her an individual personality lacking in the images of anonymous beauties so popular in the earlier part of the century.

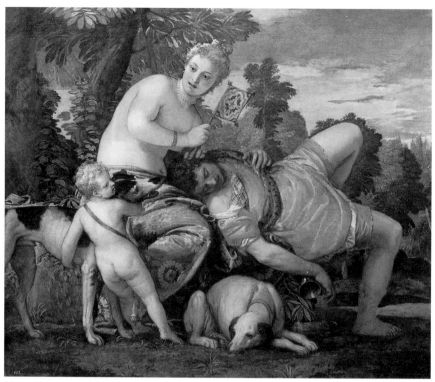

184 Veronese. *Venus and Adonis* (*c*.1580). Canvas, 162 × 191 cm. Madrid, Prado.

A not-dissimilar expression appears on the face of Venus in the rather later painting of *Venus and Adonis* (Pl. 184), painted around 1580 for an unknown patron as one of a pair with a *Cephalus and Procris* (Strasbourg, Musée des Beaux-Arts).[68] Unlike Tintoretto, Veronese had a natural talent for mythological painting, and he, too, was employed in this vein by foreign rulers such as the Emperor Rudolf II, as well as by wealthy and learned Venetians such as Jacopo Contarini, who commissioned the *Rape of Europa* (1573; Doge's Palace). The subjects both of this last work and of the *Venus and Adonis* had previously been painted by Titian for Philip II; but in his own interpretation, Veronese characteristically avoids the dramatic tension and tragic violence explored by Titian. Indeed, in an earlier representation of *Venus and Adonis* (*c*.1562; Augsburg, Städtische Kunstsammlungen), Veronese's approach had been quite lighthearted; and

this is carried over into the later version in the amusing detail of Cupid attempting to restrain one of Adonis's hounds, impatient to return to the hunt, from waking his master. Yet despite this, and despite the serene mood created by the dappled sunlight and shimmer of silks, there are undertones of sadness, since Venus – as well as the attentive spectator contemplating the picture alongside its more explicitly tragic pendant, *Cephalus and Procris* – knows that when Adonis returns to the chase, he will meet his death. It is this knowledge that informs the thoughtfulness of her expression and the tenderness of her gestures.

When Veronese died in 1588, he was only just sixty, and still at the height of his powers; and his increasing use of his brother Benedetto and sons Gabriele and Carletto as workshop assistants in the last decade and a half of his life was not due to physical infirmity, but as also in the case of Tintoretto, to a vastly increased burden of work. As well as playing an important role in the redecoration of the Doge's Palace after the fires of 1574 and 1577 (pp. 255ff), the Veronese shop was flooded with commissions from churches in and beyond Venice that were undergoing refurbishment in the wake of the Tridentine reforms. A typical and impressive example of this type, for which Veronese himself seems to have taken the main responsibility, is represented by the *Last Supper* of *c*.1585 (Pl. 185). Like Tintoretto's *Washing of the Feet* (Pl. 162) and its original pendant, Veronese's picture was commissioned by a parish confraternity of the Sacrament, in this case at the church of S. Sofia.[69] Unlike Tintoretto's canvases, it seems to have been originally placed on the entrance wall rather than in a side chapel flanking the chancel; but in this position, it

185 Veronese. *Last Supper* (*c*.1585). Canvas, 230 × 523 cm. Milan, Brera.

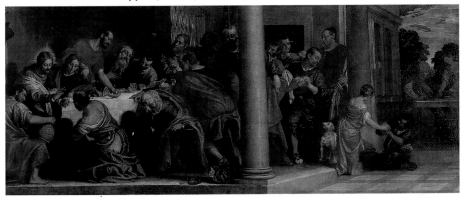

would have had an equally close ideological connection with the high altar. The moment depicted is accordingly not the announcement of the betrayal, as in Veronese's earlier painting for the refectory of SS. Giovanni e Paolo (Pl. 180), but the Institution of the Eucharist.[70] In the left foreground, a priest-like Christ is giving bread and wine to a kneeling disciple; and to the left, the same spiritual gifts are passed by the disciples as future apostles to a kneeling beggar. There is even a hint in the figure of the turbaned Oriental behind the balustrade in the background that these gifts would be available to any Muslim willing to convert to the true religion of the Catholic church. In keeping with the socially modest character of his patrons, and also with the growing sense of religious urgency of the times, Veronese seems to have deliberately adopted here a number of stylistic and compositional characteristics associated with Tintoretto. As in Tintoretto's *Last Supper* in the Scuola di S. Rocco (Pl. 170), and in contrast with his own previous practice, the table is place obliquely to the picture plane; the setting, with its plate-rack, is relatively humble, and the gleaming white architecture characteristic of the earlier Veronese has disappeared; the colours are subdued, and often disappear into dark shadow.

Even more moving in the depth of religious emotion expressed is another, more intimate work from the last decade of Veronese's life, the *Agony in the Garden* (Pl. 186).[71] This was commissioned by the wealthy citizen and ducal secretary Simone Lando,[72] and although on his death he donated it with a number of his other pictures to the church of S. Maria Maggiore, the picture was originally intended for private contemplation in the home. Unlike other versions of the subject, such as that by Bellini (Pl. 47), or more recently by Tintoretto in the Scuola di S. Rocco, Veronese's picture is not so much a representation of the biblical episode as a meditation on its inner significance; and the angel, instead of dramatically arriving with the cup, gently offers Jesus physical and moral support in his agony. As in the *Last Supper*, the composition is slightly asymmetrical, with the figure group on the left dynamically contrasted with the sharply receding background on the right. Yet the internalisation of the spiritual drama is emphasised by the suppression of outward action, and by the effect of fusion between light and shade, figure and landscape. The forms, especially in the background, have become dematerialised; and light and colour are used more for the sake of emotional expression than of description or decoration. Like Titian's *Pietà* and Tintoretto's *Entombment* in their different ways, the picture conveys a deep sense of the suffusion of the material world with divine mystery.

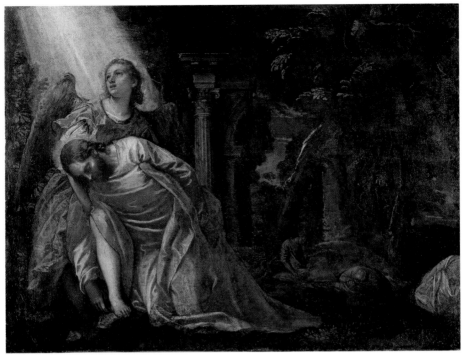

186 Veronese. *Agony in the Garden* (*c*.1582–3). Canvas, 80 × 108 cm. Milan, Brera.

The Painters of the Doge's Palace

Throughout the Renaissance period, the decoration of the many council chambers of the Doge's Palace had provided a constant and prestigious source of employment for Venetian painters; and most of the leading figures had worked there, from the Bellini brothers to Carpaccio, Alvise Vivarini and Giorgione, and from Titian to Pordenone, Giuseppe Salviati, Schiavone, Tintoretto and Veronese. Of all these, only the last two were still active at the time of the two disastrous fires of 1574 and 1577 (pp. 21, 23); and both were immediately put in charge of the enormous task of replacing what had been destroyed. The most distinguished members of the large team of painters who subsequently also participated in the redecoration were Palma Giovane, great-nephew of Palma Vecchio; Francesco Bassano, son of Jacopo; and the leading Roman painter, Federigo Zuccari.[73]

255

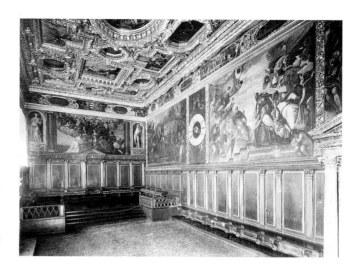

187 Venice, Doge's Palace. View of Collegio with votive pictures by Veronese (above the ducal throne) and Tintoretto.

The acreage of painted canvas that was required, and the speed with which the government wanted it to be completed, inevitably took its toll on quality, and much of the late sixteenth-century decoration of the Doge's Palace is undeniably monotonous. An outstanding exception to this generalisation, however, is represented by the Sala del Collegio (Pl. 187), a room used chiefly for the ceremonial reception of foreign ambassadors, and which before the fire of 1574 had apparently been hung with ducal votive pictures in the tradition of Giovanni Bellini's *Votive Picture of Doge Agostino Barbarigo* (Pl. 74) (pp. 22–3). After the installation of a characteristically splendid ceiling by Veronese in 1577, the walls were similarly decorated with a series of five votive pictures, the finest of which, Veronese's *Votive Picture of Doge Sebastiano Venier* (*c*.1581–2) was painted for the field opposite the entrance above the ducal throne. Doge Venier, who had died in 1578 after reigning for only one year, had been a commander of the Venetian fleet at the victory of Lepanto in 1571 (p. 186); and he accordingly wears armour under his ducal robes, while the sea battle is represented in the background. His kneeling figure is accompanied by an unusually large cast, including St Justina, the winged Lion of St Mark and the allegorical figures of Faith and Venice, as well as St Mark himself; and as in innumerable Counter-Reformation altarpieces, Christ (in the aspect of the Salvator Mundi rather of the more traditional Child with his Mother) appears not on a throne, but in clouds of glory populated by angels. As was appropriate for the painting in its conspicuous position,

256

the unusually elaborate iconography would have been devised to insist that it commemorated not just the personal achievements of Venier, but the glorious contribution of the Venetian Republic to the cause of the Catholic faith. Significantly, the other four votive pictures in the Collegio, all by Tintoretto and his assistants, are all more traditional in their content, though predictably not in their compositions. In the *Votive Picture of Doge Niccolò da Ponte*, for example (Pl. 188), the reigning doge is presented to the Virgin and Child by his patron saints, as in Bellini's Barbarigo picture of a century earlier. But the kneeling doge is the only figure to remain earthbound, and the saints swim or float through the cloud-filled air, while child-angels swirl acrobatically around them.

In keeping with their status as joint leaders of Venetian painting, Tintoretto and Veronese were also awarded the commission, together with the newcomer Palma Giovane, to paint the three principal fields of the enormous new ceiling of the Sala del Maggior Consiglio (Pl. 19). While Tintoretto's contribution is decidedly disappointing, that by Veronese depicting the *Triumph of Venice* (Pl. 189) is an example of magniloquent

188 Jacopo and Domenico Tintoretto. *Votive Picture of Doge Niccolò da Ponte* (*c.*1581–4). Canvas, 575 × 420 cm. Venice, Doge's Palace.

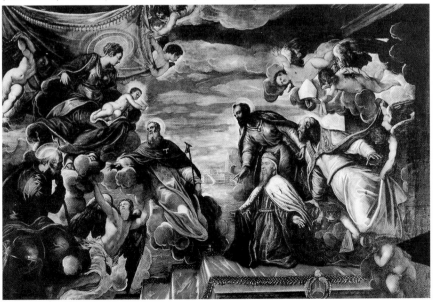

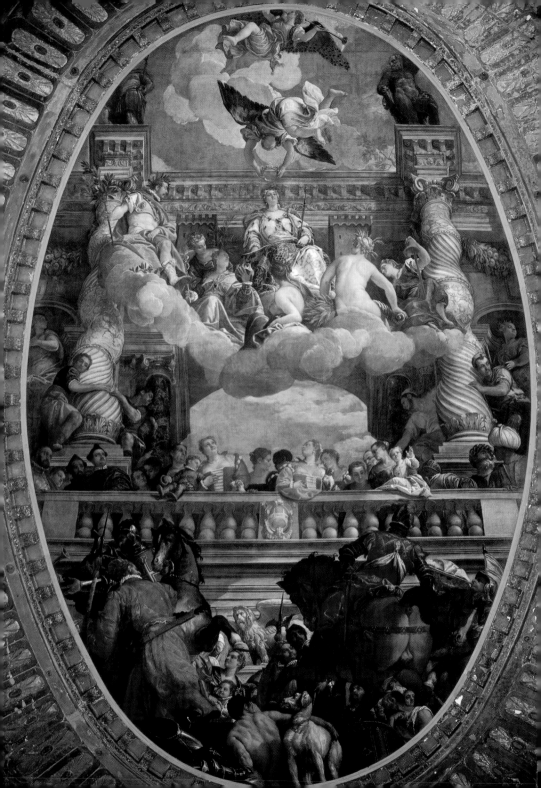

190 Palma Giovane. *Venice crowned by Victory* (*c.*1578–9). Canvas, 940 × 580 cm. Venice, Doge's Palace.

political propaganda at its best, and demonstrates the painter's ability to make use of extensive workshop assistance without excessively compromising the quality of the result. At the summit of the hierarchically ordered, architecturally structured composition, replete with festive balustrades cornices and statues, sits the matronly personification of Venice, admired by a group of virtues, and crowned by a flying victory. Symbolic of her wisdom is the pair of huge columns, which spiral like those of the palace of Solomon. Below the allegorical figures on clouds is a representative group of happy and prosperous upper-class Venetians, including prelates, while at the bottom, among the soldiers, is a group of poorer, but still happy Venetian subjects. The pendant canvas by Palma (Pl. 176) represents a very similar theme, and likewise shows the enthroned figure of Venice being crowned by a winged victory. But here the emphasis is less on the blessings of peace than on the military power of the Republic,

189 Veronese. *Triumph of Venice* (*c.*1579–82). Canvas, 904 × 580 cm. Venice, Doge's Palace.

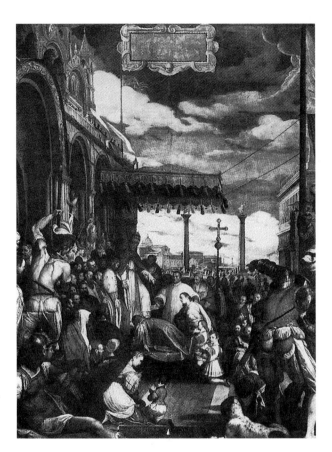

191 Federigo Zuccari. *Barbarossa kneeling before Pope Alexander III* (1582). Canvas, 575 × 420 cm. Venice, Doge's Palace.

to which defeated nations, represented by chained and naked captives, must pay homage.

Palma's *Venice crowned by Victory* was one of his first major commissions and, as well as showing a strong influence of Tintoretto in its impetuous movement and strong contrasts of light and shade (and perhaps also of Veronese in the brocaded figure of Victory), it reflects the experience of seven years spent in Rome, where he was particularly receptive to the art of Taddeo and Federigo Zuccari. Rather un-Venetian, and closer to the Roman late Mannerism of the Zuccari are the hardness of the surfaces, cool colour range, and especially the very pronounced draughtsmanship. Three or four years later Federigo himself came to Venice, and was commissioned to paint *Barbarossa kneeling before the Pope* (Pl. 191), one

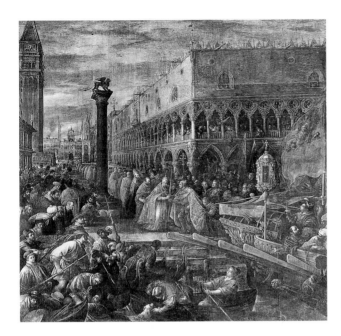

192 Francesco
Bassano. *Donation
of the Sword*
(*c*.1582–7).
Canvas, 575 ×
575 cm. Venice,
Doge's Palace.

of the ideologically most important fields of the *Story of Alexander III* cycle which, as before the fire, constituted the principal decoration of the walls of the Sala (cf. pp. 22, 81–4). According to an early seventeenth-century source,[74] Zuccari represented the scene from the same viewpoint as its predecessor by Titian, with San Marco on the left, the Library on the right, and a view over the water to S. Giorgio Maggiore beyond; and as well as following the Venetian tradition for topographical exactitude (p. 83), the painter played to his local audience by making it appear that the emperor was kneeling as much before the doge as before the pope. But Zuccari made no attempt to imitate Venetian colour, and the emphatically sculptural character of the figures that loom in the foreground suggests that, like Salviati and Vasari more than a generation earlier, the central Italian visitor meant to provide the Venetians with a demonstration of the superiority of central Italian *disegno*.

Another contribution to the *Story of Alexander III* cycle, Francesco Bassano's *Donation of the Sword* (Pl. 192) is demonstrably based on its predecessor by Gentile Bellini, since the lost work is recorded both in a drawing (Pl. 60) and in the description by Vasari (p. 83). Before settling in Venice a few years previously, however, Francesco's main activity had

been as an assistant to his father as a painter of genre pictures and genre-like details in modest-sized altarpieces; and in the *Donation* he still seems less interested in the grand, ceremonial aspect that was so important for the political message, than in the comic business in the left foreground, where a man and his dog have fallen into the water and are struggling to return to the boats. As in the late works of Jacopo, brilliant highlights are contrasted with dark shadow; but Francesco's brushwork lacks the transfiguring magic of that of his father, and the effect remains prosaic and somewhat laboured.

Francesco's transfer from provincial Bassano del Grappa to the capital in 1578 was almost certainly motivated by the desire to exploit the opportunities presented by the fire of 1577 in the Sala del Maggior Consiglio. Similarly, Federigo Zuccari, despite the fact that he already held a leading position in the major centre of Rome, was evidently sufficiently attracted by the new opportunities to undertake the visit to Venice. He had already spent two or three years in the city two decades previously, when he was invited by the Romanophile Giovanni Grimani, patriarch of Aquilea, to complete the decoration of his family chapel at S. Francesco della Vigna after it had been left unfinished by the Michelangelesque Battista Franco (Pl. 25). During that earlier visit in 1563–5, Zuccari also lost one, and perhaps two important commissions to Tintoretto. As well as being one of the unsuccessful competitors for the *albergo* ceiling at the Scuola di S. Rocco (p. 229), Zuccari seems to have been invited by the Venetian government to replace the badly decayed *Coronation of the Virgin* by the fourteenth-century painter Guariento above the ducal throne in the Sala del Maggior Consiglio (p. 21; cf. Pl. 20); but there is evidence to suggest that Tintoretto contested the invitation and drew up a design of his own, causing the government to commission neither painter, and to postpone the project.[75] Then after 1577, although Guariento's fresco was not in fact totally destroyed by the fire, its replacement finally became imperative; and in 1582 a competition was set up for the prestigious task of painting what would be the largest easel painting in the world. The competitors included Veronese, Tintoretto, Francesco Bassano and Palma Giovane; and the return of Federigo Zuccari to the city at this very time suggests that he, too, hoped to recapture the commission that had eluded him in 1563–5. Joint winners in the competition were Veronese and Francesco, perhaps as a result of a bureaucratic compromise that turned out to suit neither party; in any case, when Veronese died in 1588 he had not yet apparently even begun work. Tintoretto then finally managed to persuade the government to grant him rather than Francesco the com-

mission he had lusted after for nearly thirty years, and his gigantic *Paradise* was probably completed two years before his own death in 1594. Executed in large part by his son Domenico, and monotonous in much of its pictorial handling, it is nevertheless impressively majestic in conception, and represents a not unworthy attempt to provide a Venetian counterpart to the vast escatological vision of Michelangelo's *Last Judgement* in the Sistine chapel.

After the passing of Veronese and Tintoretto, and also in 1592 of Francesco Bassano, the uncontested leader of Venetian painting was Palma Giovane. But although Palma was to retain this position of leadership well into the seventeenth century, and was to remain highly, even obsessively productive, it is arguable that all his best work had already been accomplished by 1590. At the beginning of his most felicitous decade, the 1580s, he developed from the still relatively Roman style of the *Venice crowned by Victory* to one involving a self-conscious application of central Italian *disegno* to a synthesis of elements drawn in varying proportions from Titian, Tintoretto and Veronese. Characteristic of this eclectic manner, and characteristic also fo Palma's lifelong involvement with the needs of Counter-Reformation religion, are a pair of canvases painted in 1581–2 for the chapel of the noble Malipiero family in the parish church of S. Giacomo dell'Orio. In the last quarter of the sixteenth century the practice pioneered by the Scuole del Sacramento of commissioning horizontal narrative scenes for the side walls of their chapels (p. 223), became increasingly widespread; and Palma's canvases, showing scenes from the life of St Lawrence, were similarly intended as iconographic complements and expansions of the image above the altar – in this case a *St Lawrence and Saints* altarpiece, painted about a decade earlier by Veronese. The two scenes – *St Lawrence showing the Roman Prefect the Poor as Beneficiaries* of the Church and the *Martyrdom of St Lawrence* (Pl. 193) are both virtual text-book illustrations of the twin Counter-Reformation themes of charity towards to the poor and the dedication of the Christian life to Christ (cf. Pls 113, 131), and they both reflect very directly the Tridentine emphasis on the didactic function of art. Stylistically, the *Showing the Poor*, as a less dramatic and more courtly event, is relatively close to Veronese, while the more gloomy and tragic *Martyrdom* is closer to Tintoretto. But characteristic of Palma is the new emphasis on disciplined draughtsmanship; and although the colour range has a Venetian warmth, the surfaces remain hard and bland, and lack the suggestive softness intrinsic to Venetian sixteenth-century tradition.

Palma's attempt in the *St Lawrence* pictures, and in other major works

193 Palma Giovane. *Martyrdom of St Lawrence* (1581–2). Canvas, 283 × 490 cm. Venice, S. Giacomo dell'Orio.

of the 1580s such as the cycle of canvases for the Oratorio dei Crociferi, to follow the recipe proposed by Paolo Pino in 1548 of combining the *disegno* of Michelangelo with the *colorito* of Titian (p. 216), produced results that are sometimes strikingly impressive. In the long run, however, the dilution of *colorito* was to prove disastrous, and in a large and ambitious altarpiece of the mid-1590s such as the *Martyrdom of St Catherine* (Venice, Frari), the contrived drama and formal stylisation have become merely tedious. A work such as this marks the beginning of a long decline in Venetian painting that was not to be overcome until the beginnings of the career of Sebastiano Ricci in the 1680s, and the dawn of the silver age of the eighteenth century. It would be kinder, therefore, to the memory of Palma, and perhaps fairer to his considerable artistic qualities, to conclude here with a much smaller and more intimate work, the *Crucifixion* (Pl. 194) of about the same date as the *St Lawrence* pictures. Conceived as a mystical contemplation by the penitent Mary Magdalen on the crucified Saviour in a stormy, nocturnal landscape, the picture is no less reflective than the *St Lawrence* pictures of the religiosity of the period. But unlike them, it is a brilliant essay in Titianism, and much of its expressive force derives from the painter's ability to exploit the technical resources of oil painting. Indeed, in the smouldering intensity of

194 Palma Giovane. *Crucifixion* (*c*.1581). Canvas, 81 × 53 cm. Venice, Ca' d'Oro.

the colour, and in the free and poetically suggestive way in which the paint is brushed onto the rough canvas, the picture confirms Palma's status as the last great painter of Renaissance Venice.

* * *

It is somewhat ironic that Venetian painting should have gone into rapid decline after 1590, for the dominant style of seventeenth-century Europe – the baroque – was deeply indebted to the pictorial tradition that had been developed in sixteenth-century Venice. As early as the late 1570s and early 1580s, the leaders of the anti-Mannerist reform of Italian painting in Bologna, Lodovico and Annibale Carracci, visited Venice to study the works of Titian, Tintoretto and Veronese; and at the very beginning of the new century, the young Rubens made a similar visit, with equally important consequences for the formation of his mature style. Around the same time, Venetian pictures were beginning to arrive in quantity at what were to become the major centres of European painting of the seventeenth century.[76] As has been seen (p. 110), works by living Venetian painters had already begun to reach the courts of northern Italy by the later fifteenth century; and the dissemination process increased dramatically during the course of the sixteenth, when Titian sent his pictures to the courts of Ferrara, Mantua and Urbino, Rome and Augsburg, Brussels and Madrid. Taking advantage of the raised international profile of the Venetian school, Paris Bordone similarly worked for the French court, and Tintoretto and Veronese for the Spanish and Austrian Habsburgs. But the earlier seventeenth century saw a spectacular increase in the international demand for pictures from what was already regarded as the golden age of Venetian painting, prompting the dispersal throughout Europe of many of the rich collections hitherto confined to Venice and north-eastern Italy. The high esteem in which the art of Renaissance Venice was held by princely collectors of the period – prominent among whom was Charles I in England, who bought virtually the entire accumulated collection of the dukes of Mantua in the later 1620s – is well illustrated by one of several portrayals by David Teniers of the Italian gallery belonging to the Archduke Leopold Wilhelm in Brussels (Pl. 195). Indeed, the pictures displayed on the walls of the gallery constitute a virtual cross-section of representative works by all the major Venetian masters, from a Bellini *Madonna* to a fragment of Antonello's S. Cassiano altarpiece (Pl. 56), from Giorgione's *Three Philosophers* to a *Virgin and Child with Saints in a Landscape* by Palma Vecchio, and from portraits and mythologies by Titian (including a version of the *Danaë*) to religious narratives by Tintoretto and Veronese.[77] With the increasingly wide dispersal of Venetian pictures from their original homes to the royal collections of London, Paris and Madrid, and to the buoyant art market of Amsterdam, Venetian painting also began to make a vital and widespread impact on artistic practice. During the sixteenth century, exported Venetian pictures

195 David Teniers the Younger. *Archduke Leopold Wilhelm in his Gallery of Italian Painting in Brussels* (1651). Brussels, Musées Royaux des Beaux-Arts.

did little to fructify the soil on which they landed, largely because many of their destinations were not themselves major creative centres. By contrast, virtually every major painter of the seventeenth century – not just the early visitors Annibale Carracci and Rubens, but also Velázquez and Poussin, Van Dyck and Rembrandt – was in his different way profoundly responsive to the art of the great Venetians, sometimes before or without ever setting foot in Venice itself. Well before 1650, despite the earlier attempts by Vasari to limit Venetian painting to the margin of Italian art, the characteristic Venetian qualities of *colorito* – colour, light and expressive brushwork – had become central to a pictorial tradition that now embraced all Europe.

Notes

For further references to monographs and monographic articles, see Appendix of Biographies

Introduction

1 For a recent account of Titian's visit to Rome: Zapperi (1990).
2 For the general characteristics of Venetian painting: Bialostocki (1980); Rosand (1982), pp. 15–26.
3 For the sculptural sources of the *Danaë*: F. Valvanover in *Titian: Prince of Painters* (1990), pp. 267–9, with references. Michelangelo's *Leda* was painted in 1530 for the Duke of Ferrara; the National Gallery picture is often, but inconclusively, attributed to Rosso Fiorentino.
4 Vasari (1568; ed. 1878–85), VII, p. 446–8; Eng. trans. (1965), p. 455.
5 Schulz (1968), pp. 15–17; D. McTavish in *Da Tiziano a El Greco* (1981), pp. 86–7; Corti (1989), pp. 42–3.
6 *The Memoirs . . .* (ed. 1969), II, pp. 489–90.
7 For orientalism in Venetian painting: Raby (1982).
8 For fifteenth-century Flemish painting and Venice: Robertson (1968), pp. 8–9, 56–8; Meiss (1976), pp. 19–35; Campbell (1981).
9 For German prints and Venice: Pignatti (1973).
10 For the export of Venetian altarpieces: Humfrey (1993).
11 For painters' materials: Lazzarini (1987); Dunkerton (1991), p. 183; Hall (1992), pp. 208–9.
12 For the Venetian constitution: Chambers (1970), pp. 73ff; Lane (1973), pp. 253ff.
13 For the Myth of Venice: Logan (1972), pp. 1ff; Gilmore (1973); Lane (1973), pp. 253–8; Muir (1981), pp. 13ff.
14 For the cult of St Mark in Venice: Muir (1981), pp. 78–92, with references.
15 For the Sala del Maggior Consiglio and its decoration: Sinding-Larsen (1974); Wolters (1983), pp. 164ff; Brown (1988), pp. 272–9; Humfrey (1990); Pignatti in Franzoi, Pignatti and Wolters (1990), pp. 233ff.
16 Translated by J. Fletcher from Sansovino (1561) in Chambers and Pullan (1992), p. 392.

17 For the series of ducal portraits: Wolters (1983), pp. 84–6; Meyer zur Capellen (1985), pp. 62–3.
18 For the original placing of this picture in the Doge's Palace rather than in the Palazzo Barbarigo, and for the iconographical implications of this placing: Roeck (1991). For the votive picture as a type: Sinding-Larsen (1974); Wolters (1983), pp. 92–135.
19 For religious life in Renaissance Venice: Chambers (1970), pp. 109–22; Prodi (1973); Muir (1981).
20 *The Memoirs . . .* (ed. 1969), II, p. 490.
21 For Venetian altarpieces: Humfrey (1993).
22 For Venetian society: Logan (1972), pp. 24ff; Pullan (1973–4).
23 For the Venetian *scuole*: Pullan (1971), pp. 33ff; Pullan (1981). For their patronage of art: Logan (1972), pp. 202–12; Pignatti (1981); Humfrey and Mackenney (1986); Brown (1988); Humfrey (1993), pp. 110–21; Hollingsworth (1994), pp. 120–35.
24 Sansovino (1581; ed. 1663), p. 282.
25 For Vasari and Venetian painting: Hope (1983).
26 Vasari (1568; ed. 1878–85).
27 Frimmel (1896).
28 Sansovino (ed. 1561); idem (ed. 1663).
29 Ridolfi (1648; ed. 1914–24).
30 Ridolfi (1642; ed. 1984).
31 Boschini (1660; ed. 1966); idem (1664).
32 See Hope (1983).

1 Early Renaissance (1440–1500)

1 For Castagno in Venice: Hartt (1959); Merkel (1973).
2 For Donatello in Padua: Pope-Hennessy (1993), pp. 194–251.
3 For Verrocchio's visit of 1469: Smyth (1980); Covi (1983).
4 Vasari (1568; ed. 1878–85), II, p. 568. Cf. also Ridolfi (1648; ed. 1914–24), I, pp. 64–5.
5 For Gentile and Venice: Christiansen (1982), pp. 3, 10–11, 138–40; for the *Coronation*, painted for S. Francesco, Fabriano: ibid., pp. 18–19, 93–6.
6 The *St Michael* was probably the central panel of an altarpiece for S. Michele in Padua. For a reconstruction: Sandberg-Vavalà (1947).
7 The chronology of Jacopo Bellini's works given here follows that established by Degenhart and Schmitt (1990).
8 Edgerton (1966); Christiansen (1987), p. 170.
9 Degenhart and Schmitt (1990).
10 For this topic: Saxl (1935); Degenhart and Schmitt (1990), II/5, pp. 192–233; Brown (1992).
11 For a recent survey: De Niccolò Salmazo (1990).
12 Pope-Hennessy (1993), pp. 238, 244.
13 Humfrey (1993), pp. 177–80, 341, with references.
14 Brown (1988), pp. 266–70.
15 The chronology fo Giovanni Bellini's earlier career given here follows Lucco

(1990). This modifies and updates the lucid accounts given in Robertson (1968) and Wilde (1974).

16 For the possibility that a now-dismembered pentaptych by Bouts of *c*.1450 was in Venice at an early date: Humfrey (1993), p. 159.

17 HAEC FERE QUUM GEMITUS TURGENTIA LUMINA PROMANT/BELLINI POTERAT FLERE IOHANNIS OPUS ('When these swelling eyes evoke groans this very work of Giovanni Bellinin could shed tears'). See Robertson (1968), pp. 54–5; Belting (1985).

18 Goffen (1989), p. 43.

19 Humfrey (1993), pp. 184–8, 343–4.

20 See the recent technical analysis in *La Pala Ricostituita* (1988), pp. 88–93.

21 'Alcuni credono che el sii stato di mano de Antonello da Messina, ma li più, e più versimilmente, l'attribuiscono a Gianes, ovvero al Memelin.' Frimmel (1896), pp. 98–100; Chambers and Pullan (1992), p. 427.

22 For the reconstruction of the S. Cassiano altarpiece: Wilde (1929); for the modification: Humfrey (1993), pp. 196–7.

23 For the reconstruction: Sponza (1987). For the S. Giobbe altarpiece generally: Shearman (1992), pp. 94–9; Humfrey (1993), pp. 203ff, 347, with references.

24 Hall (1992), p. 82.

25 Meiss (1964); Turner (1966), pp. 59–65; Fletcher (1972); Fleming (1982).

26 Brown (1988); Humfrey (1990); Ames-Lewis (1994).

27 Rosand (1982), pp. 16–20.

28 Vasari (1568; ed. 1878–85), III, p. 157; (ed. 1987), pp. 62–3.

29 Humfrey (1994).

30 See Lucco (1983), pp. 460–2. Cima's altarpiece is also likely to have been influenced by Perugino's recent altarpiece for S. Giovanni in Monte, Bologna (now Pinacoteca Nazionale). For the presence of Perugino in Venice in 1494–5 and his impact on local painters: Smyth (1980), pp. 71–3.

31 Roeck (1991), p. 44.

32 Wilde (1974), p. 40.

33 Sansovino (1581; ed. 1663), p. 325.

34 For early references to Jacopo Bellini's painted portraits, none of which survives: Joost-Gaugier (1974).

35 Vasari (1568; ed. 1878–85), III, p. 168; (ed. 1987), p. 68.

36 Dülberg (1990).

37 No. 696, as Follower of Jan van Eyck; the sitter, who later became doge, is identified by an inscription. The portrait was presumably painted when Barbarigo was consul in London in 1449, and was then brought back to Venice.

38 'Hanno gran forza et gran vivacità, et maxime in li occhi.' Frimmel (1896), p. 80. See also Pope-Hennessy (1966), pp. 60–3; Wright (1987).

39 'Per far la lingua mia pronta parlare.' The portrait is possibly identical with one now in the Art Museum, Denver: Lauts (1962), pp. 241, 258; Humfrey (1991), p. 56.

40 Campbell (1990), p. 204.

41 Ibid., p. 30.

42 Translation by J. Fletcher from Sansovino (1561) in Chambers and Pullan (1992), p. 392.

43 Gibbons (1965).
44 Rosand (1982), pp. 7–14.
45 Favaro (1975); Rosand (1982), pp. 7–14.
46 Sansovino (1581; ed. 1663), p. 325. For 'ducal' sleeves: Newton (1988), pp. 12, 23, 87–8.
47 Document quoted in Eisler (1989), p. 531.
48 For documents of Gentile Bellini's biography: Meyer zur Capellen (1985), pp. 106–20; for the brothers' annual salary, or *sansaria*: C. Hope in *Tiziano e Venezia* (1980), pp. 301–5.
49 See Humfrey (1983), pp. 127–8; and Muraro (1966), pp. 67–70 respectively.
50 'Hÿ pin jch ein her, doheim ein schamarotzer.' Rupprich (1956), p. 59.
51 Eisler (1989), pp. 23, 515. It should be said that 'genius' is a somewhat misleading translation of the term *ingenium*, or *ingegno*, which in the Renaissance period carried the sense of high innate talent rather than of transcendent genius in the modern or romantic sense; even so, Jacopo is implicitly implying that his creative powers involve much more than mere acquired skill. See Kemp (1989).
52 For contemporary praise of Jacopo Bellini: Joost-Gaugier (1974). Sonnets and epigrams in praise of Gentile and Giovanni Bellini are usefully transcribed in Meyer zur Capellen (1985), pp. 121–2. For humanist friends of the brothers: Fletcher (1988).
53 Fletcher (1972), p. 209.
54 For collecting in late fifteenth-century Venice: Anderson (1989).

2 High Renaissance (1500–1540)

1 Vasari (1568; ed. 1878–85), IV, pp. 92–3; (ed. 1965), p. 272.
2 See the various contributions to the exhibition catalogue *Leonardo and Venice* (1992).
3 Humfrey (1993), p. 353, with references.
4 Pignatti (1973).
5 Howard (1975), pp. 10ff.
6 Frimmel (1896), p. 106. For modern interpretations of the *Tempest*, see the detailed survey of opinions in Settis (1978).
7 Hale (1988).
8 Document in Pignatti (1969), p. 169.
9 See especially Wittkower (1963); Rosand (1988). For a different view, which puts Titian rather than Giorgione at the centre of the pastoral tradition in Venetian painting: Rearick (1992).
10 Büttner (1986).
11 See especially Sheard (1983); Anderson (1984).
12 Vasari (1568; ed. 1878–85), VII, pp. 427–8; (ed. 1965), pp. 443–4.
13 See S. Moschini Marconi in *Giorgione e Venezia* (1978), pp. 102–6.
14 For the Giorgionesque revolution in portraiture: Anderson (1979); Sheard (1992); Shearman (1992), pp. 141–6.
15 For the dating and interpretation: Lucco (1989); A. Ballarin in *Le Siècle de Titien* (1993), pp. 702–6.
16 Fletcher (1989).

17 Cropper (1986).
18 Vasari (1568; ed. 1878–85), VI, p. 98; (ed. 1965), pp. 275–6. A similar picture by Giorgione, this time representing St George in armour, is described by Paolo Pino in 1548 (cf. p. 216).
19 The original fresco, detached from its original wall in an already ruinous state in 1938, is now exhibited in the Ca' d'Oro.
20 Meiss (1966).
21 Motzkin (1990).
22 For a recent argument in favour of Titian, together with a detailed survey of the picture's attributional history: A. Ballarin in *Le Siècle de Titien* (1993), pp. 340–8.
23 For the following argument in favour of Giorgione, see also Rosand (1988). A *terminus ante quem* of 1513 for the *Three Ages* was provided by Longhi (1946; ed. 1985), p. 233, n. 115, who pointed to an echo of the sleeping children in Romanino's S. Giustina altarpiece (Padua, Museo Civico) of that year.
24 Joannides (1992).
25 Wilde (1974), p. 104.
26 Goodman-Soellner (1983); A. Ballarin in *Le Siècle de Titien* (1993), pp. 361–3, with references. For this category of image generally: Rogers (1994).
27 Joannides (1991). For the date, see above, n. 23.
28 Joannides (1990), pp. 26–7.
29 For the x-rays: Robertson (1971); Brigstocke (1993), pp. 172–3. For Titian's technique in general: Dunkerton (1994).
30 Dülberg (1990), pp. 144, 238–9, with references.
31 For the *Preaching*: Humfrey (1985); Brown (1988), pp. 203–9, 291–5, with references; Dempsey (1988). For the recent cleaning: Tardito (1988).
32 For the *Feast of the Gods*, see most recently Bull and Plesters (1990); Colantuono (1991); and several of the contributions to the volume *Titian 500*.
33 But for a recent alternative reading, which identifies the figures on the extreme right as the fertility god Liber and the sleeping Venus, see Anderson (1994).
34 Fletcher (1988).
35 Van der Sman (1986).
36 For the *Assunta*: Gould (1972) (I); Rosand (1982), pp. 51–8; Howard (1985); Goffen (1986), pp. 73–106; Humfrey (1993), pp. 301–4, with references.
37 For instance, by Steer (1970), pp. 7–10.
38 As represented by a sketch in the Ashmolean Museum, Oxford; Shearman (1961) has suggested that this is connected with Raphael's unfulfilled project for the altarpiece of the Chigi chapel in S. Maria del Popolo in Rome.
39 Wilde (1974), p. 134; Rosand (1982), pp. 54–8.
40 Rosand (1972), p. 530; Holberton (1986); Fehl (1992), pp. 68–9; Shearman (1992), pp. 256–7.
41 For sculptural borrowings in the *Bacchus and Ariadne*: Sheard (1994).
42 Shearman (1987); idem (1992), pp. 250–8.
43 Lucas and Plesters (1978), pp. 40–4; Dunkerton (1994).
44 For the Ca' Pesaro altarpiece: Rosand (1982), pp. 58–69; Goffen (1986), pp.

107–37; Fehl (1992), pp. 30–43; Shearman (1992), pp. 99–101; Humfrey (1993), pp. 304–8, with references.

45 For the *Death of St Peter Martyr*: Shearman (1992), pp. 209–10, 222–4; Humfrey (1993), pp. 314–16, with references.

46 For the *Presentation*: Rosand (1982), pp. 85–144; Hood (1980); Fehl (1992), pp. 192–7.

47 Gould (1962).

48 Dülberg (1990), pp. 45–8, 280–1.

49 For the *Venus of Urbino*, see most recently Rosand (1994).

50 Frimmel (1896), p. 84; Eng. trans. by J. Fletcher in Chambers and Pullan (1992), pp. 424–7.

51 Ibid.

52 From the girl in the foreground of the *Andrians* (Madrid, Prado).

53 As suggested by C. Gilbert in *Giovanni Gerolamo Savoldo* (1990), p. 43.

54 Economopoulos (1992).

55 S. Béguin in *Le Siècle de Titien* (1993), pp. 428–9.

56 Humfrey (1985); L. Puppi in *Paris Bordon* (1987), pp. 95–108.

57 Gould (1962).

58 Aikema and Meijers (1989), pp. 71–4.

59 Oldfield (1984).

60 Aikema and Meijers (1989), pp. 85–8; Humfrey (1993), p. 78.

61 Pope-Hennessy (1966), pp. 228–31; Shearman (1983), pp. 144–8.

62 For the identity of the sitter and the inscription: Gould (1975), pp. 137–8.

63 Schulz (1968), pp. 14–15, 83.

64 For this work: Douglas-Scott (1988).

65 R. Pallucchini in *Da Tiziano a El Greco* (1981), p. 12.

3 Late Renaissance (1540–1590)

1 *Da Tiziano a El Greco* (1981).

2 *The Memoirs* ... (ed. 1969), II, p. 490.

3 Text in English translation in Klein and Zerner (1966), pp. 120–2.

4 Palumbo-Fossati (1984); Hochmann (1992), pp. 177–85.

5 Frimmel (1896), pp. 84–6. Eng. trans. by J. Fletcher in Chambers and Pullan (1992), pp. 424–7. The Giorgione, the Bonifacio and the Savoldo are all now lost.

6 For Jacopo Contarini as a patron: Logan (1972), pp. 159–60; Hochmann (1992), pp. 252–62.

7 For the taste and patronage of the Grimani family: Logan (1972), pp. 178–9; Perry (1981); Hochmann (1992), pp. 229–42.

8 D. McTavish in *Da Tiziano a El Greco* (1981), p. 83. For the Procurator Bernardo Moro, see also Howard (1975), pp. 148–9.

9 For the Romanophile interests of the Corner family: Howard (1980), p. 154; Hochmann (1992), pp. 220–9.

10 Watson (1978), p. 246.

11 G. Mariani Canova in *Paris Bordon* (1984), p. 108; S. Béguin in *Paris Bordon e il suo tempo* (1987), pp. 9–11.

12 For an iconographical interpretation of the picture and its original companion-piece: Fehl (1992), pp. 167–73.

13 For the decoration of the Reading Room: Schulz (1968), pp. 93–5; A. Paolucci in *Da Tiziano a El Greco* (1981), pp. 287–98; Ruggeri (1984); Hope (1990).

14 For the *Danaë*: Hope (1977); Kahr (1978); Watson (1978); Zapperi (1991); Rosand (1994). For the x-ray: F. Valcanover in *Da Tiziano a El Greco* (1981), pp. 108–9. For Titian and the Farnese family: Robertson (1992), pp. 69–74.

15 For the *Paul III* portrait: Zapperi (1990).

16 For a proposed redating of the Old Testament cycle to the period after 1546: Joannides (1990), pp. 33–4.

17 For Venetian ceiling painting in general: Schulz (1968); for the reconstruction of the Old Testament cycle: ibid., pp. 72–9. For further observations on Titian's ceilings: Echols (1994).

18 For the ideological background: Yates (1975), pp. 1–28; Trevor-Roper (1976), pp. 11–43.

19 Hope (1979).

20 Ibid.

21 Translated by J. Fletcher in Chambers and Pullan (1992), p. 421.

22 Rosand (1972); G. Padoan in *Tiziano e Venezia* (1980), p. 98.

23 Gould (1972) (II), p. 464; Brigstocke (1993), pp. 178–83 with references.

24 F. Valcanover in *Le Siècle de Titien* (1993), pp. 621–2.

25 For the *Pietà*: Bruyn (1973), pp. 306–29; Rosand (1982), pp. 75–84; Fehl (1992), pp. 306–29.

26 For a technical examination of the *Pietà* after its recent cleaning: Nepi Scirè (1987).

27 Barocchi (1962), pp. 92–139, 141–206; Eng. trans, in Pardo (1984) and Roskill (1968) respectively.

28 For general discussions of mid-sixteenth-century art criticism in Venice: Klein and Zerner (1966), pp. 53–69 (with a selection of texts); Roskill (1968); Logan (1972), pp. 129–46; Barasch (1978), pp. 90–134; Barasch (1984); Pardo (1985); Hochmann (1992), pp. 123–46. For further discussions of the *disegno-colorito* controversy, with special reference to relation between theory and practice: Freedberg (1980); Rosand (1982), pp. 15–26.

29 Aretino (ed. 1960); Eng. trans. (1976). For Aretino's art criticism: Land (1986).

30 Letter to Messer Alessandro (Corvino): *Lettere* (ed. 1957), II, pp. 175–7; Eng. trans. (1976), pp. 226–8.

31 Letter to Messer Titian: *Lettere* (ed. 1957), II, pp. 16–17; Eng. trans. (1976), pp. 225–6.

32 Barocchi (1962), p. 127; Pardo (1984), p. 358.

33 Barasch (1978), pp. 95–102, 117–18.

34 Barocchi (1962), p. 131; Pardo (1984), p. 367. As described by Pino, Giorgione's picture was similar but not identical to the one described by Vasari, also in the context of the *paragone* debate (cf. pp. 126–7).

35 Barocchi (1962), p. 145; Roskill (1968), pp. 84–5.

36 Barocchi (1962), pp. 183–5; Roskill (1968); pp. 152–5.

37 Barocchi (1962), p. 186; Roskill (1968), pp. 156–7.
38 Vasari (1568; ed. 1878–85), VII, pp. 446–8; Eng. trans. (1965), p. 455.
39 Vasari (1568; ed. 1878–85), VII, pp. 427–8; Eng. trans. (1965), p. 444.
40 Vasari (1568; ed. 1878–85), VI, p. 587.
41 Boschini (1660; ed. 1966); Sohm (1991).
42 W. R. Rearick in *Jacopo Bassano* (1993), pp. 63–4.
43 Brigstocke (1993), pp. 26–7, with references.
44 Rearick (1984).
45 Rearick (1968).
46 T. Pignatti in Franzoi, Pignatti and Wolters (1990), p. 305; W. R. Rearick in *Jacopo Bassano* (1993), pp. 153–4, n. 335.
47 Rosand (1982), pp. 206–13; Hills (1983). For the broader theme of Venetian chapels of the Sacrament in the sixteenth century: Cope (1979).
48 Gould (1962).
49 Rearick (1984), pp. 303–4.
50 Gould (1972) (III).
51 Ridolfi (1648; ed. 1914–24), II, pp. 21–2; ed. 1985, pp. 25–6.
52 For Tommaso Rangone as a patron of art: Weddigen (1974); Howard (1975), pp. 81–2, 84–7; Hochmann (1992), pp. 187–9.
53 Vasari (1568; ed. 1878–85), VI, pp. 593–4. The anecdote is also recounted by Ridolfi (1648; ed. 1914–24), II, pp. 27–8; ed. 1985, pp. 30–1.
54 Hills (1993); Nichols (1994).
55 For the iconological programme of the Scuola di S. Rocco canvases: De Tolnay (1960); A. Niero in *Da Tiziano a El Greco* (1981), pp. 330–3.
56 For Tintoretto's technique: Plesters and Lazzarini (1976); Plesters (1979).
57 For Marco Grimani and his portrait: Rossi (1974), pp. 108, 113; Shearman (1983), p. 247.
58 For Rudolf II and the arts (without, however, reference to his patronage of Venetian painters): Trevor-Roper (1976), pp. 79–114.
59 Pope-Hennessy (1966), pp. 295–6.
60 For Veronese's ceiling at S. Sebastiano: Schulz (1968), pp. 75–7; Kahr (1970); A. Niero in *Da Tiziano a El Greco* (1981), pp. 327–9.
61 Text in English translation in Klein and Zerner (1966), p. 121.
62 Marinelli (1990).
63 For the Barbaro brothers as patrons of art and arbiters of taste: Hochmann (1992), pp. 242–52, with references.
64 Fehl (1992), pp. 229–31.
65 Gould (1989–90).
66 The text of the interrogation is reproduced in the original in Fehl (1992), pp. 237–40; in English translation in Klein and Zerner (1966), pp. 129–32, and in Chambers and Pullan (1992), pp. 232–6.
67 For the lost Sidney portrait: Muraro (1990).
68 T. Pignatti in *Le Siècle de Titien* (1993), pp. 551–2, with references.
69 Kaplan (1987).
70 Gilbert (1974), pp. 396–400; Nichols (1994).
71 For the heightened religiosity of Veronese's works of the 1580s: Rearick (1991).
72 For Lando and his collection: Hochmann (1992), pp. 199–201.

73 For the later sixteenth-century pictorial decoration of the Doge's Palace: Sinding-Larsen (1974); Wolters (1983); T. Pignatti in Franzoi, Wolters and Pignatti (1990), pp. 227ff.
74 Wolters (1983), p. 179.
75 Schulz (1980).
76 For the legacy: Haskell (1983).
77 Most of the pictures represented, including those by Antonello, Giorgione and Palma, are now in the Kunsthistorisches Museum in Vienna. Bellini's Booth *Madonna*, however, is now in the National Gallery of Art, Washington, while Titian's *Death of Actaeon* – clearly visible at the top right – is now in the National Gallery, London.

Appendix of Biographies

Further bibliographical references are provided in the Notes to the Text.

ANTONELLO DA MESSINA c.1430–79

Although based principally in his native Messina, Antonello is known to have made two extensive visits to the Italian mainland, and he may well also have made others. According to an early source he was trained under Colantonio in Naples, presumably in the late 1440s or early 1450s. Documents record a number of works painted in Sicily between 1457 and 1465, but none of these has survived, and his earlier career remains obscure. In particular, it is uncertain when and where he acquired his mastery of the Eyckian technique of oil painting, with which his name has been closely associated since the time of Vasari. An absence of documents recording his presence in Sicily between 1465 and 1471 has led scholars to suppose that he spent some or all of this period in central and/or northern Italy, and it is possible that he made an initial visit to Venice at this time. Between 1471 and 1474 he executed a number of important commissions in Sicily; but again it is possible that some of the smaller pictures datable to this phase were painted at long range for Venetian patrons. He was certainly present in Venice in 1475 and early 1476, when he painted his now-fragmentary altarpiece for S. Cassiano (Pl. 56); several pictures dated to these two years, therefore, including versions of the *Crucifixion* in Antwerp (Koninklijk Museum voor Schone Kunsten) and London (Pl. 55), and portraits in the Louvre (Pl. 77) and Turin (Galleria Sabauda), were presumably also painted during the Venetian sojourn. Antonello seems to made a brief visit to the court of Galeazzo Maria Sforza in Milan in the summer of 1476, but by September of that year he was back in Messina. There is evidence, however, that he continued to send pictures to Venice during the last three years of his life: these include the *Portrait of a Man* of 1478 (Berlin, Staatliche Museen), and probably also the *St Sebastian* (Dresden, Gemäldegalerie), identifiable as the wing of a triptych once in the Venetian church of S. Giuliano.

BIBL: *Antonello da Messina* (1981); Sricchia Santoro (1986); *Antonello da Messina* (1987); Humfrey (1993); Thiébaut (1993).

BASSANO, FRANCESCO (Francesco Dal Ponte the Younger) 1549–92

Son of Jacopo Bassano, Francesco was the principal assistant in the family work-shop from the early 1560s, and seems to have played a particularly important role in the execution and replication of his father's increasingly popular pastoral genre pictures. In 1578 he moved to Venice, where he was immediately commissioned to paint four battle scenes for the new ceiling of the post-fire Sala del Maggior Consiglio in the Doge's Palace. In the 1580s he contributed to the history cycle in the Sala (Pl. 192), as well as to other major decorative projects in Venice, Brescia and Bergamo, while also continuing to practise the family specialisation in genre pictures for collectors. In 1591 he attempted suicide, and later died from his injuries.

BIBL: Arslan (1960).

BASSANO, JACOPO (Jacopo Dal Ponte) c.1510–92

Named after his native town on the Venetian *terraferma*, Jacopo Bassano was the son of a minor local painter, Francesco Dal Ponte the Elder, from whom he received his initial training. After a brief period as an assistant to Bonifacio de' Pitati (c.1533–5), Jacopo returned to Bassano, and became a leading partner in the busy family workshop. There he remained for the rest of his long career, assisted from the 1570s by his three painter sons, Francesco the Younger, Leandro and Girolamo. Despite his choice of a small and provincial place of residence, Jacopo's style never ceased to evolve over a period of nearly six decades; and despite his specialisation in subjects that called for rustic figures and settings, his art was conceptually and technically highly sophisticated. Although he received few commissions for public buildings in Venice, he enjoyed considerable success with Venetian collectors, especially from the mid-1560s onwards. The day-to-day conduct of the Bassano workshop between 1525 and c.1555 is minutely documented in an account-book only recently published (Muraro, 1992).

BIBL: Arslan (1960); Freedberg (1971; ed. 1975), pp. 540–8; Pallucchini (1982); *Jacopo Bassano* (1993).

BELLINI, GENTILE c.(?)1435–1507

Like that of his younger brother, the birthdate of Gentile is unknown, but it, too, may have been rather later than has usually been supposed (see Biography of Giovanni Bellini). Presumably trained by his father Jacopo, Gentile collaborated on the execution of the Gattamelata triptych of 1459/60 (cf. Pl. 42), and he continued to work as an assistant to Jacopo during the earlier 1460s. Gentile's earliest known independent work, the badly damaged *San Lorenzo Giustinian* of 1465 (Venice, Accademia) already shows the sharp linear precision that was to remain a hallmark of his style, and an equally characteristic use of canvas as a support. From this time onwards, until his death more than forty years later, Gentile enjoyed great official success in Venice. In the mid-1460s he painted a pair of organ shutters for the

ducal basilica of San Marco (cf. Pl. 46); in 1466 he was commissioned to continue the cycle already begun by Jacopo in the chapter hall of the Scuola di S. Marco (destroyed by fire in 1485); and in 1474 he was awarded the commission that was to constitute the main part of his life's work: the redecoration of the Sala del Maggior Consiglio in the Doge's Palace, with scenes from the so-called *Story of Alexander III*, accompanied by a series of portraits of the Venetian doges from the foundation of the Republic onwards (all destroyed by fire in 1577). Public recognition of his abilities as a portrait painter resulted in his inclusion in a diplomatic mission to Constantinople in 1479; and it was here that he painted the portrait *Sultan Mehmet II* (1480; London, National Gallery). Further commissions in Gentile's later life included his contributions to the *Miracles of the True Cross* cycle for the *albergo* of the Scuola di S. Giovanni Evangelista (1496, 1500, 1501; cf. Pl. 61), and the *Life of St Mark* cycle for the *albergo* of the Scuola di S. Marco (cf. Pl. 11). The loss of so much of his output makes it difficult to trace a coherent stylistic development, or to assess Gentile's true historical importance. But there is evidence that despite his lasting success in official circles, certain of his more discriminating contemporaries shared the modern perception that his talents were greatly inferior to those of his brother Giovanni.

BIBL: Meyer zur Capellen (1985); Brown (1988).

BELLINI, GIOVANNI *c.*(?)1438−1516

Son of Jacopo Bellini and younger brother of Gentile, Giovanni was also brother-in-law from 1453 of Andrea Mantegna. The birthdate of neither of the two brothers is known, and the evidence provided by contemporary documents and early sources is inconclusive. In recent years critics have tended to assume that Gentile was born about 1431 and Giovanni about 1433; but as argued by Lucco (1990), both dates may be too early by four or more years. In 1459/60 Giovanni co-signed with his faher and brother the altarpiece for the Gattamelata chapel in the Santo in Padua; and although his earliest independent works are datable to about this time, he apparently continued to act as an assistant to his father during the earlier 1460s. His first major independent commission is likely to have been the *St Vincent Ferrer* polyptych (Venice, SS. Giovanni e Paolo), datable on external grounds to *c.*1465−8. Already by the beginning of the 1470s he must have been generally recognised as the city's leading painter of altarpieces and smaller devotional works; and official recognition of his pre-eminent position in all branches of Venetian painting came in 1479, when he was appointed to join Gentile on the history cycle in the Sala del Maggior Consiglio. Partly in response to the burden of work imposed by this appointment, Giovanni came to employ numerous assistants; and by about 1500 he stood at the head of what was probably the largest painter's workshop in fifteenth-century Italy. Despite the artistic revolution created by Giorgione during the first decade of the sixteenth century, Bellini continued to dominate artistic life in Venice up to the time of his death.

One of the most striking aspects of Bellini's genius was his ability to respond creatively to a succession of quite diverse artistic stimuli – including those of his

father Jacopo, early Renaissance Florence, Flemish painting, Donatello, Mantegna, Antonello, Leonardo, Giorgione – while remaining true to a sense of aesthetic order and to an inner spiritual vision that were entirely his own. These external stimuli seem to have been absorbed entirely within his native city and the surrounding region; indeed, apart from a probable visit to the Marches in the early 1470s, he may never have travelled outside the Veneto. Virtually all his most important works were painted for the churches, confraternities and council chambers of Venice; and it is likely that the majority of his smaller devotional woks and portraits were similarly painted for local Venetian rather than foreign customers. But the number of requests from foreign patrons grew with his international fame; and the best-documented episode of his career concerns a protracted attempt by Isabella d'Este, marchesa of Mantua, to persuade him to paint a secular allegory for her humanist *studiolo* (1496–1505). For reasons that are not entirely clear, Bellini was reluctant to fulfil this commission, and Isabella finally had to be content with a small *Nativity* for her bedroom (lost). Yet the painter was clearly not adverse to pagan subjects as such, and in 1514 he painted a large mythology, the *Feast of the Gods* (Pl. 104), for Isabella's brother Alfonso, duke of Ferrara. Furthermore, for a Venetian painter of his generation, Bellini was unusually well acquainted with leading humanists and antiquarians, such as Bernardo and Pietro Bembo, Felice Feliciano, Leonico Tomeo and Raffaello Zovenzone (Fletcher, 1988); and these contacts are reflected in numerous classicising motifs and references in the religious works.

BIBL: Robertson (1968); Wilde (1974); Goffen (1989); Lucco (1990); Tempestini (1992); Humfrey (1993).

BELLINI, JACOPO *c.*1400–70/1

Known to have been a pupil of Gentile da Fabriano, Jacopo is likely to have first come into contact with his master in Venice before 1414, but to have served the principal period of his apprenticeship in Brescia between 1414 and 1419. A document of 1423 is often cited as evidence that the young Jacopo then accompanied Gentile to Florence, but the interpretation of the document remains controversial, and it is by no means certain that Jacopo was in Florence in the 1420s, or indeed at any other time. From about 1430 onwards his career in northern Italy is relatively well documented. In 1436 he executed a large *Crucifixion* in fresco in the cathedral in Verona; in 1441 he defeated the renowned Pisanello in a contest to paint the portrait of Lionello d'Este in Ferrara; in the earlier 1460s he painted a cycle of canvases for the chapter hall of the Scuola di S. Giovanni Evangelista; in 1466 he was commissioned to paint the initial, most important canvas in an Old Testament cycle in the chapter hall of the Scuola di S. Marco. All these works are lost, and of the rather small number of his surviving paintings, the majority are half-length Madonnas (cf. Pl. 41). Only one of these – a badly damaged picture of 1448 in the Brera, Milan – is dated; this is close, in other words, to one of the very few other securely dated works, the documented *Annunciation* painted in 1444 for S. Alessandro, Brescia (Pl. 26). Very important,

therefore, is the recent re-emergence of a panel representing *Sts Anthony Abbot and Bernardino* (Pl. 42), and plausibly identified as the left wing of an altarpiece that Jacopo is known to have painted in 1459/60 for the Gattamelata chapel in the church of the Santo, Padua, in collaboration with his sons Gentile and Giovanni. In contrast to the decimation of Jacopo's output as a painter is the survival of an extraordinarily large number of his drawings, in the form of two bound volumes now in the Louvre, Paris, and the British Museum, London. In the absence of any secure chronological framework, critics have differed widely in their dating of Jacopo's paintings and drawings, and hence also in their assessment of his historical position. An apparently growing consensus that the London Book preceded the Paris Book, and that both dated from relatively late in the painter's career, has recently been overturned by Degenhart and Schmitt (1984; 1992) who, by proposing an unprecedentedly coherent account of his chronological development, have also provided a convincing demonstration of his pioneering importance in the creation of the Renaissance style of Venetian painting.

BIBL: Joost-Gaugier (1980); Degenhart and Schmitt (1984); Eisler (1989); Degenhart and Schmitt (1990).

BONFACIO DE' PITATI 1487–1553

Also known as Bonifacio (or Bonifazio) Veronese after his birthplace, he was resident in Venice as early as 1505; nothing further, however, is known of him until the mid-1520s, by which time he was practising a style closely related to that of Palma Vecchio. In 1529 he embarked on the principal commission of his career: an extensive series of canvases painted to decorate the many government offices housed in the Palazzo dei Camerlenghi at Rialto. Bonifacio evidently made use of a large team of assistants for this enterprise, with the result that his works are rather variable in quality, and often difficult to date.

BIBL: Westphal (1931); Freedberg (1971; ed. 1975), pp. 347–8, 535–6; Simonetti (1986).

BORDONE, PARIS 1500–71

Born in Treviso, Paris came to Venice as a child and received his artistic education under Titian. By the 1520s he was producing his own versions of the whole range of domestic pictures popularised by Titian and Palma Vecchio (Holy Familys in a Landscape, half-length beauties, reclining nudes, etc.), as well as church altarpieces. According to Vasari, Paris visited Fontainebleau in 1538, where he received commissions from leading members of the French court; but present scholarly opinion inclines to doubt this date, and to postpone the French visit to *c.*1559–61. An intermediate stage in his growing international reputation, particularly as a painter of mythologies and of other pictures with a pronounced erotic content, would then be represented by a period in Milan (1548–51), where he executed a series of aesthetically highly self-conscious paintings for the nobleman Carlo da Rho.

Within a general development from the Titianesque warmth and sensuousness of his earlier works, to the more contrived and chromatically dissonant character of his later ones, Paris's chronology is often difficult to plot in detail. Particularly controversial is the dating of his most important commission for a Venetian public building, the *Fisherman delivering the Ring* (Pl. 129); thus while some critics relate it to a document of 1534, others consider its spatial complexity to be inconceivable before the more Mannerist phase of the mid-to late 1540s. In the last two decades of his life Paris seems to have withdrawn to his native Treviso, where he was active as a painter of altarpieces of increasingly feeble quality.

BIBL: Canova (1964); Freedberg (1971; ed. 1975), pp. 349–50, 536–8; *Paris Bordon* (1984); *Paris Bordon e il suo tempo* (1987).

CARPACCIO, VITTORE *c*.1465–1525/6

A native of Venice, Carpaccio is known above all for the narrative cycles he painted for various Venetian Scuole Piccole: the *Life of St Ursula* for the Scuola di S. Orsola (1490–*c*.1498; Venice, Accademia) (Pls 63, 64); the *Lives of Sts George, Jerome and Tryphonius* for the Scuola di S. Giorgio degli Schiavoni (1502s – *c*.1508; in situ) (Pl. 107); the *Life of the Virgin* for the Scuola degli Albanesi (*c*.1500–10; dispersed); and the *Life of St Stephen* for the Scuola di S. Stefano (1511–20; dispersed). He also contributed a canvas to the *Miracles of the True Cross* cycle for the Scuola di S. Giovanni Evangelista in 1494 (Pl. 7), and in the first decade of the sixteenth century he was employed in the Sala del Maggior Consiglio of the Doge's Palace. The question of his training has been the subject of considerable but inconclusive art-historical discussion; probably the most likely candidate for his teacher is Gentile Bellini, the leading Venetian exponent of history painting from the mid-1470s onwards, and the master in overall charge of the *Miracle of the True Cross* commission. Carpaccio's earliest signed and dated work is the *Arrival at Cologne* of 1490 for the *St Ursula* cycle; and the nine constituent canvases of this ensemble are the outstanding works of the artist's early maturity. The earliest of the nine surviving canvases of the S. Giorgio degli Schiavoni cycle show a comparable quality of inspiration; but the latest, exemplified by the *Miracle of St Tryphonius* (*c*.1508), already shows signs of the perfunctoriness that was to characterise much of the painter's work in the last decade of his life. In his later period he also painted an increasing number of altarpieces, a type of commission for which his talents were never well suited. On the other hand, the superb and highly original *Portrait of a Knight* (Madrid, Thyssen Collection) shows the painter still at the height of his powers as late as 1510; and his documented contacts in the following year with the Marquis of Mantua provides evidence that even after the death of Giorgione, Carpaccio remained capable of attracting the most eminent of patrons.

BIBL: Lauts (1962); Muraro (1966); Brown (1988); Humfrey (1991).

CIMA DA CONEGLIANO. Giovanni Battista 1459/60–1517/18

A native of the *terraferma* town of Conegliano in the province of Treviso, Cima seems to have established himself by the mid-1480s in Venice, where he was perhaps trained under Alvise Vivarini, and where he was to remain throughout his professional life. His major works consist almost exclusively of altarpieces, mostly representing the Virgin and Child enthroned with Saints, but also including narrative scenes such as the *Baptism of Christ* (Pl. 71), or the *Incredulity of Thomas* (London, National Gallery, and Venice, Accademia). Several were painted for churches and confraternities in Venice, but a large number was also painted for mainland destinations such as Oderzo (near Treviso), Olera (near Bergamo) and Capodistria (in present-day Slovenia), as well as for churches in and around Conegliano. The other main activity of his workshop was the production of half-length Madonnas for private devotion. Less numerous, but of particular interest, are his mythological subjects (Pl. 106), which may be counted among the earliest Venetian examples of the humanist-inspired *poesia*. Once formed, Cima's style did not undergo any fundamental alteration: although he was to make superficial concessions to the growing taste for the Giorgionesque in the early years of the sixteenth century, his artistic mentality remained rooted in the modes made current in the 1470s and 1480s by Giovanni Bellini and Antonello. With very few exceptions, his paintings were executed on panel, and his application of paint is typically smooth and meticulous, allowing great precision and refinement in the rendering of small-scale detail.

BIBL: Humfrey (1983); Lucco (1990).

DÜRER, ALBRECHT 1471–1528

The greatest German artist of his age, Dürer had a lifelong fascination with the art of the Italian Renaissance, and is known to have made two visits to Italy and Venice. On the first occasion (1494–5) he was still a young man, and although the experience made a profound impression on him, his presence apparently went unnoticed by local artists. By the time of the second visit (1505–6), his woodcuts and engravings would have been well known in Venice; and as Dürer records in a series of letters written to his friend Wilibald Pirckheimer at home in Nuremberg, his presence on this occasion excited considerable interest, and even jealousy, among his Venetian colleagues. Although the primary purpose of the second visit was almost certainly to paint the *Feast of the Rosegarlands* (Pl. 84) for the confraternity of the German community in Venice, the Scuola dei Tedeschi, Dürer was also commissioned to paint a number of other, smaller pictures during his stay, including the *Portrait of a Girl* (Vienna, Kunsthistorisches Museum) and the *Madonna of the Siskin* (Berlin, Staatliche Museen).

BIBL: Pignatti (1973); Anzelewsky (1981), pp. 48–55, 121–34.

EL GRECO (Domenikos Theotocopoulos) 1541–1614

The greatest Spanish painter of the late sixteenth and early seventeenth centuries, El Greco was a native of the Venetian colony of Crete, and began his career as an icon painter in the Byzantine tradition. He arrived in Venice in about 1567, but seems to have spent little more than three years there, before moving on to Rome in 1570. Some scholars believe that he returned to Venice for a second sojourn after 1572; in any case, by 1577, and perhaps a year or two earlier, he had settled in Spain. The identification of El Greco's earliest Italian works remains a matter of critical controversy; similarly controversial is the question of whether he spent his Venetian period as an assistant in the studio of Titian.

BIBL: R. Pallucchini in *Da Tiziano a El Greco* (1981), pp. 63–8, 246–71; J. Brown in *El Greco of Toledo* (1982), pp. 76–80; Puppi (1984).

FRANCO, BATTISTA *c.*1510–61

A native Venetian, Battista moved at an early age to Rome, where he fell under the spell of Michelangelo. Most of his career was spent in Rome, Florence and the Marches, but around 1552 he returned to Venice, where he was commissioned to paint the *Baptism* for the chapel of Daniele and Marcantonio Barbaro in S. Francesco della Vigna. In 1556–7 he contributed three roundels to the ceiling of the Library Reading Room, and in the later 1550s he also worked in the Palazzo Grimani at S. Maria Formosa and in the Grimani chapel at S. Francesco (Pl. 25). His work in the chapel was completed after his death by Federigo Zuccari.

BIBL: Rearick (1959); Freedberg (1971; ed. 1974), pp. 485–6; E. Merkel in *Da Tiziano a El Greco*, pp. 202–7.

GIAMBONO, MICHELE *c.*1395–1462

One of the leading representatives of the Venetian version of the International Gothic, Giambono was a faithful follower of the style introduced into the city by Gentile da Fabriano, above all in his frescoes for the Sala del Maggior Consiglio (1408–14). Perhaps Giambono, too, participated in the cycle in the 1420s; certainly he enjoyed high official favour by the 1430s, when he was employed to design mosaics for the so-called Mascoli chapel, founded by Doge Francesco Foscari in San Marco. The fact that he served on the committee of experts convened to evaluate Donatello's *Gattamelata* in 1453 provides evidence of a continuing respect for his art. But already by about 1440 his style was no longer keeping pace with the beginnings of the Renaissance in Venice.

BIBL: Merkel (1990).

GIORGIONE (Giorgio da Castelfranco) 1477/8–1510

Ever since the first edition of Vasari's *Lives* (1550), Giorgione has been universally acknowledged as the founder of the *modern style* (i.e. the High Renaissance) in

Venetian painting; there remain, however, enormous problems surrounding any attempt to define his oeuvre. He is known to have died in the early autumn of 1510, and the birthdate of 1477/8 given by Vasari is generally accepted as plausible; but apart from the documents relating to his ruined frescoes for the façade of the Fondaco de' Tedeschi in 1508 (cf. Pl. 92), there exists almost no other contemporary information about his life and work. A single picture, the *Laura* of 1506 (Pl. 91), is dated by an inscription on the back. The key works for establishing his oeuvre are four pictures recorded as by him in Venetian collections by Marcantonio Michiel between 1520 and 1543: the *Boy with an Arrow* (Pl. 90), the *Tempest* (Pl. 86); the *Three Philosophers* (Vienna, Kunsthistorisches Museum); and the *Sleeping Venus* (Pl. 14) – but even of the last two, Michiel says that they were completed by Sebastiano del Piombo and Titian respectively. Stylistically related to this core group is another group of some ten to fifteen works that are now almost universally accepted as by Giorgione; but beyond this is a much larger group of manifestly Giorgionesque pictures, including masterpieces of the importance of the *Concert Champêtre* (Pl. 26), about which there exists no critical consensus. Intimately related to problems of attribution are those of chronology. In recent years the view that Giorgione's career must have begun *c*.1495, rather than the more traditional *c*.1500, has begun to find favour; but this plausible extension of his short career by one third has only added to the difficulties in deciding whether the last three years of his life are characterised by such works as the *Concert Champêtre* and/or *Christ and the Adulteress* (Glasgow, City Art Museum), or rather by the very different *Two Singers* (Rome, Galleria Borghese) and/or the *Concert* (Milan, Mattioli Collection). Whatever the solution to these and other attributional conundrums, they attest to the extraordinary fascination that Giorgione's art held for his contemporaries. Part of this clearly lay in the unquestionable inventiveness of his style, composition, technique and iconography, all of which broke with traditional canons. In part, too, artists and patrons must have been attracted by the characteristically mysterious mood of his pictures, and by the obviously deliberate elusiveness of their meaning.

BIBL: Pignatti (1969); Freedberg (1971; ed. 1975, pp. 124–35); Wilde (1974), pp. 59–93; A. Ballarin in *Le Siècle de Titien* (1993), pp. 281–95, 431–50, 687–99.

GIOVANNI D'ALEMAGNA Active 1441–50

Apart from a signed and dated *St Jerome* of 1444 (Baltimore, Walters Art Gallery), all Giovanni's known works were executed in the 1440s in collaboration with his brother-in-law Antonio Vivarini. These include several polyptychs, in which Giovanni signs his name first (cf. Pls 35, 37, 39), and the documented frescoes for the vault of the Ovetari chapel in the church of the Eremitani, Padua (1448–50; destroyed 1944). Giovanni seems to have been the elder and stylistically more conservative of the two painters, but the precise nature of his contribution to their joint works remains difficult to identify. To judge from his name, he was German by birth; and, as suggested by Rigoni (1937), he is probably identical with one

Giovanni da Ulma (John of Ulm), resident in Venice, who was called to Padua to execute an important fresco cycle in 1437.

BIBL: Rigoni (1937); Pallucchini (1962); Zeri (1971).

JACOMETTO Active 1472–97

Virtually nothing is known of the life and works of Jacometto beyond what is said of him by Marcantonio Michiel, who recorded a number of small works by him in Venetian collections between 1520 and 1543. Only one of these works is now certainly identifiable: a portrait of Alvise Contarini, and its pendant, *A Nun of San Secondo*, now in the Lehman Collection at the Metropolitan Museum of Art, New York. Stylistically these show a close knowledge both of Flemish painting and of Antonello's art, and they provide a basis for attributing a number of other works, mainly portraits, to Jacometto.

BIBL: Frimmel (1896); Pope-Hennessy (1966), pp. 212–13; Mariani Canova (1969), pp. 111–12; Pope-Hennessy (1987), pp. 240–3.

LOTTO, LORENZO *c.*1480–1556/7

Lotto's career was one of constant movement. Born and presumably trained in Venice, perhaps under Alvise Vivarini, his earliest independent ativity took place in Treviso (*c.*1503–6). In response to a commission from the Dominicans of S. Domenico, Recanati, he moved to the Marches, where he stayed for another six years (1506–12). In 1509 he was briefly employed in the Stanza della Segnatura in the Vatican. The opportunity to undertake another commission for a major Dominican altarpiece took him in 1513 to Bergamo, where again he remained for several years. In 1525 he returned to Venice, where he continued to work for Bergamask and Marchigian as well as for Venetian patrons. The Venetian period was interrupted by further extended visits to the Marches (*c.*1533–9) and to Treviso (1542–5). In 1549 he finally abandoned Venice for the Marches, and he died at Loreto in 1556/7. Lotto was active above all as a painter of religious subjects, and also as a portrait painter. The deeply religious sensibility evident in his works also emerges from the account-book (*Libro di Spese Diverse*) which he kept for the last eighteen years of his life (1538–56). This important and almost unique document is richly informative not only about the artist's business practices and social world, but also about his private thoughts and feelings; critics have been far from unanimous, however, in their interpretation through the *Libro* of Lotto's personality and attitude towards the religious conflicts of his time.

BIBL: Freedberg (1971; ed. 1975), pp. 302–15; Mariani Canova (1975); Zampetti and Sgarbi (1981); S. Béguin in *Le Siècle de Titien* (1993), pp. 487–98.

MANSUETI, GIOVANNI Active 1485–1526/7

Mansueti painted a number of altarpieces and devotional half-lengths, but he is best known for his contributions to several narrative cycles commissioned by the

Venetian *scuole* in the 1490s and the early years of the sixteenth century. A canvas for the *Miracles of the True Cross* cycle (Venice, Accademia), dated 1494, declares him to be a pupil of Gentile Bellini; and, indeed, the style he practised with little change throughout his career is closely dependent on that of Gentile. Mansueti had a strong feeling for decorative colour, but the stiffness of his figures and the indiscriminate accumulation of detail lend his works a certain monotony.

BIBL: Raby (1982); Humfrey (1985); Brown (1988).

PALMA, JACOPO, IL GIOVANE *c.*1548–1628

The great-nephew of Palma Vecchio, Palma the Younger was the leading painter in Venice after the deaths of Veronese and Tintoretto. His formative years were spent at the court of Urbino and in Rome; and when he returned to Venice in the early 1570s he was already a mature artist, practising a style at first reflecting the Roman late Mannerism of the Zuccari, but then increasingly consisting of an eclectic synthesis of Titian, Tintoretto, Veronese, and even Bassano. The traditional supposition that on his return he worked as an assistant to the aged Titian may not be correct, and Palma's completion of the *Pietà* may have taken place in the early 1580s rather than immediately after Titian's death in 1576. His earliest major commission in Venice was for one of the large ceiling canvases for the post-fire Sala del Maggior Consiglio (Pl. 190), and he went on to execute other large-scale paintings in the Sala and in the neighbouring Scrutinio. Palma's finest achievements may be identified as two pictorial cycles dating from the 1580s: a eucharistic cycle for the sacristy of S. Giacomo dell'Orio (1581); and a history cycle for the Oratorio dei Crociferi (1583–92). Thereafter, although he remained immensely productive, and created a market for his pictures that extended well beyond the Veneto, his art declined in inspiration, and frequently became dull and formulaic.

BIBL: Freedberg (1971; ed. 1975), pp. 560–2; Mason Rinaldi (1984).

PALMA, JACOPO, IL VECCHIO *c.*(?)1490–1528

On the basis of Vasari's statement that Palma died aged forty-eight, it has traditionally been assumed that he was born *c.*1480; but because of the absence of a plausible oeuvre for the decade 1500–10, it has recently been suggested that his career began only around 1510, when he arrived in Venice from his native region close to Bergamo (Rylands, 1992). As is evident from a number of references in the *Notebooks* of Marcantonio Michiel, and also from an inventory of the painter's studio compiled after his death, Palma specialised in pictures destined for a domestic context: Holy Familys with Saints in a Landscape, half-length female beauties, and reclining nudes (cf. Pls 121, 122, 124). He also painted a number of altarpieces for churches in Venice, the Veneto and his native region; but his only large-scale narrative picture, the *Storm at Sea* (Venice, Accademia), commissioned for the *Life of St Mark* cycle in the *albergo* of the Scuola di S. Marco, was apparently still in progress at the time of his premature death, and was completed

by Paris Bordone. Once mature, Palma's style did not change greatly, and most of his works remain difficult to date with any precision.

BIBL: Freedberg (1971; ed. 1975), pp. 160–4, 334–7; Rylands (1992); L. Attardi in *Le Siècle de Titien* (1993), pp. 377–82.

PORDENONE (Giovanni Antonio de Sacchis) *c*.1483/4–1539

Born and trained in the Friulian town from which he takes his name, Pordenone was a painter above all of large-scale murals for churches, and also of altarpieces. After an early career spent in his native region on the Venetian *terraferma*, he began to receive a number of important commissions for churches in Lombardy and Emilia: at the cathedral in Cremona (1520–2); at Cortemaggiore (Piacenza) (*c*.1529–30); and at the Madonna di Campagna, Piacenza (1530–5). From 1527 until his death in 1539 he resided mainly in Venice, where his most important works included fresco decorations in the choir and semi-dome of S. Rocco, in the cloister of S. Stefano, and on the façade of the Palazzo d'Anna. These are almost entirely lost, as is the canvas he painted for the *Story of Alexander III* cycle in the Sala del Maggior Consiglio in 1537–8; there survives, however, a number of easel pictures painted for Venetian churches and confraternities. Pordenone's assertively plastic style, muscle-bound figures and virtuoso displays of foreshortening, have often led critics to assume that he made an early visit to Rome, perhaps *c*.1518; but a growing body of opinion now considers that these characteristics may have been based on a knowledge of the art of Michelangelo and Raphael at second hand, by way of prints and drawings, and of northern Italian intermediaries such as Correggio and Giulio Romano.

BIBL: Freedberg (1971; ed. 1975), pp. 291–301; Gould (1972) (IV); Furlan (1984); Furlan (1988).

SALVIATI, FRANCESCO 1510–63

A leading exponent of the High Mannerism of the middle years of the sixteenh century in central Italy, Salviati made his early reputation in Rome, particularly with his *Visitation* fresco in the Oratorio of S. Giovanni Decollato (1538). During his two-year stay in Venice (1539–41) he was principally occupied in the Palazzo Grimani at S. Maria Formosa, but also painted altarpieces for the church of the Corpus Domini (Pl. 138) and for S. Cristina in Bologna. Salviati spent much of his later career commuting between Rome and his native Florence; in 1555–6 he was also employed at the French court at Fontainebleau.

BIBL: Cheney (1963); Hirst (1963); Freedberg (1971; ed. 1975), pp. 437–42, 487–90; R. Pallucchini in *Da Tiziano a El Greco* (1981), pp. 15–17; D. McTavish, in ibid., pp. 81–5; Mortari (1992).

SALVIATI, GIUSEPPE (Giuseppe Porta) *c.1520/5–after 1575*

Born in the province of Lucca in Tuscany, Giuseppe Salviati studied under Francesco Salviati in Rome before accompanying his master to Venice in 1539. After Francesco's departure in 1541, Giuseppe remained in the city, becoming one of the leading local exponents of Mannerism. His earliest Venetian works, most notably the influential woodcuts for Marcolini's *Sorti* (1540), predictably reflect the artificial elegance of his master most closely. Thereafter he progressively accomodated his style to local tradition, without, however, ever abandoning the un-Venetian tendencies towards plasticity, linearism and surface blandness of his central Italian origins.

BIBL: Freedberg (1971; ed. 1975), p. 539; D. McTavish in *Da Tiziano e El Greco* (1981), pp. 88–97; McTavish (1981).

SAVOLDO, GIOVANNI GEROLAMO *c.1480/5–after 1548*

Savoldo was presumably trained in his native Brescia, but his early career up to *c*.1520, when he settled in Venice, remains mysterious. In 1548 his pupil Paolo Pino lamented that Savoldo had 'spent his life on few works and with scarce renown' (Pardo [1984], p. 304); and it may well be that his evidently slow, painstaking technique tended to exclude him from large-scale public commissions. But Marcantonio Michiel records a number of his works in Venetian private collections; and the deeply meditated and conceptually inventive character of his art seems, in fact, to have been much appreciated by connoisseurs, both in Venice and among a circle of patrons in Brescia. Many of his pictures consist of variations on Giorgionesque themes, and show single or small groups of figures in close-up, often in unusual and poetic lighting conditions (twilight, firelight, moonlight, etc.). In modern Italian art historiography, a lively debate has centred on the question of whether Savoldo should be regarded primarily as a Lombard painter, whose earthy naturalism foreshadows that of Caravaggio, or as a Venetian.

BIBL: Freedberg (1971; ed. 1975), pp. 340–4; Gilbert (1986); *Giovanni Gerolamo Savoldo* (1990); Frangi (1992).

SCHIAVONE (Andrea Medolla) *c.1515–63*

A native of the Venetian colonial city of Zara (Zadar) in Dalmatia (hence his nickname denoting him as Slavonian), Schiavone seems to have arrived in Venice in the mid-to late 1530s. Nothing is known of his training, and the evidence regarding his birthdate is purely circumstantial. Throughout his rather short career he practised as an etcher as well as a painter and his earliest etchings, datable to *c*.1538, already show a strong influence of those of Parmigianino. A relatively large number of Schiavone's paintings are small-scale mythologies, presumably originally incorporated into domestic furniture (cf. Pl. 143); but as early as 1540 he was commissioned by Vasari to paint a large battle picture (lost), and this was followed by a number of altarpieces, organ shutters (Pl. 144) and other large-scale religious

pictures. Together with other leading Venetian painters of the Mannerist tendency, Schiavone participated in the decoration of the ceiling of the Reading Room of the Marciana Library in 1556–7. In 1562 he was commissioned by Tommaso Rangone to contribute a canvas to the *Life of St Mark* cycle in the chapter hall of the Scuola Grande di S. Marco, but he died before having executed more than a preliminary drawing (Windsor Castle, Royal Library).

BIBL: Freedberg (1971; ed. 1975), pp. 532–4; Richardson (1980); P. Rossi in *Da Tiziano a El Greco* (1981), pp. 130–7; A. Perissa Torrini in *Le Siècle de Titien* (1993), pp. 538–41.

SEBASTIANO DEL PIOMBO 1485–1547

According to Vasari, who knew him well during his later years in Rome, Sebastiano was born in Venice in 1485, and was a pupil first of Giovanni Bellini and then of Giorgione. His short Venetian career, which came to a close in August 1511, when he accepted an invitation by the wealthy Sienese banker Agostino Chigi to join his entourage in Rome, is poorly documented and includes only one dated picture, the *Judith* of 1510 (Pl. 94). Sebastiano's earliest works presumably date from *c*.1504–5; these were followed by major commissions such as the unfinished *Judgement of Solomon* (*c*.1506–8; Kingston Lacy [Dorset], National Trust), the four organ shutters for S. Bartolomeo (Pl. 93) (*c*.1509–11); and the high altarpiece for S. Giovanni Crisostomo (*c*.1507–9; *in situ*). During the early years in Rome, Sebastiano's style retained a strongly Venetian character, but from *c*.1518 this was increasingly suppressed, under the personal influence of Michelangelo, in favour of a more explicitly sculptural manner.

BIBL: Freedberg (1971; ed. 1975), pp. 141–4; Wilde (1974), pp. 95–104; Lucco (1980); Hirst (1981); *Le Siècle de Titien* (1993), pp. 296–304; Lucco (1994).

SUSTRIS, LAMBERT *c*.1515–(?) after 1584

Born and probably trained in Amsterdam, Sustris became an assistant in Titian's workshop in the mid-1530s. His earliest independent works such as the *Venus* of *c*.1540 (Amsterdam, Rijksmuseum) are strongly Titianesque; but during the 1540s Sustris became increasingly responsive to the Mannerism of Salviati and Parmigianino. This stylistic shift is well illustrated by the *Venus, Cupid and Mars* of *c*.1550 (Pl. 141), probably painted for the Fugger family, together with a number of other works, on a visit with Titian to the imperial court at Augsburg in 1548 or 1550–1. Sustris was a specialist landscape painter, and many of his pictures show relatively small figures in extensive landscapes, characteristically painted in light tones, with free, fluid brushstrokes.

BIBL: Ballarin (1962); P. L. Fantelli in *Da Tiziano a El Greco* (1981), pp. 138–43; Lucco (1985); E. Merkel in *Le Siècle de Titien* (1993), pp. 541–2.

TINTORETTO, JACOPO (Jacopo Robusti) 1519–94

Born in Venice, Tintoretto spent his whole life in the city and worked almost exclusively for Venetian patrons. His nickname, signifying that he was the son of a textile dyer, served to advertise his self-identification with the social world of tradesmen and artisans; and although he was eventually to work in the Doge's Palace, his most characteristic patrons were the Venetian devotional confraternities, or Scuole. According to his first biographer Ridolfi (1648), Tintoretto studied briefly under Titian, but a personal antipathy between the two men quickly caused a rift that was never properly healed; indeed, it may have been partly because of Titian's hostility that Tintoretto found it such a struggle to gain official acceptance. Although a qualified master by 1540, he gained very few important commissions before 1548; and many of his earliest large-scale works consisted of now-lost frescoes for the external façades of palaces. In the absence of these, the earliest sage of his career is difficult to reconstruct, and although many more or less Tintorettesque works have been assigned to this period, there is wide scholarly disagreement about which are actually by the master. Despite its controversial reception, the *Miracle of the Slave* of 1548 (Pl. 163) for the very public setting of the Scuola di S. Marco marked an important breakthrough in the painter's career; and although he was to continue to be excluded from a number of important commissions, most notably from the ceiling decoration of the Reading Room of the Marciana library in 1556 (p. 194), he did not lack for others. From the early 1550s onwards, in fact, his biography corresponds to a sequence of major decorative commissions for Venetian public buildings. In *c.*1550–3 he painted an Old Testament cycle for the Scuola Piccola della SS. Trinità (Accademia). In 1552–6 he painted organ shutters, and in *c.*1562–4 a pair of gigantic paintings for the chancel walls of the Madonna dell'Orto (*in situ*). In 1562–6 he added three more scenes to the *Life of St Mark* cycle in the chapter hall of the Scuola di S. Marco (cf. Pl. 164); and in 1564 began his long association with the Scuola di S. Rocco. The decoration of the *albergo* (1564–7; Pls 166, 167) was followed by that of the large chapter hall (1575–81; Pls 168, 169, 170), followed in turn by that of the lower hall (1582–7). Meanwhile Tintoretto continued to work for other Scuole Piccole, most notably the parish-based Scuole del Sacramento at S. Trovaso and S. Cassiano, and the Scuola di S. Girolamo at S. Fantin. Although he succeeded in gaining the commission to paint the *Excommunication of Frederick Barbarossa* for the Sala del Maggior Consiglio in 1562 (destroyed 1577), Tintoretto continued to be much less successful than Veronese in gaining commissions from the Venetian government and the ruling patriciate until after the nearly simultaneous events of the death of Titian (1576) and the fire in the Sala del Maggior Consiglio (1577). Thereafter, his high productivity proved a positive asset in the extensive campaign of redecoration in the Doge's Palace, and also in Palladio's newly completed church of S. Giorgio Maggiore. To his late years also belong the relatively few works he painted for foreign princes, including a cycle of four for the Duke of Mantua (1579–80; Munich, Alte Pinakothek), a series of mythologies for the Emperor Rudolf II (cf. Pl. 172), and some pictures for Philip II of Spain.

BIBL: De Vecchi (1970); Freedberg (1971; ed. 1975, pp. 518–32); Pallucchini and Rossi (1982); Rosand (1982), pp. 182–220; Valcanover and Pignatti (1985).

TITIAN (Tiziano Vecellio) c.(?)1490–1576

Sixteenth-century documents and sources provide conflicting evidence regarding Titian's birthdate, and modern estimates have ranged between 1477 and 1490. Nor does there exist reliable contemporary information about when he moved to Venice from his native Pieve di Cadore in the Dolomites, or about his artistic training. A work generally admitted to be among his earliest, the *Votive Picture of Jacopo Pesaro* (Antwerp, Koninklijk Museum voor Schone Kunsten) shows the strong influence of Giovanni Bellini in the figure of St Peter; but an assessment of the date, and of Titian's relationship with Bellini, is complicated by the fact that the picture appears to have been executed in two phases. An even more difficult problem is that of Titian's relation with Giorgione; and there is no scholarly consensus about which Giorgionesque pictures are by Giorgione himself, and which should be attributed rather to the younger master. Titian's earliest dated works are his three frescoes in the Scuola del Santo, Padua, of 1510–11; these reveal a highly ambitious, but not yet fully mature artist, who was probably, therefore, not aged much more than twenty. Probably contemporary with these are the stylistically similar *Virgin and Child with Two Saints* (Madrid, Prado) and the *Christ and the Adulteress* (Glasgow, City Art Gallery); as argued in the Text, however (p. 129), a third picture often bracketed with these, the *Concert Champêtre* (Pl. 26), is more sophisticated in its composition and handling, and may be ascribed rather to Giorgione. The problems of dating and attribution become less acute by c.1513, and a reliable guide to Titian's style at the end of his early, 'Giorgionesque' phase is the *Sacred and Profane Love* (Rome, Galleria Borghese) which is datable on external grounds to 1515.

The *Assunta* (Pl. 109), completed in 1518, marks Titian's arrival at full maturity. Already the dominant personality in Venetian painting, he was equally versatile and inventive in every type of pictorial commission, and he quickly became one of the most sought-after painters in all Italy. The cycle of mythologies for the Duke of Ferrara (1518–25) (cf. Pl. 110) was followed by a series of commissions in the 1520s and 1530s from the Duke of Mantua; and the early 1530s also saw the beginnings of his long relationship with the Emperor Charles V, who knighted him in 1533. During this period he made frequent trips to Ferrara, Mantua, Bologna and other north Italian cities, but despite an invitation as early as 1513 to work at the court of Pope Leo X, he did not visit Rome and Florence until 1545–6. In 1548 and again in 1551–2, he crossed the Alps to attend the imperial court at Augsburg; and on the latter occasion he consolidated his acquaintance with the emperor's son Philip, from 1555 king of Spain. From his time onwards Philip was Titian's major patron; and without ever visiting Spain in person, the painter sent regular consignments of pictures from his studio in Venice to the Spanish court.

Titian's later career is exceptionally well documented, and there exists an extensive correspondence between the painter, and King Philip and his agents. There remain, however, three interrelated areas of critical controversy, all of which concern his workshop practices. Like Bellini before him, Titian could only meet the huge demand for his pictures by employing a large number of assistants, one of whom was his son Orazio; and the efficiency with which the shop operated means

that assessing the extent of the collaboration in a particular picture is often one of fine critical judgement. The two other areas of controversy derive from his habit of executing pictures over a period of years, sometimes even decades, stopping work and then resuming again after long interruptions. As a result, certain pictures are difficult or impossible to date accurately; and similarly, it is often difficult to decide whether or not a particular picture should be regarded as finished. Both these problems are illustrated by very beautiful but sketchily painted works such as the *Death of Actaeon* (London, National Gallery) and the *Flaying of Marsyas* (Kroměříž, Archiepiscopal Palace).

BIBL: Pallucchini (1969); Panofsky (1969); Wethey (1969–75); Freedberg (1971; ed. 1975), pp. 135–60, 323–34, 504–18; Wilde (1974), pp. 104–265; Rosand (1978); Hope (1980); *Tiziano e Venezia* (1980); *Titian: Prince of Painters* (1990); *Titian 500* (1994).

VASARI, GIORGIO 1511–73

Famous above all for his *Lives of the Artists* (1st edn: 1550; revised edn: 1568), Vasari was also a leading Mannerist painter and architect. Born in Arezzo in Tuscany, he was educated in Florence, and always remained a stout propagandist for the superiority of Florentine art over that of any other centre. His peripatetic career brought him twice to Venice. The first visit (1541–2) was arranged by his compatriot there, Pietro Aretino; and as well as decorating a ceiling for the Palazzo Corner-Spinelli (cf. Pl. 3), Vasari painted a *Holy Family with St Francis* for the banker Francesco Leoni (Los Angeles, County Museum of Art), and designed stage sets for the production of a play by Aretino. The second visit (1566) was undertaken at great speed, with the purpose of gathering material for the second edition of the *Lives*, and did not involve any artistic commission.

BIBL: Schulz (1961); Freedberg (1971; ed. 1975), pp. 445–54; Corti (1989).

VERONESE, PAOLO (Paolo Caliari) 1528–88

The son of a stonemason, Veronese was trained in his native city of Verona under the local painter Antonio Badile. His earliest independent works, datable to *c.*1546, were painted for local patrons and buildings, but already in 1550–1 he was working for the Venetian patrician families of the Soranzo and the Giustinian. As a result of these connections he was invited in 1553 to participate in the ceiling decoration of a series of council chambers in the Doge's Palace; and about two years later he finally abandoned Verona to settle in Venice. Responsible for devising the iconographic programme of the ceiling of the Sala del Consiglio dei Dieci was the eminent humanist and cleric Daniele Barbaro; and this association led to Veronese being commissioned in *c.*1560 to decorate the Barbaro villa at Maser, near Castelfranco, again to a programme devised by Daniele Barbaro. Another important contact made in connection with the Doge's Palace ceilings was with Girolamo Grimani, procurator of San Marco who, according to Ridolfi, took

Veronese with him on an embassy to Rome (either in 1555 or 1560), and in whose memory the painter later executed the altarpiece for S. Giuseppe di Castello. The early support of a network of wealthy and influential patricians meant that the course of Veronese's career ran much more smoothly than that of his rival Tintoretto, and the award of a golden chain for his contribution to the decoration of the Marciana Library Reading Room in 1557 (cf. Pl. 147) was only one in an almost uninterrupted series of public successes. In 1555 began his decade-long association with the church of S. Sebastiano (Pls 175, 176); and in 1562–3 he executed another major commission for a monastic patron, the huge *Wedding Feast at Cana* for the refectory of S. Giorgio Maggiore (Paris, Louvre). An almost equally grand banquet scene, the so-called *Feast in the House of Levi* (Pl. 180) incurred the disapproval of the Inquisition, and Veronese's appearance before its tribunal in 1573 represents one of the very few setbacks of his career. But he evidently remained in favour with the secular authorities, since soon afterwards he was awarded the major share in the redecoration of the Collegio and Anti-Collegio of the Doge's Palace (1575–7); and probably in 1582 he was co-victor with Francesco Bassano of the competition to paint the *Paradise* in the Sala del Maggior Consiglio. Before the death of Titian in 1576 Veronese does not seem to have received many commissions from beyond the Veneto, but thereafter he came to the attention both of Philip II of Spain, and more fruitfully, of the Emperor Rudolf II in Prague. During the last two decades of his life, Veronese made increasing use of the assistance of the various members of his family, including of his two painter sons Gabriele and Carletto Caliari; at the same time, however, he continued to paint works of the highest quality.

BIBL.: Freedberg (1971; ed. 1975), pp. 550–60; Pignatti (1976); Cocke (1980); Rosand (1982), pp. 145–81; Rearick (1988); *Nuovi studi* (1990); Pignatti and Pedrocco (1991); Fehl (1992), pp. 218–31.

VIVARINI, ALVISE 1442/53–1053/5

Son of Antonio Vivarini and nephew of Bartolomeo, Alvise was presumably trained in the family workshop; and despite a commission in 1488 to execute a canvas in the Sala del Maggior Consiglio in the Doge's Palace, he continued the family tradition of specialising above all in altarpieces. Most of these were painted for customers either from the Venetian *terraferma*, such as the Scuola dei Battuti (confraternity of flagellants) in Belluno (Pl. 60), or from towns down the Adriatic coast; towards the end of end of his life, however, he was commissioned to paint a monumental panel for the Venetian church of the Frari, by the Scuola dei Milanesi (confraternity of the Milanese community) (*in situ*; completed after Alvise's death by Marco Basaiti). Despite the relatively large number of signed and dated works, the study of Alvise's stylistic evolution remains problematic, and a number of attributions, particularly of putative early works, remains controversial. His earliest dated work, the Montefiorentino polyptych of 1476 (Urbino, Galleria Nazionale delle Marche), while already mature, does no yet reveal the impact of Antonello's visit of that year; by 1480, however, in the *Virgin and Child with Saints* painted

for S. Francesco, Treviso (now Venice, Accademia), Alvise has developed a style which while preserving a Vivarinesque emphais on sharp contour, reveals an Antonellesque concern with solid sculptural shapes modelled by light. Unlike the elder members of his family, Alvise also painted a number of portraits, which are similarly dependent on formulae introduced into Venice by Antonello.

BIBL: Pallucchini (1962); Steer (1982); Lucco (1990); Humfrey (1993).

VIVARINI, ANTONIO c.1418–76/84

Antonio's only documented work comprises the frescoes executed in 1448–50 in collaboration with his brother-in-law, Giovanni d'Alemagna, on the vault of the Ovetari chapel in the church of the Eremitani, Padua (destroyed 1944). But there exists a comparatively large number of signed and dated works, consisting above all of Gothic-framed polyptychs, destined for cities and regions as diverse as Bologna, Brescia, the Marches (Pl. 44), Istria, Dalmatia and Apulia. Several of the most important examples were also made for the churches of Venice, and they attest to the high reputation enjoyed there by the Vivarini shop in the central decades of the fifteenth century. Antonio's signatures show that throughout the 1440s he collaborated closely with Giovanni d'Alemagna, and throughout the 1450s with his younger brother Bartolomeo; indeed, the only works signed by Antonio alone date from the very beginning of his career (the polyptych in Parenzo [Poreč, Istria] of 1440) and from towards the end (the Pesaro polyptych of 1464; Pl. 44). Comparison between these two works shows little consistent development: while the earlier is relatively advanced for its date, and suggests some knowledge of contemporary developments in Florence, the later one retains the gold back-ground, linear draperies and uncertain ponderation of the Gothic style, and shows little interest in the recent momentous changes introduced by the new leaders of Venetian painting. The suffix DE MURANO that accompanies the names of both Antonio and Bartolomeo on several of their works refers to their origins from a family of glass-workers on Murano; as painters, however, they lived and worked in Venice itself.

BIBL: Pallucchini (1962); Merkel (1990); Humfrey (1993).

VIVARINI, BARTOLOMEO c.1430–after 1491.

Although Bartolomeo was commissioned in 1467 to contribute a canvas to the Old Testament cycle in the Scuola di S. Marco (destroyed by fire in 1485), his most characteristic works are altarpieces, many of which are signed, and carry dates ranging from 1450 to 1491. The signature on virtually all the works of the 1450s in paired with that of his elder brother Antonio, whose pupil he evidently was, and whose specialisation and clientele he largely inherited. In addition to numerous polyptychs painted for the churches of Venice, Bartolomeo sent works to Padua, Dalmatia, the Marches, southern Italy (Apulia and Calabria); and especially also towards the end of his life, he exploited a new market in the towns and villages of

the Bergamask (Pl. 66). Historically, the most significant period of his career was between c.1460 and c.1475. His works of this phase reveal a concern to adapt the still prevalently Gothic style of his brother to the modern style made current in Padua by Mantegna and the other followers of Squarcione. But although advanced in the early 1460s, this style had become old-fashioned by the mid-1470s; and Bartolomeo was never to accomodate himself to the innovations in form, colour and light introduced into Venetian painting by Antonello and the mature Giovanni Bellini. After about 1482 Bartolomeo made a virtue of his conservatism by working almost exclusively for provincial markets.

BIBL: Pallucchini (1962); Lucco (1990); Humfrey (1993).

ZUCCARI, FEDERIGO 1540/1–1609.

The leading painter in late sixteenth-century Rome, Federigo was a native of Urbino, and he collaborated extensively with his elder brother Taddeo until the latter's early death in 1566. Federigo travelled widely in and beyond Italy, and in 1574 he visited France, Antwerp and England, where he is believed to have painted a portrait of Queen Elizabeth. He made two visits to Venice: first in 1562–5, on the invitation of Giovanni Grimani, patriarch of Aquilea, when he completed the decoration of the Grimani chapel in S. Francesco della Vigna (Pl. 25); and again in 1582–3, when he painted a scene for the Sala del Maggior Consiglio (Pl. 191). Federigo practised his late Mannerist style with self-conscious deliberation, and his establishment of an academy in 1593 in his own palace in Rome was followed in 1607 by his publication of a treatise propounding his ideals of beauty and design, L'Idea de' Scultori, Pittori e Architetti.

BIBL: Freedberg (1971; ed. 1975), pp. 494–5, 643–7.

Bibliography

The following Bibliography is intended primarily as a key to the bibiographical references in the Notes to the Text and the Appendix of Biographies. It makes no attempt to provide a comprehensive, or even a balanced, coverage of the vast bibliography of Venetian Renaissance painting, and priority has been given to publications that are recent and available in English. Brief mention may be made here, however, of a number of books on broader aspects of Venetian Renaissance painting that are not adequately signalled in the Notes and Appendix. A stimulating survey covering much the same chronological span as the present book is provided by the relevant chapters of Huse and Wolters (1986). For a briefer survey within the context of Venetian painting as a whole: Steer (1970). Venetian painting is discussed within the broader panorama of painting in sixteenth-century Italy in the volume in the Pelican History of Art by Freedberg (1971). A series of lectures on Bellini, Giorgione, Sebastiano del Piombo and Titian is published in Wilde (1974). Chapters on Venice by various authors are included in the century-by-century volumes on Italian painting, *La pittura in Italia* (ed. Zeri [1987]; ed. Briganti [1988]). Of a complementary series concerned with Venice and its territories, *La pittura nel Veneto*, the volume on the fifteenth century has been published (ed. Lucco [1990]), but that on the sixteenth century is still in preparation. Collections of essays by leading contemporary scholars of Venetian Renaissance painting include Rosand (1982) and Fehl (1992). In addition to a number of important monographic exhibitions held in the past ten to fifteen years, there have been three major exhibitions of sixteenth-century Venetian painting: in Venice in 1981 (*Da Tiziano a El Greco*); in London in 1983–4 (*The Genius of Venice*); and in Paris in 1993 (*Le Siècle de Titien*) (all of which were accompanied by informative catalogues). For the social and cultural background: Chambers (1970); Logan (1972).

Aikema, B., and Meijers, D., *Nel regno dei poveri: arte e storia dei grandi ospedali veneziani in età moderna 1474–1797*, Venice, 1989.

Ames-Lewis, F., 'The image of Venice in Renaissance narrative painting', in idem (ed.) (1994), pp. 15–27.

——, (ed.), *New Interpretations of Venetian Renaissance Painting*, London, 1994.

Anderson, J., 'The Giorgionesque portrait: from likeness to allegory', in *Giorgione: Convegno Internazionale di Studi 1978*, Castelfranco (1979), pp. 153–8.

——, 'La contribution de Giorgione au génie de Venise', *Revue de l'Art*, LXVI (1984), pp. 59–68.

——, 'Collezioni e collezionisti della pittura veneta del Quattrocento: storia, sfortuna e fortuna', in Lucco (1990), pp. 271–94.

——, 'The provenance of Bellini's *Feast of the Gods* and a new/old interpretation', in *Titian 500* (1994), pp. 265–87.

Antonello da Messina (Catalogue of exhibition held at Museo Regionale, Messina, 1981–2), Rome, 1981.

Antonello da Messina: Atti del Convegno di Studi tenuto a Messina 1981, Messina, 1987.

Anzelewsky, F., *Dürer: His Art and Life*, New York, 1981.

Aretino: *see Lettere.*

Arslan, E., *I Bassano*, Milan, 1960.

Ballarin, A., 'Profilo di Lamberto d'Amsterdam (Lamberto Sustris)', *Arte veneta*, XVI (1962), pp. 61–81.

Barasch, M., *Light and Color in the Italian Renaissance Theory of Art*, New York, 1978.

——, *Theories of Art from Plato to Winckelmann*, New York, 1985.

Barocchi, P., *Trattati d'arte del Cinquecento*, I, Bari, 1962.

Belting, H., *Giovanni Bellini Pietà: Ikone und Bilderzählung in der venezianischen Malerei*, Frankfurt-am-Main, 1985.

Bialostocki, J., *Die Eigenart der Kunst Venedigs*, Wiesbaden, 1980.

Boschini, M., *La Carta del Navegar Pittoresco* (1660), ed. A. Pallucchini, Venice and Rome, 1966.

——, *Le minere della pittura*, Venice, 1664.

Branca, V., and Ossola, C. (eds), *Cultura e società tra Riforme e Manierismi*, Florence, 1984.

Briganti, G. (ed.), *La pittura in Italia: il Cinquecento*, 2 vols, Milan, 1988.

Brigstocke, H., *Italian and Spanish Paintings in the National Gallery of Scotland*, 2nd edn, Edinburgh, 1993.

Brown, P. F., *Venetian Narrative Painting in the Age of Carpaccio*, New Haven and London, 1988.

——, 'The antiquarianism of Jacopo Bellini', *Artibus et Historiae*, XIII no. 26 (1992), pp. 65–84.

Bruyn, J., 'Notes on Titian's *Pietà*', in *Album Amicorum J. G. Van Gelder*, ed. J. Bruyn *et al.*, The Hague (1973), pp. 66–75.

Bull, D., and Plesters, J., 'The *Feast of the Gods*: conservation, examination and interpretation (*Studies in the History of Art*, XL), Washington, D. C., 1990.

Büttner, F., 'Die Geburt des Reichtums und der Neid der Götter: neue Überlegungen zu Giorgiones *Tempesta*', *Münchner Jahrbuch der bildenden Kunst*, XXXVII (1986), pp. 113–30.

Campbell, L., 'Notes on Netherlandish pictures in the Veneto in the fifteenth and sixteenth centuries', *Burlington Magazine*, CXIII (1981), pp. 467–73.

——, *Renaissance Portraits*, New Haven and London, 1990.

Canova, G., *Paris Bordon*, Venice, 1964.

Chambers, D., *The Imperial Age of Venice, 1380–1580*, London, 1970.

——, and Pullan, B. (eds), *Venice: A Documentary History, 1450–1630*, Oxford, 1992.

Cheney, I., 'Francesco Salviati's north Italian journey', *Art Bulletin*, XLV (1963), pp. 337–49.

Cocke, R., *Veronese*, London, 1980.

Colantuono, A., '*Dies Alcyoniae*: the invention of Bellini's *Feast of the Gods*', *Art Bulletin*, LXXIII (1991), pp. 237–56.

Commynes: *see The Memoirs....*

Cope, M., *The Venetian Chapel of the Sacrament in the Sixteenth Century*, New York, 1979.

Covi, D., 'Verrocchio and Venice 1469', *Art Bulletin*, LXV (1983), pp. 253–73.

Christiansen, K., *Gentile da Fabiano*, London, 1982.

——, 'Venetian painting of the early quattrocento', *Apollo*, CXXV (1987), pp. 166–77.

Cropper, E., 'The beauty of women: problems in the rhetoric of Renaissance portraiture', in *Rewriting the Renaissance: The Discourses of Sexual Difference in Early Modern Europe*, ed. M. Ferguson, M. Quillingan and N. Vickers, Chicago (1986), pp. 175–90.

Da Tiziano a El Greco: Per la storia del Manierismo a Venezia 1540–1590 (Catalogue of exhibition held in the Doge's Palace, Venice, 1981), Milan, 1981.

Degenhart, B., and Schmitt, A., *Jacopo Bellini: the Louvre Album of Drawings*, New York, 1984.

——, *Corpus der italienischen Zeichnungen 1300–1450. Teil II: Venedig. Jacopo Bellini* (vols 5–8), Berlin, 1990.

Dempsey, C., 'Renaissance hieroglyphic studies and Gentile Bellini's Saint Mark preaching in Alexandria', in *Hermeticism and the Renaissance*, ed. I. Merkel and A. Debus, Washington, D. C. (1988), pp. 342–65.

De Nicolò Salmazo, A., 'Padova', in Lucco (1990), pp. 481–540.

De Tolnay, C., 'L'interpretazione dei cicli pittorici del Tintoretto nella Scuola di San Rocco', *Critica d'arte*, VII (1960), pp. 341–76.

De Vecchi, P., *L'opera completa del Tintoretto* (Classici dell'Arte Rizzoli), Milan, 1970.

Dolce: *see* Barocchi (1962); Roskill (1968).

Douglas-Scott, M., 'Pordenone's altarpiece of the Beato Lorenzo Giustiniani for the Madonna dell'Orto', *Burlington Magazine*, CXXX (1988), pp. 672–9.

Dülberg, A., *Privatporträts. Geschichte und Ikonographie einer Gattung im 15. und 16. Jahrhundert*, Berlin, 1990.

Dunkerton, J., 'Developments in colour and texture in Venetian painting of the early sixteenth century', in Ames-Lewis (ed.) (1994), pp. 63–74.

——, *et al.*, *Giotto to Dürer: Early Renaissance Painting in the National Gallery*, New Haven and London, 1991.

Echols, R., 'Titian's Venetian *soffitti*: sources and transformations', in *Titian 500* (1994), pp. 29–49.

Economopoulos, H., 'Considerazioni su ruoli dimenticati: gli *Amanti* di Paris Bordon e la figura del compare dell'anello', *Venezia Cinquecento*, II no. 3 (1992), pp. 99–123.

Edgerton, S., 'Alberti's perspective: a new discovery and a new evaluation', *Art*

Bulletin, XLVIII (1966), pp. 367–78.

Eisler, C., *The Genius of Jacopo Bellini*, New York, 1989.

El Greco of Toledo (Catalogue of exhibition held in Madrid, Toledo [Ohio], Washington and Dallas, 1982–3), Boston, 1982.

Favaro, E., *L'arte dei pittori in Venezia e i suoi statuti*, Florence, 1975.

Fehl, P., *Decorum and Wit: The Poetry of Venetian Painting*, Vienna, 1992.

Fleming, J., *From Bonaventure to Bellini: an essay in Franciscan exegesis*, Princeton, 1982.

Fletcher, J., 'The provenance of Bellini's Frick *St Francis*', *Burlington Magazine*, CXIV (1972), pp. 206–14.

——, 'Harpies, Venus and Giovanni Bellini's classical mirror: some fifteenth-century Venetian painters' responses to the antique', *Rivista di archeologia* (1988), supplemento 7, pp. 170–6.

——, 'Bernardo Bembo and Leonardo's portrait of Ginevra de' Benci', *Burlington Magazine*, CXXXI (1989), pp. 811–16.

Florence and Venice: Comparisons and Relations (Acts of two conferences at Villa I Tatti, 1976–77), 2 vols, Florence, 1980.

Frangi, F., *Savoldo*, Florence, 1992.

Franzoi, U., Pignatti, T., and Wolters, W., *Il Palazzo Ducale di Venezia*, Treviso, 1990.

Freedberg, S., *Painting in Italy 1500–1600* (1971), rev. edn, Harmondsworth, 1975.

——, '*Disegno* versus *colore* in Florentine and Venetian painting of the Cinquecento', in *Florence and Venice* (1980), II, pp. 309–22.

Frimmel, T., *Der Anonimo Morelliano: Marcanton Michiels Notizie d'opere del disegno*, Vienna, 1896.

Furlan, C. (ed.), *Il Pordenone: Atti del Convegno Internazionale di Studio*, Pordenone, 1985.

——, *Il Pordenone*, Milan, 1988.

Gibbons, F., 'Practices in Giovanni Bellini's workshop', *Pantheon*, XXIII (1965), pp. 146–54.

Gilbert, C., 'Last Suppers and their refectories', in *The Pursuit of Holiness in Late Medieval and Renaissance Religion*, ed. C. Trinkaus and H. Oberman, Leiden (1974), pp. 371–402.

——, *The Works of Girolamo Savoldo. The 1955 dissertation with a review of research, 1955–1985*, New York, 1986.

Gilmore, M., 'Myth and reality in Venetian political theory', in Hale (ed.) (1973), pp. 431–44.

Giorgione a Venezia (Catalogue of exhibition held in the Gallerie dell'Accademia, Venice, 1978), Milan, 1978.

Giovanni Gerolamo Savoldo (Catalogue of exhibition held in Monastero di S. Salvatore e S. Giulia, Brescia, 1990), Milan, 1990.

Goffen, R., *Piety and Patronage in Renaissance Venice: Bellini, Titian and the Franciscans*, New Haven and London, 1986.

——, *Giovanni Bellini*, New Haven and London, 1989.

Goodman-Soellner, E., 'A poetic interpretation of the "Lady at her toilette" theme in sixteenth-century painting', *Sixteenth Century Journal*, XIV (1983), pp. 426–42.

Gould, C., 'Sebastiano Serlio and Venetian painting', *Journal of the Warburg and Courtauld Institutes*, XXV (1962), pp. 56–84.

——, 'The Cinquecento at Venice I: Two crises'; 'II: The *Death of Actaeon* and Titian's mythologies'; 'III: Tintoretto and space'; 'IV: Pordenone versus Titian', *Apollo*, CXV (1972), pp. 376–81, 464–9; CXVI (1972), pp. 32–7, 106–10.

——, *National Gallery Catalogues: The Sixteenth-Century Italian Schools*, London, 1975.

——, 'Veronese's greatest feast: the interaction of iconographic and aesthetic factors', *Arte veneta*, XLIII (1989–90), pp. 85–8.

Hale, J., 'Michiel and the *Tempesta*: the soldier in a landscape as a motif in Venetian painting', in *Florence and Italy: Renaissance Studies in Honour of Nicolai Rubinstein*, ed. P. Denley and C. Elam, London (1988), pp. 405–18.

——(ed.), *Renaissance Venice*, London, 1973.

Hall, M., *Color and Meaning: Practice and Theory in Renaissance Painting*, Cambridge, 1992.

Hartt, F., 'The earliest works of Andrea del Castagno', *Art Bulletin*, XLI (1959), pp. 159–81, 225–36.

Haskell, F., 'Venetian sixteenth-century painting – the legacy', in *The Genius of Venice* (1983), pp. 47–8.

Hills, P., 'Piety and patronage in Cinquecento Venice: Tintoretto and the Scuole del Sacramento', *Art History*, VI (1983), pp. 30–43.

——, 'Tintoretto's marketing', in *Venedig und Oberdeutschland in der Renaissance: Beziehungen zwischen Kunst und Wirtschaft*, ed. B. Roeck, K. Bergdolt and A. J. Martin, Sigmaringen (1993), pp. 107–20.

Hirst, M., 'Three ceiling decorations by Francesco Salviati', *Zeitschrift für Kunstgeschichte*, XXVI (1963), pp. 146–56.

——, *Sebastiano del Piombo*, Oxford, 1981.

Hochmann, M., *Peintres et commanditaires à Venise (1540–1628)* (Collection de l'Ecole Française de Rome, 155), Paris and Rome, 1992.

Holberton, P., 'Battista Guarino's Catullus and Titian's *Bacchus and Ariadne*', *Burlington Magazine*, CXXVIII (1986), pp. 347–50.

Hollingsworth, M., *Patronage in Renaissance Italy*, London, 1994.

Hood, W., 'The narrative mode in Titian's *Presentation of the Virgin*', in *Studies in Italian Art and Architecture, 15th through 18th Centuries* (Memoirs of the American Academy in Rome, 35), ed. H. Millon, Rome (1980), pp. 125–62.

Hope, C., 'A neglected document about Titian's *Danaë* in Naples', *Arte veneta*, XXXI (1977), pp. 188–9.

——, 'Titian as a court painter', *Oxford Art Journal*, 1979 no. 2, pp. 7–10.

——, *Titian*, London, 1980.

——, 'The historians of Venetian painting', in *The Genius of Venice* (1983), pp. 38–40.

——, 'The ceiling paintings in the Libreria Marciana', in *Nuovi studi* (1990), pp. 290–7.

Howard, D., *Jacopo Sansovino: Architecture and Patronage in Renaissance Venice*, New Haven and London, 1975.

——, *The Architectural History of Venice*, London, 1980.

——, 'Giorgione's *Tempesta* and Titian's *Assunta* in the context of the Cambrai

wars', *Art History*, VIII (1985), pp. 271–89.

Humfrey, P., *Cima da Conegliano*, Cambridge, 1983.

——, 'The Bellinesque Life of St Mark cycle for the Scuola Grande di San Marco in its original arrangement', *Zeitschrift für Kunstgeschichte*, XLVII (1985), pp. 225–42.

——, 'Politica e devozione: la tradizione narrativa quattrocentesca', in Lucco (1990), pp. 295–338.

——, *Carpaccio*, Florence, 1991.

——, *The Altarpiece in Renaissance Venice*, New Haven and London, 1993.

——, 'Bartolomeo Vivarini's *Saint James* polyptych and its provenance', *The J. Paul Getty Museum Journal*, XXII (1994), pp. 11–20.

——, and Mackenney, R., 'The Venetian trade guilds as patrons of art in the Renaissance', *Burlington Magazine*, CXXVIII (1986), pp. 317–30.

Huse, N., and Wolters, W., *Venedig: die Kunst der Renaissance* (1986). Eng. Trans. as *The Art of Renaissance Venice*, Chicago, 1990.

Joannides, P., 'On some borrowings and non-borrowings from central Italian and antique art in the work of Titian *c*.1510–*c*.1550', *Paragone*, no. 487 (1990), pp. 21–45.

——, 'Titian's *Daphnis and Chloë*: a search for the subject of a familiar masterpiece', *Apollo*, CXXXIII (1991), pp. 374–82.

——, 'Titian's *Judith* and its context: the iconography of decapitation', *Apollo*, CXXXV (1992), pp. 163–70.

Jacopo Bassano c.1510–92 (Catalogue of exhibition held at Bassano del Grappa, Museo Civico, and Fort Worth, Kimbell Art Museum, 1992–3), ed. B. L. Brown and P. Marini, Bologna, 1993.

Joost-Gaugier, C., 'Considerations regarding Jacopo Bellini's place in the Venetian Renaissance', *Arte veneta*, XXVIII (1974), pp. 21–38.

——, *Jacopo Bellini: Selected Drawings*, New York, 1980.

Kahr, M., 'The meaning of Veronese's paintings in the church of S. Sebastiano, Venice' *Journal of the Warburg and Courtauld Institutes*, XXXIII (1970), pp. 235–47.

——, 'Danaë: virtuous, voluptuous, venal woman', *Art Bulletin*, LX (1978), pp. 43–55.

Kaplan, P., 'Veronese's last *Last Supper*', *Arte veneta*, XLI (1987), pp. 51–62.

Kemp, M., 'The super-artist as genius: the sixteenth-century view', in *Genius: The History of An Idea*, ed. P. Murray, Oxford (1989), pp. 32–53.

Klein, R., and Zerner, H., *Italian Art 1500–1600* (Sources and Documents in the History of Art series), Englewood Cliffs, N. J., 1966.

Land, N., '*Ekphrasis* and imagination: some observations on Pietro Aretino's art criticism', *Art Bulletin*, LXVIII (1986), pp. 207–17.

Lane, F., *Venice: A Maritime Republic*, Baltimore, 1973.

La Pala Ricostituita. L'Incoronazione della Vergine e la cimasa vaticana di Giovanni Bellini: indagini e restauri (Catalogue of exhibition at Pesaro, Museo Civico, 1988–9), Venice, 1988.

Lauts, J., *Carpaccio: Paintings and Drawings*, London, 1962.

Lazzarini, L., 'The use of color by Venetian painters 1480–1580: materials and techniques', in *Color and Technique in Renaissance Painting*, ed. M. Hall, Locust Valley, N. Y. (1987), pp. 115–36.

Lazzarini, L.: *see also* Plesters.

Leonardo and Venice (Catalogue of exhibition at Palazzo Grassi, Venice, 1992), Milan, 1992.

Le Siècle de Titien: L'âge d'or de la peinture à Venise (Catalogue of exhibition at Grand Palais, Paris, 1993), Paris, 1993.

Lettere sull'arte di Pietro Aretino, ed. E. Camesasca, 4 vols, Milan, 1957. Eng. trans. in part by G. Bull as Aretino: *Selected Letters*, Harmondsworth, 1976.

Logan, O., *Culture and Society in Venice 1470–1790*, London, 1972.

Longhi, R., *Viatico per cinque secoli di pittura veneziana* (1946), ed. Florence, 1985.

Lucas, A., and Plesters, J., 'Titian's *Bacchus and Ariadne*', *National Gallery Technical Bulletin*, II (1978), pp. 25–47.

Lucco, M., *L'opera completa di Sebastiano del Piombo* (Classici dell'Arte Rizzoli), Milan, 1980.

——, 'Venezia fra Quattrocento e Cinquecento', in *Storia dell'arte italiana*, V, Turin (1983), pp. 447–77.

——, 'Il Cinquecento (parte seconda)', in *Le pitture del Santo a Padova*, ed. C. Semenzato, Vicenza (1985), pp. 165–74.

——, 'Le cosidette *Tre età dell'uomo* di Palazzo Pitti', in '*Le tre età dell'uomo*' *della Galleria Palatina* (catalogue of exhibition at Palazzo Pitti, Florence, 1989–90), Florence (1989), pp. 11–28.

——, 'Venezia 1450–1500', in Lucco (1990), pp. 395–480.

——, 'Some thoughts on the dating of Sebastiano del Piombo's S. Giovanni Crisostomo altarpiece', in Ames-Lewis (1994), pp. 40–6.

—— (ed.), *La pittura nel Veneto: il Quattrocento*, 2 vols, Milan, 1990.

Mariani Canova, G., *La miniatura veneta del rinascimento*, Venice, 1969.

——, *L'opera completa del Lotto* (Classici dell'Arte Rizzoli), Milan, 1975.

——: *see also* Canova.

Marinelli, S., 'La pala per l'altar maggiore di S. Giorgio in Braida', in *Nuovi Studi* (1990), pp. 323–32.

McTavish, D., *Giuseppe Porta called Giuseppe Salviati*, New York, 1981.

Meiss, M., *Giovanni Bellini's St Francis in the Frick Collection*, Princeton, 1964.

——, 'Sleep in Venice: ancient myths and Renaissance proclivities' (1966). Repr. in idem, *The Painter's Choice*, New York (1976), pp. 212–39.

Merkel, E., 'Un problema di metodo: la *Dormitio Virginis* dei Mascoli', *Arte veneta*, XXVII (1973), pp. 65–80.

——, 'Venezia 1430–1450', in Lucco (1990), PP. 49–79.

Meyer zur Capellen, J., *Gentile Bellini*, Wiesbaden, 1985.

Michiel: *see* Frimmel.

Mortari, L., *Francesco Salviati*, Rome, 1992.

Motzkin, E., 'The meaning of Titian's *Concert Champêtre* in the Louvre', *Gazette des Beaux-Arts*, CXVI (1990), pp. 51–66.

Muir, E., *Civic Ritual in Renaissance Venice*, Princeton, 1981.

Muraro, M., 'Un celebre ritratto. Sir Philip Sidney nel 1574 sceglie Veronese per farsi ritrarre', in *Nuovi studi* (1990), pp. 323–32.

——, *Il Libro Secondo di Francesco e Jacopo Dal Ponte*, Bassano del Grappa, 1992.

Nepi Scirè, G., 'Tiziano, *La Pietà*', *Quaderni della Soprintendenza ai Beni Artistici e Storici di Venezia*, XIII (1987), pp. 31–9.

Newton, S. M., *The Dress of the Venetians, 1495–1525*. Aldershot, 1988.
Nichols, T., 'Tintoretto's poverty', in Ames-Lewis (ed.) (1994), pp. 96–107.
Nuovi Studi su Paolo Veronese, ed. M. Gemin, Venice, 1990.
Oldfield, D., 'Lorenzo Lotto's arrival in Venice', *Arte veneta*, XXXVIII (1984), pp. 144–5.
Pallucchini, R., *I Vivarini*, Venice, 1962.
—, *Tiziano*, Florence, 1969.
—, *Bassano*, Bologna, 1982.
—, and Rossi, P., *Tintoretto: le opere sacre e profane*, Milan, 1982.
Palumbo-Fossati, I., 'L'interno della casa dell'artigiano e dell'artista nella Venezia del Cinquecento', *Studi veneziani*, n.s. VIII (1984), pp. 109–53.
Panofsky, E., *Problems in Titian, mostly iconographic*, London, 1969.
Pardo, M., 'Paolo Pino's "Dialogo di Pittura": a translation with a commentary', Ph.D. dissertation, University of Pittsburgh, 1984.
Paris Bordon (Catalogue of exhibition held in the Salone del Trecento, Treviso, 1984), Milan, 1984.
Paris Bordon e il suo tempo (Atti del Convegno Internazionale di Studi, 1985), Treviso, 1987.
Perry, M., 'A Renaissance showplace of art: the Palazzo Grimani at Santa Maria Formosa', *Apollo*, CXIII (1981), pp. 215–21.
Pignatti, T., *Giorgione* (1969), Eng. trans., London, 1971.
—, 'The relationship between German and Venetian painting in the late Quattrocento and early Cinquecento', in Hale (ed.) (1973), pp. 244–73.
—, *Veronese*, Milan, 1976.
— (ed.), *Le scuole di Venezia*, Milan, 1981.
—, and Pedrocco, F., *Veronese: catalogo completo*, Florence, 1991.
—: *see also* Franzoi.
—: *see also* Valcanover.
Pino: *see* Barocchi (1962); Pardo (1984).
Plesters, J., 'Tintoretto's paintings in the National Gallery', *National Gallery Technical Bulletin*, III (1979), pp. 3–24.
—, and Lazzarini, L., 'Preliminary observations on the technique and materials of Tintoretto', in *Conservation and Restoration of Pictorial Art*, ed. N. Bromelle and P. Smith, London (1976), pp. 7–26.
—: *see also* Lucas.
Pope-Hennessy, J., *The Portrait in the Renaissance*, Princeton, 1966.
—, *The Robert Lehman Collection I: Italian Paintings*, Princeton, 1987.
—, *Donatello Sculptor*, New York, 1993.
Prodi, P., 'The structure and organization of the church in Renaissance Venice: suggestions for research', in Hale (ed.) (1973), pp. 409–30.
Pullan, B., *Rich and Poor in Renaissance Venice: The Social Institutions of a Catholic State*, Oxford, 1971.
—, 'The significance of Venice', *Bulletin of the John Rylands Library*, LVI (1973–4), pp. 443–62.
—, 'Natura e carattere delle Scuole', in Pignatti (1981), pp. 9–26.
—: *see also* Chambers.
Puppi, L., 'Il soggiorno italiano del Greco', *Studies in the History of Art*, XIII (1984), pp. 133–50.

Raby, J., *Venice, Dürer and the Oriental Mode*, London, 1982.

Rearick, W. R., 'Battista Franco and the Grimani chapel', *Saggi e memorie di storia dell'arte*, II (1959), pp. 107–39.

——, 'Jacopo Bassano's later genre paintings', *Burlington Magazine*, CX (1968), pp. 241–9.

——, 'Jacopo Bassano and Mannerism', in Branca and Ossola (1984), pp. 289–311.

——, *The Art of Paolo Veronese* (Catalogue of exhibition held at National Gallery of Art, Washington, 1988–9), Cambridge, 1988.

——, 'The 'twilight' of Paolo Veronese', in *Crisi e rinnovamenti nell'autunno del Rinascimento a Venezia*, ed. V. Branca and C. Ossola, Florence (1991), pp. 237–53.

——, 'From Arcady to the barnyard', in *The Pastoral Landscape* (*Studies in the History of Art*, XXXVI), ed. J. Dixon Hunt, Washington (1992), pp. 137–59.

Richardson, F., *Andrea Schiavone*, Oxford, 1980.

Ridolfi, C., *Le maraviglie dell'arte* (1648), ed. D. von Hadeln, 2 vols, Berlin, 1914–24.

——, *The Life of Tintoretto* (1642), ed. C. and R. Enggass, University Park and London, 1984.

Rigoni, E., 'Giovanni da Ulma è il pittore Giovanni d'Alemagna?' (1937), in idem, *L'arte rinascimentale in Padova*, Padua (1970), pp. 51–6.

Robertson, C., '*Il Gran Cardinale*'. *Alessandro Farnese, Patron of the Arts*, New Haven and London, 1992.

Robertson, G., *Giovanni Bellini*, Oxford, 1968.

——, 'The x-ray examination of Titian's *Three Ages of Man* in the Bridgewater House Collection', *Burlington Magazine*, CXIII (1971), pp. 721–6.

Roeck, B., *Arte per l'anima, arte per lo stato. Un doge del tardo quattrocento ed i segni delle immagini* (Quaderni del Centro Tedesco di Studi Veneziani, 40), Venice, 1991.

Rogers, M., 'Reading the female body in Venetian Renaissance art', in Ames-Lewis (ed.) (1994), pp. 75–88.

Rosand, D., '*Ut pictor poeta*: meaning in Titian's *poesie*', *New Literary History*, III (1972), pp. 527–46.

——, *Titian*, New York, 1978.

——, *Painting in Cinquecento Venice: Titian, Veronese, Tintoretto*, New Haven and London, 1982.

——, 'Giorgione, Venice and the pastoral vision', in *Places of Delight: the Pastoral Landscape* (Catalogue of exhibition held at National Gallery of Art, Washington, 1988), Washington, 1988, pp. 21–81.

——, 'So-and-So reclining on her couch', in *Titian 500* (1994), pp. 101–19.

Roskill, M., *Dolce's 'Aretino' and Venetian Art Theory of the Cinquecento*, New York, 1968.

Rossi, P., *Jacopo Tintoretto: i ritratti*, Venice, 1974.

——: *see also* Pallucchini.

Ruggeri, U., 'La decorazione pittorica della Libreria Marciana', in Branca and Ossola (1984), pp. 313–33.

Rupprich, H., *Dürer. Schriftlicher Nachlass*, I, Berlin, 1956.

Rylands, P., *Palma Vecchio*, Cambridge, 1992.

Sandberg-Vavalà, E., 'The reconstruction of a polyptych by Michele Giambono', *Journal of the Warburg and Courtauld Institutes*, X (1947), pp. 20–6.

Sansovino, F., *Delle cose notabili che sono in Venetia*, 2nd edn, Venice, 1561.

——, *Venetia città nobilissima et singolare* (1581), ed. G. Martinioni, Venice, 1663.

Saxl, F., 'Jacopo Bellini and Mantegna as antiquarians' (1935), repr. in idem, *A Heritage of Images*, London (1970), pp. 57–70.

Schmitt: *see* Degenhart.

Schulz, J., 'Vasari at Venice', *Burlington Magazine*, CIII (1961), pp. 500–11.

——, *Venetian Painted Ceilings of the Renaissance*, Berkeley, 1968.

——, 'Tintoretto and the first competition for the Ducal Palace *Paradise*', *Arte veneta*, XXXIV (1980), pp. 112–26.

Settis, S., *La Tempesta Interpretata* (1978). Eng. trans. as *Giorgione's 'Tempest': interpreting the hidden subject*, Chicago, 1990.

Sheard, W. S., 'Giorgione's *Tempesta*: external versus internal texts', *Italian Culture*, IV (1983), pp. 145–58.

——, 'Giorgione's portrait inventions *c.*1500: transfixing the viewer', in *Reconsidering the Renaissance* (Medieval and Renaissance Texts and Studies, XCIII), ed. M. A. Di Cesare, Binghampton, N. Y. (1992), pp. 141–76.

——, 'Antonio Lombardo's reliefs for Alfonso d'Este's *studio di marmi*', in *Titian 500* (1994), pp. 315–57.

Shearman, J., 'The Chigi chapel in S. Maria del Popolo', *Journal of the Warburg and Courtauld Institutes*, XXIV (1961), pp. 129–60.

——, *The Early Italian Pictures in the Collection of Her Majesty the Queen*, Cambridge, 1983.

——, *Only Connect . . . : Art and the Spectator in the Italian Renaissance*, Princeton, 1992.

Simonetti, S., 'Profilo di Bonifacio de' Pitati', *Saggi e Memorie di Storia dell'Arte*, XV (1986), pp. 83–133.

Sinding-Larsen, S., *Christ in the Council Hall: Studies in the religious iconography of the Venetian Republic* (*Acta ad Archaeologiam et Artium Historiam Pertinentia*, V), Rome, 1974.

Smyth, C. H., 'Venice and the emergence of the High Renaissance in Florence', in *Florence and Venice* (1980), I, pp. 209–49.

Sohm, P., *Pittoresco: Marco Boschini: His Critics and their Critiques of Painterly Brushwork in Seventeenth- and Eighteenth-Century Italy*, Cambridge, 1991.

Sponza, S., 'Osservazioni sulle pale di San Giobbe e di San Zaccaria di Giovanni Bellini', *Arte veneta*, XLI (1987), pp. 168–75.

Sricchia Santoro, F., *Antonello e l'Europa*, Milan, 1986.

Steer, J., *A Concise History of Venetian Painting*, London, 1970.

——, *Alvise Vivarini: His Art and Influence*, Cambridge, 1982.

Tardito, R., 'Il restauro della *Predica di San Marco in Alessandria d'Egitto di Gentile e Giovanni Bellini*', *Arte veneta*, XLII (1988), pp. 258–66.

Tempestini, A., *Giovanni Bellini*, Florence, 1992.

The Genius of Venice 1500–1600 (Catalogue of exhibition held at the Royal Academy of Art, London, 1983–4), ed. J. Martineau and C. Hope, London, 1983.

The Memoirs of Philippe de Commynes (1465–98), ed. S. Kinser, trans. I. Cazeaux, 2 vols, Columbia, S. C., 1969.

Thiébaut, D., *Le Christ à la Colonne d'Antonello de Messine* (Les Dossiers du Musée du Louvre), Paris, 1993.

Titian: Prince of Painters (Catalogue of exhibition held at Doge's Palace, Venice, and National Gallery of Art, Washington, 1990–1), Venice, 1990.

Titian 500 (Center for Advanced Study in the Visual Arts, Symposium Papers XXV, ed. J. Manca), *Studies in the History of Art* XLV, Washington, D.C., 1994.

Tiziano e Venezia: Convegno Internazionale di Studi, 1976, Vicenza, 1980.

Trevor-Roper, H., *Princes and Artists: Patronage and Ideology at Four Habsburg Courts 1517–1633*, London, 1976.

Turner, A. R., *The Vision of Landscape in Renaissance Italy*, Princeton, 1966.

Valcanover, F., and Pignatti, T., *Tintoretto*, New York, 1985.

Van der Sman, G. M., 'Un studio iconologico sull'*Endimione dormiente* e sul *Giudizio di Mida* di Cima da Conegliano: pittura, poesia e musica nel primo Cinquecento', *Storia dell'arte*, LVIII (1986), pp. 197–203.

Vasari, G., *Le vite de' più eccellenti pittori, scultori ed architettori* (2nd edn, 1568), ed. G. Milanesi, 9 vols, Florence, 1878–85. Eng. trans. in part by G. Bull as *Lives of the Artists*, 2 vols, Harmondsworth, 1965–87.

Watson, P., 'Titian and Michelangelo: the *Danaë* of 1545–6', in *Collaboration in Italian Renaissance Art*, ed. J. Paoletti and W. S. Sheard, New Haven and London (1978), pp. 245–54.

Weddigen, E., 'Thomas Philologus Ravennas, Gelehrter, Wohltäter und Mäzen', *Saggi e Memorie di Storia dell'Arte*, IX (1974), pp. 7–76.

Westphal, D., *Bonifazio Veronese*, Munich, 1931.

Wethey, H., *The Paintings of Titian*, 3 vols, London, 1969–75.

Wilde, J., 'Die "Pala di San Cassiano" von Antonello da Messina', *Jahrbuch der Kunsthistorischen Sammlungen in Wien*, III (1929), pp. 52–72.

——, *Venetian Art from Bellini to Titian*, Oxford, 1974.

Wittkower, R., 'Giorgione and Arcady' (1963), in idem, *Idea and Image*, London (1978), pp. 161–73.

Wolters, W., *Der Bilderschmuck des Dogenpalastes. Untersuchungen zur Selbstdarstellung der Republic Venedig im 16. Jahrhunderts*, Wiesbaden, 1983.

——: *see also* Franzoi.

——: *see also* Huse.

Yates, F., *Astraea: The Imperial Theme in the Sixteenth Century*, London, 1975.

Zampetti, P., and Sgarbi, V. (eds), *Lorenzo Lotto: Atti del Convegno Internazionale di Studi per il V Centenario della Nascita (Asolo, 1980)*, Venice, 1981.

Zapperi, R., *Tiziano, Paolo III e i suoi nipoti: nepotismo e ritratto di Stato*, Turin, 1990.

——, 'Alessandro Farnese, Giovanni della Casa and Titian's *Danaë* in Naples', *Journal of the Warburg and Courtauld Institutes*, LIV (1991), pp. 159–71.

Zeri, F., 'Un *San Girolamo* firmato di Giovanni d'Alemagna', in *Studi di storia dell'arte in onore di Antonio Morassi*, Venice (1971), pp. 40–9.

—— (ed.), *La pittura in Italia: il Quattrocento*, 2 vols, Milan, 1987.

Index

311

313

316

318

Photograph Credits

Antella (Florence), Scala, 4
Berlin, Staatliche Museen Preussischer
 Kulturbesitz, 38, 64, 68, 88
Brussels, Koninklijk Instituut voor het
 Kunstpatrimonium, 195
Budapest, Szépmüvészeti Múzeum, 159
Cambridge, Deborah Howard, 85
Cambridge, Fitzwilliam Museum, 123
Dresden, Staatliche Kunstsammlungen, 14,
 133, 165
Edinburgh, National Galleries of Scotland,
 98, 99, 102, 152, 153, 158
Florence, Alinari, 24
Florence, Berenson Collection, 30
Frankfurt, Ursula Edelmann, 69
Göteborgs Konstmuseum, 140
Hampton Court, Royal Collection, © 1994
 Her Majesty Queen Elizabeth II, 133
Hartford, Wadsworth Atheneum, 144
London, British Museum, 33, 34, 43, 60
London, National Gallery, 2, 15, 47, 53, 55,
 65, 78, 79, 94, 95, 103, 110, 124, 125,
 134, 172, 174
Lovere, Accademia Tadini, 41
Madrid, Museo del Prado, 118, 151, 162,
 171, 184
Madrid, Patrimonio Nacional, 155
Malibu, J. Paul Getty Museum, 29, 66, 127,
 182

Modena, Soprintendenza per i Beni Artistici
 e Storici di Modena e Reggio Emilia, 160
New York, Frick Collection, 59
Paris, Bulloz, 142
Paris, Réunion des Musées Nationaux, 26,
 31, 77, 97, 126, 141, 183
Parma, Soprintendenza per i Beni Artistici e
 Storici di Parma e Piacenza, 72, 106
Pasadena, Norton Simon Museum, 76
Prague, National Gallery, 84
Rome, Monumenti Musei e Gallerie
 Pontificie, 44
Venice, Böhm, 5, 7, 10, 17, 19, 23, 35, 37,
 39, 46, 61, 63, 64, 73, 74, 86, 93, 107,
 108, 109, 112, 115, 116, 129, 130, 136,
 145, 146, 147, 156, 163, 164, 166, 167,
 168, 169, 170, 173, 175, 176, 177, 180,
 187, 188, 189
Venice, Mario Fernato, 71
Venice, Mark Smith, 25
Venice, Museo Correr, 6, 9, 20, 75, 92
Verona, Soprintendenza per i Beni Artistici e
 Storici del Veneto, 40, 143, 178
Vienna, Kunsthistorisches Museum, 90, 91,
 96, 105, 121, 132
Washington, National Gallery of Art, 13,
 80, 101, 104